ART AN

Materializing
Art History

MATERIALIZING CULTURE
· ·
Series Editors: Paul Gilroy, Michael Herzfeld and Danny Miller

Barbara Bender, *Stonehenge: Making Space*

Laura Rival (ed.), *The Social Life of Trees: Anthropological Perspectives on Tree Symbolism*

Materializing
Art History

GEN DOY

Oxford • New York

First published in 1998 by
Berg
Editorial offices:
150 Cowley Road, Oxford, OX4 1JJ, UK
70 Washington Square South, New York, NY 10012, USA

Berg is an imprint of Oxford International Publishers Ltd.

Library of Congress Cataloging-in-Publication Data

A catalogue record for this book is available from the Library of
Congress.

British Library Cataloguing-in-Publication Data

A catalogue record for this book is available from the British Library.

ISBN 1 85973 933 4 (Cloth)
 1 85973 938 5 (Paper)

Typeset by JS Typesetting, Wellingborough, Northants.
Printed in the United Kingdom by Biddles Ltd, Guildford and King's
Lynn.

Dedicated to Av and Liz, Mary and Ruth . . . with love and thanks for all the time you've spent with me.

Contents

Acknowledgements

Thanks to the staff of De Montfort University Library, especially the staff in the inter-library loans section. I am also grateful to the Research Committee of the School of Arts and Humanities, De Montfort University, for funding to help with the costs of photographs and permissions. I have attempted to contact all the copyright holders. However I was not always successful. If there are any who would like to contact me, I would be happy to rectify omissions.

I am greatly indebted to Adrian Lewis for his meticulous reading of my manuscript and his very helpful comments, and to my editor Kathryn Earle at Berg Publishers, who was her usual efficient and cheerful self throughout the production of this book. I was helped enormously by the Pat Hearn Gallery and the Jack Tilton Gallery, New York, who lent me slides of Lyle Ashton Harris' and Renée Green's work. Marie-Cécile Miessner sent me material I needed from France, for which, as always, many thanks. Grateful thanks too to Lucy Marder and her successor at Jersey Museums, Louise Downie, for all their help with material on Claude Cahun. Very many thanks to David King for sending me a photo of Zina Bronstein from his collection, and to Helen Kornblum, for kindly allowing me to reproduce a Modotti photograph. Martin Richards lent me some of his collection of books on left politics and culture for which I am, as always, grateful. I am also indebted to Paul Mason and Keith Hassell for help with information about Ernest Mandel and various aspects of Marxism, politics and culture in the twentieth century. Special thanks to Pete Challis for finding me a new computer at a crucial stage in the preparation of this book.

Throughout the book any words in square brackets are my additions to quoted texts.

Finally, thanks and love to my sons Sean and Davey for giving me some peace to get on with preparing and writing this book. I am a very fortunate parent.

List of Figures

Introduction

As I write this introduction, I exist in a society whose leading cultural theorists and news media invite me to situate myself in the 'new world order' and accept the demise and disintegration of Marxism. No doubt my readers will be in the same position, since they are likely to encounter this book in one of the countries positioned within the dominant imperialist economies of the world. Some readers conversant with postmodern theoretical writings may also be wondering why I am addressing them resolutely in the first person from a conscious authorial position as an individual subject, when the death of the author and the individual subject in history, society and psychic space have been proclaimed. As will become clear in this book, I accept neither of these arguments, so will not be speaking/writing as "I". Why then am I engaged in a project to re-examine social histories of art and re-formulate a Marxist approach to the study of culture, since the Marxist method has apparently been proved disastrously wrong, and the existence of an imperialist 'new world order' self-evident? Can't we all conclude from what we see and hear daily that a new world situation exists, demanding new theoretical approaches and shifts within our understanding of ourselves and our position within contemporary society, culture and politics? The terms postmodern and postcolonial denote new cultural, economic and political formations which apparently require a revision, in part or perhaps in totality, of previous oppositional theoretical approaches to culture and its historical development.

It will be my argument in the course of this book that Marxism, far from being proved inadequate and flawed by the events of twentieth century history, still provides the best methodological framework from which to understand culture and its living historical development. Indeed I will argue that the Marxist strand within 'the social history of art' needs to be retrieved and refocused. I want clearly to distinguish,

and distance, Marxism from Stalinism. I will also be attempting to show how various figures and theoretical approaches within the non-Stalinist left contributed to a tradition of Marxist analysis of visual culture. I want to examine what Marxism actually is, what its theoretical method entails, and what the relationship of Marxism was and is to the rise of Stalinism and the collapse of the bureaucratically controlled societies of Eastern Europe in the period after 1989. I will seek to show that Marxism had very little to do with these societies after the late 1920s, hence their collapse cannot be regarded as a proof of Marxism's failure. However it is also important to recognize that the Marxist tradition itself has suffered serious setbacks, and that organizations throughout the world which seek to continue and refocus the political theories of Marxism are themselves fragmented and split. Of course Fascism and Stalinism played a significant part in this disintegration, but material, objective factors such as physical violence, isolation, and legal and political persecution were not completely responsible. Errors by the Marxist left and failure to grapple with new problems and developments thrown up by imperialism in its modern phase since the end of the Second World War cannot simply be blamed on adverse material conditions in which political and cultural theoreticians and activists of the left must operate. I will also be considering weaknesses in Marxist thought which need to be addressed, for example, the lack of a Marxist theory of the human subject.

Throughout this book I will be arguing that conscious thought plays an important role in historical events, whether cultural or political. Marxism argues that both objective (material circumstances) and subjective factors (human consciousness) interact in historical and social change. When material circumstances are overwhelmingly unfavourable to Revolution, no amount of subjective will by small numbers of people can change this. However, in favourable situations with a strong and conscious working-class leadership correctly analysing the situation, things are very different. Yet all too often Marxist organizations in the twentieth century have failed to take advantage of objective material conditions, for example in May 1968 in France. Marxism itself must be subjected to a political and historical analysis to see why mistakes were made, and why many Marxists and/or Marxist sympathizers rejected Marxism and materialism and moved increasingly in the later twentieth century to an analysis of history and culture based on idealist thinking.

The fragmentation of the left and of Marxism in the present period might at first sight imply that Marxists should accept the main thrust

of many arguments put forward by the theorists of postmodernism. Surely, they might argue, the fragmentation of the left is simply another example of the universal disintegration of so-called master narratives, the fragmentation and impossibility of achieving consciousness, either as an individual or as a collective class-conscious organization or social grouping. I will be arguing in this book that the premises on which many postmodernist arguments are based are flawed, and indeed idealist, and that they fail to explain developments in contemporary culture and society because they give too much weight to the images, signs and texts of contemporary culture, and subordinate the material reality from which these cultural products emerge to a very minor role, as for example in the writings of Baudrillard. The fragmentation, alienation and lack of understanding experienced individually and collectively by many people in contemporary society is not inevitable, but can be explained and understood theoretically, and I hope to show that Marxism can still enable us to do this.

However this will mean (re-)examining all sorts of terms that are largely taken for granted, or else thought to have been long ago dismissed as useless by many cultural theorists on the left, such as imperialism, class, consciousness, Marxism and the like. For example Marxism is still regularly dismissed by writers who appear to know little of it, and who perpetuate misunderstandings about Marxism, not by argument and academic discussion, but by assertions and statements. Another problem is the persistence of the notion, even among scholars who are sympathetic to Marxist theory, of Marxism as economic determinism. For example in a recent anthology on critical terms in art history, Terry Smith, writing on 'Modes of Production', describes Marxism as 'inescapably, systemic determination' and 'inflexible determinism'.[1] An example of the former type of less sympathetic and knowledgeable but equally dismissive assessment can be seen in a recent book, *Critical Aesthetics and Postmodernism*, where Paul Crowther states that the 'neo-marxism' of Fredric Jameson fails to deal adequately with postmodern society and suggest a response to it. Now while I have some areas of agreement with this view, which I will discuss at greater length when I look later at Jameson's writing, I would take issue with the method used by Crowther to deal with Jameson's approach. Crowther writes as follows: 'This (Jameson's failure) reflects fundamental problems which have always bedevilled Marxism; namely its continuing failure to articulate theoretically a positive theory of the relationship between the individual agent and broader socio-historical forces; and to clarify the relation between the cultural superstructure

and socio-economic infrastructure of society.'[2]

It is not difficult to find discussions of the problems mentioned by Crowther in Marxist texts, and it is true that they have been the subject of much debate by left cultural theorists.[3] However the fact that not all Marxists agree about these questions does not mean they do not have theories about them. In fact Crowther does not explain what a 'positive theory' on these questions might mean (as opposed to a negative one), and in fact if Marxist theorists did not have differences it would probably be interpreted in a negative way by opponents of Marxism and taken as a proof that all Marxists were party hacks and were incapable of independent thought.

Not surprisingly, Crowther goes on to argue that Kant, not Marx, is a more fruitful model for those who want to understand the postmodern.[4] This is a position that is very common at present, and I want to examine the reasons for this more fully later on. Rather than revisit Marx and subsequent Marxist writers, cultural theorists are much happier to turn to the work of pre-Marxist writers, and especially philosophers. Hegel's influence is commonly met with in some recent books, especially those of Fredric Jameson, while Lynda Nead discusses the Kantian sublime in a book on the female nude, and references to the Kantian notion of the simulacrum in discussions of visual art are not uncommon.[5] Not just Kant and Hegel but also F.W.J. Schelling, a lesser known German philosopher, have been taken as models for an understanding of developments in postmodernist culture not only by writers who see themselves as critical of Marxism, but by writers who see themselves as Marxists. Slavoj Žižek, for example, sees himself as a Marxist, but his publisher's catalogue describes the main emphasis of his new book as follows:

> F.W.J. Schelling, the German idealist who for too long dwelled in the shadow of Kant and Hegel, was the first to formulate the postidealist motifs of finitude, contingency and temporality. His unique work announces Marx's critique of speculative idealism, as well as the properly Freudian notion of drive, of a blind compulsion to repeat which can never be sublated in the ideal medium of language.[6]

Marxists and non-Marxists alike appear not just to have retreated to pre-Marxist theoreticians for models with whose help they can understand the world in the late twentieth century, but, also significantly, to have decided to take their methodological lead from philosophers. Of course anyone who has read any Marx and Engels

knows what the problem with philosophers is – as the famous quote points out, they 'have only *interpreted* the world, in various ways; the point, however, is to *change* it.'[7] In the course of this book I will be asking why it is in the late twentieth century that a number of cultural theorists are turning to pre-Marxist philosophy, rather than to Marx and Engels themselves. Is this because academics have accepted rigorously formulated arguments that Marxism has failed as a political body of theory that can be utilized to understand the contemporary world and its culture, or is it because they did not understand, or did not want to understand, Marxism in any case? Or if they do utilize Marxism, do they turn Marxism into a philosophical rather than a revolutionary mode of thought?

In discussing this, I also want to ask, what is, or could be, a Marxist theory of cultural production and meaning, and what does this entail for the practice of the art and cultural historian/theorist? What questions does it raise for the existence of this book and my own intervention into the current debates in cultural theory as it relates to class, gender, 'race' and other disputed theoretical categories and/or constructs?[8]

The various chapters of this book will attempt to clarify the issues set out above by discussing what I consider the most useful debates that arise in trying to put a Marxist approach to visual culture back on the agenda in the late twentieth century. This book is not attempting to be a history of Marxist thought, nor a comprehensive history of attempts to relate Marxism to cultural products, nor a detailed discussion of Marxist aesthetics. Rather, by identifying some key issues I want to restate and refocus some previously discussed views, but also to tackle some issues that Marxist approaches to visual culture have tended to shy away from, such as non-figurative painting, for example, or issues of 'race' and representation. Also, by identifying the different strands in Marxist thought and their relation to the study of visual culture, I want to show why different practitioners of Marxist art history and 'the social history of art' took the theoretical positions that they did and what practical consequences this has had.

Chapter one will explain what Marxist method and theory is, and how it depends on dialectical materialism. Some of the major criticisms of Marxism will be examined and refuted, such as its supposed economism and 'blindness' to conceptualizing issues of 'race' and gender while emphasizing class. In order to understand some of the criticisms levelled at Marxism I will also set out briefly what happened to Marxism after Marx and Engels, and what happened in the Soviet Union after

1917, since events in the Soviet Union are seen as irrefutable proof that Marxism as a theoretical tool for understanding the world and changing it for the better has failed dismally. It is necessary to understand these historical developments in order to understand why contemporary Marxist cultural theorists themselves offer little in terms of a revival and refocusing of Marxist theory, given their considerable disorientation.

The second chapter will examine the trend within art history and cultural studies known as 'the social history of art'. Taking T.J. Clark, a major Marxist art historian, as a central figure in this and the following chapter, I want to look at what 'the social history of art' has come to mean now, and the various strands within it. Not all of them are radical, by any means. In an important article, often quoted, published in the *Times Literary Supplement* in 1974, Clark put forward his proposals for re-establishing a 'social history of art', which would concentrate and sharply focus a re-elaborated method, rather than exist in 'cheerful diversification' with other fragmented and proliferating approaches in art and cultural history.[9] In fact what I will show is that the situation which Clark argued against more than twenty years ago is similar to what we have today, where even within radical spheres of cultural history and criticism an interest in Marxism (or even an interest in class) is only one of many existing and diverse strands. I want to show how Clark himself unwittingly contributed to the confusion about what 'the social history of art' might actually be, by avoiding a discussion about how a Marxist social history of art would not necessarily be the same as a 'social history of art'. This is made more confusing by writers who offer versions of social history and sociology of art, for example Janet Wolff, which are neither Marxist nor based on dialectical materialism, but which posit themselves as radical, and indeed contain a great deal of interesting material.

The following chapter will further investigate the differences between 'the social history of art' and Marxist art history, asking in particular whether social historians of art are socialists, and, if so, of what sort? This raises the issue of the application of Marxism as a body of theory divorced from any political practice. So what might the practice of the Marxist cultural theorist and historian actually be? In addition, if the writer claims to be, or is generally recognized to be, Marxist, what kind of Marxism is usually espoused by such writers? By considering the work of Max Raphael, Meyer Schapiro and T.J. Clark, I will examine these issues with the intention of showing that the Marxism of these writers stems from a particular tradition which has split off Marxism

as a method of understanding visual culture, from Marxism as a method of politically transforming society. In Clark's case I want to show how his understanding of Marxism situated his theory and practice (briefly as a member of the Situationist International) within an anti-party, anti-Bolshevik and ultra-left version of Marxist politics. This explains in some measure his apparent rejection of any practical political activity in favour of radical cultural intervention.

Chapter four will discuss issues of politics, gender and visual imagery by examining the work of two women photographers working in the 1920s and 30s, Claude Cahun (pseudonym of Lucy Schwob), and Tina Modotti. Cahun's alignment with the Trotskyist opposition to Stalinism in the 1930s will be examined in relation to Modotti's association with the Communist Party and her work for the Stalinists in Spain and other parts of Europe. I want to situate their photographic works within the context of left politics of the period, and to examine how debates about art and forms of representation, gender and sexuality intersect with them. In discussing Cahun's association with the Surrealists and her lesbianism, I also want to consider psychoanalysis in relation to Marxism, and theories of the unconscious in relation to the conscious mind of the individual and the class. In order to examine these issues I will also discuss the film *Zina* (1986), directed by Ken McMullen, whose central character is Trotsky's daughter Zina Bronstein. From my research on this material, I would argue that there is a pressing need for work on a Marxist theory of the human subject to understand fully the situation of the individual in relation to class, sexuality, gender and 'race' in a dialectical materialist way. Much of the recent influential work on some of these issues, for example the work on the subject and the materiality of bodies by Judith Butler, has confused some important theoretical categories of enquiry.

In chapter five I want to consider examples of Marxist writing on non-figurative art. Marxists have been generally reluctant to discuss this kind of work, being much happier with representational art which can be analysed in terms of its subject matter, imagery, patronage, relation to social history and so on. They have been correctly criticized, in my view, for avoiding more 'difficult' kinds of paintings. I will argue that it is essential to apply a Marxist method to the understanding of all culture of whatever representational mode, and will look at Marxist writings on Cubism and American Abstract Expressionism, and Althusser's writings on Cremonini to attempt to discuss issues raised by the approaches of various writers, including T.J. Clark.

The final chapter will focus on the influential book by Jameson,

Postmodernism: The Cultural Logic of Late Capitalism. Having teased out where Jameson is coming from in terms of the Marxist tradition, I want to look at whether he is correct in his identification of the differences between the modern and the postmodern, and his assessment of the economic, political and cultural situation in the late twentieth century. His discussion of Van Gogh's painting of *Old Boots* (or *Old Shoes*) will be examined in relation to what John Walker, Meyer Schapiro and others say about the *Old Boots* and art historical method. I also want to discuss whether the approach of Jameson is indeed a historical one or whether he (and other key postmodern theorists) are philosophers rather than art or cultural historians. As philosophers, do they situate themselves outside possible criticisms based on historical or dialectical materialist methods? The problem is also raised as to whether it is theoretically possible for the postmodern artwork to exist, since if we cannot truly know reality, situate ourselves in history or be a coherent conscious subject, by what means can we transform material reality into art? What is the relation of postmodern theory to visual art practice? Can the actual art works produce meanings which go beyond the theories of postmodernism which insist that totalizing approaches to history and culture are now impossible? It appears that postmodern art can effectively engage with cultural discourses and reject or modify them, thereby undermining the argument that there is nothing that can escape construction and/or creation by discourse.

Regarding postmodernism and late twentieth-century capitalism, I will argue that the fragmented and confused state of 'the social history of art', and much other radical writing on the cultural history seems to be part and parcel of many radical academics' move away from, rejection (or ignorance of) Marxism, and espousal of postmodern theories without any adequate method to situate themselves in relation to these theories or to criticize them. The reasons for this are ultimately to be found in the material conditions of late twentieth century culture and society, in the political disorientation and pessimism of liberals and much of the left in what Jameson (and Mandel) describe as late capitalism. The way forward is not to retreat to a pre-Marxist situation where Kant and Hegel are the best available models, and the proletariat has hardly yet come into being. This is more a means of avoiding the current economic, political and cultural situation with all its problems, than actively engaging with it, understanding its contradictions, and seeking a way forward. An essential part of this engagement is to refocus the Marxist method on our situation in the world today, neither to dismiss it as a thing of the past and 'a dead letter', nor to gut Marxism

of its political and interventionist thrust in order to make it a phil-
osophy in which to express the erudite observations of cultural
theoreticians. Also important is the need to develop Marxism creatively
as a living body of thought practised by actual people in a material
historical situation, as 'sensuous practice', not as an objectified thing.

Developing the examination of new areas for a Marxist art and
cultural history, I will also be looking in the final section of the book
at some recent writings on 'race', black culture and the visual arts.
Crucial to this will be a discussion of the use and understanding of the
term postcolonialism. Does this term obscure the real economic, polit-
ical and cultural relations of imperialism and semi-colonial countries,
and issues of immigration, political asylum, deportation, citizenship
and identity? What implications does the postmodern periodisation
of twentieth century economy and history have for the theory and
practice of black art and culture in the postmodern age? By looking at
writings by some postcolonial critics, and art works by contemporary
black artists based in the USA, I again want to question the contention
that Marxism has little to offer in terms of an understanding of issues
of 'race' and culture.

It was interesting for me to note the publication of a collection of
previously published articles by Fred Orton and Griselda Pollock just
as I finished the first draft of this book. This indicated to me that there
was a perceived revival of interest in the origins of 'the social history
of art', a desire by academics to situate themselves within its formation
and elaboration, as well as an awareness by their publishers that here
was a marketable commodity. Of course my book also, cannot escape
such commodification as I attempt to communicate with my largely
unknown and anonymous readers in a capitalist publishing and
academic 'marketplace'. Pollock and Orton write that their collaborative
teaching and writing practices should be understood as examples of 'a
historical intervention in, and effect of, a particular moment'.[10] I too
would view my work, in some senses, in a similar way. However rather
than return like Orton and Pollock to the period 1972–82 and review
and revisit the reconstruction of Marxist and/or social histories of art
in Britain and the USA I want to unequivocally situate a refocused
Marxist social history of art in the present, at the close of the twentieth
century. Pollock and Orton close their introduction by writing: 'If
nothing else, the essays brought together here . . . will serve as a
collection of documents ready to be transformed into monuments for
an, as yet, unwritten archaeology of the social history of art.'[11] This
book excavates the remains and survivals of Marxist cultural history

with such an archaeology in mind, but the term archaeology suggests a relegation to the past, rather than a living presence and future potential. My archaeology is not of the type envisaged by Foucault. My suggested archaeology is directed towards a utilization of the past in order to understand the present and lay the groundwork for possible future interventions in debates on visual culture, and wider social issues.

Notes

1. T. Smith, 'Modes of Production', in R.S. Nelson and R. Schiff, *Critical Terms for Art History*, Chicago and London, 1997, p.240 and p.244.

2. P. Crowther, *Critical Aesthetics and Postmodernism*, Oxford, 1993, p.ix.

3. For example *Marxism and Art: Essays Classic and Contemporary*, ed. M. Solomon, 1979 is a readily available selection of Marxist texts on ideology, base and superstructure, the individual and the collective subject in history as well as many other issues.

4. Crowther, p.xii.

5. L. Nead, *The Female Nude: Art, Obscenity and Sexuality*, London and New York, 1992. Nead uses Lyotard's writings to gain access to Kant. Marcia Pointon used the notion of the simulacrum to discuss the flower paintings of the English artist Mary Moser in a paper given in Brighton accompanying an exhibition devoted to the work of Angelica Kauffmann in 1993.

6. Verso publisher's catalogue, Spring, 1996, p.9, referring to S. Žižek, *The Invisible Remainder: Essays on Schelling and Related Matters*.

7. K. Marx, 'Theses on Feuerbach', no.xi, in K. Marx and F. Engels, *Selected Works in One Volume*, London, 1973, p.30.

8. I am using 'race' as I do not believe that there are scientific grounds for existence of this social and cultural category.

9. *Times Literary Supplement*, May 1974, p.562, column 1.

10. F. Orton and G. Pollock, *Avant-gardes and Partisans Reviewed*, Manchester and New York, 1996, p.viii.

11. Ibid., p.xxi.

Marxism and Dialectical Materialism

In this opening chapter I want to look at what Marxism actually was, and is, so as to lay down a secure basis for developing the discussions which follow in subsequent chapters. I will look first of all at the method of Marxism and its development by Marx and Engels in order to clarify some misunderstandings, for example, the view that Marxism is economic determinism. Also I will look at how Marx developed his method out of the idealist philosophy of Hegel, superceding it. This will be important later when we consider attempts to split the method of Engels from that of Marx, and designate the former as a scientific but crude materialist, and the latter as a sophisticated philosopher in the tradition of the great German thinkers such as Kant and Hegel. Engels is then denigrated as a kind of early version of the unsubtle party hack, while Marx, especially the early Marx, is respected as a subtle and sensitive humanist.

It is obviously important to explain and emphasize the anti-idealist trajectory of Marx and Marxism, since this is of fundamental importance in developing a critique of the greater part of contemporary postmodern theory. Within the Marxist method of dialectical materialism I want to situate some comments on art and culture by Marx and Engels, not to investigate their opinions on particular types of art, but to show how they conceived the relationship of art and culture to particular economic and social formations. In conclusion I want to situate briefly the development of Marxism after Marx and Engels within historical and political developments in the twentieth century.

Obviously I cannot do this in great detail given the space available, but it important to be aware of some profoundly important factors which have influenced contemporary theorists' views of Marxism and its successors, such as Trotskyism. For example I will be discussing the

rise, development, and recent disintegration of Stalinism in order to show that Stalinism is not Marxism, and therefore arguments which base themselves on the evidence of the collapse of Eastern Europe governments since 1989 to prove that Marxism has failed are fundamentally flawed. It is also important to draw attention to the continuation of Marxist method in the writings and practice of Trotsky, since most cultural theorists working within a Marxist framework have tended to ignore Trotsky, preferring to situate themselves in relation to figures such as Gramsci, Lukács, Korsch and so on. I will look at possible reasons for this in a later chapter.

The Method of Marxism

First of all, it is necessary to remind ourselves that Marx' and Engels' main priorities were to understand capitalist society and build organizations of politically conscious workers and their allies in order to destroy this society based on profit, and move on to construct a socialist society based on production to meet needs, thus paving the way for a communist society free of all oppression and alienation. In his early writings Marx attempted to elaborate a theoretical and methodological framework concerned with being and knowledge, matter and thought. Struggling through the work of German idealist philosophers, he found their idealism unsatisfactory, but in Hegel discovered a contemporary form of dialectical thinking within this idealism which he wanted to preserve and turn into a modern dialectical materialism. Hegel saw the material world as uninterrupted movement and development. Nothing is fixed and everything is unstable due to contradictory forces within it. The struggle between these two principles results in a higher synthesis of both. Hegel saw this as the result of the Idea or the Spirit unfolding itself through the material world and determining its evolution.

Ludwig Feuerbach, a follower of Hegel, argued that the Absolute Idea did not determine material life but that, on the contrary, Being determines Consciousness. This clearly materialist position argued that ideas and thoughts ultimately arose in human minds from a conscious being's situation in material reality, and not the other way around. However Marx criticized Feuerbach for remaining within the realms of philosophy and argued that, having understood the world, we should go on to change it, and the key social force which must assume the task of changing society through revolution is the proletariat or industrial working class.[1]

Marx's materialist method was the basis of his life's work as a theorist and political figure. In *Capital*, he states:

> My dialectical method is not only different from the Hegelian, but is the direct opposite. To Hegel, the life-process of the human brain, ie. the process of thinking, which, under the name of "the Idea", he even transforms into an independent subject, is the demiurgos of the real world, and the real world is only the external form of "the Idea". With me, on the contrary, the ideal is nothing else than the material world reflected by the human mind, and transformed into forms of thought.[2]

For Marx and Engels the brain itself was the highest form of matter, capable of generating thought that could itself transform material reality.

Marx and Engels certainly did not believe at this point that they had said the last word on human scientific and philosophical cognition of the world. For the dialectical materialist, nothing could be final or absolute in terms of truth. As Engels put it: 'It [dialectical thinking – GD] reveals the transitory character of everything and in everything; nothing can endure before it except the uninterrupted process of becoming and of passing away, of endless ascendancy from the lower to the higher. And dialectical philosophy itself is nothing more than the mere reflection of this process in the thinking brain.'[3] Is the material world and, for example, cultural development, simply then a confusing mess in constant flux? What exactly is dialectical materialism and can it enable us to better understand the development of human history and culture, if it cannot offer any final truths?

Drawing on work by Marx and himself, notably *The German Ideology* (1845), *Critique of Political Economy* (1859) and volume one of *Capital* (1867), Engels wrote between 1876 and 1878 a polemical book restating the dialectical materialist method. This was known for short as *Anti-Dühring*. The book was intended to break the German Social Democratic Party politically from the dangerous ideas of Professor Eugen Karl Dühring (1833–1921) who had joined the party as an influential bourgeois intellectual and was denigrating the work of Marx, Engels, and indeed all previous socialists, and propagandizing for his own 'socialitarian' system. Marx was working as hard as he could to complete the remaining volumes of *Capital*, so it fell to Engels, encouraged by Marx, to refute Dühring's arguments as a matter of political urgency.[4]

Engels outlines the difference between the dialectical materialist conception of human history, and dialectical materialism which

encompasses the whole of nature. At the same time Engels shows the similarity of dialectical processes at work in both social history and nature. Because human beings are conscious and have the ability to transform their material surroundings through thought and labour, members of human societies are not the same as, for example, a cluster of crystals. Engels repeatedly distinguishes between the spheres of natural history, human history and human thought, while preserving an awareness of their interconnections. However his method of investig-ation and argument was scientific in that he argued that the laws of thinking must correspond to the objects of thought, the world, the universe and its laws. The laws of dialectics had to be discovered in human society and in nature, not artificially built onto them utilizing a system of thought unrelated to its objects.[5]

Again in *Ludwig Feuerbach*, Engels discusses the methodological errors of philosophic systems, the way they ignore material reality, and the way in which the material reality of human societies also has its lawfulness, which can be understood by the dialectical materialist:

> But what is true of nature, which is hereby recognized also as a historical process of development, is likewise true of the history of society in all its branches and of the totality of all sciences which occupy themselves with things human . . . Here too, the philosophy of history, of right, of religion, etc., has consisted in the substitution of an interconnection fabricated in the mind of the philosopher for the real interconnection to be demonstrated in the events; has consisted in the comprehension of history as a whole as well as in its separate parts, as the gradual realisation of ideas – and naturally always only the pet ideas of the philosopher himself. According to this, history worked unconsciously but of necessity towards a certain ideal goal set in advance – as, for example, in Hegel, towards the realisation of his absolute idea – and the unalterable trend towards this absolute idea formed the inner inter-connection in the events of history . . . In nature – in so far as we ignore man's reaction upon nature – there are only blind, unconscious agencies acting upon one another, out of whose interplay the general law comes into operation . . . In the history of society, on the contrary, the actors are all endowed with consciousness, are men acting with deliberation or passion, working towards definite goals; nothing happens without a conscious purpose, without an intended aim. But this distinction, important as it is for historical investigation, particularly of single epochs and events, cannot alter the fact that the course of history is governed by inner general laws . . . the conflicts of innumerable individual wills

and individual actions in the domain of history produce a state of affairs entirely analogous to that prevailing in the realm of unconscious nature.[6]

So what are these laws which enable us to understand change and development in the material world and in human society, given the distinctions which need to be drawn between the two spheres, while always bearing in mind their interconnectedness? All things need to be understood not as separate entities, but as interconnected and in continual development, as a complex of processes. As Trotsky later put it: 'Dialectical thinking is related to vulgar thinking in the same way that a motion picture is related to a still photograph. The motion picture does not outlaw the still photograph but combines a series of them according to the laws of motion.'[7] This also entails the dialectical interaction between abstraction and concretization:

> Striving toward concreteness, our mind operates with abstractions. Even "this", "given", "concrete" dog is an abstraction because it proceeds to change, for example, by dropping its tail the "moment" we point a finger at it. Concreteness is a relative concept and not an absolute one: what is concrete in one case turns out to be abstract in another: that is, insufficiently defined for a given purpose. In order to obtain a concept "concrete" enough *for a given need* it is necessary to correlate several abstractions into one – just as in reproducing a segment of life upon the screen, which is a picture in movement, it is necessary to combine a number of still photographs.[8]

That is to say that the concepts of concrete and abstract are not fixed, but constantly changing, and attempts to theorize concrete moments and their implications need to bring abstractions to bear on the situation. For example, if we decide we need to buy a tin of dog food for a concrete dog, various detailed instances indicative of the dog's hunger combine to convince us that, conceived as a totality, the dog's behaviour signifies an abstract concept of dog hunger which we cannot possibility experience concretely ourselves. So the concrete is different from the empirical, and should not be conflated with it. The concrete and the abstract interact and interpenetrate.

Laws of Dialectics

The laws of dialectics are set out by Engels as follows. Firstly, the unity and interpenetration of opposites. No single thing is to be regarded as

fixed or static, as being absolutely identical to any other thing, or even (as a result of its constant motion) as being identical to a fixed or static version of itself. On the contrary, the motion of each object is impelled by inner contradictions, by an antagonistic relationship between differing aspects of its composition. To take an example (not used by Engels!) from the sphere of art history, a painting by Van Gogh is a painting by Van Gogh. It should be identical to itself and remain so. Aside from debates about whether it is or not a genuine Van Gogh painting, partly by Van Gogh, a forgery etc., as a material object it is constantly changing according to ageing processes of the materials of which it is constructed, changes in temperature, deterioration of paint, changes in colour due to chemical alteration of the materials making up the pigments, etc. This is only to take account of what is internal to the picture itself. Given that the work cannot exist as a static isolated object but is related to the totality of material and human life that surrounds it, any advances in Van Gogh scholarship may change the meaning of the work, a feminist scholar may intervene in academic discourse about the work, for example, thereby changing the meanings of the work. It can never again be what it was before. Though it preserves elements of what constituted it before, it is nevertheless now different. It has now superceded its previous meaning and being. Take also the case of, for example, two Van Gogh paintings of old boots or shoes. Commonsense logic would say that these were two versions of the same thing, or, abstracting from this, two Van Gogh paintings. Concretely, however, we would ultimately have to conclude that they were different because they would both be part of processes, changing and developing along the lines described above, and not static, and their relationship to one another would also be changing. Therefore not for even a short time would one Van Gogh painting be identical to another, or two Van Gogh works remain in exactly the same relationship to one another. This is true whether we view the painting as an object in itself as part of inanimate nature, or as part of human cultural history. For ultimately it is human labour, in this case that of Vincent Van Gogh, that has transformed materials into something other than these materials, and through this process this labour constructs artefacts that certain societies call art. The manual and intellectual labour of art historians and museum staff also contributes to processes of change.

The second law of dialectics states that quantity is transformed into quality. Gradual changes in an object's development eventually reach a point at which the thing itself is transformed. Engels here refers to processes of life and death, which are not sudden but gradual, and

specifically gives the example of the development of the embryo within the mother's body. The embryo at a certain point becomes a being capable of sustaining independent life, although still within the mother's body, and this is quantity (size, number of weeks' development, number of bodily functions, etc.) transformed into quality. However this will not happen at the same point in every case, and indeed sometimes it will not happen at all, even when the baby is born. Human society interacts with these processes of nature, for example, by attempting to fix laws to regulate essentially contradictory and unstable processes of foetal development, or to carry out medical research which will enable (some) foetuses to become children. As Engels points out, legal scholars have 'cudgelled their brains in vain to discover a rational limit beyond which the killing of the child in its mother's womb is murder. It is just as impossible to determine absolutely the moment of death, for physiology proves that death is not an instantaneous momentary phenomenon, but a very protracted process.'[9] Notions of the transformation of quantity into quality have not really been extensively discussed by art historians in a focused way. However it might be fruitful to consider the emergence of visual styles and some of the debates surrounding notions of, for example, Realism or Impressionism with a view to investigating the way an increasing use of a number of artistic features becomes qualitatively something different. Although many students of art history are aware of the problems of such terms as Impressionism and Post-impressionism, we cannot simply refuse to recognize that important changes did occur in later nineteenth century French painting. If we do not like the style labels as explanatory concepts theorizing artistic change, we need some other theories of historical development and lawfulness to put in their place, otherwise we risk reverting to the famous view that history is 'one damn thing after another'.

 Lastly we need to understand the concept of the negation of the negation, the most important law of Marxist dialectics. In some ways, this last law incorporates and unites all the others. In the course of the unfolding of inner contradiction, a change in the quality of an object takes place. Yet the original object is not merely obliterated by a separate thing which takes its place. A more complex process occurs by which the original thing and the prevailing force that transforms it are both themselves transcended and replaced by a new higher development incorporating aspects of the character of both. A classic Marxist example of this process is the development of capitalism. Within itself, and essential to its own existence, capitalism develops the proletariat who

have nothing but their labour power to sell to the capitalist, and whose labour power is the source of surplus value and profits. However this essential part of capitalism, and its contradiction, is driven to oppose the capitalists and destroy the system as a whole. By negating the capitalist system, the proletariat will also destroy itself as a class. It will gradually lose its identity as the proletariat since, after it has abolished capitalism, there will be no need for bourgeoisie and proletariat and so class society and classes will gradually disappear. The negation is itself negated. To take a much more mundane example of this process in art, we could look at art movements which seek to undermine or even destroy the whole notion of high art. In Dada, for example, we can see the attempt, especially by the Berlin members of Dada, to destroy concepts of aesthetic worth and market value. However in negating this, Dada itself negated its own nihilism by drawing attention to itself as a cultural movement with a body of theory and practice, thereby negating its own attempts to destroy culture. Similarly we could see such a process in certain aspects of Pop art, where high culture is challenged and negated by images of popular mass culture, only for this new Pop art to enter the domain of high culture, the museum, gallery and art market. Obviously, though, we cannot view these processes in the art world as separate from the totality of capitalist social and economic relations in which they exist, so these brief examples are inevitably lacking in complexity.

Engels argues that all truth is relative, though it is scientifically knowable. Truth can only be established through interaction with the objective world. In natural sciences this is done by observation, analysis and experiment. In the historical (social) sciences it has to be done through the gathering of economic, social and political data, analysing it and verifying it in theory-guided practice.[10] Obviously as more information is discovered, intellectual theories advance, and scientific discoveries progress. The basic foundations of knowledge will change and previous knowledge will be superceded.

Engels argues also that truth is relative to the sphere of its investigation. Scientific and mathematical truths concerning inanimate nature he says, can be more accurately researched than, for example, the development of living organisms. The most inexact results, he says, can be found in the scientific investigation of human society, social relationships, politics and legal formations, 'with their ideological superstructure in the shape of philosophy, religion, art, etc.'[11] While we can test our method and findings in a scientific way, we should never expect to study art and culture with the aim of discovering total

certainties, absolute truths and watertight, immutable conclusions. What we can do, however, is to attempt to apply the method advocated by Marx and Engels which will enable us to conceptualize in thought (and in speech and writing) the contradictions and complexities in actual living culture of particular historical periods, including our own.

For dialectical materialists, there is no impenetrable boundary between relative and absolute truth. However as Lenin explains in a later defence of Engels' thought, we should avoid falling into relativism as a basis of knowledge. Relativism not only recognizes the relativity of our knowledge, which is all well and good, but, unfortunately, denies any objective model to which our relative knowledge approximates. What we should be seeking in our use of dialectical materialism in a scientific way, says Lenin, is 'the *correspondence* between the consciousness which reflects nature and the nature which is reflected by consciousness.'[12]

This also applies to thought directed towards the understanding of human society. This is to say, the methods by which we analyse history, economics, art or whatever, need to be constantly related to, and engaged with, the actual processes and developments in our field of study.

The Object of Study

In an excellent discussion of Marx's method in *Capital*, volume one, Ernest Mandel examines how the use of a dialectical materialist method enabled Marx to understand the workings of capital, and also how this method resulted in a particular method of setting out his arguments and conclusions. In the postface to the second edition, 1873, Marx states:

> Of course the method of presentation must differ in form from that of inquiry. The latter has to appropriate the material in detail, to analyse its different forms of development and to track down their inner connection. Only after this work has been done can the real movement be appropriately presented. If this is done successfully, if the life of the subject-matter is now reflected back in the ideas, then it may appear as if we have before us an *a priori* construction.[13]

The final exposition may appear so accurate in its correspondence with the material studied, that it may appear to have been worked out prior to the actual investigation, however this is not what has happened.

Mandel explains that, having gathered all the empirical facts, and grasped the given state of knowledge, then a dialectical reorganization of the material can be carried out in order to understand the given field of enquiry as a totality. 'If this is successful', says Mandel, 'the result is a "reproduction" in man's thought of this material totality.'[14] Mandel shows how Marx delves further and further into successive layers of phenomena towards the uncovering of laws of motion which can explain why and how these phenomena evolve. However these upper layers are no less real than their hidden interrelations. Their 'appearance' needs to be interrogated and the reasons for particular concrete manifestations of, for example, capital, need to be understood in terms of the basic forces and contradictions which lie beneath them. Mandel explains how this method functions in Marx's analysis of capital.

> In fact, he starts from elements of the material concrete (the commodity) to go to the theoretical abstract, which helps him then to reproduce the concrete totality in his theoretical analysis. In its full richness and deployment, the concrete is always a combination of innumerable theoretical "abstractions". But the material concrete, that is, real bourgeois society, exists before this whole scientific endeavour, determines it in the last instance, and remains a constant practical point of reference to test the validity of the theory. Only if the reproduction of this concrete totality in man's thought comes nearer to the real material totality is thought really scientific.[15]

If we relate this to the study of art/cultural history, we can see that the aim is to evolve a method and approach which is scientific ie. which seeks to focus investigative thought processes as closely as possible to the actual changes and developments of the material under scrutiny. Theories should not be constructed apart from the material, and then applied to them from 'outside'. Nor should theory be conceptualized as something which brings into being and constructs the object of study, which has no reality outside the discourse of the theorist.

It ought to be clear from this that a Marxist method is not an easy short-cut to facile conclusions, such as, art is all ideology, Impressionism is bourgeois art, proletarian art is better than modernist art, etc. Such statements, as well as the supposed economic determinism of Marxist methods of understanding material and social life are distortions of dialectical materialist method. By this stage we should also be aware that both Marx and Engels developed and utilized this method, in

theory as well as in practice, and it is wrong to claim that Marx was fundamentally at odds with Engels in terms of his approach. I want to look briefly at this last point in more detail, since it is significant for much of the discussion that follows in this book.

Engels vs. Marx?

It is not unusual to find arguments which seek to split Engels from Marx, and portray Engels as a crude and rigid theoretician who tried to turn the study of history and nature into a series of wooden predictions about the inevitable victory of socialism, the goal towards which all natural and human life was teleologically directed. Thus Engels is made responsible for Stalinism and all undialectical versions of Marxism which succeeded him. Actually Marx and Engels always thought socialism could only succeed capitalism if brought about by conscious individuals. There was no inevitability about social development other than to say that if socialism did not triumph over capitalism, the end result would be barbarism.

On the other hand, Marx is portrayed as an intellectually sophistic-ated philosopher, whose thought was distorted by Engels after his death. In the 1920s and 1930s there had already been a reaction against the so-called 'scientism' of the Second International, an international organization of workers' movements which succeeded the First Inter-national and collapsed when most of its members decided to side with their own ruling classes on the outbreak of the First World War.

Lukács and Gramsci wanted to improve Marxism and cleanse it of Engels' influence, which was seen as a factor in the politics of the Second International. Eduard Bernstein, in particular, sought to question the dialectical and revolutionary aspects of Marxism, confining the working-class movements to immediate reforms in economic and political conditions. Bernstein rejected Marx's theories of capitalist crisis, and looked instead to the then current revival of interest in Kant's ideas. Following Kantian theory, Bernstein believed that certain knowledge of the natural and historical world was something we could not achieve. He concluded from this that the aims of socialists had to be modest and reformist.[16] In this context Engels' supposed exposition of a mechanically evolving historical process leading to socialism was used to absolve political leaders of the responsibility of formulating political strategies and a programme for the overthrow of capitalism. They could just wait for it to happen.

Lukács and Gramsci wanted to improve Marxism by a return to Hegel,

rather than Kant, appealing to philosophy rather than science, a trend we can see quite clearly in the late twentieth century in the work of a number of radical academics and intellectuals. However, Lukács and Gramsci did not divorce their theory entirely from political practice, unlike many of their later admirers. The two attacked Karl Kautsky from this standpoint, and, along with other left intellectuals in the 1930s, were probably only prevented from attacking Engels because of the oppressive bureaucracy of Stalinism, whose line in politics and aesthetics Lukács was eventually to toe.

Attacks on Engels multiplied as the so-called New Left emerged in the 1960s, including Marxist and 'post-Marxist' writers such as Lucio Colletti, Louis Althusser and Lesek Kolakowski. To take just one example, George Lichtheim in 1961 stated that socialism came to reflect the 'materialist doctrine' expounded by the late works of Engels. This led to 'the transformation of Marxism into a "scientific" doctrine emptied of genuine philosophic content – and hence powerless to stop the inrush of romantic irrationalism which began in the 1890s and reached a disastrous climax in the 1930s'. Stockton rightly comments that this view makes Engels responsible for Stalinism and even for fascism.[17] The assault on Engels reached a climax in the 1980s in the work of such writers as Levine and Carver.

It is a distortion of reality to claim that Marx was the creator of Marxism, and Engels responsible for its distortion as the following examples should show. Marx read much of Engels' work before it was published, including the *Anti-Dühring*, and contributed a chapter to the book.[18] Without engaging in any long polemical debates we can see the similarity in approach between Marx and Engels later in the nineteenth century by reading the postface to the second edition of *Capital* written by Marx himself. He provides a very long quotation taken from a review of his book by I.I. Kaufman, a Russian Professor. Marx quotes this reviewer approvingly, stating that his views give an excellent account of *Capital*. Kaufman writes:

> Marx treats the social movement as a process of natural history, governed by laws not only independent of human will, consciousness and intelligence, but rather, on the contrary, determining that will, consciousness and intelligence . . . In short, economic life offers us a phenomenon analogous to the history of evolution in other branches of biology . . . that social organisms differ among themselves as fundamentally as plants or animals . . . The scientific value of such an enquiry lies in the illumination of the special laws that regulate the origin, existence, development

and death of a given social organization and its replacement by another, higher one. And in fact this is the value of Marx's book.

Marx comments: 'Here the reviewer pictures what he takes to be my own actual method, in a striking and, as far as concerns my own application of it, generous way. But what else is he depicting but the dialectical method?'[19] Thus Marx agrees that he saw the study of economics and society as scientific, and subject to the same laws as natural history. This is what Engels is accused of doing to distort Marx's more subtle approach.

The application of a dialectical materialist method does not, of course, exist in a vacuum, but in a specific historical totality. Thus a formal understanding and exposition of the main principles of dialectical materialism can sometimes be accompanied by anti-Marxist politics, especially when actual material reality is distorted to 'fit' the theory. Take for example, Stalin's writings on dialectical and historical materialism, published under his direct supervision (of course) in 1938. Dialectical materialism is explained using quotations from Engels and Lenin, in particular. While there is nothing exactly wrong with how Stalin explains the method, it is applied in a formalistic and wooden way. First, it is described as the world outlook of the Marxist-Leninist party, and, once the party follows the guiding star of dialectical materialism, it can do no wrong. Because the party has followed the correct policies, developed in line with dialectical materialism, the USSR is socialist and 'because of this, economic crises and the destruction of productive forces are unknown.'[20] This assertion, from the political leadership responsible for forced collectivisation and the ensuing mass slaughter of livestock by the peasantry, as well as famine and death by starvation and in labour camps, can hardly be said to reflect in thought the material reality of the USSR at the time. Furthermore, the world situation and the impending outbreak of war, and Stalin's erratic political swings between ultra-left and opportunist positions in the 1930s are of course ignored.

Similarly Maurice Cornforth, in a more recent work on dialectical materialism, gives quite a useful explanation of the main principles and laws of dialectical materialist thought, but then uses this to prove that 'schematic' blue-prints are wrong because, contrary to the claims of Trotsky (and others of course), socialism *can*, after all, be built in one country. The achievements of the Soviet Union prove this, asserts Cornforth.[21] Dialectical materialism can therefore be divorced from political and social reality by, for example, Stalinist theoreticians, just

as it can be divorced from politics and made into a philosophy by modernist and postmodernist theoreticians such as Adorno and Jameson. An understanding of dialectical materialism as a method cannot be abstracted from its social and historical context at any given time and of course individuals who put it into practice.

Hegel on Art and Culture

Now that we have some understanding of dialectical materialism, and how the development of this method enabled Marx and Engels to supercede Hegel's dialectics of idealism, I want to look briefly at what this means for Marx's and Engels's views of the relationship of culture to its material social existence, and how this differed from Hegel's understanding of art.

Hegel's essays on aesthetics were written up from notes made from lectures he delivered, the section on painting dating from 1829. In his *Aesthetics*, Hegel had traced the realisation of the Spirit in an ascending movement through cultural history. For Hegel, forms of art and culture were the means by which men (and women) organized sensuous data in such a way that the presence of the Idea became recognisable. The visual and plastic arts for Hegel were inferior to religion and philosophy in their ability to manifest the Idea. However, art played an important role in paving the way for philosophy, the only producer of real knowledge. The sensuousness of artistic activity was therefore, not surprisingly, seen by Hegel as something to be overcome on the way to a higher goal.[22] This is very different from Marx's notion of material reality as 'sensuous practice'.

Hegel designates the symbolic stage of art as primarily expressed in architecture. The next stage is the classical, primarily expressed in sculpture, where the human form reveals the spiritual in sensual form, and represents man as he ought to be, a perfect fusion of mind and matter. However sculpture should be concerned with form, not emotions. Sharp, pointed forms are to be avoided, since they give the impression of the physical rather than the spiritual and the ideal. For example 'old fussy wenches' nagging and bickering should be avoided, as should nudity, which is animal, and the covering of nudity shows the artist's perception of the ideal.[23] Moving on to the Romantic phase of art, by which Hegel means medieval and Renaissance art, we find the highest form of man's spiritual struggles to present the Idea. All this is driven by an underlying force which urges man to express it in material form. Yet not all human beings have reached this stage.

According to Hegel, black people were still in the childhood stage of humanity and did not possess 'the Idea' and therefore could not produce art as such.[24] However, by the early nineteenth century, argues Hegel, this Romantic and Christian spirit is in decay, and art no longer concerns itself with the Idea, as, for example, Raphael did. Now art concerns itself with everything and anything, and can develop no further. The Idea can only be grasped from now on by thought. This rather dismal idealist view of art has little in common with the cultural theories of Marx and Engels, who were concerned to locate the production of culture in sensuous material life, not as the emanation of some Idea. Sensual enjoyment of visual or tactile art is seen as suspect by Hegel, since it obviously belongs to a lower order of existence than the spiritual. In fact, for a dialectician, Hegel's theory of artistic development is strangely lacking in dialectics, and he does not explain particularly well why certain forms of art succeed one another when they do, other than to point to the unfolding of the Idea in different forms throughout history. His assertion that religion no longer plays a leading role in the creative urges of modern artists is stated but not investigated to discover the reasons for this change. He very rarely mentions conflict or contradiction, other than to cite it as a motivation for great art. For example social conflicts, the individual pitted against society, can result in an ideal action which can then be made into an exemplar of the ideal in art.[25]

However, Hegel's thoughts on the nature of painting as compared with the other arts are quite interesting and thought-provoking. Painting, says Hegel, is more concerned with individual feelings than sculpture:'Painting, that is to say, opens the way for the first time to the principle of finite and inherently infinite subjectivity, the principle of our own life and existence, and in paintings we see what is effective and active in ourselves.'[26] Painting can be seen in two ways, as visual appearance and as a representation of something other than itself, but both are ultimately understandable as manifestations of the Spirit – 'painting as representation and as painting is pure appearance of the inner spirit contemplating itself.'[27] Both the formal technique and invention of painterly means of representation, and the subject matter are ultimately determined by subjectivity, realized when the inner spirit becomes aware of itself:'The chief determinant of the subject-matter of painting is, as we saw, subjectivity aware of itself.'[28] Hegel then interestingly argues for a form of visual modernism, that painting must press on 'to the extreme of pure appearance, i.e. to the point where the content does not matter and where the chief interest is the artistic

creation of that appearance.'[29]

The reduction from three to two dimensions is part of the principle of inwardness and inferiority of painting, and indeed constitutes an advance in abstraction over sculpture, an advance seen by Hegel as necessary. Painting cancels out the real existing thing and transforms it into a pure appearance, which is a higher form than the real object or thing. The spirit can only reveal its spiritual quality by negating the real and turning it into a pure appearance destined for apprehension and comprehension by the spirit. The real must be destroyed as the real, yet reconstituted by art for the spirit, for the spirit cannot be aware of itself other than through an object of its perception, but this object cannot be an ordinary material object existing independently of the spirit. Hegel puts it thus:

> In painting, however, the opposite (from sculpture) is the case, for its content is the spiritual inner life which can come into appearance in the external only as retiring into itself out of it. So painting does indeed work for our vision, but in such a way that the object which it presents does not remain an actual total spatial natural existent but becomes a reflection of the spirit in which the spirit only reveals its spiritual quality by cancelling the real existent and transforming it into a pure appearance in the domain of spirit for apprehension by spirit.[30]

The emphasis on the two-dimensionality of painting as an advance on sculpture constituting the abstract specificity of painting sounds similar to Clement Greenberg's definition of modernism at some points, but it is firmly rooted in German idealist philosophy in its insistence in reading everything as a manifestation and embodiment of the spirit. It is also clear that Hegel is not pointing the way forward to completely abstract or non-figurative painting, since he talks about reading the subject-matter too as a manifestation of the spirit, and gives up on painting in the modern period in favour of a more abstract art, that of philosophy. However, this whole discussion is interesting in terms of attempts by T.J. Clark to offer a Hegelian reading of Jackson Pollock's work, which I shall consider later.

Marx and Engels on Culture

I want now to look at Marx's and Engels's views on the relationship of art to society, not in any great detail, for much has been written about this topic, but to distinguish them from those of Hegel.[31] Also I want

to make it clear that Marx and Engels did not take a crude deterministic view of art and culture. What we need to understand is their method, and whether it can be refocused, re-utilized and applied to art of later periods which has very little in common with the art of the period in which the two men wrote.

I do not think Marx's and Engels's views on the relationship of art to society have much to do with debates on modernism vs. realism, since such debates from the 1920s onwards relate to a specific historical and political situation which I would want to separate from the actual theoretical method of Marx and Engels. This whole debate is something of a red herring, if this is not the wrong expression in such a context, and sets up the whole debate in terms of Marx (and anyone later who is seen following in Marx's footsteps) as a materialist and therefore an advocate of realism, and modernists (whether theoreticians, practitioners of abstract thought or creative art) as anti-realists.

Jameson, in an essay written 1977, does not succeed in breaking out of this rather false opposition of the two positions, and states, confusing things further, that 'The originality of the concept of realism, however, lies in its claim to cognitive as well as aesthetic status.'[32] As we have already seen above, dialectical materialism sees the relationship of the concrete and the abstract as essential, and real, concrete material reality needs to be apprehended also by abstract thought and method, so it is not really the case that Marxists, as materialists and also dialecticians, would automatically be realists, advocate realist art (because it is concrete) and a realist/naturalist technique, etc. Nor would they necessarily be opposed to forms of art which abstract from material reality in dialectical relationship to concrete phenomena, since this is what the dialectical method is supposed to do anyway. Processes of abstraction are not dismissed by materialism. Jameson, in any case, prefers to turn to Lukács and/or Hegel for models of abstract method, thus perhaps giving the impression that there is none to be found in Marx.[33] However, in examining issues of concrete and abstract thought, realism and non-objective art, we need to avoid confusing and conflating processes of *theoretical abstraction* and *abstract painting*. Yet there are many occasions when the two interact and influence one another, as we shall see in a later chapter.

Engels, in a letter to W. Borgius in January 1894, set out his views on the relationship of culture to its material situation.

Political, juridical, philosophical, religious, literary, artistic, etc. development is based on economic development. But all these react upon one

another and also upon the economic basis. It is not that the economic situation is *cause, solely active,* while everything else is only passive effect. There is, rather, interaction on the basis of economic necessity, which *ultimately* always asserts itself ... So it is not, as people try here and there conveniently to imagine, that the economic situation produces an automatic effect. No. Men make history themselves, only they do so in a given environment, which conditions it, and on the basis of actual relations already existing, among which the economic relations, however much they may be influenced by the other – the political and ideological relations, are still ultimately the decisive ones, forming the keynote which runs through them and alone leads to understanding ... The further the particular sphere which we are investigating is removed from the economic sphere and approaches that of pure abstract ideology, the more shall we find it exhibiting accidents in its development, the more will its curve run zigzag.[34]

This was written by the late Engels, who, according to some, was a mechanistic determinist who wished to submit living reality to a scientific straightjacket, but as we see here his argument is nothing like the caricature drawn of it.

Engels was quite clear that people who thought he and Marx were suggesting that historical development of human and material life could be determined with scientific and mathematical precision were totally distorting their views. In a letter to J. Bloch Engels writes the following:

According to the materialist conception of history, the *ultimately* determining element in history is the production and reproduction of real life. More than this neither Marx nor I have ever asserted. Hence if somebody twists this into saying that the economic element is the *only* determining one, he transforms that proposition into a meaningless, abstract, senseless phrase. The economic situation is the basis, but the various elements of the superstructure – political forms of the class struggle and its results, to wit; constitutions established by the victorious class after a successful battle, etc., juridical forms, and even the reflexes of all these actual struggles in the brains of the participants, political, juristic, philosophical theories, religious views and their further development into systems of dogmas – also exercize their influence upon the course of the historical struggles and in many cases preponderate in determining their *form.*

The complex interaction of these many factors and their sometimes obscure relation to economics, means the understanding of historical development is a matter for in-depth study and comprehension. 'Otherwise the application of the theory to any period of history would be easier than the solution of a simple equation of the first degree.'[35]

However Engels acknowledged that he and Marx had not developed a fully rounded exposition of their views in certain respects. He wrote to Franz Mehring in 1893 that he and Marx had concentrated their efforts on stressing how political legal and other ideological factors arose from basic economic facts. 'But in doing so we neglected the formal side – the ways and means by which these notions, etc. come about – for the sake of content. This has given our adversaries a welcome opportunity for misunderstandings and distortions . . .'[36] Processes of thought exist in their own historical time, but the thinker and creator of these thoughts and concepts believes them to be solely the product of her/his own consciousness. S/he does not always see that they could be bound by the limitations of his/her predecessors, or indeed that they have some 'more remote source independent of thought', as Engels puts it. He and Marx, he admits, did not pay sufficient attention to showing how thought, culture, religion, legal theory, etc. took particular *forms* in their dialectical relation to economics. This lack of attention has bedevilled Marxist cultural history almost since Engels wrote these letters in the 1890s, as we shall see in more detail later. Various forms of Marxist cultural history have been far happier relating content to specific historical, political and economic conjunctures, than analysing both form and content within the theoretical model.

Much earlier, in his 'Preface to *A Contribution to the Critique of Political Economy*' of 1859, Marx also set out his view that relations of production were the real basis for a legal and political superstructure, 'to which correspond definite forms of social consciousness.' With a conflict between the relations of production and the material productive forces, a period of social revolution begins. Thereafter, the superstructure is transformed. Marx adds the following point:

In considering such transformations, a distinction should always be made between the material transformation of the economic conditions of production, which can be determined with the precision of natural science, and the legal, political, religious, aesthetic or philosophical – in short ideological – forms in which men become conscious of the conflict and fight it out.[37]

However, Marx did not consider that everything in the superstructural sphere was totally ideological. As Slaughter points out, in the *Theories of Surplus Value* Marx states that there are both ideology *and* advances in cultural achievement embodied in spiritual production of each historical epoch. Criticizing Storch, Marx states that because the latter did not conceive material production at a specific historical stage 'he deprives himself of the basis on which alone can be understood partly the ideological component parts of the ruling class, partly the free spiritual production of this particular social formation.'[38]

Marx and Engels hardly mentioned painting and other visual arts in their writings, since they were much more concerned with the practical application of dialectical materialism to the understanding and over-throw of capitalism than with devoting themselves to a study of culture. However it should be clear from the above that they did not see culture as an unproblematic reflection of economics or class ideologies. As far as we can tell, Marx did not seem to regard painting as a reflection or symbol of anything in the material world in any simplistic way. In *A Contribution to the Critique of Political Economy*, he draws an analogy between the material relationship of money to value, and painted forms to the real world. Coins made of precious metal, and even more so, coins made of base metal, become worn out and therefore are not worth what they signify socially and economically. Their value is therefore arbitrarily established by law, which also deprives forgeries of value. The coins are symbols of valuable coins, not because they are valuable, but because they have little or no value. They can only have a symbolic existence, because they cannot be symbols of themselves, they can only symbolize something else:

> . . . in this way the process of circulation converts all gold coins to some extent into mere tokens or symbols representing their substance. But a thing cannot be its own symbol. Painted grapes are no symbol of real grapes, but are imaginary grapes. Even less is it possible for a light-weight sovereign to be the symbol of a standard-weight sovereign, just as an emaciated horse cannot be the symbol of a fat horse.[39]

Therefore for Marx, painted forms are not symbols of things in nature. They have an ontological status of their own, and their being made in a 'realistic' way should not alter this fact. Any painted representation will have its own status whether it is naturalistic or non-figurative, although obviously there was no non-figurative art in Marx's day. Thus

we should not assume that Marxists would advocate realistic art as a form of privileged knowledge above other types of art.

Marx is probably thinking here of the classical story of the public competition between the artists Zeuxis and Parrhasios. Zeuxis fools birds into taking painted grapes for real grapes, but Parrhasios tricks Zeuxis into attempting to pull back drapery that is only painted. In a discussion of more modern examples of such *trompe l'oeil* painting by the French artist Boilly, Susan Siegfried proposes to read such works as examples of male artists' games which had the potential to reveal 'the fiction of men's symbolic visual ownership of art'. She also points out that Baudrillard has argued that 'the effect of these simulacra is to throw radical doubt on the very principle of reality'.[40] This is hardly surprising, since Baudrillard seems to find that anything at all throws doubt on the existence of reality!

The painting exists in a social context, as part of real material life, but it does not have to represent it, and, according to Marx' observations above, it cannot in any case, since a painting will represent itself, it will not be a symbol of what it represents. For Marxists this certainly does not throw any doubt on the existence of material reality. However just like the coins, a painting can be evaluated and defined socially, culturally and even legally, in a particular historical period, for example by copyright laws, by the institutions of museums and art galleries, by arts funding bodies, public and private collectors, teaching institutions and the art press, etc. Similarly the value of the painting is not primarily based on what pigments it is made of, or the gilding on its frame, but the amount of socially necessary labour it contains, and in that sense it is a commodity embodying relations between people transformed into relations between things, in a similar way to the coins.

However the painting is different to the coin since, at certain historical periods, we expect the painting to represent (or symbolize) something other than itself in a concrete way, as opposed to the more abstract way in which social relations are embodied in money. However the painting need not do this, since it remains a representation, an imaginative construct. Hence there is no theoretical barrier within Marxism to conceptualizing the status of painting as painting which does not symbolize anything in the material world, of painting which is nothing but itself. The reasons why certain Marxists have focused on realist art rather than non-figurative art are therefore social and historical rather than already embedded within Marxist theory. This point must be emphasized.

Marxism after Marx

Having looked at Marx's and Engels's methods of conceptualizing the relationship of art to society, I want to close this chapter by briefly examining the development of Marxism after Marx, and giving a necessarily rather general overview of related political developments. Obviously within the space I have, I cannot give a comprehensive view of political and social history in the later nineteenth and first half of the twentieth century, but some awareness of this is necessary to understand issues which will be raised in subsequent chapters. It would be wrong to discuss the ideas of Marxist art and cultural historians without some idea of the political and historical trajectory of Marxism within which these ideas on culture need to be situated. I do not intend here to discuss the period after the Second World War, since that relates to the issue of postmodernism which will be discussed in the final chapter. In the course of this political and historical overview, I will be mentioning individuals who will appear again in later chapters, not because they are the most important or interesting Marxists, but because they have influenced certain Marxist art historians whose work has been important to the discipline and who have demonstrated allegiance to a particular strand within Marxism and/or the social history of art.

Marx and Engels hoped that the First International (1864–1876) would prove to be the basis of a communist international workers' organization. After the defeat of the Paris Commune in 1871 and the ensuing climate of political reaction accompanied by demoralisation in the European workers' movement, arguments for communism were under attack, particularly from the anarchist Bakunin and his organization. Rather than see the International fall under Bakunin's control, Marx and Engels allowed it to collapse. From the experience of the Commune, Marx and Engels concluded that to successfully take power and defeat capitalism, workers could not take hold of an existing state apparatus, but had to destroy it. Furthermore revolutions needed to internationalize, otherwise they would be defeated. Bakunin argued that any kind of state, whether controlled by the workers or not, was oppressive and unnecessary. Rather than centralization and internationalization, Bakunin argued for decentralization with mini-communes in every town.

By the time the Second International was founded in 1889, the workers' movement had recovered considerably and a mass social democratic party existed in Germany. Within this party, the main task of Engels after Marx's death was to orientate the party and its

programme towards bridging the gap between the immediate day to day struggles of the oppressed and the final goal of socialism. Because Marx and Engels had greatly underestimated the resilience of capitalism and the revolutionary potential of the bourgeoisie in 1848, they had been obliged to formulate tactics and strategies to deal with an expanding and dominant capitalism throughout Europe and North America, and the effects of this on the rest of the world. Major figures in German Social Democracy distinguished the movement for socialism from its goal – in Bernstein's famous phrase: 'The end is nothing, the movement is everything.'[41] Kautsky too separated Marxist principles from day to day tactics, resulting in the disastrous collapse of German Marxism when faced with decisions concerning the party's attitude to the First World War. Almost all members of parliament voted for war credits in support of the military and political aims of their own ruling class. As we noted above, the late Engels was blamed for this, by critics of the time and by later writers such as Lucio Colleti. However, even in his lifetime Engels had angrily protested to Kautsky for publishing material he had written, heavily edited and out of context, to give the wrong impression of his views.[42] Engels did not, however, fully foresee the passage of world capitalism into the new epoch of imperialism, and it is hardly likely that as an old man busy with many other things he could have devoted himself to a study of this development. Lenin and Rosa Luxemburg were later to publish material on this, and we will return to Lenin's assessment of imperialism later.

The inter-imperialist rivalry of the First World War opened up Europe to a period of extreme instability, the outcome of which were revolutionary situations in several European countries towards the end of the war and after. The successful bourgeois revolution in Russia was followed by the first proletarian revolution in world history, contradicting the expectations of many Marxists that revolutions in capitalist countries would be more likely in highly developed economies where the proletariat was organized and highly concentrated. How was it then that a revolutionary party was able to lead workers to state power in a backward and unevenly developed capitalist country? Furthermore, what sort of party was this? The nature of the Marxist party is an important issue, both for Marxists and non-Marxists, and this is a key factor for understanding why many intellectuals (and others) object to Marxism. They see a revolutionary party as anti-democratic, oppressive and an organization which sets itself up over and above the workers it claims to represent. It is quite noticeable, as we shall see later, how many intellectuals and academics were adamant anti-Stalinists and

therefore at certain times sympathetic to Trotskyism, yet always drew back from associating themselves with the kind of political organization that Trotsky always stood for after 1917 i.e. a revolutionary Bolshevik party.

In spite of criticism from Kautsky and Luxemburg, Lenin was adamant in the period before the First World War that unity around a revolutionary programme was more important than a unity cobbled together with all kinds of elements on 'the left'. Maximum internal discussion of tactics and strategy had to be allied to the duty of party members to carry out loyally decisions arrived at by majority votes. Lenin's resolute struggle against opportunism during the period 1903–12, when he argued against becoming a legal party with all the limitations that would entail for the Bolsheviks' political programme and activity, meant that there was a party built in Russia which was able to lead a revolution. This did not happen in Germany, the revolutionaries Luxemburg and Liebknecht were among many murdered during the suppression of the German Revolution, and by 1923 the chance for the organized workers to destroy capitalism had slipped away.

Luxemburg had her differences with Lenin about the nature of the revolutionary party, and she failed to emphasize its central role in leading and directing the struggle for power, as we shall see later. Also, Lenin and Luxemburg differed in their understanding of imperialism, Luxemburg's approach failing to explain why imperialism could go on expanding after having dominated the remaining areas of the colonized world. Luxemburg, and Anton Pannekoek, whom I will discuss in more detail later, fought resolutely against the reformist party bureaucracy of the German Social Democrats and Kautsky, but this whole experience correctly made them suspicious of any party bureaucracy. Yet they would not accept that a democratic and accountable revolutionary organization was a necessary alternative. The Germans did not have the experience of Lenin in developing a different type of party from social democracy, which in Germany was encumbered by mass, legalist, bureaucratized organizations, including the trade unions.

Some of the most intransigent opponents of the betrayal of workers in the First World War were to be found in the parties like the Russian, Bulgarian and Dutch (including Pannekoek and Gorter) that had experienced principled political splits before 1914.[43] However Pannekoek later, and also Karl Korsch, were doubtful about the role and need for a revolutionary party, and placed far more emphasis on councils of workers in the struggle for power, with the party as a subordinate organization.

Nevertheless it was in Russia that the Bolsheviks were able and willing to demonstrate the living proof of Lenin's political programme by winning a majority in the soviets (workers councils) and taking state power as the biggest party in the soviets of workers' deputies. Two years later the Third International was founded to guide and formulate political tactics, strategy and programme for world revolution. However by the early twenties with the failure of revolution in Germany it was clear that similar failed revolutionary situations in Italy and Hungary had left the Soviet Union isolated. Lukács was the people's commissar for culture and education in the short-lived Hungarian Republic of Councils, and in fact it was during a lecture by him entitled 'Culture: Old and New' on 21 March 1919 that the Hungarian intelligentsia learnt of the founding of the new republic.[44]

Having taken power as the vanguard of the workers' movements, the Bolshevik party – 250,000 strong in October 1917 – was faced with world historic opportunities but terrible material difficulties. Much of the Russian Empire was backward and devastated. This devastation was to increase as, in 1918 and 1919, the armies of fourteen capitalist countries waged war against the new Soviet Republic and invaded. Many of the early democratic reforms, such as the election of officers in the army, were revoked in this period of life or death struggle. Similarly the government was obliged to fight against its own former supporters, for example during the uprising at the Kronstadt naval base early in 1921, where the peasant conscripts, tired and disillusioned by years of privations, were open to the propaganda of agitators inciting them to defy the central government and call for new elections to the soviets, free trade for the peasants in the countryside and for the small craftsmen.[45] This uprising and its suppression, obviously only resorted to in the direst circumstances and after negotiations with the Kronstadters had failed, was seen, and still is, as proof that any party organization is oppressive and ultimately alienates itself from the workers it is supposed to represent. Also the exclusion of other political parties from the Soviets at various times is seen as proof of the fundamentally totalitarian nature of Bolshevism.[46]

War Communism and later the introduction of the New Economic Policy in the early 1920s were seen by the Bolsheviks as temporary and regressive measures, not examples of steps on the path to the withering away of the state machine and the advance to future communism. For many on the left, this was seen as a restoration of capitalism, and many left organizations still believe that the Soviet Union became state capitalist in the early twenties. For Trotskyists, the

Soviet Union at this period remained post-capitalist, with an economy whose driving force was not the law of value, but a conscious plan for meeting people's needs, albeit in an increasingly alien and bureaucratized manner.[47] This definite growth of bureaucratism within the proletariat's party, and a temporary ban on the forming of factions within the party was agreed along with the expulsion of careerist elements in 1921. The bureaucratization of the party was not an inevitable characteristic of all revolutionary organizations, but explicable in terms of the material situation in the USSR at the time. The weariness of the workers and party members, the deaths of many of the best communists at the front or from disease, and international isolation took their toll. By 1923 less than ten per cent of the party had joined before the Revolution and two thirds of the members and half the candidate members were in non-manual jobs. Lenin's last writings show him to have been greatly concerned about this, and its negative effect on attempts to get rid of aspects of the old state and move forwards to the transition to socialism. Trotsky identified the roots of the bureaucracy:

> No help came from the West. The power of the democratic Soviets proved cramping, even unendurable, when the task of the day was to accommodate those privileged groups whose existence was necessary for defence, for industry, for technique and science. In this decidedly not "socialist" operation, taking from ten and giving to one, there crystallized out and developed a powerful caste of specialists in distribution.[48]

Trotsky, who had only joined the Bolshevik party himself in 1917 after having been finally convinced of the correctness of Lenin's criticisms of his attempt to remain independent, believed that only a struggle for democracy could defeat the growth of bureaucratism. However Trotsky's attempts to defeat the right and the centre of the party (around Stalin) resulted in his expulsion from the Soviet Union and the eventual murder of Trotsky himself and most of his sympathisers both inside and outside the Soviet Union.

As early as 1924 Stalin had put forward his theory of 'socialism in one country', denying the necessity of international revolutions for the building of socialism, and by 1936 had decreed that socialism had been achieved. By this time Communist Parties in other countries were minor partners in the Third International, virtually directed from Moscow by specially trained Stalinists. Oppositionists watched in horror as the leading group of Soviet bureaucrats led various revolutionary

struggles to defeat, and failed to realize other opportunities – the British General Strike in 1926, the sacrifice of the Chinese workers in the mid-twenties, and eventually, worst of all, the defeat of the huge German workers' movement by Hitler in 1933 due to the disastrous Third Period policies of Stalin.[49] Taken up in 1928, this policy abandoned any idea of united fronts with non-Communists designed to oppose in action the growing repressive power of the fascists, and stated that German Social Democracy and fascism were twins, not opposites. This refusal to wage a joint struggle against fascism with Social Democratic workers was a fatal strategy which allowed opposition to the fascists to remain split and weakened. Similarly in Spain the Stalinists played a decisive role in strangling a revolutionary movement, this time because they had turned from an ultra-left Third Period to an opportunist popular front policy, and their bourgeois allies in this front were not to be attacked whatever the cost to workers and poor farmers. This unstable political trajectory was seen as proof by Trotsky that the Third International could not be reformed. Its leadership was counter-revolutionary. It is not difficult to show that Stalin and Stalinism had nothing to do with a real application of Marxist theory to revolutionary politics, and those who argue that the events which took place under Stalin's leadership in the USSR demonstrate the failure of Marxism need to look again. Trotsky delayed breaking with the Third International as long as he could, because it was a mass movement which still had within it thousands of subjectively revolutionary members, but after the debacle in Germany and his belief that an inter-imperialist war was close, he decided that a new International political workers' organization had to be built.[50]

Founded in 1938, the Fourth International was strong in terms of its programme and politics but weak in numbers, although Trotskyists in the USA and in Vietnam had built up a strong presence in working-class struggles. It faced terrible difficulties, not least of which was physical attack by Stalinist agents. The Stalin-Hitler pact of 1939 disgusted many members of the Communist parties, and intellectual fellow-travellers, but also confused Stalin's opponents. How could Trotsky still defend the Soviet Union against the imperialist powers when it seemed just as unprincipled in seeking its own survival above the needs of workers all over the world? Trotsky argued that the inability to see reality in dialectical terms was confusing oppositionists into equating the degenerated Soviet Union with the imperialist states. In his book *In Defence of Marxism*, Trotsky explains the contradictory nature of the USSR as a state based on post-capitalist property relations,

and therefore progressive, and *at the same time* presided over by a counter-revolutionary parasitic body, the Stalinist bureaucracy. He wrote:

> The fundamental flaw of vulgar thought lies in the fact that it wishes to content itself with motionless imprints of a reality which consists of eternal motion. Dialectical thinking gives to concepts, by means of closer approximations, corrections, concretizations, a richness of content and flexibility; I would even say a succulence which to a certain extent brings them close to living phenomena. Not capitalism in general, but a given capitalism at a given stage of development. Not a workers' state in general, but a given workers' state in a backward country in an imperialist encirclement, etc.[51]

When Trotsky wrote *The Transitional Programme* as the political manifesto of the Fourth International, he thought it likely that the war would result in a number of developments which did not, in fact, take place. He felt a mass revolutionary wave would develop, that the Fourth International would make huge gains from this, capitalism would not survive the war (or if it did it would be on a totalitarian basis), the Stalinist bureaucracy would be destroyed by a political revolution or by a victorious imperialism, and the old working class leaderships would disintegrate with the destruction of their material basis of relative privilege.[52]

In fact things turned out very differently. The Fourth International survived in a weak state, so did Stalinism and imperialism. Stalin, Churchill and Roosevelt divided up the world between them at Yalta towards the close of the war. The old leaderships of the working-class movements did not disappear either. In the mid-late forties, Stalinism overturned capitalist property relations in Eastern Europe, creating post-capitalist economies, but accomplishing this in a completely counter-revolutionary and un-Marxist manner, ensuring that conscious working-class revolutionaries played no leading role in these bureaucratic overturns.[53] Far from demonstrating the Marxism of the Soviet leadership, these events were ultimately the actions of a bureaucracy intent on clamping down on working-class political independence, balancing between the workers of the Soviet Union and their imperialist opponents abroad.

However, the Trotskyists were disorientated by the events following the war, and in the early fifties the first of many splits and splinters in the Fourth International began. Postmodernism for the Trotskyist

movement came early. But are postmodern theories really the best theoretical method for understanding the disintegration of left politics following the expansion of imperialism on a world scale after the Second World War? Marxist economists still grapple with what exactly accounts for the long boom in capitalist economy in the post-war period, and whether this fact contradicts what Lenin said early in the twentieth century about imperialism. Ernest Mandel, a leading figure in one fragment of the Fourth International, wrote his book *Late Capitalism* in 1972 as an attempt to analyse the latest manifestations of capitalist development world-wide. Fredric Jameson has based his analysis of postmodernism closely on Mandel's work, and I will return to this in a later chapter, when I will also look at cultural and political developments in the so-called postmodern period. The disorientation of the non-Stalinist left from the early fifties onwards has certainly played a role in creating a view of Marxism as marginalized, confused and living in a somewhat fetishistic past.

In addition, the achievements of revolutionary Marxists in the earlier part of the twentieth century were almost totally obliterated by Stalinist persecution and misleadership, and also of course by bourgeois (democratic) opponents and fascists. It is not surprizing than that for many people there is an ignorance of the nature of Marxism itself, and its developments by theoreticians and political activists in the workers' movement after Marx's death. The admittedly unfinished work by earlier Marxist theoreticians on gender, racial and sexual oppression, for example, was almost completely ignored for years and had to be rediscovered and reformulated under the pressure of modern movements combatting social and sexual oppression. The collapse of Stalinism in Eastern Europe from 1989 onwards supposedly was the final nail in the coffin of Marxism. Eastern Europe was opened up to the market, with the European Union targeting the richer parts of the Stalinist bloc as its preferred spheres of influence. The bloody collapse of the former Yugoslavia was, and is, the most dire example of similar resulting conflicts on a smaller scale. It would seem in this situation that the left needs rather more than philosophy to engage with this situation, and that immersion in increasingly theoretical cultural analysis must not be regarded as a refuge from an increasingly barbaric material world situation.

In conclusion, I hope I have shown that Marxism is not economic determinism, that it is not to be equated with Stalinism, and that events after the deaths of Marx and Engels, as well as political errors, resulted in a weakening of genuine revolutionary Marxism. Defeats and murders

of Marxists such as Luxemburg and Trotsky were seen by some as proof that the theoretical basis of Marxist practice was deeply flawed. The understandable, but mistaken, reaction for many, especially intellectual workers, was to abandon Marxism, except as a set of interesting ideas. In the following chapter I want to look more closely at the politics of works on cultural history and their authors' relation to the Marxist tradition outlined above.

Notes

1. For a concise account of Marx's and Engels's early thought see D. Riazanov, *Karl Marx and Friedrich Engels: An Introduction to their Lives and Work*, New York and London, 1973, chapter 3.

2. *Capital*, vol.1, p.19, quoted on p.29 of C. Slaughter, *Marxism and the class struggle*, London, 1975. This excellent little book is a useful introduction to the development of Marx's thought from philosophical theory to revolutionary praxis.

3. F. Engels, *Ludwig Feuerbach and the End of Classical German Philosophy*, Moscow, 1978, p.14, originally published in 1888.

4. The context of Engels's book is explained in the useful article by D. Stockton, 'The struggle for scientific socialism', *Trotskyist International*, 17, May–August, 1995, pp.1–7.

5. F. Engels, *Anti-Dühring*, Moscow, 1978, p.18.

6. Engels, *Ludwig Feuerbach*, pp.47–9.

7. L. Trotsky, *In Defence of Marxism*, New York, 1973, pp.50–1.

8. Ibid., p.118.

9. Engels, *Anti-Dühring*, p.32.

10. Stockton, 'The struggle for scientific socialism', p.5.

11. Engels, *Anti-Dühring*, p.111.

12. V.I. Lenin, *Materialism and Empirio-Criticism*, Moscow, 1947, first published 1908.

13. K. Marx, *Capital*, vol.1, ed. and intro. by E. Mandel, Harmondsworth, 1976, p.102.

14. Ibid., p.19.

15. Ibid., p.21.

16. C. Slaughter, *Marx and Marxism: An introduction*, Harlow, 1985, pp.73–4.

17. Stockton, 'The struggle for scientific socialism', p.1. The quotation is from G. Lichtheim, *Marxism: An historical and critical study*, London, 1961, p.243.

18. G. Novack, *Polemics in Marxist Philosophy*, New York, 1995, p.193 (first published in 1978). This book has a chapter entitled 'In Defence of Engels', and although unfortunately the material in it is not up to date, the whole book is very useful for understanding some of the attempts to split Marx's method from Engels', and also for understanding attempts to return to pre-Marxist philosophy, or indeed to philosophize Marx.

19. *Capital*, vol.1, pp.101–2.

20. B. Franklin ed., *The Essential Stalin: Major Theoretical Writings 1905–52*, London, 1973, p.322.

21. M. Cornforth, *Dialectical Materialism*, 3 vols, rev. ed., London, 1961, vol.1, pp.79–80.

22. G.W.F. Hegel, *Aesthetics: Lectures on fine art*, translated by T.M. Knox, 2 vols, Oxford, 1975, vol.1, pp.170–1. For example Hegel finds *genre* painting vulgar and too close to mundane life, and only suitable for very small pictures.

23. J. Kaminsky, *Hegel on Art: An Interpretation of Hegel's Aesthetics*, New York, 1962, p.78.

24. This is noted by Marx in *The German Ideology*, in Marx and Engels, *Collected Works*, vol.5, London, 1976, p.169.

25. Kaminsky, p.36. Hegel believes psychological conflict can have similar results.

26. Hegel, *Aesthetics*, vol.2, p.797.

27. Ibid., p.801.

28. Ibid., p.802.

29. Ibid., p.812.

30. Ibid., p.805.

31. See for example M.A. Rose, *Marx's Lost Aesthetic: Karl Marx and the Visual Arts*, Cambridge, 1984; L. Baxandall and S. Morawski eds, *Marx and Engels on Literature and Art*, New York, 1974; M. Solomon ed., *Marxism and Art: Essays Classic and Contemporary*, Brighton, Sussex, 1979; D. Laing, *The Marxist Theory of Art: An Introductory Survey*, Brighton, Sussex, 1978. By far the best secondary book on Marxism and culture which I came across is Cliff Slaughter, *Marxism, Ideology and Literature*, London and Basingstoke, 1980. I strongly recommend this and many thanks to Paul Mason for pointing this book out to me.

32. F. Jameson, 'Reflections in Conclusion', in E. Bloch, G. Lukács, B. Brecht, W. Benjamin, T. Adorno, *Aesthetics and Politics*, London, 1977, p.198.

33. Ibid., p.212, where Jameson suggests it is to Lukács that we should turn for indications as to how to solve the problems of aesthetics and politics in the later twentieth century. In a recent interview Jameson has reaffirmed his interest in Lukács, and the view that we should go back to Hegel 'for an enlargement of the way we have normally understood Marx'. See E.L. Corredor, *Lukács after Communism: Interviews with Contemporary Intellectuals*, Durham and London, 1997, p.93.

34. K. Marx and F. Engels, *Selected Works in One Volume*, London, 1973, pp.694–5.

35. Solomon, p.30.

36. F. Mehring, *On Historical Materialism*, London, 1975, p.57.

37. Marx and Engels, *Selected Works*, p.182.

38. Slaughter, *Marxism, Ideology and Literature*, p.19.

39. *A Contribution to the Critique of Political Economy*, London, 1971, pp. 111–12.

40. S.L. Siegfried, *The Art of Louis-Léopold Boilly: Modern Life in Napoleonic France*, New Haven and London in association with Kimbell Art Museum, Fort Worth and National Gallery of Art, Washington, 1995, p.193, note 37.

41. Slaughter, 'Marxism after Marx' in *Marx and Marxism*, p.73. Also useful for this period are Riazanov, and Stocking, 'From Communism to Social Democracy: Party and Programme, part 2', *Workers Power*, Autumn, 1977, no.5, pp.21–34.

42. Stocking, pp.31–2.

43. D. Hughes, 'From Social Democracy to Communism: Party and Programme part 3', *Workers Power*, no.6, Summer, 1978, pp.27–39, is a politically astute discussion of these questions.

44. *The Hungarian Avant Garde: The Eight and the Activists*, exhibition catalogue, Hayward Gallery, London, 1980, p.41.

45. See the introduction by Pierre Frank to V.I. Lenin and L. Trotsky, *Kronstadt*, New York, 1979. Of course the repression of the Kronstadt rebellion in March 1921 has been interpreted in various ways. Bolsheviks defend the decision as necessary to save the fragile workers' state from renewed civil war, foreign invasions, total destruction and the mass murder of all Communist workers and their sympathisers. Others see the suppression of the Kronstadters' mutiny as the end of any hope of progress to real workers' democracy in the Soviet Union, and proof that Bolshevism is the same as Stalinism. I should make it clear here that I agree with the Trotskyist and Bolshevik analysis of the implications of the Kronstadt uprising in the specific historical context of early 1921 in the devastated Soviet Union, when foreign powers were waiting for the Kronstadt uprising to break out so that they could take advantage of it to reinvade the Soviet Union. I do not conceive of the debate as an abstract moral one on 'democracy'. It is nevertheless arguable that the Bolsheviks who went to address the mutineers could have done a better job of trying to win them over, but according to the available evidence the reception the Bolsheviks got was so hostile that they could not really have turned the situation round. For further reading see P. Avrich, *Kronstadt 1921*, Princeton, New Jersey, 1970, and I. Getzler, *Kronstadt 1917–1921: The Fate of a Soviet Democracy*, Cambridge, 1983.

46. For details of exclusions and readmissions of Mensheviks and Left Social Revolutionaries (SRs) see E.H. Carr, *The Bolshevik Revolution 1917–1923*, vol.1, Harmondsworth, 1966, pp.169–85. The main reason for the expulsion of the Left SRs was their assassination attempts, sometimes successful, on members of the Bolshevik party and, in 1918, on the German Ambassador. See also Part 111 of M. Liebman, *Leninism under Lenin*, London, 1975, and Section 1 of Part 1 in S. Farber, *Before Stalinism: The Rise and Fall of Soviet Democracy*, Cambridge, 1990.

47. Workers Power and the Irish Workers Group, *The Degenerated Revolution: The Origins and Nature of the Stalinist States*, London, 1982, pp.10–28. For a discussion of the political debates on the class nature of the Soviet Union see J. Townshend, *The Politics of Marxism: The Critical Debates*, London, 1996, chapter 10. Townshend concentrates on the state capitalism and degenerated workers' state positions. The third theory, that the USSR is an example of bureaucratic collectivism, hedges its bets on whether the Soviet state is capitalist or not.

48. L. Trotsky, *The Revolution Betrayed*, London, 1967, p.59.

49. This Third Period was supposedly the final period before the collapse of a crisis-ridden capitalism, after which the victorious Communists were to come to power. For a discussion of Stalin's policies and the rise of fascism in Germany see the introduction by E. Mandel to L. Trotsky, *The Struggle against Fascism in Germany*, New York, 1971, and Townshend, *The Politics of Marxism*, pp.110–12.

50. For a very useful account of this see Workers Power and the Irish Workers Group, *The Death Agony of the Fourth International and the Tasks of Trotskyists Today*, London, 1983. Also P. Frank, *The Fourth International*, London, 1979; and for the French section of the Fourth International see J. Roussel, *Les Enfants du Prophète: Histoire du Mouvement Trotskyiste en France*, Paris, n.d., (1972?).

51. L. Trotsky, *In Defence of Marxism*, New York, 1976, p.50.

52. *The Death Agony*, pp.23–4.

53. See the chapter 'The survival and expansion of Stalinism after the Second World War' in *The Degenerated Revolution*.

A Social or a Sociological History of Art?

In 1943, F.D. Klingender who had arrived in England as a refugee from European fascism, published his short book on *Marxism and Modern Art*. Nailing his colours to the mast of 'social realism', and bemoaning 'the sterile character of the "modern movement"' so beloved of Roger Fry, Klingender slips around uneasily between philosophy, social history and sociology with some veiled politics somewhere in the background. He even manages to quote Stalin on dialectical materialism. But his book is hardly an inspiring example of Marxist art history, and his refusal to consider any modern art as worthy of a Marxist's consideration in 1943 is a major flaw. Towards the end of his book, he sums up his Marxist view of art as follows. There are two main traditions in art throughout history. A realist one, which started when art began and which will last until the end of art, and an idealist one, which will vanish 'with the final negation of the division of labour – i.e. in a Communist world'. He then states 'A Marxist *history* of art should describe, first, the *struggle*, which is absolute between these two opposite and mutually exclusive trends, and secondly, their fleeting, conditional and *relative union*, as manifested in the different styles and in each work of art, and it should explain both these aspects of art in terms of the social processes which they reflect.'[1]

There are several problems with Klingender's views. Firstly he ties Marxist art history to a political commitment to realism as against modernism. This frequently encountered position has meant that Marxist art history, even of a more subtle kind, has tended to be happier with content and has seen this as amenable to social history or sociological analysis, while avoiding non-figurative art. Secondly, while actually quoting words describing and referring to dialectical materialism, an actual grasp of dialectical materialism as a method is lacking.

Furthermore dialectical materialism is located in a tradition beginning with Marx and ending with Stalin. The dialectics of art history are seen not in terms of contradictions within phenomena and social movements themselves, but in terms of a struggle between two relatively timeless conceptualizations of art, realism and idealism. In any case there is no suggestion in anything Marx wrote to imply that a Marxist theory of art would see idealism as an approach to visual art as vanishing under Communism. Marx is only prepared to say that with the end of the division of labour there will gradually be no more specialist artists or painters, and that everyone will have the chance to become an artist: 'In a communist society there are no painters but at most people who engage in painting among other activities.'[2]

I want to look in this chapter at how Marxist art history grappled with this undialectical heritage in the last twenty to thirty years – a heritage that was much more visible than the genuine dialectical materialist theoretical basis that had been almost buried alive (or more usually dead) by a re-vivified capitalism and the persecutions of Stalin and his successors. For much of the recent past, Marxist art and cultural history has been only one strand of a heterogeneous body of thought, writing, and teaching practice, within such formations as 'the new art history', the 'social history of art', the 'sociology of art' and, even more recently, 'materialist art history'. I want to look at these different sorts of art and cultural history and the reasons for their development, assessing to what extent they are informed by Marxism and/or dialectical materialism, or whether a Marxist art and cultural history still needs to be developed for the present period. In particular I want to try to tease out the differences between social history of art, sociology of art and Marxist art history, although clearly there are some important points of contact and areas of overlap. Having examined in this chapter examples of the approaches mentioned above, I want to look more closely in the next chapter at three writers who are generally claimed to be practitioners of Marxist art history – Max Raphael, Meyer Schapiro and T.J. Clark. I will look at their work in its historical and political context, for their interest (or lack of interest) in particular strands of the Marxist tradition, can tell us much about their method of understanding art history.

The New Art History

The term 'the new art history' emerged in the early 1980s and was described by the editors of a collection of essays of the same name as

'a capacious and convenient title that sums up the impact of feminist, marxist, structuralist, psychoanalytic, and social-political ideas on a discipline notorious for its conservative taste and its orthodoxy in research'.[3] As one of the contributors to this volume stated, this ambiguity (not to say hotch-potch), 'usually takes the guise of "complexity" and "shifting meanings", falling over backward to avoid the abyss of vulgar marxism'.[4] While many of the new theories were taken up from French film theory and philosophy, the 'new art history' developed only weakly in France, and many of its American exponents were influenced by such English writers as T.J. Clark who left Leeds for a post at Yale in 1979, never to return (so far). Other 'new art historians' such as John Tagg, heavily influenced by such theoreticians as Althusser and Foucault, grappled within the Communist party framework for a method of writing a non-reductionist history of visual culture. In fact Tagg went so far as to say that 'Althusser's theory made a cultural politics possible'.[5] Disappointed and demoralized after years of lecturing work on temporary contracts and in the midst of the massive strike by British miners in 1984–85, Tagg too left Britain for the States, where similar attempts to found a new social history of art had taken place resulting in various Caucuses within, and on the edges of, the College Art Association of America.

The emergence of 'the new art history' occurred in a period of expansion in higher education in Britain and a growth in the numbers of students doing art history. The Coldstream Report stipulated that twenty per cent of fine art courses should be made up of art history, which was no longer being considered a 'finishing-school' type of subject. In the late sixties and early seventies radical students, in particular those at Hornsey Art College and the Royal College of Art, London, showed by occupying their colleges and engaging in other political activities that the practice of art and its teaching were not divorced from wider ideological and political concerns. In the seventies, student radicalism gradually waned, and this was accompanied by an interest in a radicalized growth of cultural studies and the development of media studies degrees. Students in the field of culture who were interested in critiques of ideology moved towards these new academic routes. Thus to some extent students learning art practice tended to move back towards a more traditional notion of art history, even if their productions still appeared linked to notions of avant-garde practice. Interest in theory and 'the new art history' began to wane.

In the sixties and early seventies a whole new layer of younger art historians, many of whom had not been through the old universities

of Oxford and Cambridge, or the Courtauld Institute, nor came from upper-class families, were appointed to lecturing posts, often, like me, in the new polytechnics rather than universities.[6] However, politically Britain did not experience anything like May 1968 in France, or the effects of the defeat in Vietnam on the USA and the rise of the black liberation movement. The most significant social movement in British political and cultural life in the 1970s and 1980s was the women's liberation movement, most of whose leading members were deeply anti-Marxist. Paul Overy comments that '1968 revealed that marxism was no political threat at all in Britain and could henceforth be allowed its run in British academic life . . .'[7] This is partly true, but there were nevertheless many examples of trade union struggles during the seventies and eighties in Britain and also in the USA. The famous 'winter of discontent' of 1978–79 saw an upsurge of strikes against wage limits demanded by the Labour government. Many skilled workers even saw the Thatcherites' free market as a means to restore their wage differentials over the low-paid, and, deserting Labour in their droves, voted for a Tory government. However during the eighties the attacks on the trade unions continued, accompanied by cuts in welfare spending. The miners in particular were made the target of a determined Tory attack to destroy their industry, and even a major strike spanning 1984–85 failed to stop the government. As unemployment figures rose, it became cheaper for the government to guide more young people towards higher education, where many supported themselves on meagre grants and low-paid part-time jobs.

The situation is somewhat different now, with a boom/slump development in Higher Education in Britain. A few years ago student numbers were pushed up, now we are told there are too many qualified people and no jobs, so numbers must fall, probably through government plans to abolish student grants and further develop a two-tier system of elite research and inferior teaching institutions, some of which will be closed. Plans are now in place to abolish grants altogether and charge students for fees under the new Labour Government. Cuts in funding have taken place, and in schools the imposition of a National Curriculum on pupils from five years upward focuses basically on the three Rs in the form of a concentration on Maths, Science and English. There is little space in the school curriculum for students to specialize in either art or history let alone put the two together! Judging from the first months of the new British Labour government's actions, the situation is unlikely to alter very much, in spite of the desire for change expressed in the landslide victory of Labour at the polls. Without

instigating punitive taxes on the very rich, Labour could not find money to pay for the cost of high quality further and higher education, the restoration of cuts in the Museum services, and pay students a living wage rather than a small means-tested grant. Student interest in radical politics is small, while the most militant youth engage not in student politics but in animal rights protests and anti-roads/runways occupations, often risking serious harm to themselves. In recent years the 'social history of art' is not the force that it was, and a more clearly a-historical philosophical interest has become apparent in radical art and cultural history, to which the more inquisitive students turn.

However, it may be that the tide is turning slightly away from the overly idealist discourse theories of postmodernism, which have pre-occupied many art and cultural historians for the last few years. In a recent interesting essay examining the development of critical art history, John Roberts gives an up-to-date assessment of the state of radical Anglophone art history. He locates the essays in his edited anthology within the dialectical tensions between three critical positions and their interaction in Anglophone culture and its material context. Firstly he identifies older forms of the sociology of art and Marxist art history in their respective detachment from models of cultural study more concerned with form, secondly 'the new art history', thirdly modernist approaches which emphasize individual aesthetic experience above historical analysis.[8] We should perhaps ask if it is sufficient to interact dialectically with the 'old' Marxist art history when the theoretical method to criticize it and go beyond it is at our disposal? It is hard to discern an overall aim in Roberts' collection. This is precisely what is required at the present moment, in my view, and demands a forceful argument for a refocused Marxist art and cultural history.

A more recent publication also sought to situate and investigate some of the historical roots of the social history of art. Fred Orton and Griselda Pollock recently reissued some of their old articles from 1972–82 in a collection, the introduction to which outlined the trajectory of radical art history during these years. They emphasize their workplace, Leeds University in England, as a key site for the development of radical art history, and also situate themselves squarely within a Western Marxist/New Left tradition and the particular inflections of Marxist theory put forward by Gramsci and Althusser. During the seventies in the aftermath of May '68, as they put it, 'Certain dogmas about the necessary determination of the cultural superstructure by the economic base of production in society were reformulated in varying ways

following the New Left's re-readings of Marx's own writings'.[9] This is interesting, and seems to differ from some of Pollock's earlier positions when she was keen to distance herself from Marxism as patriarchal and economistic, and also keen to argue that, for example, there was no reality to which different images of women could be compared. All images of women were texts through which any 'reality' was constructed for the viewer.[10] Her uneasy stance between modernism and postmodernism seems to shift at various times for different audiences e.g. the social historian of art or the feminist historian of art. For example, in this latest book Pollock and Orton situate their practice within a modernist tradition emphasizing its commitment to 'continual reconceptualization' and 'pursuit of this self-critical tendency in respect of the social history of art.'[11] I do not know whether this reflects a genuine theoretical uncertainty/openness on Pollock's part (Orton's approach is more consistent), or whether there is a definite intention by Pollock to take on different personae and public voices within the field of 'the social history of art' in different situations and contexts. Certainly in this latest book there is no attempt by Pollock to distance herself from Marxism as in previous works, however there is a clear statement of what Marxism it is that she and Orton want to be associated with. Interestingly while their development in 1972–82 is situated within the intellectual climate of the time, there is nothing on the economic and political situation during those years which is crucial for an understanding of precisely why the particular New Left readings of Marxist texts came to the fore. It is also interesting that the reissued collection situates the development of the social history of art in a past moment (Pollock contributes a new essay on gender and Abstract Expressionist painting to rectify the omission of women from their previous work), rather than arguing that a social history of art basing itself on Marxism is a necessary project for the present.

The Emergence of the New Art History

So who were these modern pioneers of the social history of art and what legacy have they left us to carry on into the twenty-first century? Although the most interesting and significant publications in modern 'social history of art' were the two books published in 1973 by T.J. Clark which were seen by many as exemplars, Clark was not the only scholar in 1973 advocating a social theory of art. A special issue of the journal *New Literary History* in Spring 1973 was devoted to discussions of what the social history of culture might entail. James Ackerman,

then at Harvard, wrote an article 'Toward a New Social Theory of Art', suggesting ways forward to 'a social theory of art' that would be 'more consistent with the way we look at things in this country at this moment. The attempt could be only primitive and faulty because there is no body of theoretical writing in the field on which to build, except in the idealist and Marxist traditions which, in my view, are misleading and incomplete in complementary ways.'[12]

Ackerman argues that 'the few good Marxist' cultural historians there have been were at their best when in some crucial way independent of Marxism. He states there has been no Marxist architectural criticism, since architecture is linked very closely to patronage and there has been no progressive patronage(!). In the sphere of the figurative arts, cultural productions have been seen as subordinate to particular social and political goals, and not deemed of interest in their own right. Marx and his orthodox followers (no names mentioned) did not 'trust' the arts, and in any case had more pressing political concerns. 'The historical theory of Marxism represents a reactionary force in the history of art in that its outlook is in application similar to that of Hegel, with an external force directing innovation toward a preestablished goal.' Artists are thus deprived of individual initiative and independence. However, argues Ackerman, if we can emulate the sort of coherence we see in Marxist theory, without taking on board 'the specific assumptions of dialectical materialism' which are no longer relevant, we could develop a better social history of art than we have at present. This implies that we can have an 'acceptable' dialectical materialism to the extent that it does not function as a critique of capitalism.

Ackerman points out that the same works of art are still selected and interpreted on the old principles, and the basic theoretical structure of art history remains, but with social and economic factors grafted on to it to enable a better interpretation of the given works to be made. Now at least Ackerman sees the problems associated with a superficial approach to the social history of art, but his rejection of 'orthodox' Marxism (is this code for Stalinism and an equation of it with Marxism?) and his schematic characterisation of Marxist attitudes to art, ignoring such figures as Trotsky and Lunacharsky, really throws out the baby with the bathwater. As we can see, there are calls for a non-Marxist social history of art, which views itself as prepared to select 'good' qualities from Marxism, while rejecting the 'bad' ones, as if dialectical materialism could accept that phenomena and thought could be split into 'good' and 'bad' elements, rather than possessing these qualities in dialectical interaction in any case. We also have to ask from whose

point of view certain qualities are deemed 'good' or 'bad'.

In the same issue of *New Literary History* in 1973 American scholar O.K. Werckmeister published 'Marx on Ideology and Art'. However his attitude to Marxism was very different from that of Ackerman. Werckmeister's work is interesting, for not only is he one of the few cultural historians who actually states that he is working on a Marxist basis, but he also has a teaching practice which is intended to make his students critically assess their consciousness of their situation in material reality and history. As he himself points out, this is not always successful. However it seems to me important for social historians of art, and especially for Marxist historians of art, to ask themselves what their practice is, how their theoretical foundations relate to their teaching and writing, what practical results they can expect or aim for, and if they see themselves utilizing an approach which they consider superior. Might these results be academic, political, consciousness-raising or what? Werckmeister bravely attempts to tackle these issues, which is what we might expect from a Marxist art historian, but do not often get.

But there are some problems with Werckmeister's positions, which I will discuss in relation to a number of articles written over the last twenty years, by and about him. In his article of 1973, Werckmeister argues that Marxists in the twentieth century have attempted to revitalize culture, since they have been defeated and demoralized politically and have been forced to accept 'a politically stabilized, static socioeconomic order – with ostensible enthusiasm in the Soviet Union and other communist states, with unaverred resignation in the capitalist states of Western Europe and in the USA'.[13] Now it is a plausible line of investigation to enquire whether defeat in the political sphere results in a turn to non-political, sublimated political energies in the study of culture, and this has also been suggested as a factor for the rise of a radical cultural studies after the defeats of May 1968. It might also be possible to investigate this in, for example, the development of neo-Hegelianism and the work of the Frankfurt school after the possibilities for successful European revolutions definitely receded after 1923, and even more so after the triumph of fascism in 1933.

However the description of world politics and economics given by Werckmeister is not really an accurate one. In 1973 the world could hardly have been described as 'static' and without contradictions. Anti-imperialist struggles continued. Latin America in particular was unstable due to the pressures of imperialism on the economies of this continent, and within a couple of years the Portugese revolution would occur in

Europe, along with continued struggles against Stalinist repression in Eastern Europe. Thus Werckmeister's model of world immobility is not accurate. Also he too equates Stalinism with Communism. Any brief examination of the Soviet block would come to the conclusion that a state which politically repressed workers to such an extent could hardly be a state where anyone who wished could become an artist, where each person was provided with what s/he needed, and where all forms of oppression had been eradicated. Again we see a lack of understanding of the contradictions between the economic basis of the Soviet block at that time (a post-capitalist economy where there is no generalized commodity production and the law of value is subordinated to a planned economy, however bureaucratically managed), and the political and administrative bodies of the state apparatus, which function very much like a dictatorial, totalitarian capitalist state form. Further on in his article, Werckmeister states that Soviet administrators forced artists to 'depict political themes realistically', but totally ignores the early years after the 1917 revolution when this was certainly not the case, and when Trotsky, to name only one example, argued that the party had no competence to tell artists what sort of art to make.[14]

In a later article published in 1991, 'A Working Perspective for Marxist Art History Today', we can see that Werckmeister's political views have not changed. He still equates 'Marxist politics in action' with Stalinism, and many of the problems for Marxists are, according to Werckmeister, located in this equation. Arguing that Marxism must be rescued from this position, he criticizes the kind of academic Marxism that secures for itself a place with the academy as one 'method' among many others with which to study culture – the linguistic, semiotic, aesthetics of reception, etc. This multi-methodological social history of art is not what Werckmeister is after. His great merit is that he comes out clearly and says this, instead of pussyfooting around the term 'social' as a code-word for something else which readers 'in the know' will interpret as Marxism.

However he does not seem to have any interest in the Trotskyist development of Marxism, and therefore has to go back to the drawing board in trying to rescue Marxism from Stalinism. He does at one point mention Trotsky:

> The tradition of Marxist art history, with the possible exception of Meyer Schapiro, is lacking in authors of the stature of Trotsky, Brecht, Gramsci, Lukács, or Breton, whose active political engagements compelled them to navigate between the two poles of Marxism's political legitimacy, that

is, the commitment to workers' movements on the one hand and to socialist governments on the other.

Trotsky did not 'navigate' between workers' movements and the 'socialist' government of the USSR but, on the contrary, argued that workers must overthrow that bureaucratized government controlled by Stalin in a political revolution. Trotsky made a distinction between defending the post-capitalist property relations of the USSR against imperialism, and giving political support to a repressive bureaucracy, which was in no way a 'socialist' government. The nature of Stalinism and the Soviet state is never really grasped in a dialectical manner by Werckmeister. He goes on to argue that the conflicts and contradictions of the above writers have made them more satisfactory as models of critical analysis. Contemporary Marxist art historians of the 1990s, he writes, do not operate under such pressures as these forerunners. 'Their preferred model, Walter Benjamin, was an intellectual with no political ties, unsuccessful in his ambition, during the first three years of his exile, to link up with the political culture of the Left, and hence thrown back on the ideological idiosyncracies and enforced continuities of his own reflections.'[15]

In a review of Werckmeister's book on Paul Klee, David Craven gives some quite justified criticisms of Werckmeister's method, pointing out that 'all these essentialist interpretations of art, human nature, history and ideology make quite clear that Werckmeister's reading of Marx involves a profoundly *non-dialectical* project.'[16]

In his most recent article, 'From a better history to a better politics', 1995, Werckmeister points to the demise of 'socialist' governments in 1989 as an even more urgent reason for 'a historical revision of the Marxist tradition that informs my thought'. Having watched 'one Communist government after another' falling in Eastern Europe, Werckmeister reoriented his research and teaching on Klee to look at the artist's work in relation to major political events of his lifetime. In a later seminar, in 1994, he discussed with his class the statue by Vera Mukhina and her assistants, *Worker and Collective Farm Worker*, 1937. 'This, I said, was the supreme propaganda image of Bolshevik certainty about the trajectory of world history, the ultimate direction it would take, and the active engagement of the working class to make it happen.'[17] Now unfortunately we see here that Werckmeister still talks about Bolshevism in 1937 when most of the old Bolsheviks had been murdered by Stalin or were in exile or labour camps. The ruling caste of bureaucrats in the USSR were Stalinists, who in the previous year in

the new constitution of the Soviet Union, had announced that Socialism had definitely been built in one country, in complete contradiction to what Marx, Engels, and later the Bolshevik party had argued. The contradictions which Werckmeister struggles to understand elude him, since he lacks a dialectical understanding of the contradictory nature of the Soviet state as resting on post-capitalist property relations with a bourgeois state form, which he could have gleaned from reading Trotsky's *In Defence of Marxism*.[18] However it is to Werckmeister's credit that, in spite of his lack of understanding of the nature of Stalinism and its counter-revolutionary nature, (and all the problems this raises in terms of what is offered as an alternative to capitalism) he does try to engage his students in a debate about their own political consciousness and expectations for the future in a bourgeois democracy.

Other scholars calling for versions of Marxist art history are rather more vague than Werckmeister about where they are coming from politically, exactly how they see a Marxist art history operating, and what its aims could or should be. Baldwin, Harrison and Ramsden (Art Language), in an article published in 1981, entitled 'Art History, Art Criticism and Explanation', dismiss a 'crude Marxist formula' of base determining superstructure, in favour of a 'tentative suggestion for a research project in social history' devoted to understanding the relationship of class and modernist art. The actual conclusions of this tentative outline are a bit dubious, locating the class support for early modernism in the ranks of the hereditary bourgeoisie, which is not really true of the development of early modernist painting in France, for example, where early patrons included department store owners, doctors, actors and opera singers, a customs service employee and picture dealers, as well as, of course Caillebotte, a painter himself and a member of a rich family but not really a representative of the hereditary bourgeoisie.[19] Art Language write:

> What we have to offer is not a form of economic reductionism. It does not go to a rigid materialist inversion of Hegel. It does not go to the overthrowing of all claims for the autonomy of art. It rather goes to the matter of fraudulence of the discursive or analytical closures performed in art, and to its hermeneutical circularity, which are the principal symbols of its ideological purpose.

So what a reformulated 'research project in social history' should do is to unravel the quasi-coherent and closed systems of making and understanding art which restrict comprehension of art to the field of

art itself, and in so doing preserve for it a status as ideology, instead of knowledge. However it would be clearer if this call was made along the lines of a refocusing and reformulation of the method of Marxist dialectical materialism (if this is indeed what is intended) and it is confusing that the new proposal is for a 'social history' investigation. Also confusing is that the authors constantly warn of the pitfalls of economic reductionism, yet set up the statement explaining artistic motivation ('He did it for the money') as an example of materialism from which the cultured academic shies away in horror. This indeed is vulgar economism which would certainly have little to do with an elaborated Marxist view on the relationship between culture and its material base.[20]

The last article I want to look at in this section is by Hollis Clayson, 'Materialist Art History and its Points of Difficulty', 1995. She too discusses her practice as an educator within a certain academic constituency. She calls for an examination of the difficulties encountered by the teacher working in 'Materialist art history', using her own experience to discuss some problematic areas. She argues that 'the acknowledgement that the "objects" of our study cannot be wholly separate from its "subjects", from us the interpreters, fosters an essential reorientation in materialist thinking'.[21] I do not think this 'reorientation' is anything original, nor is it absent from Marxist dialectical materialist thought, which, although emphasizing the primacy of the material world in its independence from thought, has always recognized the interaction of the thinking subject and the material world. Marx' first thesis on Feuerbach states the following.

> The chief defect of all hitherto existing materialism – that of Feuerbach included – is that the thing, reality, sensuousness, is conceived only in the form of the *object* or of *contemplation*, but not as *human sensuous activity, practice*, not subjectively. Hence it happened that the *active* side, in contradistinction to materialism, was developed by idealism – but only abstractly, since, of course, idealism does not know real, sensuous activity as such.[22]

Clayson then states that materialist art historians, basing themselves on Marxism which states that the real 'is prior to culture', find themselves at a loss when they face the 'incommensurability of the textual (the visual) and the material'.

I think that Clayson's difficulties here arise from the fact that she is conceptualizing materialism in a pre-Marxist way, seeing it as incapable

of grasping the interrelationship of the objective and the subjective, while supposing that she is addressing herself to Marxist theory. She is essentially using materialism as an undialectical methodological tool. Later she explains how the materialist is also struggling to deal with individual subjectivities, and is only able to do so due to the 'more diversified and nuanced theoretical models' which have recently become available. 'The modern materialist packs tools for handling racial and gender differences as well as class in her fin-de-siècle port-folio.'[23] In this rather embarrassing formulation, Clayson again betrays an underdeveloped understanding of dialectical materialism. I would not, of course, argue that Marxism has nothing to learn from the women's movement, psychoanalysis, etc. but it would have been help-ful if more academics had actually understood what Marxism was, and what its method is, before pronouncing it theoretically incapable of dealing with issues of individualized gendered and racialized subject-ivities, a proposition which, in any case, I would dispute. However it is certainly the case that a developed Marxist theory of the subject is sorely needed.

Clayson's article has the merits of self-interrogation about her own theory and practice, and openly raises doubts and questions about the way forward so that readers of her article can ponder them and perhaps find ways forward which Clayson admits herself to be unsure of. This stance is so much more welcome than the dismissive rejection of Marxism and materialism so commonly met with in the writings of academic feminists in particular, but also in the writings of many theorists of 'black' culture, who regard 'the left' (monolithically conceived) with a suspicion sometimes genuinely deserved, but at other times due to a failure to distinguish Marxism from Stalinism, economism, and forms of political centrism which oscillate between opportunism and sectarianism. Such centrist organizations vacillate between accommodation to black nationalism and separatism, and the rejection of any notion of social oppression based on 'race' as distinct from class.

I want now to look at examples of 'the social history of art' and 'sociology of art' to see whether these are in fact part of a project for a Marxist understanding of culture. This is far from clear, and, as we have seen above, for one reason or another, scholars are often not specific as to whether they see themselves as Marxist cultural theorists even when they are willing to situate their method of working in relation to the use of Marxist concepts and the Marxist tradition.

The Sociology of Art

First let us turn to the sociology of art/aesthetics. Sociology after the Second World War emphasized notions of systems in equilibrium studied in terms of their functionalism. One author has linked this trend to methods of investigation developed during the war, and the economics and politics of the post-war period. Computers and their capacity to manage information systems, coupled with the advances made by military and other government agencies in sponsoring field research during wartime, were utilized in a new historical and political world situation in the 1950s and 1960s. The capitalist boom of the post-war period, the so-called de-Stalinization of the Soviet Union and the resistance of East European oppositions to Soviet domination, the end of McCarthyism and the view of open-ended prosperity in western Imperialism all worked towards a perception of society as functioning in terms of a balanced system, a status quo which was beneficial and did not require criticism or serious change. The 'social system' was not perceived as riven with contradictions which rendered it unstable.

By the 1960s there were moves to more critical applications of sociology, accompanying the rise of civil rights movements, women's movements and the results of an Imperialist war in Vietnam. There emerged differing perceptions of the nature of 'society' and what methods could be used to study it. In 1965 Tom Bottomore read his paper entitled 'Karl Marx: Sociologist or Marxist?' to the Conference of the American Sociological Association. Yet many sociologists were wary of Marxism. R.W. Friedrichs stated in his book on sociology that Marxism of a certain kind (stripped of its goal of socialism and vision of the future, as he put it) could be useful to scientific social research and is close to certain kinds of sociology.[24]

Henri Lefebvre in 1966 argued that Marx was not a sociologist, and we should not try to transform him into one, but that *'there is a sociology in Marx'*.[25] Lefebvre argues that Marxism aims to grasp the totality of material and human life in all its spheres and that since specialization and compartmentalisation have developed in the human sciences since Marx's day, it is no longer possible to deal with all human knowledge as Marx and Engels could. Thus we have to confine ourselves to discrete disciplines, of which the study of society (sociology) is one.[26] Lefebvre leaves out the important fact that for Marxism the economic sphere was in the end the most crucial one, interacting and underpinning the very structure of society, and to split economics, society, politics

and the state leaves a pretty useless version of Marxism. However this is what much Marxist-inspired sociology does.

The concept of society as understood by Marxism and by sociology is rather different. For Marxists human society is part of the whole history of the material world, and can be understood by the same method. Further, even in moments of apparent stability, human society is in conflict and inner contradiction since all society is class society after the demise of primitive communism very early in human history. Any sense of balance and equilibrium in society is illusory. Also any human society in a particular country could not be understood without understanding its inter-relation with the rest of the world. Even the use of similar terms by Marxists and sociologists may mean different things and belong within a different conceptual method. 'Working-class' identity for example, will be described by a sociologist in terms of income, how many times the theatre is visited or the football match, possession of a car or cars, number and location of holidays, whether the individuals would describe themselves as working-class or not, and so on. This fundamentally descriptive empirical characterization is replaced in a Marxist characterization of the 'working-class' by an evaluative one. For Marxists, the working class is defined not by its possessions or even primarily by its idea of itself, though this is important, but by its positioning within economic relations of production. The working class has to sell its labour power as a commodity. Within the working class are different layers, labour aristocracy, the lumpen proletariat, etc. which are in process of change. The working class cannot be defined once and for all. However the working class for Marx is the class which has the possibility, and the most reason, for destroying the system which created it. Some sociologists may individually agree with this political view, but in general this tends not to be embedded in sociological theory. Marxism is one strand in sociological theory which even now debates its usefulness along with the heritage of Hegel, Comte and Weber. Their response to the modern industrialized world and the social structures within it, are now re-examined in the light of developments in the 'late modernity' of the later twentieth century, and their 'abstract theoretical ideas . . . translated into empirical research programmes'.[27]

Similarly if we take a concept like 'art', the sociologist will investigate notions of art, the breakdown of museum visitors in terms of class fractions, the kind of pictures they hang in their houses, the kind of music they prefer, etc. in the manner of Bourdieu's work, producing a kind of sociology of taste. For Marxism, art would need to be seen as a

changing historical concept particular to certain historical and class societies, but nevertheless existing within certain relations of production which mean that art is a form of labour and the art work is a commodity. The knowledge and awareness to be gained by making and enjoying art nevertheless have a certain transhistorical validity which cannot be totally equated with class ideology. Art is made by social individuals and cannot be seen as an entity abstracted from actual human society in conflict and contradiction, or simply described in relation to different classes and economic income groups who are somehow seen as separate from art and who view it 'from the outside' as it were. However even subtle approaches to the sociology of culture, such as Bourdieu's, fail to utilize dialectics. Contradictions giving rise to new developments are not seen as generated within cultural productions themselves, but are seen as *reflections* of struggles that take place elsewhere. As Bourdieu puts it:

> The science of cultural works has as its object the correspondence between two homologous structures, the structure of the works (i.e. of genres, forms and themes) and the structure of the literary field, a field of forces that is unavoidably a field of struggle. The impetus for change in cultural works – language, art, literature, science, etc. – resides in the struggles that take place in the corresponding fields of production. These struggles, whose goal is the preservation or transformation of the established power relations in the field of production, obviously have as their effect the preservation or transformation of the structure of the field of works, which are the tools and stakes in these struggles.[28]

Of course there is critical sociology and empirical sociology, but I do not feel that even the critical variety often engages with Marxism and its method. As for the empirical, a quote from Goffman should give an idea of its limitations:

> I am not addressing the structure of social life but the structure of experience individuals have at any moment of their social lives. I personally hold society to be first in every way and any individual's current involvement to be second; this report deals only with matters that are second . . . The analysis developed does not catch at the differences between the advantaged and the disadvantaged classes . . . I can only suggest that he who would combat false consciousness and awaken people to their true interests has much to do, because the sleep is very deep. And I do not intend here to provide a lullaby but merely to sneak in and watch the way people snore.[29]

In response to such an approach, some Marxists, for example Slaughter, have dismissed sociology altogether, seeing it as irredeemably bourgeois, and only capable of providing an ideological description of the status quo without any critical analysis. While I would not go this far, as I feel that certain sociological investigations may yield knowledge which could be utilized in ways not intended by the commissioning body or the individual sociologist, the examples I have read which use a form of sociology to study art are (apart from Janet Wolff's books) very disappointing.[30] Slaughter's rejection of sociology and sociologies of literature and art are based on the following arguments. Sociology reduces social life to interaction of 'roles' and 'social personalities' and any higher reality is endowed with a mystical nature. Society is fragmented into facts to be classified, analysed and quantified, usually by a 'well-behaved computer'. Against positions like Lefebvre's, Slaughter maintains the need to study as many different academic and scientific disciplines as possible to gain the best comprehension of any given social formation in relation to its material base.

> Historical materialism does not substitute itself in some mysterious way for the detailed work of investigators in specialized fields, but it does reject those a-historical divisions between the different social sciences and between social sciences and humanities which obstruct a critical and materialist analysis of society and culture.[31]

Slaughter argues that art does not mirror social conditions as the sociologist implies, and that culture seeks to go beyond 'mere repetitive mirroring of the forms of appearance to the contradictory whole constituted by essence *and* its necessary and obscuring appearance.'[32] Now I am not sure the majority of art works set out to do the second part of this, but it is certainly a problem for sociological approaches that describing society in various ways does not tend to produce theories of how that society can be imagined differently in a novel, painting or otherwise, in political theory or activity, for example.

I want to look now at some recent works on the sociology of art/ aesthetics and evaluate them. What is apparent is that these books are different in approach from 'social history of art' projects, as most of them are either ahistorical, or actually have no theoretical model for understanding historical change and development, so I would clearly distinguish them from writings on 'the social history of art' though they have all been influenced by such art historians as T.J. Clark and critical historians of art.

At this point it is worth briefly mentioning some problems with the whole concept of a sociology of aesthetics. Adorno would have found this whole project a contradiction in terms. For him, aesthetics is concerned with 'real' art which arouses a true aesthetic experience in the viewer or listener. With most commercially produced culture, there is no aesthetic response and commitment whatsoever, and a study of commercial culture in its relation to the consumer is the field of sociology, not aesthetics. Therefore the sociology of aesthetics is a non-starter.

> Culture industry tends to pervert the subjective response to works of art. As a result, the latter have withdrawn more and more into their own structure, contributing in no small way to the lack of impact of modern art, which is unlike anything art history has ever seen. In short, artistic experience calls for cognitive rather than affective-emotional behaviour in relation to art works. The subject dwells in them and their dynamic as a moment among others. If the subject is made to confront them externally and without being subjected to their discipline, it becomes alienated from art and properly belongs to the domain of sociology.[33]

This statement obviously betrays Adorno's distaste for commercial art, and its detrimental effect on 'high' art. The perceived difference between 'high' and mass culture is obviously of great significance, yet some leading sociologists of art and taste do not really discuss this.

This is true of the first author I want to discuss, Janet Wolff, perhaps the most influential contemporary scholar in this field. Her two books, *The Social Production of Art*, 1981 (the better book in my opinion), and *Aesthetics and the Sociology of Art*, 1983, are really part of the same work. It is noticeable that all the examples of art referred to by Wolff are famous examples of high art, so she does not interrogate the notion of art or the examples commonly agreed on to exemplify interesting and worthy artworks.

Wolff defends critical sociology against attacks by Marxists, arguing that her own approach utilizes historical materialism. However it is clear that Wolff's knowledge of Marxism is minimal, whatever she may say about her own method and historical materialism. There is not a single work by Marx, Engels or Trotsky in her bibliography, no mention of the accessible collection of Marxist writings on art edited by Maynard Solomon, nor any reference to Dave Laing's book on *The Marxist Theory of Art*, published in the later 1970s. 'Historical materialism *is*, among other things, the study of society, and it is with this meaning that I

intend the term "sociology".'[34] This is not very satisfactory, as any number of methods could claim to be studying society, and this is probably the most general description of sociology one could come up with. There is no model of change or conflict in Wolff's method, although she situates her sociology within historical materialism. However to say her approach is a part of historical materialism is not the same as saying that she has understood and wishes to apply to society the whole of the method of historical materialism, which should include dialectics.[35]

In *Aesthetics and the Sociology of Art*, Wolff aligns her project with that of the social history of art, in interrogating the contingent nature of 'aesthetics' and 'aesthetic judgements'. However she is concerned to rescue aesthetics from social, political or ideological definitions. Both 'radical sociology of art' and 'the social history of art', she says, might lead aesthetics into equating aesthetic worth with politics, and total relativity.[36] However she herself falls into the trap which claimed many before her (and has done since) and fails to distinguish between politics and ideology. She states that 'all works of art, being produced in political-historical moments by particular, located people using socially established forms of representation cannot fail to be, however implicitly, about politics.'[37] Now while I agree that in some cases the political and the ideological can coexist and overlap, for example in a painting such as David's *Death of Marat* (1793) ideology and politics are not the same. Her statement also seems to imply that all works of art must be ideological, and also political, which is highly debatable. She insists that aesthetics and politics are inseparable, and that this has been demonstrated by the social history of art and the sociology of art.[38]

She praises Max Raphael for his insistence on the 'relative autonomy' of art from its economic and material base: 'Even in 1933 Raphael was aware of the importance of this non-reductionist approach and it is possible that his current popularity and influence is connected with the relatively recent general recognition of its validity.'[39] Anyone who had read Marx and Engels on the relation of culture to society would know this was not a 'recent' discovery. The reasons for the hegemony of a different kind of approach can be linked to the rise of Stalinism and the persecutions of those who attempted to develop a genuine Marxist approach to politics, culture and problems of social oppression, as outlined in the previous chapter. Fortunately however, Wolff argues against the then recent developments in cultural history which saw *everything* as a text, including social and historical reality, because, not only is it mistaken, but, from her point of view, it renders a sociology

of art impossible, since social organizations, practices and institutions will be afforded the same status and level of (non) reality as literary and artistic 'texts'.[40]

A crucial problem with Wolff's work is that she does not theorize the possibility of non-ideological cultural production and knowledge, thus undermining her own position as an author offering knowledge on this subject. Also Wolff does not escape the problems of relativism within her mode of sociological approach. As one reviewer of her work pointed out, Wolff sees important problems, but her method is not fully equipped to deal with them: 'As Wolff acknowledges, there is a need for a defence of the aesthetic, but for this defence we have to escape the prevailing relativism – recognize the dialectic of reality and discourse, rather than define reality as discourse.'[41] Now Wolff herself does not see reality as discourse, but it is true that there is little conceptualisation and theorization of any lawfulness underlying processes of historical change in her work, with the result that her writings can seem somewhat descriptive and open to justified charges of relativism.

More recent work on the sociology of art has been published by Elizabeth Chaplin. Her project on sociology and visual representation has a useful survey of literature on the topic, but again her overall method leaves much to be desired, and has little concern with Marxist methods. She makes the usual equation of Communism with Stalinism, and uses sociology in the very general sense of the study of society.[42] She explains her method as follows. There are two paradigms in sociology, the critical and the empirical. She divides the structure of her book into these two sections, which remain, as far as one can see, quite separate. She has no overall method with which to integrate them. In fact she sees herself as in a position between the two, acting as a 'buffer'.[43] Her final chapter entitled 'A Coming Together', is only five pages long in a work of 279 pages! In this final section, Chaplin's conclusions indicate why she fails to develop any overall theory of visual representation in society. She writes:

> There is also a tendency towards fragmentation in both paradigms; in the critical paradigm, through a refutation of grand theory and an emphasis on local, empirical, minority group-based projects in which a diversity of accounts are acknowledged and embraced; and in the empirical paradigm, through the fragmentation of the authorial voice which allows consideration of "alternative realities".[44]

Thus a 'grand' theory, termed by others a 'master narrative', is out-moded and no longer viable, and in any case it no longer conforms to the vibrant reality of local, minority groupings whose fragmented voices are of more validity than the 'author' of books about them. This position results in a very unsatisfactory book, which, although it contains useful summaries of many interesting secondary source books on critical cultural theory, is never adequately linked to the practice Chaplin undertakes as a sociologist and writer due to the limitations of her theoretical position. Her position as a 'buffer' is obviously rather an uncomfortable one, and she never attempts to go beyond the limitations of her two paradigms, critically working through them, theorizing their connections and interactions, and working towards a new synthesis which would supercede them.

Finally I want to look briefly at a recent book in the sociology of art mode by Robert Witkin. He sets out to theorize the link between art styles and social structure in terms of 'semiotic necessity'. The author discusses T.J. Clark, Hauser and Berger, and uses some sociological concepts from Piaget and Durkheim, but his model of society is one of 'social systems' without any notion of dialectical conflict or instability. His method is undialectical and rather unsophisticated :'the principles of social organization are made visible in art styles'. In the section entitled 'A Scaffolding for a Sociology of Art' he basically argues that in more developed societies art is more abstracted and detached from the material conditions of reproducing that society i.e. producing clothes, food, fuel, etc.[45] There is nothing very new in this, and neither is the relationship between art and 'social organization' conceptualized in a very subtle way.

In my opinion, it is not from sociological attempts to relate art to society that we can expect to find material to rejuvenate and refocus a Marxist approach to art and culture. None of these books are written by people who have made attempts to integrate a knowledge of Marxism into their work, in spite of Wolff's claim to be a historical materialist. Detailed study of the complexities of cultural history at specific moments is necessary to accompany the construction of theoretical frameworks. This is precisely what many books devoted to various aspects of the sociology of art fail to provide.

The Social History of Art

I want now to turn to 'the social history of art' to see whether we can expect to find a more fruitful source of developing Marxist art history.

However, as we shall see, by no means all social historians of art are interested in Marxism, and some at various points are philosophers rather than historians. The literature on this subject is immense and I cannot hope to cover it adequately here. I am going to look briefly at Hauser and Hadjinicolaou as examples of social historians of art who have been described as Marxists, before going on to look in more detail in the next chapter at the art historical writings and political allegiances of Max Raphael, Meyer Schapiro and T.J. Clark.

I want to look at two works by Hauser, his *Social History of Art*, and *The Philosophy of Art History*, both published in the 1950s. There seems to have been a noticeable interest in the social history of art and sociology of culture at this time, and Karl Mannheim's *Essays on the Sociology of Culture*, originally written in Germany in the early 1930s, were published in 1956 by Routledge and Kegan Paul, the publishers in 1951 of Hauser's *Social History of Art*. The *Social History of Art* is a massive project and it is perhaps unfair to deal so briefly with only certain aspects of it. However in my view Hauser's project is not based on an understanding of dialectics, and his view of the relationship of culture to society is rather crude. Hauser believes that the history of art is the history of 'styles', with Impressionism being the last great 'style' of Western art. We find the usual reluctance, therefore to discuss non-figurative art, and his series of books concludes with the 'film age', in which art was seen as propaganda in the Soviet Union. Now Hauser must know that this was not the case in the years immediately following the 1917 Revolution, and I suspect his omission of this has less to do with ignorance or politics than an aversion to discussing the non-figurative art of the Soviet avant-garde. His idea of 'style' deprives it of any inner dialectic, as for example, in his discussion of the (neo)-classicism of David: 'David's classicism represents the conception of art most in harmony with the political aims of the Consulate and the Empire.' However, it was also apparently found already created by David for the monarchy and its state by the bourgeois revolutionaries in 1789. Yet the real style of the Revolution was to be Romanticism, says Hauser, which the Revolution itself was incapable of bringing into being.[46] The desire to give political class characterizations to styles results in this awkward and contradictory summary, because Hauser cannot see that tensions and contradictions exist within so-called styles, and also within ideological and political views of sections of society. Instead Hauser sees styles as having different meanings in succession, not the possibility of conflicting potential meanings at the same time. Impressionism is characterized in various class terms as follows. It is

described as having 'nothing plebian about it', and was an aristocratic style 'elegant and fastidious, nervous and sensitive, sensual and epicurean, keen on rare and exquisite subjects, bent on strictly personal experiences, experiences of solitude and seclusion and the sensations of ever-refined senses and nerves'. Yet, states Hauser, Impressionism was created by the lower and middle bourgeoisie. These artists were not theoreticians but craftsmen and technicians.[47] Thus there are (dubious) sociological characterizations of the style, and the producers of Impressionism, and both style and makers are categorized separately without any way of relating these contradictory elements as part of a whole developing process. In other words, there is no dialectical framework.

As to the function of his art historical work, Hauser states that at this historical time progressive art is complicated, avant-garde and modernist, and he concludes with a moral/political point that the share of the masses' enjoyment in this art must be increased. 'The preconditions of a slackening of the cultural monopoly are above all economic and social. We can do no other than fight for the creation of these preconditions.'[48]

In an interesting article analysing the reception of Hauser's work on the social history of art, Michael Orwicz shows how Hauser was variously identified as a Marxist, dialectical materialist, materialist, and economic determinist by many of the critics and art historians who reviewed his book.[49] However Orwicz himself seems to accept Hauser's method as dialectical materialism, which I consider is not the case, and in fact this methodological weakness did open up his work to some valid criticisms. But Orwicz interestingly demonstrates how critics like Greenberg and Rahv in the States wanted to preserve a kind of apolitical Marxism, and this influenced their view of Hauser's book – locating in it a Marxist view of society, and a non-Marxist view of art. Greenberg wrote for example that Hauser's

analysis of the development of society is unequivocally Marxist – appropriately so, because no other *available* method can extract equally plausible meanings from the seeming contradictoriness of social evolution, especially in its relation to art. Mr Hauser's Marxism is too "orthodox", in the Bolshevik sense, for my taste and his interpretation of social history as such follows the standard lines too closely . . . but it rarely interferes with his view of art, since he does not extend his Marxism to aesthetic questions proper.

Orwicz correctly points to the fact that

> For Greenberg, Rahv and their comrades, there were clearly two Marxisms. An "acceptable" one, which elaborated a theory of history and accounted for the complexities of social and economic relationships. There was also a "crude" and "vulgar" Marxism, which reduced the intricacy of social and political relations to essentially economic ones, and whose theory they considered materialized in party positions and in Soviet politics.[50]

Greenberg and most of the other 'independent' leftists around the journal *Partisan Review* were anti-Stalinist, but since they equated Stalinism with communism and Bolshevism, and never really committed themselves to the Trotskyist opposition, they were basically anti-party and drifted away from Marxism. This was the logical outcome of their desire for a Marxism divorced from political responsibilities. These 'independent' Marxists were treated with scorn by Trotsky, and he needed some persuading to write anything for the *Partisan Review*. He was in a good position to know exactly where such independent Marxists were coming from, since he himself had been a far more politically active and more committed anti-party Marxist before joining the Bolsheviks in 1917. In a discussion with Cannon and Shachtman, the American Trotskyists, in 1938, Trotsky discussed tactics towards left intellectuals like Rahv and the group around the *Partisan Review*. Trotsky suggested collaborating in the review and offering 'friendly criticism', but not taking any responsibility for the journal's political positions.

> If we are to have a workers' party we are to make the intellectuals feel that it is a great honor to be accepted by our party and that they will be accepted only if they are approved by the workers. Then they will understand that it is not an intellectual petty-bourgeois party but a workers' movement, which from time to time can use them for its purpose.[51]

This was obviously rather different from the way most of the participants in *Partisan Review* viewed their contribution to left cultural politics!

Hauser's *The Philosophy of Art History* was, as its title suggests, more concerned with philosophy and art history than the social history of classes and their culture. He states that art history is not the same as social history, for some works that are artistically feeble may be very

interesting as social history. This in itself raises many interesting issues which Hauser does not develop. Art history is still seen as a history of 'styles', and styles only develop when 'a social outlook . . . cannot find expression directly'.[52] Thus, sublimated and deflected social views are embodied in the different styles of art. One has to wonder why Impressionism is the last style of art in this case. The desire to be free of ideology is an impossible utopia, writes Hauser, as all ideology is an expression of some need, and history is an endless dialectical struggle between truth and ideology: 'All talk of an end to the movement (of struggle) that is, an end to history, whether on Hegelian or on Marxian lines, is pure speculation.'[53] However Hauser seems to contradict himself on the issue of truth vs. ideology when later, following Marx, he states that the nineteenth-century novelist Balzac was perhaps unconsciously able to transcend his own ideological positions in his portrayal of the real motor forces of French nineteenth-century society.[54] There is much interesting material in Hauser's book, including suggestive remarks on psychoanalysis and art, and a discussion of 'art history without names', but again this book does not really contain the methodological basis for a specifically Marxist and dialectical materialist understanding of art and culture. Probably Hauser's weakest point is his notion of art history as a history of styles, which are somehow the products of desires to engage in meaningful social activity which have been thwarted (by whom?) Are these social outlooks the views of class-conscious groups or identified in sociological terms? For Hauser the dialectic is posed not as inherent in all natural and historical phenomena but as an eternal struggle between truth and ideology, which is not exactly how a Marxist understanding of dialectics posits the development of the pre-human material world and of human society.

Hadjinicolaou's *Art History and Class Struggle* is in many ways a successor to Hauser's project on the social history of art. Published in French in 1973 and English in 1978, Hadjinicolaou set out to avoid reductionist art history, but argued for a history of art as a history of 'visual ideologies' which did not in fact allow him to escape accusations of economic determinism, and rightly so. It was easy to set him up as a practitioner of an economically determinist method, which saw paintings as visualisations of the ideologies of 'class fractions'.[55] Fairly crude in his application of Althusser's and Poulantzas' theories, Hadjinicolaou 'actually pushed Marxist art history back into a deterministic and sociological mode', as John Roberts puts it.[56]

However Hadjinicolaou does a fairly convincing demolition job on

histories of art as a succession of 'styles', or the works of great individual geniuses, or expressions of the 'spirit of the age'. In the context of the 1970s, this was a useful exercise, and this first part of his book cleared the way for an examination of what kind of art history should replace these discarded models. He then proceeds to demonstrate his understanding of art works as embodiments of visual ideologies. However he refuses to discuss any examples of twentieth century art, presumably because it is non-figurative in many cases, which is a major failing of the book. Another weakness is his inability, or unwillingness, to discuss what the practice of a Marxist art historian might be. Is it to teach, research, write books of Marxist art history, campaign for better resources in education or what? After all, to paraphrase a famous authority on Marxism, the point is not simply to understand art history, but to change it. Only in one footnote does Hadjinicolaou deal with this question. Art history, he says, is concerned with the past.[57] Art criticism, on the other hand, is concerned with the present and does therefore have some practical relevance to artists and the state of art at the present time. Thus we find that art history has perpetuated itself even here as an academic discipline in the same spirit as that of the scholars previously rejected as 'bourgeois art historians'. Hadjinicolaou chooses examples of high art throughout, mentioning only a print by Callot as the exception. Since the 'struggle of visual ideologies' he analyses is between different sections of the same class, the art we are shown constitutes the art of a tiny minority of people from the dominant classes of European society. Now this is true of most art history books, but we might expect better from a self-proclaimed Marxist author. Not surprisingly, dialectics merits hardly a mention in this work, which is ultimately, and by the author's own hand, recuperated into the art historical academic world he criticizes, and distanced from any contemporary concerns whether political or artistic. It remains to be seen whether I can avoid this with the present work, of course.

In conclusion, it can be seen from an examination of the works of many authors hailed as radical, leftist, and even Marxist, that their method fails to engage with much that is essential to Marx' and Engels' elaboration of dialectical materialism. Many of these works continue to give the impression that Marxism entails a reductive and economistic approach to culture. The works on art and sociology are probably the weakest due to the lack of interest on the part of many of the writers in actually examining historical material in detail. The social history of art writings discussed in this chapter have the merit of considering

history more directly, but again there is little evidence of any attempts to really understand how the method of Marxism might be applied to the study of culture and its historical development and meanings.

In the following chapter I want to move on to investigate the works of some writers on the social history of art who have been seen as key figures in the formulation and revival of a Marxist study of art. Perhaps their work may lead us to change these preliminary conclusions concerning the social history of art.

Notes

1. F.D. Klingender, *Marxism and Modern Art: An approach to social realism*, London, 1943, pp.47–8.

2. Marx and Engels, from 'The German Ideology', (1845–6) in L. Baxandall and S. Morawski eds, *Karl Marx and Frederick Engels on Literature and Art*, New York, 1974, p.71.

3. A.L. Rees and F. Borzello, *The New Art History*, London, 1986, p.2.

4. P. Overy, 'The New Art History and Art Criticism', in *The New Art History*, p.139.

5. From an interview with Tagg in *Afterimage*, January 1988, p.8, quoted in John Roberts' very useful introduction, 'Art has no History! Reflections on Art History and Historical Materialism', *Art has no History! The Making and Unmaking of Modern Art*, London and New York, 1994, p.9.

6. In the mid-seventies I was briefly a slide librarian at Middlesex Polytechnic (which incorporated Hornsey Art College), the home of *Block* magazine, and site of the conference on 'The New Art History' in 1982. For some years after that, although I changed jobs, I lived in North London and was a participant in the first few editorial meetings of the new journal. However at this time I decided to join a political organization and made a choice as to how my non-working time would be prioritized. I'm afraid *Block* lost out, and I stopped attending editorial meetings, which did teach me something about my own views concerning cultural politics. I later felt the need to integrate my commitment to politics with my interest in visual culture, but still believe that when choices have to be made, politics in action are more important than cultural politics. However my work is as an art and cultural historian, and I am fortunate enough to be able to openly integrate aspects of my politics and my labour as a professional academic. This book is an outcome of these endeavours in a particular historical and cultural situation.

7. Overy in *The New Art History*, p.134.

8. Roberts, *Art has no History!*, p.1.

9. Pollock and Orton, *Avant-gardes and Partisans Reviewed*, p.xiii.

10. See her essay 'Missing Women: Rethinking Early Thoughts on Images of Women', in C. Squiers ed., *The Critical Image, Essays on Contemporary Photography*, London, 1990.

11. Pollock and Orton, *Avant-gardes*, p.iii.

12. J.S. Ackerman, 'Toward a New Social Theory of Art', *New Literary History*, vol.IV, no.31, Spring 1973, p.509. Other Ackerman quotations cited here are also from this article.

13. Werckmeister, 'Marx on Ideology and Art', *New Literary History*, vol.IV, no.31, Spring 1973, p.509.

14. L. Trotsky, *Literature and Revolution*, Ann Arbor, 1960, p.218.

15. O.K. Werckmeister, 'A Working Perspective for Marxist Art History Today', *The Oxford Art Journal*, vol.14, no.2, 1990, p.94. The previous quotation is also from this article.

16. D. Craven, 'Karl Werckmeister and the Role of Critical Scholarship', *The Oxford Art Journal*, vol.13, no.2, 1991, p.86. However Craven himself does not seem to know the difference between Stalinism, guerillaism and Marxism, since he describes Che Guevara as a 'major Marxist theoretician', and cites developments in Cuba as part of the 'genuine process of democratizing culture', in line with the softness of much of the American left towards Cuban Stalinism. For a useful assessment of Guevara's life and political ideas see the article 'Guevara's Legacy. A Review of *Che Guevara: A Revolutionary Life*, by Jon Lee Anderson', by M. Abram, *Trotskyist International*, Issues 22, July–December, 1997, pp.50–9.

17. Werckmeister, 'From a Better History to a Better Politics', *Art Bulletin*, vol.LXXVII, no.3, September 1995, p.390.

18. For a detailed discussion of Mukhina's sculpture and its meanings in mid-thirties Stalinist culture, see my book *Seeing and Consciousness: Women, Class and Representation*, Oxford and Washington D.C., 1995, chapter 5.

19. On the patrons of Impressionism see A. Distel, *Impressionism: The First Collectors*, New York, 1990.

20. All these quotations are from M. Baldwin, C. Harrison, M. Ramsden, 'Art History, Art Criticism and Explanation', *Art History*, vol.4, no.4, December 1981, pp.432–56. The article raises many thoughtful points, but I feel it is not particularly clear on dialectical materialism.

21. Hollis Clayson, 'Materialist Art History and its Points of Difficulty', *Art Bulletin*, vol.LXXVII, no.3, September 1995, pp.367–71.

22. Marx and Engels, *Selected Works in One Volume*, p.28.

23. Clayson, 'Materialist art history', p.369.

24. R.W. Friedrichs, *A Sociology of Sociology*, New York and London, 1970, p.268. See the whole section on 'normal' and 'revolutionary' sociology in his book (chapter 2).

25. H. Lefebvre, *The Sociology of Marx*, Harmondsworth, 1972, p.22.

26. Ibid., p.23.

27. J. Scott, *Sociological Theory: Contemporary Debates*, Aldershot, 1995, introduction p.xiv.

28. P. Bourdieu, *The Field of Cultural Production: Essays on Art and Literature*, Cambridge, 1993, chapter 6, 'Principles for a Sociology of Cultural Works', 1986, p.183. See also chapter 9 in the same book, 'Manet and the Institutionalization of Anomie', 1987.

29. E. Goffman, *Frame Analysis*, New York, 1974, pp.13–14, quoted in E. Chaplin, *Sociology and Visual Representation*, London and New York, 1994, p.15.

30. For example Jean Duvignaud, *The Sociology of Art*, London, 1972.

31. Slaughter, *Marxism, Ideology and Literature*, p.6.

32. Ibid., p.46.

33. T.W. Adorno, *Aesthetic Theory*, London, 1984, p.487.

34. J. Wolff, *The Social Production of Art*, p.6.

35. She finds Marxism deficient in many ways, especially in its analysis of women's oppression. Her criticisms of Marxism's supposed blindness to women's oppression and issues of sexism in society are ones that are often met with in contemporary feminist scholarly writing, and usually betray a scant knowledge of any writings by Marxists on women's oppression. This is dealt with in detail in my book *Seeing and Consciousness*, chapter 1.

36. Wolff, *Aesthetics and the Sociology of Art*, p.21.

37. Ibid., p.64.

38. Ibid., p.65.

39. Ibid., p.83.

40. Ibid., p.114. Wolff specifically refers to the work of Lynn Hunt as an example of this tendency.

41. T. Hinks, 'Aesthetics and the Sociology of Art: A Critical Commentary on the Writings of Janet Wolff', *British Journal of Aesthetics*, vol.24, no.4, Autumn 1984, p.349.

42. E. Chaplin, *Sociology and Visual Representation*, p.29.

43. Ibid., pp.14–15.

44. Ibid., p.279.

45. R.W. Witkin, *Art and Social Structure*, Cambridge, 1995, pp.11–15.

46. A. Hauser, *The Social History of Art*, vol.3, London, 1951, pp.139–43. Apparently a new book on Hauser is forthcoming, but was not available to me at the time of going to press. See D. Wallace and J. Zaslove eds, *Arnold Hauser and the Social History of Art, Modernism and Modernity*, Vancouver, forthcoming.

47. Hauser, vol.4, p.166.

48. Hauser, vol.4, p.245.

49. M. Orwicz, 'Critical Discourse in the Formation of a Social History of Art: Anglo-American Response to Arnold Hauser', *The Oxford Art Journal*, vol.8, no.2, 1985, p.55. The Greenberg quote which follows is also from this article.

50. Ibid., p.57.

51. L. Trotsky, *Writings of Leon Trotsky (1937–38)*, New York, 1976, p.297.

52. Hauser, *The Philosophy of Art History*, London, 1959, p.29.

53. Ibid., p.40. There is an extensive discussion of dialectics in Hauser's last work, the monumental *The Sociology of Art*, Chicago, 1982. In this work Hauser argues that Engels distorted Marx's notion of dialectics, turning it into a mechanical materialist interpretation of the world. Hauser maintains there are no dialectics in nature, only in human history. In a useful review of the book Louis Harap points out that Hauser 'has modified his approach [from his earlier works] "above all" by drawing a line between "theoretical and practical Marxism, in antithesis to the orthodox unity of theory and practice in the sense in which Marx proclaimed that dogma." Hauser now "heretically" believes it possible to "agree with Marxism as a philosophy of history and society without being a Marxist in the politically activist sense," or even a socialist "in the narrower sense". The theory of the prognosis of the classless society he now calls "metaphysical ballast."'See L. Harap, 'Arnold Hauser: Philosopher of the Arts', *Science and Society*, vol.XLIX, no.1, Spring 1985, pp.84–90, quote from pp.86–7.

54. Ibid., p.94.

55. Griselda Pollock, for example, made easy work of attacking his book in her feminist critique of Marxist art history. G. Pollock, *Vision and Difference: Femininity, Feminism and the Histories of Art*, London and New York, 1988, chapter 2.

56. Roberts, *Art Has no History!*, p.9.

57. N. Hadjinicolaou, *Art History and Class Struggle*, London, 1978, p.87.

A Social or a Socialist History of Art?

In this chapter I want to look at the methods of T.J. Clark, Max Raphael and Meyer Schapiro, and their contribution to the social history of art. While all three are described as Marxist art historians, it is Clark who, above all, has been perceived as clearly left-wing and pre-eminent as a social historian of art. His contribution to radical art history is one of the most important available in English, certainly among living scholars. However the way in which Clark's work has been set up as a model of Marxist art historical method certainly needs some careful re-evaluation. I would argue it is perhaps not as clearly an example of Marxist art history as many of his admirers and critics have led us to believe.

I want to look first at the early work of T.J. Clark, and specifically his comments on the nature of the social history of art, on the sort of questions it might ask, and on the way they need to be posed. In so doing I want to explain just what kind of a radical tradition Clark wants to situate himself in, and whether it really is a Marxist one.

In an essay on Clark and the new art history, Paul Overy referred to Clark's book *Image of the People*, (1973) and his article in *The Times Literary Supplement*, (1974). He stated that had Clark been writing anywhere else but in the *TLS* he would 'have described what he wanted as a "historical materialist" history of art'.[1] However in his own book in the previous year, Clark had done nothing of the sort, calling instead for a 'social history of art'. Why did he do this, and what did he mean? If he was a Marxist art historian, then why not call for the development of a Marxist art history and refer to a number of writers who in the past have contributed to method and theory in this field, for example Marx himself or Max Raphael? Clark does mention Marx but the main figures he singles out for attention in his *TLS* article are the great figures of German idealist art history, and George Lukács.[2]

So first of all, what does Clark want in his 'social history of art'? The section in his book *Image of the People* entitled 'On the Social History of Art', is no doubt intended as a 'jokey' allusion to the sort of titles used by members of revolutionary parties when they published speeches, for example Lenin's 'On the National Pride of the Great Russians'. These short speeches and articles were later published cheaply by Progress Publishers in Moscow, and were widely available until fairly recently. It may have amused Clark to use a 'party' formulation for his title, while avoiding the issue of Marxism completely in his discussion 'On the Social History of Art'. He used the same mode of addressing the reader in a later conference paper 'More on the Differences between Comrade Greenberg and Ourselves', from a conference on Modernism and Modernity at Vancouver. Since Clark is against any notion of a revolutionary party, the reference to 'comrade' is deeply ironic and no doubt he was aware that it might raise a laugh with radical intellectuals who would perceive themselves as on the left, but, of course, unaligned and distanced from such activities and terminology.[3] Clark argues that it is easier to state what he thinks must be avoided by a social history of art, than to actually define it. Among the key issues he is 'not interested in' are the idea that artworks reflect ideologies, social histories, etc., the way history is presented as a 'background' to the artworks, artworks explained as being 'influenced' and 'determined' by historical conditions, philosophies, etc. One of his main areas of research is writings by critics of art, which he uses to look for the 'repressions' where real meaning can be discerned in a manner he argues is analogous to Freudian psychoanalysis. However it is not clear if this 'unconscious' he may discover in the writings of the critics and their pattern of obsessive repetition or incomprehension is the unconscious of the individual critic, the art world, a social group, or a historical moment. Clark calls it 'the public' of the artist.

In a crucial passage, Clark explains what he really wants to investigate and how he will do it. This is the nearest he comes to defining the object of study and the methods of a social history of art:

> What I want to explain are the connecting links between artistic form, the available systems of visual representation, the current theories of art, other ideologies, social classes, and more general historical structures and processes . . . If the social history of art has a specific field of study, it is exactly this – the processes of conversion and relation, which so much history takes for granted. I want to discover what concrete transactions are hidden behind the mechanical image of "reflection", to know

how "background" becomes "foreground"; instead of analogy between form and content, to discover the network of real complex relations between the two. These mediations are themselves historically formed and historically altered; in the case of each artist, each work of art, they are historically specific.[4]

Clark here in the first sentence sets out the interconnection between various elements necessary to understand Courbet's work, but it is noticeable that there is no primacy given to any one of them, and certainly not the economic, which is not mentioned, only 'more general structures and processes'. These relations and their workings, these 'processes of conversion and relation' are what Clark sees as the key to the object of study of the social history of art, not artworks, not the material history in itself, but the processes and relations. These processes are made concrete and this is how we can grasp and understand them. These 'mediations' can be studied by the social historian of art in all their historical specificity. On the following page Clark states clearly that: 'I have been arguing for a history of mediations.'[5]

Now Clark here is in a precarious position. He is not exactly putting forward an idealist notion of structures determining concrete historical reality, but sometimes he is pretty close. These 'relations' and 'mediations' he talks about sometimes have the air of abstract historical processes which manifest themselves in concrete form so that we can perceive them, in some Hegelian manner, rather than being seen as the product of human activity in social history. Whatever processes we are talking about in mid nineteenth-century France can only be the result of human activity unless of course we are talking about the inanimate material world, and Clark clearly is not.

In his article in the *TLS*, Clark is much clearer on where he is actually coming from with this method. At the beginning of his article he quotes Lukács' 'great essay' *Reification and the Consciousness of the Proletariat*, 'which sticks in my mind':

And yet as the really important historians of the nineteenth century such as Riegl, Dilthey and Dvořák could not fail to notice, the essence of history lies precisely in the changes undergone by those *structural forms* which are the focal points of man's interaction with environment at any given moment and which determine the objective nature of both his inner and outer life. But this only becomes objectively possible (and hence can only be adequately comprehended) when the individuality, the uniqueness of an epoch or an historical figure, etc. is grounded in

the character of these structural forms, when it is discovered and exhibited in them and through them.[6]

It is absolutely clear here that this is the method Clark puts forward for the social history of art in his book, and also designates its objects of study – the structural forms. The source is in Lukács' Hegelianized Marxism, which sees the 'structural forms' of history manifesting themselves in concrete form and only then perceivable by us and identifiable as the unique characteristics of an epoch. The latter are not defined by economic systems and the relations of production which develop out of them but by the 'structural forms' through which humans interact with their environment (though of course relations of production might be included in these structural forms, but not privileged).

A little later Clark refers to Hegel himself, obviously piqued by what he sees as unfair criticisms of the philosopher.

> In the best art historical circles now, this mode of thinking is scorned –
> an Hegelian habit . . . It is odd how reactionaries of Right and Left present
> as their clinching case these days the same caricature of Hegel, a cardboard
> idealist Hegel . . . In art history – and, I believe, elsewhere – it is precisely
> the Hegelian legacy that we need to appropriate: to use, criticize, reform-
> ulate.[7]

So Clark wants to re-elaborate a Hegelian art history in the tradition of the great central European art historical scholars, and resents and rejects cardboard cut-out caricatures of Hegel as an idealist. Unfortunately for Clark's argument, whether we have a two-dimensional or multi-dimensional picture of Hegel, he is still an idealist. What is far more important was that he was a dialectician, and that is more significant for us, just as it was more significant for Marx and Engels.

All of the Marx and Engels critiques of Hegel's work are painstaking and full of admiration for Hegel's method, but remorseless in under-mining its idealist slant. Clark surely knows this and could have referred to these works if he had really wanted to indicate an alternative to the 'caricatures' of Hegel offered by art historians in the 1970s (not that I can readily bring any to mind). When Clark actually mentions Marx, it is in the context of what Marx says about Raphael in *The German Ideology*, in relating art to the history of the conditions of artistic production, and Clark seems to think that it is in this area that Marx is most useful, not in terms of his overall method. His article ends with a

stimulating, but rather unclear, discussion of ideologies, and a plea for the art historical study of how ideologies work. However it is not clear in this discussion whether Clark thinks all art is ideology or not. The implied conclusion is that it is.

Lukács and Marxism

Now it is worth looking briefly at the writings of Lukács which Clark refers to, in order to understand the heavily Hegelianized Marxism which Lukács formulated. The essay 'Reification and the Consciousness of the Proletariat' formed part of *History and Class Consciousness*, published in 1923. Lukács argues in this work that history begins when the proletariat becomes conscious of itself as the subject-object of history. It thus overcomes and supercedes its alienation. This is clearly influenced by Hegel, except that the proletariat takes over from the Hegelian 'spirit' or 'idea'. Lukács also stated in this work that 'it is possible – as with Kant – to view the object of thought as something "created" by the forms of thought', which of course is a rejection of materialism. The brain, without which thought cannot exist, is itself matter.[8] Lukács goes so far as to imply that nature is the creation of humankind and even of its consciousness. He considered the dialectic to be proletarian, but materialism to be bourgeois, slicing dialectical materialism down the middle in a crude reductionist manner. Lukács' metaphysical conception of the proletariat, formed in thought, down-plays the formation of class consciousness during the struggle to reconstruct society. Most of Lukács' reasoning is highly abstract with little connection to history. What, for example, are we to make of the bourgeois revolutionaries of 1789 in France? Had they no class consciousness in this 'pre-historical' period when the proletariat was not the subject of history?

As Novack comments, Lukács was more of a Hegelian than a Marxist when he asserted that 'the structure and hierarchy of the categories . . . are the central theme of history'. Lukács thus inverts the relation between the ideas and concepts constructed by human beings and their practical activities. In *History and Class Consciousness*, the dialectical method of Marxism is not used to analyse the development of material life in motion but 'rather a selection or system of abstract categories (totality, reification) on which Lukács erects his theoretical construc-tions'.[9] As Ernst Bloch stated in his original review of Lukács' book '. . . Marx has not placed Hegel on his feet so that Lukács can put Marx back on his head.'[10] Lukács misses out the crucial link that Feuerbach

provided in the development of the thought of Marx and Engels, enabling them to fuse Hegel's dialectics with materialism. Lukács argued that Marx simply continued where Hegel left off, and he himself rejected the valuable lessons of materialism.

Lukács was condemned by the Soviet Communist Party officials Zinoviev and Bukharin in 1924, the year after his book was published, for deviating from Marxism. He was already rather suspect as an ultra-left member of the Hungarian Communist Party. At this time, ultra-left politics meant a rejection of any orientation to, and work in, organizations which were seen to be bourgeois, such as trade unions and bourgeois democratic parliaments. Thus revolutionary politics and organization was simply counterposed to workers' existing reformist bodies. In effect, workers were given an ultimatum by ultra-lefts, not won over to revolutionary politics in joint struggle. As late as November 1918 Lukács still had not given his support to the October Revolution, wondering whether it was sufficiently revolutionary. His writings must be seen in the context of both the beginnings of bureaucratization of the Soviet party, and the failure of most of the European revolutions after the First World War.

In terms of the application of Marxist theory to the real material tasks of destroying the capitalist system, Lukács' stance as a Marxist was inadequate. He did not side with the struggle to oppose Stalin in the 1920s, and by the later twenties swung over to the right and supported Stalin and praised the Stalinist doctrine of 'socialism in one country'. In order to remain in the party he kept quiet about differences with the Stalinist leadership in order to avoid expulsion (or worse). His fellow philosopher Karl Korsch, of whom more later, was expelled from the German Communist Party in 1926. Lukács was opposed to Trotskyism, and he sublimated his political activity into the fetishization of the Communist party, which he saw as the embodiment of proletarian class consciousness. However these developments in Lukács' politics are not just products of his thought but ultimately explicable in terms of the material reality of the defeats of the working class and the rise of Stalinism in the 1920s and 1930s. Thus the sophisticated dialectician lapsed into formalism, fetishism and advocacy of 'realist' art.

It is possible to see more clearly now, where Clark is coming from in his writings of 1973–74. The fact that he does not call for a Marxist history of art is no accident, nor can it be put down to the fact that he is writing for the *TLS*. What he does call for is a Hegelian-Lukácsian history of art. Fortunately, what Clark actually delivers in his two books

about French art, the 1848 Revolution, and the Second Republic, is far better than his methodological sources might suggest. His work is based on solid historical research, but most fundamentally, Clark's great virtue is that he applies dialectics to cultural history, and this is what makes his two early books tower far above any similar undertakings, and, for me, also far above the Germanic art historical works he admires so much himself. Clark's methodological sources in the Marxist tradition are heavily Hegelianized ones.

Clark and 'Leftist' Politics

What then, of Clark's political sources within this tradition? Clark's interest in the politics of Pannekoek and Gorter, the Dutch Marxists, and his later brief membership of the Situationists, locates him in the tradition of 'leftist' politics. This tradition, in which Lukács also figures strongly, is deeply suspicious of the Bolshevik model of the democratic centralist cadre organization (an organization of trained and disciplined revolutionaries), preferring to emphasize a view of revolution brought about by changes in consciousness, allied to the creation/emergence of workers' councils. This is usually termed 'council communism'. Now not all political figures in favour of workers councils wanted to do away with a revolutionary party completely, but they definitely saw it as external and sometimes even parasitic on genuine organizations of the workers themselves. This view ignores the fact that many workers were members of, for example, the Bolshevik party, and that the Bolshevik party was able to take state power in the Soviet Union because it won over, by discussion, example and joint work, the majority of workers in the workers' councils (or soviets) to their programme. It is on the question of programme that Pannekoek and Gorter are perhaps weakest. Without a strategy and leadership organized around a programme to take power, the workers' organizations will be in a weak position in relation to the capitalist class, who are well organized, have a leadership, and know what they want in terms of holding on to state power for their class. However it must be said that a suspicious attitude to parties and state power on the part of 'council communists' was due not only to unease with the Bolsheviks in power, but also to the bad experiences many of them went through in combatting the parliamentarianism and opportunism of the parties of the Second International before their treacherous betrayal of the working class in the First World War.

Two books by Richard Gombin give a very useful account of this 'leftist' tradition, and I will draw on them here in giving a brief summary

42

of Pannekoek's views. While there is much in these books I totally disagree with, for example the ultra-left view, shared by Gombin, that the October Revolution was only a bourgeois revolution which did not abolish capitalism, that Trotsky was a figure of the political right who was equally responsible for the rise of Stalinism, and so on, the books are clearly written and do a good job in showing the links between 'council communism' and the Situationists in the 1960s.[11]

Gombin explains that 'leftism' sees the USSR's economy as state capitalist (this is also Clark's position on the former USSR). Socialism, writes Gombin, should be decentralized and run by self-governing bodies, not 'a workers' state'. The early writings of Marx should be a model for theory according to Gombin. He rejects the later Marx and his agreement with Engels' 'scientific' distortions which were responsible for 'official' Marxism, and he designates Marxism an 'ideology'. According to Gombin, Lenin's argument that all ideas come from being, not consciousness, denies the possibility of the proletariat becoming class conscious, a bizarre argument in my view. Gombin argues that Lenin's model of the Revolutionary party is wrong. Lenin argues that workers' spontaneous consciousness is not revolutionary, and thus a party with revolutionary strategy and tactics must engage with workers in struggle and recruit workers into an organization of trained and educated revolutionaries, some of whom will be workers (the more the better) but some of whom definitely will not. Gombin argues that this must be mistaken, for if being determines consciousness, then the bitter experiences of exploited and oppressed workers should make them revolutionaries, not trade unionists or members of reformist parties. This is truly economic determinism. Gombin is completely against the idea of a Leninist-Boshevik party along with many other 'leftists', including Clark.

Gombin states that 'Leftism' follows Lukács in seeing 'consciousness of the proletariat as itself the factor affecting historical evolution'.[12] Gombin then explains the theories of the German and Dutch 'council communists'. Pannekoek viewed the Russian Revolution as a bourgeois revolution which merely took over a bourgeois state and built a state capitalist economy. This obviously fails to apply Marx's definition of capitalism as generalized commodity production dominated by the operation of the law of value in the economy to early Soviet society. According to Pannekoek, the soviets were not the state in the USSR, therefore there were no genuine soviets there, either immediately after the October Revolution or later. Pannekoek shared the ultra-left view of rejecting any revolutionary work in trade unions or parliament in

capitalist countries, since these were not genuine soviets or workers councils.[13]

Gorter wanted a councillist party, which was rather different from Pannekoek's view. Gorter saw the need for two sorts of organizations, one in the workplace, and one which brought 'enlightened militants' together in a 'party'.[14] However this did not solve the problem of developing 'trade union' consciousness into a political consciousness, which is one of the key tasks of revolutionaries in the workplace.

The Situationists, founded in 1957, were strongly influenced by the ideas of council communism, Lukácsian Marxism, and anarchism.[15] T.J. Clark was briefly a member of the British section of the Situationist International as part of the Heatwave group, and was expelled in December 1967. The expulsion document is a turgid and sectarian piece of writing. Considering that this document was produced by an organization made up of people who condemned the Bolshevik party as undemocratic, their own dealings with members leave much to be desired.[16] In 1967 Clark helped to translate into English a Situationist text *On the poverty of student life considered in its economic, political, psychological, sexual and particularly intellectual aspects, and a modest proposal for its remedy*.[17] This apparently influential text was a good example of the confused politics of the Situationists, ultra-left, sectarian, anarchist-influenced and ultimatist. Bourgeois higher education and students were utterly condemned. There was no room for reform, and the whole of higher education needed to be destroyed. Higher education merely trained unthinking students to administer bourgeois society and make them into passive consumers. There was no attempt to see the contradictions in education within a capitalist state, or the struggles waged by workers' organizations and education workers to improve conditions in education, or any of the important gains education can bring people who have the chance to participate. Many young people in countries which are politically and/or economically dominated by imperialism have no chance at all to take a degree or anything like it. The ultra-left Eurocentrism of the Situationists did not allow them to see any contradictions in the cultural institutions of capitalism, or why masses of the world's poor might thirst after education. The Situationists did not see any means of transforming the institutions of higher education in a way which might preserve what was useful, and move in a transitional way to what was far better and more democratic. Surely Clark would agree now that his own contribution to the academic discipline of art history has been a fruitful one, although he has a professorial chair and his books are sold on the capitalist market.

Similarly the Situationists' views on the state argued that the working class should not seize hold of the state, destroy the power of the capitalists, and form a different kind of workers' state as a temporary weapon of power to suppress enemies of the working class, but should immediately abolish the state altogether. The Situationists believed in total contestation of capitalism.

The Situationists also believed that the Bolshevik revolution had been a defeat, instigating a regime of bureaucratic state capitalism. The analysis of the Soviet Union by Trotsky, which argued that the USSR had been a genuine workers' state which had bureaucratically degen-erated, was rejected, and the whole world was seen as dominated by capitalism and totalitarian social systems. Thus Debord in his 1967 book *The Society of the Spectacle*, outlines two models of the spectacle: the concentrated, seen in Nazi Germany, Stalinist USSR, Maoist China, etc., and the diffuse, seen in developed capitalist economies with an abundance of commodities.[18] The proletariat, who were just about everyone according to Debord, were alienated and reified, living in a society of the spectacle. The spectacle was not a collection of images but had taken over the representation of social relations between alienated individuals. Debord wrote in 1960:

> Having from the workshop to the laboratory emptied productive activity of all meaning for itself, capitalism strives to place the meaning of life in leisure activities and to reorient productive activity on that basis. Since production is hell in the prevailing moral schema, real life must be found in consumption, in the use of goods . . . The world of consumption is in reality the world of the mutual spectacularization of everyone, the world of everyone's separation, estrangement and nonparticipation . . .[19]

Thus previous capitalist economies have been superceded by econ-omies based on consumption, according to this argument. It is not difficult to see problems with this analysis in terms of its revision of Marxism. No commodities would be produced without production, and watching videos, for example, means the production of television sets, video tapes, film and video cameras, production of building materials to construct video rental premises, etc. Also those with no money, whether in imperialist or imperialized countries would find it difficult to enter into the society of the spectacle. According to the Situationists' view, this exclusion would probably make them better off.

Apart from vague and general calls for students and workers to unite, build councils and oppose capitalism, there was little in the way of a

programme, although by early 1968 Debord invited the Situationists to engage in revolutionary praxis, in which 'conscious' councillists in the workers' councils would lead the way.[20] However most important was the realisation of the end of reification through art. This was obviously a very different emphasis from that of the major influences on 'council' communism such as Pannekoek, Korsch and Lukács. The influence of the Situationists on certain postmodern theorists such as Baudrillard has been commented upon, and I will return to this later in discussing postmodernism.[21]

Clark in the 'Leftist' Tradition

Clark's book *The Painting of Modern Life: Paris in the Art of Manet and his Followers*, published in 1985, displays the author's enduring sympathy for Situationist theories of modern capitalism. This also colours his view of mid-nineteenth century capitalism in Paris. The society of the spectacle and consumption was present even in an economy of capitalist production, it seems, when consumption was not yet paramount. In the introduction to his book, Clark returns to some of the issues raised in his article in the *Times Literary Supplement*, as well as some Situationist arguments. He argues that society appears to be established 'most potently by representations or systems of signs'. This view, he says, is not idealist, and by viewing society as a 'hierarchy of representations' we can avoid the 'worst pitfalls of vulgar Marxism', which believes that economic life is made of more solid matter than 'signs'. 'Economic life . . . is in itself a realm of representations.' Clark argues that it is possible to put this stress on representations and remain a historical materialist: 'Everything depends on how we picture the links between any one set of representations and the totality which Marx called "social practice".' Society is a 'battlefield of represent-ations'.[22]

Here Clark is clearly articulating the same Hegelian/Lukácsian Marx-ism that was evident in his previous article. His method is clearly not completely idealist, yet the relationship between the material world and its representations is posited in a way that leans towards idealism. Of course Marx, as we have seen in his discussion of money and banknotes, does argue that these representations of economic and material relations are no less real for being representations. Try paying your bill at the supermarket with an 'imaginary' cheque! However the meaning of the representations can only be understood by relating them to material life. This is the key factor, not the particular way we

'picture the links'. Society is a battlefield of representations because society is a society based on the containment and opposition of classes in struggle. If we do not picture the links properly it will *still* be a society based on class struggle whether we perceive it or not. It is perfectly fine to speak of the ways in which representations relate to society, which is what the social history of art is all about, but Clark treads a very fine line between emphasizing the material base of these representations and the primacy of the representations, emphasizing *our conceptualisations of the representations* as themselves explaining the material base of any particular society.

Clark argues that the analysis of modern capitalism in the 1960s by the Situationist International also explains the development of commodified leisure in mid nineteenth-century Paris. A new phase of commodity production developed 'the marketing, the making-into-commodities, of whole areas of social practice which had once been referred to casually as everyday life'. Quoting Debord with approval, Clark argues that 'The spectacle is *capital* accumulated until it becomes an image'. It is not clear from this whether it has stopped becoming capital once it becomes an image, which would be nonsense, or if capital had accumulated sufficiently in the 1860s in Paris to become spectacle in any case. Clark is uncertain when spectacular society begins, but roots this process in the shift from 'one kind of capitalist production to another'.[23] Basically this sounds very similar to postmodern 'end of history' views about the expansion of service industries, the demise of heavy industry, and the supposed corollary of working class passivity and impotence (or even the so-called 'end of the working class').

Clark sees the society of the spectacle as representing all-embracing economic change in the 1860s, though it is unclear whether he sees this as a new form of capitalism, i.e. whether this is supposed to be a definition of imperialism, or whether there is an intermediate phase of capitalism in between early modern capitalism and imperialism.[24] Throughout his book, he attempts to show by analysing examples of paintings how spectacle and appearance are crucial to the meanings of emerging modernist art.

However Clark's method here, is not, I would argue, an attempt to reformulate a Marxist art history, but rather one which is based on a tradition of 'leftist' political theory which places little emphasis on Marxism and much more on Lukács and Debord (and those who influenced the Situationists). Strangely, this influence seems far stronger in his later book than in his two books on French art in the aftermath of the 1848 Revolution, written in the years immediately after May

1968. Clark has, however, been criticized by other art and cultural historians for rather different reasons than my own. It has been pointed out that it is ironic to base an academic work on the theories of Situationism, depoliticizing them completely.[25] The Situationists become fashionable, rather than destructive.[26] I personally do not find this a particularly convincing criticism, since it would imply that by writing about capitalism in libraries Marx was betraying his revolutionary ideas, and no one should write scholarly books about revolutionary theory or issues of class struggle. Some other criticisms are more interesting though. For example Harrison, Baldwin and Ramsden criticize Clark for concentrating on conditions of interpretation rather than conditions of production in his discussion of *Olympia*. Since, according to Clark and Debord, the society of the spectacle privileges consumption over production, this is not surprising. The result of this though, the authors point out, is that Clark's deductions move in the wrong way, from the art to the society, 'the reading of art makes the picture of society', and not the other way about.[27]

Clark's Marxism is certainly a long way from any sort of Trotskyist Marxism in its view of the revolutionary party, the nature of the Soviet Union and even the relation of theory to practice. Also we might say that Clark, for all his talk of questioning the spectacular nature of the reality of representation, seemed much happier to study representational art which was fairly easy to relate to social reality, rather than non-figurative art, which poses more difficult, but no less interesting problems for the Marxist art historian. In a later chapter I will be looking at how Clark theorizes the art historical understanding of examples of American Abstract Expressionist art.

Max Raphael

For those later twentieth century art historians engaged with political activity in some way, the preferred model of art history has been that offered by the work of Max Raphael. He lived through momentous events in Europe, the First World War and the period of revolution and counter-revolution which followed, the Russian Revolution and the rise of fascism in Germany, which eventually forced him to flee to France in 1933 and then to the USA in 1941. He died there in 1952, existing with his wife on her meagre earnings as an office cleaner. Few of his prolific writings are available in English. A major work of 1934, dedicated to John Shapley and Meyer Schapiro, is only available in

Serbo-Croat and German.[28] As far as I know, however, Raphael's interest in Marxism was purely academic, and he never engaged in any political activity as such. He believed that his contribution to changing society was as a teacher and a scholar. He stated that art and the study of art can mobilize people's desire for a new social order: 'We can and we must be satisfied with the awareness that art helps us achieve the only just order. The decisive battles, however, will be fought at another level.'[29] In the writings by Raphael translated into English, I have been unable to find any direct comments on the political events of Raphael's lifetime, or any comments on political theory or method, the role of the party and so on. Any remarks on class, consciousness and social change that I came across were all mentioned as part of a discussion primarily devoted to art.

Raphael taught groups of working men and women to study art at the Berlin Volkshochschule for a time. This study group demanded intense concentration and participation from every member. The essays in Raphael's *The Demands of Art* were based on some of these classes. Raphael starts with the work of art itself, analyses it in painstaking detail, to reconstitute it from nothing all over again, thus setting free the creative energies in every true work of art. This is important for several reasons. Firstly, Raphael's teaching in practice, though demanding, must have been far more accessible than trying to follow his visual analyses through his written essays. Raphael standing demonstrating his points in front of a slide must have been more comprehensible than the comparable written version. Also although Raphael's method was intended to be based on dialectical materialism and understanding the work of art in relation to its economic and historical situation, he is much happier dealing with the work first and foremost, moving later, if at all, to the precise historical moment of its production. For example *The Demands of Art* was apparently the first part of a project which began with the detailed analysis of the works. The second part, never completed, was to move on to deal with the historical material. As Tagg explains, Raphael's project was eventually to formulate a scientific theory of art as opposed to the sociology of art. However, confusingly, on a number of occasions he calls his approach the sociology of art, distinguishing it from bourgeois forms of sociology: 'To establish a sociology of art, we must first of all study the relations between ideological and material production, with reference to various social groupings (taking the classes first).'[30] However this is a difficult undertaking: 'To construct a sociology of art in such an epoch was – and still is today – a highly complicated enterprise for it requires, to

begin with, penetration and mastery of the materials of the history of
art all over the world and, further, the joint collaboration of several
special sciences (economics, sociology, politics, psychology, theory of
knowledge, history of religions, philosophy etc).'[31] The critical and
culturally revolutionary aspects of this project cannot be accomplished
by bourgeois scholars, says Raphael: 'It follows that a sociology of art
must first of all analyse the foundations and limits of a "given" social
pattern, a task that cannot be performed by bourgeois scholars with
their class prejudices. In the foregoing essay, we have shown that
Marxism, if interpreted correctly, i.e. dialectically, is capable of perform-
ing this task.'[32] However Raphael argues that the historical (sociological)
study and the critical (aesthetic) study of art should be kept separate:
'Rembrandt is the greatest of the Dutch artists, but this tells us nothing
about his sociological position: questions of artistic value and socio-
logical function must be kept strictly separated.'[33] This is probably
theoretically just about possible, but not very easy in practice, and
Raphael does not succeed in this himself. In fact, as we shall see, for
all his subtlety and philosophical skills Raphael makes some surprisingly
reductive comments on class and art alongside highly interesting and
fruitful ones.

Raphael grappled with the problems involved in integrating his
interest in Marxist theory with the philosophical texts he had studied
earlier. Sometimes, as we see, he never really gets rid of idealist notions
such as 'the general psychology of the age', which is conceptualized as
devoid of contradictions and class conflict. He also in the same passage
talks of 'a class psychology'.[34] Similarly his idea of obliterating any
previously known reality, beginning with a blank slate, and reconstit-
uting the work of art over again was influenced by his study of Husserl's
phenomenology. According to Husserl, this method superceded both
idealism and materialism by rejecting all 'presuppositions'. Any facts
known about a phenomenon had to be rejected along with any theory
of knowledge. As Novack explains: 'The internal logic of a phenomenon
was to be reconstructed from the appearances of it available to the
observer. Thus far the method appeared to parallel empiricism, but
Husserl then posited that the aim of such an investigation was to
intuitively grasp the real essence of the phenomena under observ-
ation.'[35] Now this is exactly what Raphael tries to do in the study of
art works described in *The Demands of Art*. However this method has
been criticized for giving as much weight to superstructural/cultural
factors in social causation as to the material foundations of class society.
While sometimes clearly emphasizing the primacy of material life,

Raphael at other times stated that 'the influence of artistic consciousness on historical reality can be greater than that of historical reality on artistic consciousness.'[36] He also posed the question, to which we know his answer in practice: 'Do we start from the general historical conditions and deduce the work of art from them or, conversely, do we first analyse the work of art and then link it with the general historical situation?'[37] He chose the latter, but never actually moved on to the stage of linking the work and the historical situation. His alternatives also raise the issue of whether it is ever valid to isolate any work of art from others in this manner, if we want to consider art works as part of a social and cultural totality.

In some cases, Raphael does not avoid making quite reductive comments about the meaning of art works in class terms, or drawing general parallels between economic and cultural formations in quite a surprising way. I think one of the reasons for this is his desire to separate aesthetic from historical factors. He asks: 'What class is objectively revolutionary? Only the answer to this question can determine the degree of modernity of a work of art.'[38] If this had been written by Lenin or Trotsky everyone would be throwing up their hands in horror or perhaps even bewilderment! Raphael is unusual for a social historian of art in his interest in contemporary abstract works, and some of his comments on Picasso are most interesting. However generally he rejects abstract art as merely an 'illusion of "modernity"', commenting that much of it is simply a petty-bourgeois desire to escape from the crisis of monopoly capitalism.[39] Abstract art is seen as the embodiment of alienation in capitalist society, as in Picasso, for example, who 'has achieved an organized individualism, a schematization of the monad – an advance which corresponds to the transition from free-enterprise to monopoly capitalism'.[40] He does not distinguish between abstract and non-figurative art produced in the Soviet Union in the early years after the Revolution, and the Cubism and Surrealism produced in imperialist countries, perhaps because he too has come to see the Soviet Union as capitalist by the 1930s, but this is unclear.

In his 'reconstitution' of the progressive states of a Degas etching, *Leaving the Bath*, (figure 1), we can see Raphael go through a meticulous visual analysis of the images. However when he comes to explain the meanings of the works and the artist's motives in his particular historical situation, there is little evidence provided, and the essay is not ultimately very different from the sort of art criticism and history which relies on the sensitive reading of works by scholars seeking to draw intuitive analogies between artistic forms and economic and historical

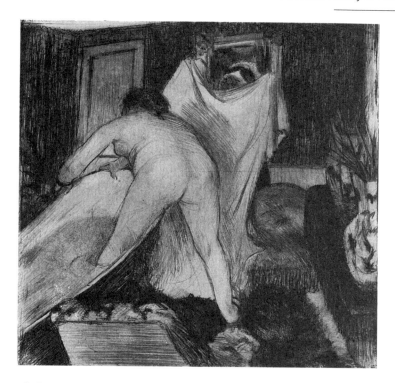

Figure 1 Degas, *Leaving the Bath*, ca.1882, etching 12.5 × 12.5 cms State 5, Cabinet des Estampes et de la Photographie, Bibliothèque Nationale, Paris.

configurations. Raphael demonstrates how in the composition three-dimensional movements are turned away from their original goal in space between the woman's legs and right buttock: 'The implication is that of a cynical, pessimistic devaluation of love, a view that is in sharp contrast to the central and metaphysical role of love in the nineteenth century.'[41] Moving on to discuss state 5, illustrated here, Raphael shows how the tensions and contradictions meet in the woman's back, embodying the psychological struggles of the artist in creating the image.'Degas comes to only *one* conclusion; the metaphysical inadequacy and worthlessness of action and consciousness alike.'[42] The alienating capitalist world which Degas inhabited was perceived by him only in a negative light, argues Raphael. In his art he was able to move through more demanding and fulfilling creative processes, denied in bourgeois society, 'the complex system of mechanical forces by which he understood the world knows only one pleasure – the pleasure in the artistic means of representation'.[43]

This may or may not be true, but Raphael deduces all of this, and more, from a meticulous analysis of the works themselves, without any real investigation of French economics, society or culture in the 1880s. I think this is a real problem for his work as a model for a dialectical materialist history of art, even allowing for the fact that we do not have all of his writings in translation, or that he never wrote the second part of *The Demands of Art*. We are not really offered any method which enables us to test the validity of Raphael's findings, because as he takes us through the visual analysis with him, we become totally concentrated on the visual analysis alone and therefore reluctant to detach ourselves from it to a position which conceptualizes the historical and the aesthetic as simultaneously existing and dialectically interactive.

Meyer Schapiro

I want to look briefly now at Meyer Schapiro, approvingly quoted by Clark at the very beginning of his book *The Painting of Modern Life*, as a pioneer of the social history of art. Yet Schapiro too had a complex relationship to the Marxist tradition. One of his former students remarked: 'It never occurred to me, while hearing Schapiro's lectures, that he was even a socialist.'[44] This student also remarked that Schapiro was remarkably unprejudiced and open-minded, implying by this that it was for those reasons that he did not consider his teacher a Marxist!

Schapiro, who died very recently, had a long career as an art historian and teacher, and was in New York in the thirties and early forties when a number of left intellectuals gravitated to the anti-Stalinist left, without ever really committing themselves to Trotskyism. Many of them published articles in the *Partisan Review*, or the *Marxist Quarterly*. Greenberg at this time was publishing in *Partisan Review*, and felt that it was 'necessary to quote Marx word for word' but not Trotsky.[45] Similarly, although Schapiro admired Trotsky's stand against Stalinism, he refused to describe himself as a Trotskyist, disagreed with the Bolshevik conception of the revolutionary party to which Trotsky had been won over by Lenin, and rejected what he (wrongly) defined as Engels's and Trotsky's 'doctrine' of dialectical materialism. In some recent articles Schapiro's politics and his particular inflection of the Marxist method have been discussed, and I want to spend a little time on these now, since I have some differences with both Schapiro's understanding of Marxism, and with the approach to Marxism put forward by the authors of the articles. They give a misleading reading of Marxist dialectics,

and, in the case of David Craven, a misleading view of Lenin and the degeneration of the Soviet Union.

Schapiro had joined the American Communist Party by 1932 and was an active supporter until he began to doubt the Stalinist line in the later thirties when the show trials started in the USSR. Until then, he had gone along with such disastrous political positions as the Third Period Stalinist argument that social democrats and fascists were indistinguishable.[46] Hemingway argues that Schapiro's break with Stalinism, however, did not mean that he stopped being a Marxist. I wonder about this though. Schapiro recently spoke of his 'great regret' that he did not pay enough attention to the Bolsheviks' brutal and undemocratic suppression of their socialist opponents in the early years of the Revolution, and after toeing the Stalinist line himself, he became much more sympathetic to the arguments of Luxemburg and Korsch against the Leninist conception of the democratic centralist party of cadreized and trained revolutionaries.[47] This line of development suggests to me that his experience in a Stalinized party had led him to condemn Bolshevism by, wrongly, equating it with Stalinism. Therefore rather than become a supporter of the small Trotskyist organizations in the USA who wanted to defend the degenerated but, according to Trotsky, post-capitalist USSR against imperialism, Schapiro seems to have been put off organized politics. Of course he was not the only one to do this in late thirties America, and elsewhere. Schapiro regarded the Soviet invasion of Finland in 1940 as imperialist aggression, and very probably disagreed with the Trotskyist definition of the Soviet Union as a 'degenerate workers' state'.[48] I would argue that the experience of Stalinist politics in the Communist Party of the USA left Schapiro politically disorientated and he fell back on the common explanation for Stalinist misleadership by believing this was the result of Leninist lack of democracy, and ultimately Engels's 'doctrinal' view of dialectical materialism. He appears to have lacked an understanding of the circumstances in the early Soviet Union which led to the suppression of democratic rights in the Soviets for certain left parties – the refusal of the Mensheviks and Social Revolutionaries to recognize the Soviet regime, the armed attempt to destroy the regime by the Left Social Revolutionaries, an assassination attempt on Lenin by a member of another left party, and the terrible conditions of the Civil War. Schapiro wrote as follows:

> Although I do not believe Engels and LT (Trotsky) were right in their conception of diamat (dialectical materialism) as a formal science and as

a set of laws, they were correct in their ideal that experience itself, the world of man and the world of non human nature show characteristic features of process, movement, concreteness, crucial increment in change, interaction, and (in man) continuity and mutual determination of theory and practice . . . [49]

As we have seen above, it was never the aim of Marxist dialecticians to apply dialectics in a formal manner to force reality to conform to a set of laws imposed from without, but to show how processes, change and conflict in the natural and social world could be understood, not as formless flux, but according to properties of development inherent in matter and social phenomena themselves. The whole point of dialectics in the late thirties for Trotsky was to enable communists to understand what was really going on in the world, what Stalinism and fascism were, what the Soviet State actually was and the property relations it rested on, not simply by empirical observation but through an investigation based on dialectical understanding. In my view, Schapiro's understanding of dialectics was faulty, and he was probably not helped in trying to understand it by throwing out the baby of Marxism along with the scummy bathwater of Stalinism. Max Raphael wrote to Schapiro and told him his article on Courbet was not dialectical, while Schapiro returned the compliment and told J.T. Farrell that Raphael 'intensifies the defects of Engels and Lenin by his extreme systematization of their orthodoxy'.[50]

David Craven, in his article on Schapiro, is obviously sympathetic to the trajectory of Schapiro's political development after his break with Stalinism. Craven states that dialectical materialism 'is a profoundly *non*-dialectical form of Marxism', with an essentialist understanding of history. The early Marx and Engels produced much more fruitful writings than the 'later Marx and Engels', believes Craven, and also adds that ideological struggle is just as important as changing material conditions :'orthodox Marxism had simply failed to address this issue with any stringency or sensitivity.'[51] I do not have the space here to repudiate all of Craven's mistaken assertions in the detail they deserve. However I do want to question what he says about Schapiro and dialectics, and also the political positions of Luxemburg and Korsch which Schapiro was influenced by, and which Craven thinks are vastly superior to the views of Lenin, Trotsky, and even the later Marx and Engels.

Schapiro has highlighted 'double meaning' and 'intriguing opposites' (terms taken from an early essay of 1847 by Engels on Goethe) in his

understanding of dialectics, thus avoiding, says Craven 'the hierarchical framework and economic reductionism of the base/superstructure scheme'. We have already seen that dialectical materialism does not conform to this description in any case, but Craven obviously thinks the contrary. According to Craven, Schapiro's use of dialectics enables him to conceptualize cultural forms as 'juxtaposed and shifting elements from variously converging domains and intersecting spheres', and 'contrapuntal interaction'.[52]

In his study of the sculptures of Souillac church, Schapiro discerns harmony in chaos and incoherence, in a balance dependent on the negation of the usual order of the symmetrical scheme. This is an example of contradiction, says Craven, only possible with 'a markedly non-Eurocentric concept of non-linear and uneven historical development . . . fundamentally opposed to . . . orthodox Marxist studies in this period'. Craven continues: 'Schapiro's heterogeneous and multilateral approach to uneven art-historical development was largely without historical precedent.'[53] Actually attempts by Marxists, including Lenin, to understand why the first socialist revolution had taken place in a backward capitalist country and not in Europe had already formulated the concept of 'uneven and combined development' (for example where huge areas of backwardness coexist with highly developed and concentrated capital and proletarian consciousness). Also even within the writings of Marx and Engels themselves there are suggestions for the sort of complex analysis and theory that is necessitated by the study of art, most famously in the 'problem' of Greek art and its development in an early relatively 'undeveloped' society based on slave ownership and limited democracy. Basically everything that Craven thinks is innovative and subtle about Schapiro's method of artistic analysis is very much influenced by dialectical thinking, but Craven does his best to deny that it has anything to do with dialectical materialism at all. However, I think Schapiro's method does not properly grasp the idea of contradiction within phenomena themselves or the transition from quantity into quality.

Craven ends his article with a statement from Schapiro emphasizing his 'humanity' (apparently people who agree with Bolsheviks do not have this quality). This statement is most instructive: 'The real opposition is between the ideal of an essentially personal radicalism . . . without a party or a carefully thought-out theory *and* a highly energetic, constantly active, scientific-minded radicalism like Lenin's and RL's (Rosa Luxemburg's), which is so independent that it may even denounce that party and fight against it.'[54]

Now Schapiro's alternatives both emphasize independence and individualism, which, given his experience inside Stalinism, he obviously values, and counterposes to the idea of a revolutionary party. Even Luxemburg and Lenin are held up as fiercely independent and critical of revolutionary parties. The possibility of a democratic, centralist revolutionary party, based on an agreed programme and tactics and rooted firmly in the working class does not even enter into Schapiro's set of alternatives. There is only the idea of safeguarding the personal as the political, and basically that is what Schapiro did for the rest of his life. His Marxism, if it can be called such, became apolitical, academicized, and he did not fully grasp dialectical materialism, using it merely as a tool for understanding culture, not the contemporary world.

Craven ascribes Schapiro's correct and 'human' response to Marxism to the influence on him of Luxemburg's attack on 'Lenin's anti-democratic version of Marxism', and Korsch's views, especially the latter's essay 'Leading Principles of Marxism: A Restatement' published in 1937 in *Marxist Quarterly* a few months after Schapiro's famous article on 'The Nature of Abstract Art'. Korsch was a member of the German Communist Party and a university lecturer. He supported workers councils, devizing a hypothetical economic system based on these bodies. After the defeat of the various attempts at revolution in Germany in the post-World War One period, Korsch argued that the revolutions had failed due to the lack of belief that they could succeed. More ideological struggle should have been carried out, Korsch concluded. During the period 1924–29 as Stalin took control of the Soviet Party, the German party was also transformed along Stalinist lines, and oppositional views were heavily attacked and even censored. This was not a democratic climate for Korsch to put forward his views, but unfortunately in any case they were somewhat mistaken. In 1926 after the defeat of every other revolutionary movement apart from the Soviet one, Korsch was arguing that capitalism had not managed to stabilize itself, revolution was still on the agenda, and revolutionaries should forge socialist states built on clear class politics. This involved splitting from the trade unions to form breakaway red unions, and avoiding any political work in bourgeois parliamentary organs – a move which at another time might have been tactically justified. Korsch had been expelled from the party in 1926. By 1927 he was arguing against Lenin's previous strategy for revolution in Russia, saying only a bourgeois revolution had ever been possible, and in 1938 he published an article stating that Lenin had transformed Marxism into 'an ideological form assumed by the material struggle for putting across the capitalist

development in a pre-capitalist country'.[55] Korsch could by this time see no difference between Marxism and Stalinism, and blamed Marxism for encouraging capitalism in Russia and the USSR. It is easy to see how anyone in Korsch's circle and influenced by his politics would not join Trotsky's oppositionists, although Schapiro was prepared to debate with the CP in Trotsky's defence at a meeting (which was called off).

Luxemburg, also an important influence on Schapiro (and, it appears, Craven), is a rather different political figure, never disagreeing with the idea of a revolutionary party as such. She argued vehemently against Lenin's attempts to build a cadre-based centralized party in pre-revolutionary Russia because she was deeply suspicious of the party as a conduit for opportunism, which she had bitterly opposed within her own German organization. She trusted the 'unconscious' and spont-aneously revolutionary potential of the working class more than parties. Her weakness on the issue of the party's programme intensified her faith in the spontaneity of the working class once it entered into action. However it is worth pointing out here (because references to Luxem-burg's anti-Leninism come up again and again), that she was not against party control over its members, since the party discipline would be the 'coercive instrument enforcing the will of the proletarian majority in the party'. However, 'If this majority is lacking, then the most dire sanctions on paper will be of no avail'.[56]

The dangers in Russia, thought Luxemburg, were the lack of a politically educated proletariat and the impossibility, in conditions of suppression and illegality, of educating workers politically to enable them to participate fully in writing for party papers, producing conference documents, etc. In these conditions a centralized party could not be controlled by its members. Luxemburg was not saying that the party was in itself dictatorial or undemocratic, as later writers have implied. In fact she writes:

This [the supremacy of proletarian politics – GD] is only possible if the social democracy already contains a strong, politically educated prolet-arian nucleus class conscious enough to be able, as up to now in Germany, to pull along in its tow the declassed and petty bourgeois elements that join the party. In that case, greater strictness in the application of the principle of centralization and more severe discipline, specifically formulated in party bylaws, may be an effective safeguard against the opportunist danger . . . A modification of the constitution of the German social democracy in that direction would be a very timely measure.[57]

The lack of objectively favourable conditions in Russia meant, for Luxemburg, that social democratic centralism could not be created there: 'It [social democratic centralism – GD] can only be the concentrated will of the individuals and groups representative of the most class-conscious, militant, advanced sections of the working class. It is, so to speak, the "self-centralism" of the advanced sectors of the proletariat. It is the rule of the majority within its own party . . . These conditions are not fully formed in Russia.'[58] I am not trying to argue here that Lenin and Luxemburg had no differences on this. But these differences were rather less than has been made out, and are certainly less than the differences between Luxemburg and Korsch, and it is very misleading of Craven to set the two up as similar in their 'anti-Leninism'.

Conclusion

In conclusion, I would argue that Schapiro is similar to other acknowledged Marxist art historians in his anti-Stalinism. However this anti-Stalinism is very close to a rejection of Marxism, except as an intellectual theory. It is also rather difficult to discover many Marxist art historians in twentieth century academic life when most will not actually call themselves Marxists and their students profess amazement when asked about their teachers' supposedly revolutionary worldviews! However as I have tried to show, the basis for a Marxist understanding of culture is still available, is not flawed by economic determinism, and is not responsible for the existence of the deeds of Stalinism. Surely now it should be possible to refocus on dialectical materialism and Marxism as a means of understanding human society and its cultural productions. In a later chapter on postmodernism I will discuss the reasons why this has not taken place. At the Association of Art Historians' conference recently (1996) in Newcastle, England, I was struck by the number of papers concentrating on Kant, and the relief with which scholars turn to the pre-Marxist, even pre-Hegelian period of early modern history, when dialectics and the modern proletariat were not a necessary topic of theorization. A contented, if convoluted Kantianism, viewed through the spectacles of postmodernism, displayed its latest academic theorizations. I was reminded of one of the factors Rosa Luxemburg detected in Russia which persuaded her that the time was not ripe there for the formation of a democratic socialist revolutionary party: 'Added to the immaturity of the Russian proletarian movement, . . . is an influence for wide theoretical wandering, which

ranges from the complete negation of the political aspect of the labour movement to the unqualified belief in the effectiveness of isolated terrorist acts, or even total political indifference sought in the swamps of liberalism and Kantian idealism.'[59] I am not suggesting any political and economic parallels here, and there certainly did not appear to be many terrorist sympathizers at the conference, but there were a number of participants who could certainly have been included in the last of Luxemburg's categories, such is the hold of idealist postmodern theory on radical art and cultural historians.

Notes

1. P. Overy, 'The New Art History and Art Criticism', in Borzello and Rees eds, *The New Art History*, p.133.

2. For the German art historians referred to by Clark, including Riegl, see M. Podro, *The Critical Historians of Art*, New Haven and London, 1982.

3. In conversation with me Clark pointed out his rejection of the notion of a revolutionary party and his sympathy with the views of Pannekoek and Gorter.

4. Clark, *Image of the People*, London, 1973, p.12.

5. Ibid., p.13.

6. Quoted in Clark, 'The Conditions of Artistic Creation', *The Times Literary Supplement*, 24 May, 1974, p.561.

7. Ibid., p.561.

8. G. Lukács, *History and Class Consciousness*, London, 1971, p.200.

9. G. Novack, *Polemics in Marxist Philosophy*, p.125. The chapter on Lukács in this book is very helpful, much more so than that of S.E. Bronner, 'Philosophical Anticipations: A Commentary on the "Reification" Essay of Georg Lukács' in his book *Of Critical Theory and its Theorists*, Oxford and Cambridge, 1994.

10. Quoted by Novack, p.128. This is a reference to the aim of Marx and Engels to stand Hegel on his feet, rooting his dialectics in materialism. Previously Hegel had been standing on his head i.e. his dialectics had been idealist.

11. R. Gombin, *The Origins of Modern Leftism*, Harmondsworth, 1975, and Gombin, *The Radical Tradition: A Study in Modern Revolutionary Thought*, London, 1978.

12. Gombin, *The Origins*, p.78.

13. He was equivocal on the need for, and nature of a party, contradicting himself on many occasions. He accepted that the capitalist state would have to be smashed up, but did not say how, or in what ways councils would formulate a programme for power. All this was close to the ultra-left politics of the KAPD (Communist Workers Party of Germany) founded in 1920. No revolution could take place until the consciousness of the masses was ripe. Of course the need for a state based on workers' councils was quite correct, but this was mixed up with all kinds of mistaken positions in Pannekoek's theory, and he did not take into account the far from ideal conditions of war, foreign invasion, etc. which began to distort the Soviet workers' state very early on. He tended to blame the problems caused by these external factors on the party. For more information on Pannekoek see P. Mattick, *Anton Pannekoek*, a Workpress pamphlet, London, no date; A. Pannekoek, *Workers Councils*, in five pamphlets, a reprint of the Australian edition of 1950, London, no date; D.A. Smart ed., *Pannekoek and Gorter's Marxism*, London, 1978.

14. Gombin, *The Radical Tradition*, p.110.

15. There is a very useful section on the Situationists in Gombin, *The Origins*, pp.61–71 and pp.106–13. See also P. Wollen, 'The Situationist International', *New Left Review*, March/April 1989, no. 174, pp.67–96. There are a number of interesting articles in the January 1989 issue of *Arts Magazine*, M.D. Maayan, 'From Aesthetic to Political Vanguard', pp.49–53; K. Stiles, 'Sticks and Stones: The Destruction in Art Symposium', pp.54–60; E. Ball, '"The Beautiful Language of My Century" From the Situationists to the Simulationists', pp.65–72.

16. The expulsion document is in K. Knabb ed., *Situationist International Anthology*, Berkeley, 1981, pp.293–4. M. Jay comments: 'Its vituperative and punishing tone captures the Situationists at their most sectarian.' Jay, *Downcast Eyes: The Denigration of Vision in Twentieth-century French Thought*, Berkeley, 1993, p.433, note 191.

17. This is according to S. Ford, *The Realization and Suppression of the Situationist International: An Annotated Bibliography, 1972–1992*, Edinburgh, 1995, p.22. The text of the manifesto is available in Knabb, pp.319 ff.

18. J. Crary, 'Spectacle, Attention, Counter-memory', *October*, 1989, Fall, part 50, pp.97–107.

19. Reproduced in C. Harrison and P. Wood eds, *Art in Theory 1900–1990*, Oxford, 1992, p.698.

20. Gombin, *The Origins*, p.108.

21. See for example Jay, *Downcast eyes*, and Crary, 'Spectacle, Attention, Counter-memory'.

22. T.J. Clark, *The Painting of Modern Life: Paris in the Art of Manet and his Followers*, London, 1985, p.6.

23. Ibid., p.9.

24. This also puzzles Crary, 'Spectacle, attention, counter-memory', p.99, who however thinks that Clark pays insufficient attention to the way in which the society of the spectacle structures the subject within capitalism. As a former member of the Situationists, Clark would be well aware of this, I feel.

25. K. Stiles, 'Sticks and Stones: The Destruction in Art Symposium', *Arts Magazine*, January 1989, p.55.

26. B. Brown, 'The Look we Look at: T.J. Clark's Walk Back to the Situationist International', *Arts Magazine*, January 1989, p.61.

27. C. Harrison, M. Baldwin and M. Ramsden, 'Manet's "Olympia" and Contradiction. (A Propos T.J. Clark's and Peter Wollen's recent articles)', *Block*, 5, 1981, pp.34–43. Clark's article on *Olympia*, published in *Screen*, Spring, 1980, formed the basis of his chapter on this painting in *The Painting of Modern Life*. Adrian Rifkin's review of Clark's book is slightly unpleasant in tone and, in my opinion, fails to discuss issues of dialectical materialism and art history in a useful way, see 'Marx' Clarkism', *Art History*, vol.8, no.4, December 1985, pp.488–95. Clark has been accused of paying little attention to gender and the effects which women's oppression can have on both spectators of art and consumers and producers of culture. Griselda Pollock is the main academic who has criticized him for this, arguing that this is undoubtedly due to his Marxism, since Marxism views 'sexual divisions (as) virtually natural and inevitable and (they) fall beneath its theoretical view . . .'. G. Pollock, *Vision and Difference: Femininity, Feminism and the Histories of Art*, London and New York, 1988, pp.4–5. Actually Clark does discuss women and gender oppression in his book, but obviously not in the feminist manner that Pollock would prefer. It has also been pointed out that the Situationists themselves could be accused of sexism since they did not question the denigration of women in images of mass culture, merely the reifying effects of these images on everyday life for all alienated people under capitalism, none of whom are seen are more oppressed than others, whether black, female or homosexual.

28. For information on Max Raphael and his writings see the pioneering work of John Tagg in his edition of Raphael's *Proudhon, Marx, Picasso: Essays in Marxist Aesthetics*, London, 1980, and Tagg's two articles, 'The method of Max Raphael: Art History Set Back on its Feet', *Radical Philosophy*, 12, Winter, 1975, pp.3–10, and 'Marxism and art history', *Marxism Today*, June 1977, pp.183–92.

29. Raphael, *The Demands of Art*, London, 1968, p.204.

30. Raphael, *Proudhon*, p.35.

31. Ibid., p.76.

32. Ibid., p.115.

33. Ibid., p.61.

34. Raphael, *The Demands of Art*, p.xviii.

35. Novack, *Polemics in Marxist philosophy*, p.317.

36. Raphael, *Proudhon*, p.41.

37. Raphael, *The Demands of Art*, p.4.

38. Raphael, *Proudhon*, p.35.

39. Ibid., p.3.

40. Ibid., p.128. Raphael uses the term abstract rather loosely. Picasso produces abstract works, but not non-figurative or non-objective ones which represent no recognisable objects.

41. *The Demands of Art*, p.54, concerning state 1 of the etching.

42. Ibid., p.63.

43. Ibid., p.71.

44. W. Andersen, 'Schapiro, Marx and the Reacting Sensibility of Artists', *Social Research*, Spring 1978, p.68. Andersen concludes that Schapiro must have been a 'semi-conscious Marxist'.

45. Cited by Orton and Pollock, '*Avant-gardes* and Partisans Reviewed', in F. Frascina ed., *Pollock and After: The critical debate*, London, 1985, p.175.

46. We know this from a book review where he described the group of architects and technicians around Buckminster Fuller, the Structural Studies Associates, as one of a number of groups who '. . . are the first allies of Fascism'. A. Hemingway, 'Meyer Schapiro and Marxism in the 1930s', *The Oxford Art Journal*, vol.17, no.1, 1994, p.16.

47. Hemingway, p.20.

48. Ibid., p.23.

49. Ibid., p.23, letter of 1943.

50. Ibid., p.28.

51. D. Craven, 'Meyer Schapiro, Karl Korsch, and the emergence of critical theory', *The Oxford Art Journal*, vol.17, no.1, 1994, p.46.

52. Ibid., pp.44–5.

53. Ibid., p.49.

54. Ibid., p.52, dated 1943–4. The debates between Luxemburg and Lenin on the nature of the revolutionary party have not been particularly well discussed. The best account available to me is an unpublished conference paper by B. Collins, 'Lenin and the vanguard party', 1996, full of sharp political analysis backed up by documentation and quotations. For example, Lenin in his *Collected Works*, vol.7, p.473: 'Comrade Luxemburg says that in my view "the Central Committee is the only active nucleus of the Party". Actually this is not so. I have never advocated any such view.' Before his death Lenin certainly was deeply concerned about the bureaucratization of the party and the increasing influence of Stalin. However Schapiro takes Lenin's opposition to particular developments at a particular time out of context, and makes it appear

as if both Lenin and Luxemburg criticized the Bolshevik party for the same reasons.

55. D. Kellner ed., *Karl Korsch: Revolutionary Theory*, Austin and London, 1977, p.77. On Korsch see also the edition of Korsch's *Marxism and Philosophy*, London, 1970.

56. Luxemburg, 'Organisational Question of Social Democracy', *Rosa Luxemburg Speaks*, ed. M.A. Waters, New York, 1970, p.128.

57. Ibid., p.128.

58. Ibid., p.119.

59. Ibid., p.125.

four

How is the Personal
Political?

I want now to look at some questions of visual culture and political theory and practice in the 1930s. This period is of key importance for understanding the development of Marxism in the twentieth century, and also the divergence of Stalinism from Marxism and the continuation of genuine Marxist praxis in Trotskyism. The political degeneration of the Soviet Union, the first workers' state, the triumph of fascism over the German workers' movements, the French revolutionary crisis and the ensuing Popular Front in the mid-thirties, and the eventual defeat of the Republican forces and their international supporters in the Spanish Civil War marked this period as one of profound crisis for the economic interests of the capitalist states, but also as one of dire political crisis for the dwindling forces of Marxist revolutionaries.

After the disastrous (mis)leadership of the German workers by the Stalinized Communist International, Trotsky realized with regret that the Third International was beyond reforming, and a new Revolutionary International had to be built. Time was short and war seemed the likely outcome of the economic and political rivalries of the various European and World powers. In Paris in 1938 delegates of various international groups committed to Trotsky's political manifesto for world revolution, the *Transitional Programme*, founded the Fourth International, weak in numbers but strong in political programme. By 1940 Trotsky had been murdered in Mexico by a Stalinist agent, the Second World War had begun, and the destruction and barbarism of war, national chauvinism, isolation and persecution were the daily obstacles facing active Marxists. The small numbers of forces in conscious political opposition to Stalin were further eroded during the wartime years by persecution and isolation. However the material weakness of Marxists who opposed

105

Stalinism and reformism in the workers' movements in the thirties did not mean they gave up the struggle for revolutionary politics. In addition, even in the midst of the direst struggles against repression, many were able to produce artworks, and writings on art and culture which utilized political thought and understanding to articulate an opposition to Stalinist ideas of Realism in culture. I do not mean by this statement that I believe this is a defining feature of all good visual culture, and that no one who is not an anti-Stalinist can produce worthwhile art. It is quite possible that even adherents of Stalinism can produce stunning art works, for example Vera Mukhina's famous statue of *Worker and Collective Farm Worker*, done with assistants in 1937 for the international exhibition in Paris. Many striking and deservedly famous images have no strictly political meanings at all, oppositional or celebratory, for example Manet's *Olympia*, 1863. I do not wish to be accused of having a utilitarian and Leninist view of visual culture. My view is that while understanding art on its own terms is necessary, our understanding can be deepened by considering art in all the ways in which it interacts with aspects of its particular social totality, and this includes politics. At times politics will be an important element of the work's meaning, at times it will be insignificant.

In this chapter I will be considering questions of the personal and the political as they are embodied in representations of and by three women. They are Claude Cahun, a French Surrealist, Tina Modotti, photographer, political activist and eventual Communist Party agent, and Zina Bronstein, Trotsky's daughter and central character of the film *Zina* directed by Ken McMullen (United Kingdom, 1985). In situating these women in relation to the conflicting oppositions of Stalinism and Trotskyism in the thirties, I want to discuss issues of politics and representation, and the relationship of the individual to wider class and historical issues. In so doing I want to consider the question of the unconscious and the conscious with regard to the individual and the class, and thus the question of the relationship of psychoanalysis to Marxism.

Gender and Subjectivity

I want briefly to look at the question of the social construction of femininity, psychoanalysis and Marxism, since this relates closely to the material discussed in this chapter. In particular I will examine some of the arguments of Jacqueline Rose, since her work on this has been so influential. Rose argues from a feminist understanding of history

and women's position within it i.e. she sees sexual difference as the core of social and political oppression: 'sexual difference should be acknowledged in the fullest range of its effects and then privileged in political understanding and debate.'[1] In her book Rose actually discusses Marxism very little, and concentrates on how feminism and psycho-analysis can illuminate the 'dis-integrated' subjectivity of woman. However her purpose is unclear. Is it to change this condition by therapy, to illuminate cultural representations of women, or to cons-truct a feminist political activity based on her theoretical findings? Also it is not clear how she feels that the psychic 'dis-integration' of subject-ivity relates to the position of men in class society, though she very occasionally refers to this: 'To understand subjectivity, sexual difference and fantasy in a way which neither entrenches the terms nor denies them still seems to me to be a crucial task for today. Not a luxury, but rather the key processes through which – as women and as men – we experience, and then question, our fully political fates.'[2] The internal-ized experience of sexual difference is therefore seen as the key to under-standing oppression and the way to a conscious politics which will question this. However in another passage Rose seems to imply that women will always experience themselves as 'dis-integrated' subjects which will not be 'normalized'.[3] This is rather confusing. The point of practising a politics dedicated to the self-liberation of the oppressed, including women, is not to help women achieve a norm (which I think Rose is correctly rejecting here), but to create the material prerequisites, by abolishing a system of economic exploitation based on private property, which is at the root of this oppression. This of course will not get rid of the distinction between conscious and unconscious, or psychic mechanisms for repressing urges and desires, but it should enable many women to enjoy a psychic life superior to the one they have at present, existing in a social and economic system which requires the oppression of women to function. The damage this causes to the mental life of women is surely too evident to need extensive proof here, from images of ideal bodies, marriage and motherhood, to limitations on the intellectual development of women throughout the world. The additional physical damage to women under capitalism and imperialism is arguably worse. Whether the socially oppressed – women, homosexuals, and black people will always experience themselves as 'dis-integrated' subjects, even under socialism, is something we cannot know in advance. However we can understand the reasons for their psychic and material oppression and fight to change things.

I would argue that both psychoanalysis and feminism need to be

understood and assessed as methods of understanding human society from within the framework of dialectical materialism, a position which clearly Rose would not agree with. For Rose the psyche is the key locus for understanding the oppression of women (for men she is less clear). For Marxists the psyche is part of human existence and experience in all its complexity, but is not seen as the key explanatory factor in exploitation and oppression. It is of course where every individual experiences this oppression, consciously or unconsciously, but it is not the source of this oppression, nor where it can be politically tackled. Rose appears to have very little interest in the role of the state in capitalist society, and skims over the relationship between ideology and the state.[4]

Rose writes: 'Like many feminists, the slogan "the personal is polit-ical" has been central to my own political development; just as I see the question of sexuality, as a political issue which *exceeds* the province of Marxism ("economic", "ideological" or whatever), as one of the most important defining characteristics of feminism itself.'[5] It is certainly true that the emphasis on the construction and experience of sexuality, and the subordination of other spheres of oppression to it, has been a defining feature of feminism. However I would certainly question Rose's characterization of Marxism as unconcerned with this question.[6] The personal can certainly be political, as I hope to show in this chapter by looking at works by Cahun and Modotti, and McMullen's film *Zina*. But in order for the personal to become political, the personal psyche with all its conflicts and contradictions needs to negate itself as the purely personal, and supercede its personal individuality in an engage-ment with the social. To investigate the psyche and femininity raises many questions, but these need not automatically result in political conclusions or activity, as Rose claims. And in any case, we have seen that diametrically opposed political choices, such as Trotskyism and Stalinism, can result from the experience of women in modern class society. Surely we do not want any old politics – we need to ask *what* politics are chosen as a result of the personal. Rose's book does not suggest that we might find them in Marxism, but solely in some form of feminism.

More recent investigations of gendered subjectivity, such as the works of Judith Butler, attempt to avoid the over-emphasis on subjects being constructed by discourse, and argue that individual subjects live out, cite and constantly re-enact the performative norms of sexual identities. However although this approach sees the subject as lived through a body and materiality, ultimately for Butler matter is still constructed

by discourse. We are offered no way to understand why this might be so, whether this has always been the case, or indeed always will be. Butler's idealist method, although densely argued, is ultimately rather reductive. As Ebert perceptively asks 'How is making discourse or the matter of the body the ground of politics and social analytic any less reductive than the economic base? . . . To articulate the relations connecting seemingly disparate events and phenomena is in fact a necessary and unavoidable part of effective knowledge of the real'. [7] However it must be said that there is a pressing need for an elaboration of a Marxist theory of the human subject. Subjectivity is an important area of debate in cultural scholarship at present, but much of the work on this sees the subject in terms of rather idealist poststructuralist and/ or postmodern theory, and there have been few attempts to argue against the likes of Butler and other feminist followers of Foucault. We need a theory of the historically situated subject, individual and at the same time part of a social totality, who consciously and unconsciously engages with a contradictory and changing reality to create new representations, not passive reflections, of her/his material and psychic existence. I do not pretend to offer such a developed theory of the subject here, but can perhaps orient the debate towards the historical and the material, whilst preserving some dialectical subtlety.

Dialectics and Representation

I also want to consider the possibilities and limits of visual culture in terms of creating or awakening some kind of individual or class consciousness, and indeed of producing some kind of class awareness either on the part of the artist or the spectator. Is it possible, for example, that the historicity of particular media prevent them from fully representing or grasping the historical realities in which they were produced where this is the intention of the artist?

Trotsky's own comments on photography and film are interesting in this respect. Trotsky compared still photographic images to formal logistic thought, and filmic imagery to dialectical thought. This should not be taken too literally, as he is speaking metaphorically here.

> The fundamental flaw of vulgar thought lies in the fact that it wishes to content itself with motionless imprints of a reality which consists of eternal motion. Dialectical thinking gives to concepts, by means of closer approximations, corrections, concretizations, a richness of content and flexibility; I would even say a succulence which to a certain extent brings

them closer to living phenomena . . . Dialectical thinking is related to vulgar thinking in the same way that a motion picture is related to a still photograph.[8]

In another comment, Trotsky underlines the qualitative difference in thought processes that the distinction between the still and the moving image has for him:

Cognizing thought begins with differentiation, with the instantaneous photograph, with the establishment of terms – conceptions, in which the separate moments of a process are placed but from which the process as a whole escapes. These terms – conceptions, created by cognizing thought, are then transformed into its fetters. Dialectics removes these fetters, revealing the relativity of motionless concepts, their transition into each other.[9]

Now of course the content of the thought does not depend merely on the form in which it is presented, though it would be false to divorce one from the other. However I think it is possible to argue that there are limitations to what the still photographic image can present and allow the spectator to conceptualize, and this certainly becomes an issue in the work of Tina Modotti. Cahun's photographic work includes photomontage as well as still images, and her interest in Surrealist ideas endows her imagery with a complexity and instability of meanings that are very different from either the 'aesthetic composition' or the 'social documentary' modes utilized (sometimes together) by Modotti. Cahun's constructions and 'found objects' are resolutely opposed to the notion of a simple 'motionless imprint of a reality', even in her 'still' images. McMullen's film, produced much later of course, is able to utilize much more dense and complicated visual and aural strategies in an ambitious presentation of history and politics and their inter-section with the personal.

Just as no particular medium can automatically embody the dial-ectical materialist conception of its producer or its consumer, we need also to consider whether and how the unconscious comes into play, and the relationship of the unconscious to ideology. Can people be 'unconscious' dialecticians? In a polemic with Burnham over the nature of the Soviet State, Trotsky returned to a statement he had made earlier, when he had described Charles Darwin as an 'unconscious dialectician' since his great scientific advances had been made without the knowledge of, or application of, dialectical materialism. Trotsky points out that every individual is, to some extent, such an unconscious

dialectician, adding : 'an illiterate peasant woman guides herself in cooking soup by the Hegelian law of the transformation of quantity into quality', because she will know when she has put too much salt into it. Even a fox's legs, says Trotsky, can be 'unconscious dialecticians' and equipped with Hegelian tendencies, when it chases and eats a chicken, but perceives a qualitative difference and runs from a wolf. Our thoughts are not merely arbitrary constructions of our reason but expressions of actual relationships and contradictions in the material world itself. Hence anyone seriously concerned to interact with the material world does become something of an unconscious dialectician, in a very broad sense. Human beings developed these forms of consciousness transforming them into more probing investigative and scientific tools.[10]

In spite of Trotsky's humorous explanation of his view of Darwin's method, I think there needs to be a distinction made between the conscious and the unconscious dialectician, just as we need to preserve a distinction between the conscious and the unconscious mind. To take an example – would we see the still photograph of a beehive as embodying an unconscious dialectical view of nature, since it attempted to closely document an aspect of nature and show to the viewer some of its intricate detail? Would this be more dialectical that a photograph which showed non-objective or non-figurative shapes? Would a film of a beehive be more dialectical still? As Trotsky correctly (in my view) observes, a still image generally has difficulty in conveying notions of process or development, which would be an essential aspect of a dialectical perception of the material world or social reality. We should avoid equating an attention to the material world and its motionless rendering in a realist manner with an understanding of the material world in a dialectical way, and I seriously doubt whether this can be done unconsciously. However is also not the case that a film of a beehive would necessarily be informed by an understanding of dialectical materialism. However the complex interactions between the unconscious and conscious of the producer *and* the viewer of visual images, both situated within specific historical situations, is of great importance for a Marxist understanding of visual culture – indeed this is the crux of a Marxist understanding of art.

Consciousness and Representation

What are some of the problems then, in investigating the psyche, ideology, the individual and the class in relation to visual culture? For

Marxists, consciousness of oppression is necessary before an individual can oppose that oppression. However an individual thinking and acting on her/his own will be relatively powerless as opposed to the state power which is in the position to secure the social and economic system in which the oppression exists. Marxists believe that individual solutions to oppression are therefore limited, and that class solutions are more effective and, indeed, necessary. But how does the individual relate to a class, and how could visual imagery deal with, or embody, the relationship of the individual to the class? This is obviously a very difficult task. Not all visual images are 'about' class, for one thing. While most people would agree that visual images could involve perception and/or knowledge of some kind, and might therefore change the consciousness of the artists and the viewer in some general aesthetic or cultural sense, not all images intend to change the consciousness of the individual viewer into a class consciousness, or change the consciousness of the individual viewer in a social sense. Even if the image set out to do these things, how would this occur? Representations of workers do not equal class consciousness either on the part of the producer or the spectator. Given that one's place in the economic order does not automatically determine class consciousness, then how might such consciousness be represented, or offered as a reading possibility for the viewer of a given image? How do artists become conscious of what they want to visualize and produce as imagery and can we take the finished image as part of the artist's experience?

I believe that we can, but at the same time we cannot reduce the meaning of the image to the artist's experience, since all sorts of other factors will influence how we read the work, and the situation in which it was produced may not have been completely experienced by the artist or in any way subject to her/his control. Also the visual image cannot be simply the embodiment of the consciousness of the artist, since elements of chance and aspects which are not completely consciously worked through may appear. What seems to be crucial is that a process of engagement, evolution and change on the part of the spectator of the work, is necessary if consciousness is to emerge or develop as a result of viewing the work. If this consciousness is then to develop into class consciousness, certain circumstances must exist for this transformation to take place. For example the viewer must have access to a body of political thought or political activity with which to engage alongside others. Otherwise the individual's class consciousness would be merely abstract. Also the consciousness of the individual would be misled and misguided if, for example, the individual had

joined the Communist Party in the mid-thirties through becoming conscious of oppression through viewing a Stalinist art work executed in a Realist manner. If the individual had joined a Stalinist party because of viewing a non-figurative image, believing, say, that such work gave a glimpse of the potential of human creativity unfettered by material need and political oppression, s/he would soon have discovered they had made a serious error and would have been forced to leave the party or be 're-educated'. Such images were vilified by party hacks, and by the later thirties Trotsky was adamant that any kind of visual imagery, however avant-garde and difficult for proletarians to relate to, was an embodiment of freedom greatly preferable to Soviet Socialist Realism.

If the artist produces images related to material life in a particular society, however abstracted from that material life, it is likely that the work will embody aspects of the ideology of that society unless that artist has made a conscious effort to reject that ideology and substitute a representation of the true forces underlying that social reality. However the spectator can cling to an ideological perception of social reality and refuse the invitation of the image presented. The artist can also, perhaps unconsciously, produce an image intended merely to embody decorative compositonal qualities, or notions of 'beauty', and unwittingly generate a feeling of unease in a spectator who may feel art should concern itself with more pressing human needs of one kind or another. In the 1930s there were certainly plenty of those.

Where does the unconscious enter into this? For some of the Surrealists, the unconscious was not affected by the dominant bourgeois ideology of their society and therefore the less consciously planned the art work, the more likely it was to disrupt and damage the ideological perceptions of the spectator. It is debatable, however, if any art work can really be unconsciously produced, and in any case many writers have pointed out the unconscious fantasies (if such they are) produced by Surrealists such as Magritte and Dali, for example, do not seriously question the ideologically articulated view of women in the dominant culture of France in the inter-war period.[11]

It is also claimed that Marxists are not interested in the unconscious or in questions of sexuality, since their activity is practical, dedicated to overthrowing the state, and 'after the Revolution' any problems of social or sexual oppression will be solved since they are all due to capitalism anyway.[12] As we will see, the relationship of Marxism to psychoanalysis is not this simple!

While it is difficult to see how art works could be completely produced from the unconscious, it is also difficult to accept the Lacanian view

that all forms of language and symbolic systems of concepts mediate our thinking to such an extent that it is impossible consciously to make sense of reality, since we must articulate it through the symbolic order. This idealist notion excludes the possibility for the woman artist to articulate her views using the language of the symbolic (male) order. In this theory, also, there is no escape from the ideological. However there is also no automatic escape from the ideological in the unconscious, I would argue.

The unconscious is historical, not ahistorical, and while the relationship of the conscious to the unconscious and the mechanisms of this relationship may be relatively unchanging, the unconscious itself is only relatively autonomous from the conscious mind which exists in a particular historically specific context. It should be clear also that I am arguing from a position which accepts the possibility of an individual conscious of her/himself and her/his situation in a historical class formation, and that I do not accept the notion that the self is necessarily a fragmented, shifting and always incoherent construction of conflicting discourses and perceptions. Also I do not accept the equivalences of 'race', class, gender, and sexuality within the incoherent subjectivity of the individual. In a discussion of class representation and photography, John Roberts makes the following interesting statement: '. . . working-class identity as it is constructed in tension with relations of gender, sexuality and race cannot take its place simply as one identity amongst many. For being working-class or not determines *how*, and *under what conditions*, the individual experiences themselves as a "man" or a "woman" or as "gay" or "black"'.[13]

It is quite clear that art cannot in itself 'solve' any of these problems. Art cannot get rid of oppression or directly embody conceptualizations of historical processes in single images, though many artists have set themselves these ambitious tasks. The limitations of the visual image in relation to political Marxist consciousness are many. It is not un-Marxist to point out that art and politics have different ends and functions within societies. Trotsky stressed this in the late thirties, but this was not entirely brought on by his disgust at Soviet Socialist Realism and those who advocated it. In 1924 Trotsky wrote that: 'Art must make its own way and by its own means. The Marxian methods are not the same as the artistic . . . The domain of art is not one in which the Party is called upon to command. It can and must protect and help it, but it can only lead it indirectly.' However this was not supposed to result in a liberal free-for-all. Any art subversive to the interests of the workers' state, he wrote, must be greeted with hostility.[14] This latter part of

Trotsky's position was considerably muted by the later thirties, since he had no wish to give the slightest ground to Stalinist art or political policies.

These problematic areas of investigation cannot be solved in the abstract, and indeed, they cannot be 'solved' in the sense of a mathematical problem. What I hope to do in the ensuing investigation, however, will be to show how issues of the historical individual and the class, sexuality, and gender, can be studied in the works of Cahun and Modotti, and the representation of Zina in McMullen's film. I also want to examine how psychoanalysis might relate to a Marxist understanding of these works.

Claude Cahun

The key work by Cahun which I want to focus on is the photograph *Poupée 1*, dated September 1936 (figure 2), and produced at a period of intense political and social crisis in France. Before examining the meanings of this photograph, let us look at Claude Cahun and her 'identity'. Cahun has not been discussed in books on women and Surrealism in any great detail. It is only in the last few years that her work has been more widely discussed and exhibited.[15] It is indeed a revelation, and its discovery has prompted a questioning of many previous assumptions about Surrealism and photography, and the role of women in (heterosexual) Surrealism. Renée Hubert briefly mentions Cahun and her companion and collaborator Suzanne Malherbe, pointing out that a study of their work 'might conceivably show us another path' different from the 'heterosexual teamwork' that was the most usual strategy for women artists active in avant-garde art movements.[16] However after a brief introduction of this interesting hypothesis, the matter is pursued no further, and Cahun is absent from the rest of the book. Whitney Chadwick does not discuss Cahun in her book on women and Surrealism, and it is possible that she thought Cahun was actually a man.[17] This is certainly the case in Helena Lewis' book, where the author refers to Cahun as 'he'.[18] The collection of essays in *Surrealism and Women*, which is crucial for any discussion of this topic, does not include a study of Cahun's work.[19] Susan Suleiman's book on gender, politics and the avant-garde discusses Surrealism but not Cahun, whose name is not in the index.[20]

Cahun's use of a pseudonym disguised her identity and protected her from public scrutiny effectively, even until very recently. Born Lucy Schwob in Nantes in 1894, she was a member of a family of Jewish

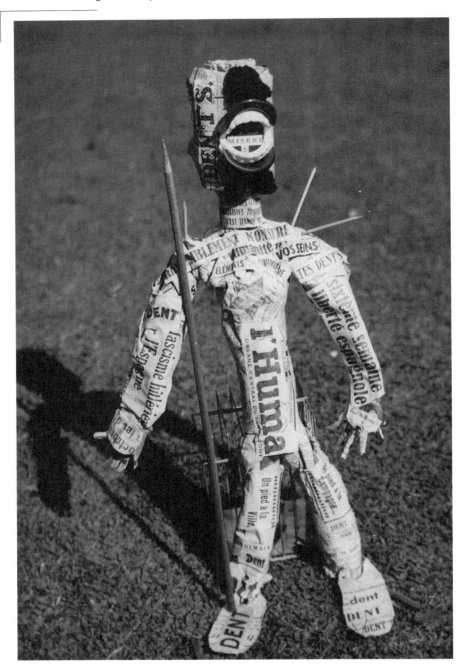

Figure 2 Cahun, *Poupée 1*, September 1936, photograph, 20.5 × 15.5 cms, Jersey Museum.

intellectuals and publishers. She eventually used the surname of her great-uncle, Léon Cahun, a librarian, Orientalist and novelist. The choice of the first name Claude is an interesting one. Unlike such pseudonyms as that of George Sand, for example, which was clearly masculine, Claude (like Camille and unlike Claudette) can be either a male or a female name in France. (I remember as a student spending some time under the impression that the painter Camille Pissarro was a woman!) This name was therefore unstable and could be modulated towards masculinity or femininity, or both simultaneously in bisexuality. Cahun's photographic self-portraits also construct complex sexual identities which multiply her/him through a body of photographic works in single images, and also construct images of simultaneous complexity and multiplicity in the photomontages Cahun produced with her partner for her book *Aveux non Avenus*, 1929–30. Cahun did drawings to illustrate her ideas for the photomontages, which were then assembled by her partner.[21] Cahun's partner and step-sister, Suzanne Malherbe, also adopted a pseudonym but hers was clearly masculine, Marcel Moore. However the relative weight of Cahun in the artistic partnership was heavier, and although many of the works are coproductions by the two women, it is Cahun who appears in the images, constructs and acts out the staged scenarios, and publishes the writings. It is clear, though, that the two women shared a collaborative and fulfilling partnership, which included political activity during the 1930s in France and anti-fascist activities in Jersey where they lived during the Nazi occupation of the island. At this time they clandestinely produced photomontages (each one an original) and tracts, but were finally arrested and condemned to death. The sentence was not carried out before the liberation of the island from Nazi occupation, but a large body of Cahun's photographic work was destroyed by the Nazis. However what remains is still a stunning collection of original work.

Cahun's photographs include photomontages, 'straight' photographs of herself in disguises and different costumes, manipulated and distorted images of herself, (for example with an elongated head), photographs of staged objects and fabricated objects, and portrait photographs of friends. Some of her work was produced to accompany either her own writings or writing by others.[22] Cahun also wrote a political tract (unillustrated) in 1934 which I will discuss later.

Cahun (and Moore's) work certainly disturbs the spectator used to the fetishization and distortion of the female body as a site of male spectacular fantasy in photographs by, for example, Raoul Ubac, Brassaï, Kertész and Man Ray. Rosalind Krauss has argued that these images are

not oppressive to women, or 'anti-feminist', stating that they manipulate straight photography in the interests of creating formlessness (the *informe*). This manipulation and contrivance therefore dissolves a state of 'normalcy' and the woman is therefore the key subject in dissolving the oppressive regime of the patriarchal symbolic realm in a progressive way. Krauss compares the feminine *informe* of manipulated Surrealist photographs, blurred and indistinct, with the clearly-focused and carefully composed 'fine art' prints of, for example Edward Weston: '. . . *woman* and *photograph* become figures for each other's condition: ambivalent, blurred, indistinct, and lacking in, to use Edward Weston's word, "authority".'[23] This Lacanian scenario locates the feminine in the undifferentiated and chaotic world of the imaginary, and the phallic in the realm of the symbolic where conceptualization, expression and communication take place. Any attempt to articulate the imaginary/feminine will fail since the means of its articulation are already, according to this argument, structured by patriarchal power. Now if we accept this argument, and many do not, it is possible to read, as Krauss does, Surrealist representations of distorted images of women as progressive and disruptive. However Kuenzli states that the male Surrealist does not enter the realms of the *informe*, nor does he really want to see his ego disintegrate: 'In order to overcome his fears, he fetishizes the female figure, he deforms, disfigures, manipulates her; he literally manhandles her in order to reestablish his own ego, and not his own *informe*.'[24]

Freud's own reference to photography posits a rather different analogy. He explains that foreconscious (or preconscious) ideas are like photographic negatives. Unconscious ideas never reach the stage of the negative:

> A rough but not inadequate analogy to this supposed relation of conscious to unconscious activity might be drawn from the field of ordinary photography. The first stage of the photograph is the "negative"; every photographic picture has to pass through the "negative process", and some of these negatives which have held good in examination are admitted to the "positive process" ending in the picture.[25]

Thus a mechanism of selection and repression operates in the psyche as it does in the practice of the photographer, where some ideas are allowed to progress and others stifled. Darkroom practice, therefore, is offered here as an analogy to the workings of the mind as it deals with non-material entities. However there is nothing overtly present in

Freud's analogy that genders this process. The photographer is in the position of the conscious ego which suppresses material or allows it to develop further, not by language but through the image.

In the case of Cahun's photographic works, we also need to be aware of Freud's remarks on narcissism. For Freud, this was the product of some 'disturbance' in 'normal' sexual development: 'We have discovered, especially clearly in people whose libidinal development has suffered some disturbance, such as perverts and homosexuals, that in their later choice of love-objects they have taken as a model not their mother but their own selves.'[26] Freud here is talking about male narcissists. How does this apply to women, and what might it mean for the understanding of Cahun's works?

Elizabeth Grosz, in an interesting discussion of possibilities of lesbian fetishism, concludes by deciding that the terms of Freudian psychoanalysis must be stretched to deal with notions such as lesbian fetishism, or indeed the desire of a lesbian as a woman for another woman, without any notions of masculinity entering into the discussion.[27] A possible model of a lesbian fetishist would entail the subject making her own body into the phallus, as she refuses to accept her own castration, by illusion, travesty, make-up, etc. However this still accepts the idea of castration as disempowerment put forward in Freud's views. And why would the desired lesbian partner want a phallic fetishized woman, unless she saw herself as a castrated woman in need of a phallicized object of desire as reassurance? Also interesting in relation to Cahun's many self-portraits in masquerade and disguise are notions of narcissism and exhibitionism. The narcissistic ego for Freud and Lacan can take itself or a part of its body as one of its libidinal objects – it is not self-contained and depends on the subject's relations with the other, as Cahun's self-constructed images depend on being photographed and observed by the invisible Malherbe (Moore). Instead of being dominated by the demands of reality (as in Freud's more common model of the realist ego) the narcissistic ego 'is governed by fantasy, and modes of identification, and introjection, which make it amenable to the desire of the other'.[28]

In terms of disguise, masquerade and performance, Cahun's self-portraiture does not reiterate the performance of 'the feminine' in order to conceal what is unconscious and opaque, thereby preserving the facade of gender stability.[29] Her self-portraits, on the contrary, continually reinvent Cahun, in collaboration with Moore, as a multi-faceted subject in control of her own image, desired by her collaborator, yet not phallicized/fetishized. The photographs may be interpreted as a

realisation of this moment of desire. These disguises and identities are selected from a range of 'races', genders and personae seemingly invented from stories. Cahun's fantasy and desire combine elements of conscious and unconscious (made especially important in the photomontage portraits) in the photographs which disturb the notion of a gendered viewer and a gendered object of the look at the same time.[30]

While I do not agree with Krauss' remarks on Surrealist photography of female nudes or the theoretical framework on which her conclusions are based, her points do, indirectly, raise interesting questions about Cahun's self-representations. Cahun's self-constructed and self-proclaimed bisexuality in terms of her name and her visual representations clearly cut through a conceptualization of gendered conscious and unconscious in the individual and social persona. Since Cahun presents her creative thoughts and self-image in writing and photography, she is obviously not prevented by the phallic symbolic realm from thinking and representing for others her feminine/masculine contradictory self. She thus demonstrates in practice that such binary conceptualizations of our psychic and social existence can be changed and transcended (if they were ever clearly fixed in this manner in the first place). Cahun's self-portrait of c.1921 demonstrates this well (figure 3). Cahun tended to give her self-portraits to friends, and did not primarily see them as destined for public exhibition, unlike some of her other photographic work. Also since much of her work was destroyed by the Nazis, who reported finding 'a quantity of pornographic material of an especially revolting nature' at the couple's house when they were in prison, it is likely that there were more photographic works where Cahun in collaboration with Moore represented investigations of eroticism and the fe/male body.[31]

Untitled

Cahun and Moore's *Untitled*, 1932 (figure 4) combines the self-presentation of the masquerade 'self-portraits' with the photograph of a constructed and assembled object. The image appears to have been constructed from two superimposed negatives. One shows Cahun, the upper part of her body and head truncated by the frame, clutching long fronds of seaweed against her lower body. They fall to the ground like an exotic 'native' skirt, or like blood trickling down her legs. In one of her drawings for the montages in *Aveux non Avenus*, 1929, a naked female torso is shown with breasts, an eye in the place of the

Figure 3 Cahun, *Self-Portrait*, photograph, ca.1921, 10.9 × 8.2 cms. Private collection.

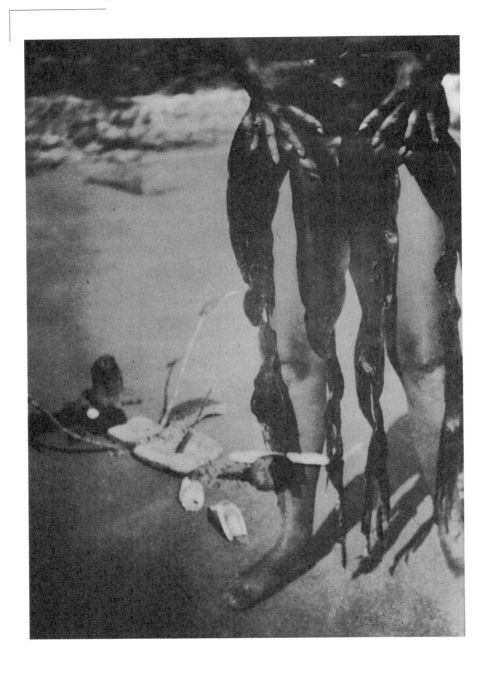

Figure 4 Cahun, *Untitled*, photograph, 1932, 9 × 7.5 cms, Jersey Museum.

navel, and what appears to be streams of blood flowing down from the lower abdomen. The precise meaning of this image is not clear.[32] As this figure of power and mystery stands on the beach in *Untitled*, the leg and what appears to be a wooden spoon placed between the legs of a small mannequin are superimposed on her leg. This small figure, lying on the beach and constructed from found objects such as cork, a wooden spoon, seaweed(?) and cuttlefish bones(?) appears alone in another photograph by Cahun entitled *Le Père*, 1932.

In this photograph the image of the mannequin is the reverse of that seen in *Untitled*, and the spoon is placed at the end of its right arm, making a hand. A twig(?) is placed in the navel of the figure (as in *Untitled*), suggesting an erect penis, or phallus, depending on whether this is a symbolic figure or not. The chances are that it is. In *Le Père*, there is no spoon placed between the legs of the figure. Instead there is a long hole in the sand, suggesting both a penis and a vaginal opening. In the *Untitled* photograph, the wooden spoon is stuck into the hole, and thus the potential reading of the figure as bigendered is made less likely, as the phallic spoon obliterates the hole in the sand. The comic and vulnerable figure of *Le Père* is now overshadowed by a figure to whom is transferred the aspects of the feminine, yet these are ambiguous. The ambiguity of the image as a whole is heightened by the softness of the image and its lack of sharp focus, as well as by the use of the two negatives superimposed one on another. Is it possible that this is indeed an example of Georges Bataille's *informe*, which Krauss detected in Surrealist photography? However this image is consciously constructed by a lesbian, perhaps bisexual. Therefore it goes against the theory that the woman is imprisoned by patriarchal symbolic language and therefore cannot give voice or sight to representations of the feminine.

Cahun knew Bataille and was a member of the short-lived *Contre-Attaque* group with him in 1935, to be discussed later. However Cahun and Moore might have had other sources for the use of these formal devices in their photographic works. Also it seems to me that the image troubles, rather than constructs, categories and locations of gender (for example male/conscious: female/unconscious). The superimposition of the mannequin's leg and 'penis' on the standing figure's leg may suggest priority and foregrounding, but the mannequin is so small and comical like a child's play-thing left abandoned to the mercy of the next incoming tide that it hardly seems like a figure of power and authority. The hands of the standing figure seem to clutch the seaweed to her body and squeeze out tendrils flowing down from her fingers.

Yet this does not appear to invite the equation of the terms woman/nature/inferiority/materiality as opposed to the male mannequin. Significant of course, is the fact that the image is a collaborative work between two women, almost certainly lovers, who lived in what we might term an Oedipus-Complex-free zone. They had no particular need for recourse to the pre-Oedipal stage of ungendered infantile sexuality to glimpse images of their sexual desires. However, their no less demanding task was to construct images of desire and the self that were very different even from the supposedly revolutionary images of sexual desire in Surrealism.

Playful Politics

Poupée 1 [Doll 1] (figure 2) September 1936, is one of a series of photographs of a little mannequin constructed from pages of the Communist Party newspaper, *L'Humanité*. Some images show the figure outside propped up on grass. Another shows the figure in front of boxes of cosmetics. Wearing what appears to be a postal delivery worker's hat, or even a Nazi military hat, the figure opens a mouth of false teeth. He (?) balances a sharpened stick against his right arm and it rests on his foot. Some sharp sticks (cocktail sticks) are pushed into his shoulders. Leperlier says that this figure was intended for a series of photographs Cahun made to illustrate thirty-two children's poems by Lise Deharme, published in 1937.[33] I would argue, however, that this figure probably has political meanings which would not have been particularly appropriate for inclusion in the children's poems collection. It is not absolutely clear when this was made, as it is dated September 1936, but the date 24 August appears on one of the pieces of newspaper on the figure's left leg, so Cahun must have made the figure in early September from a copy (or copies) of the newspaper bought in late August. I want to argue here that this photograph can be considered a political image in the sense Cahun argues for in her polemical booklet of 1934, *Les Paris Sont Ouverts (Place Your Bets)*.

I do not think Leperlier's comments on *Poupée 1* are sufficient to clarify the meanings of the work in 1936. He reads the work as symptomatic of Cahun's (and the Surrealists') interests in metamorphosis and transience, since the figure is made of an emphemeral daily newspaper which only has its status as knowledge of the world for a brief time before it is superceded by a process of historical change. Leperlier designates the 'derisory doll' a 'political firebrand' with Nazi fascism making up its left arm and Spanish Republicanism its right.[34] This gives

the impression that the work is rather politically detached, and that Cahun sees engagement with politics as emphemeral, transitory, and perhaps as something to be mocked. Furthermore the implication in Leperlier's statement is that somehow equal weight is given to the 'extremes' of fascism and Spanish Republicanism, since the figure is balanced by the two arms aligned to opposing political movements. Let us look first of all to see exactly how the figure has been constructed, and what is actually written on the paper cut, or torn, from *L'Humanité*. The construction of the figure from text is interesting as an artistic strategy, though it is rather different from the poststructuralist and postmodernist emphasis on the subject as constructed by language and discourse. The events referred to in the Communist Party newspapers were real enough, though the CP interpretation of them for public consumption certainly constructed a particular discourse which made perception of the real nature of these events almost impossible.

The word 'dent' (tooth) appears several times on the figure, suggesting that Cahun may have used several copies of the paper or even copies of other papers. 'Dent' is probably cut out from 'president' or some other similar word. The word for teeth appears on the feet, on the tops of both arms and on the side of the head. However where the teeth of the figure are situated appears a set of false plastic teeth, shouting or crying out, either to convey news or expressing pain. In the middle of the gaping mouth is written 'misère' (misery). Or is the mouth open to bite or attack? The phrase 'être sur les dents' means to be overwhelmed and exhausted, and this could possibly be suggested by the figure, given the political situation at the time, as we shall shortly see. The neck of the figure is constructed from an article referring to the show trials of so-called 'Trotskyistes' and 'Zinovievites' in Moscow, designed to discredit and stifle any opposition to Stalin and Stalinist politics both within the Soviet Union and abroad. Trotsky, Zinoviev and other 'old' Bolsheviks were accused of being fascist agents and counter-revolutionaries. Gradually the rule of a section of the Soviet Bureaucracy was transformed into the rule of one man, as Stalin quelled his opponents. In the first trial of the 'terrorist counter-revolutionary Trotskyist Zinovievist bloc' the defendents made grotesque extorted confessions admitting to being fascist agents under Trotsky's leadership and were summarily shot. The second wave of trials began in January 1937 and in mid-1937 Stalin purged the Red Army. The purges made possible the dramatic about-turns of Stalin in the later 1930s, as he manoeuvred between left and right of the bureaucracy, between the

'democratic imperialisms' and fascism. The result was the creation of a party totally loyal to Stalin and made up largely of his followers.

The Party Congress of 1939 had been dramatically transformed by terror since the last congress of 1934. The majority of delegates at that conference were now dead, murdered in the purges. Most of the party secretaries at Republic and District level had joined the Communist Party since 1924 and therefore knew no other form of party than one increasingly dominated by one man, Stalin. The party had also dropped in size from 3,500,000 members in 1933 to a mere 1,900,000 by 1937, such was the drastic effect of the purges.[35] The French Party had been similarly Stalinized and uttered no word of criticism in their press concerning either Stalin's disastrous policies or his state terror. We know that Cahun definitely had Trotskyist sympathies at this time, since *Les Paris Sont Ouverts* had been dedicated to Trotsky.

At the top of the figure's chest we read 'rassemblement monstre' (huge rally), and under this 'humanité'. At the top of the left arm is written 'vos seins' (your breasts – *vos* is the polite form of you) and 'tes dents' (your – familiar form – teeth). Along the arm reads 'sixième semaine liberté espagnole' (sixth week Spanish freedom) and the hand has 'bout du monde' (end of the world). In the middle of the chest is the Communist five-pointed star which seems to have a slogan on it for the annual 'fête' of *L'Humanité* which the Communist Party organizes every year in France, and down the centre of the body is part of the mast-head of the paper 'L'Huma . . .'. Underneath the large print is written 'Organe central du parti com . . .'. The missing part torn off at the end is, ironically, the 'organe central', the phallus, which in this figure is nowhere to be seen. I think this is intentional on Cahun's part, and that the lack of the phallus is not supposed to signify a female figure here, but rather an emasculated male. Above the large letters of the mast-head we read 'convoi funèbre' (funeral procession). The suggestion here, on several levels, is of a damaged, perhaps mutilated, Communist Party, aggressive, noisy, perhaps even suffering, but cert-ainly not politically empowered. Rather the figure is dismembered and incoherent, assembled from a newspaper which polemically articulates a monolithic political line, but in reality is fragmented, in pieces. The party which publishes it is like a puppet, not a creature endowed with life and ability to engage with changing situations in the contemporary world. Its politics are indeed ephemeral and unable to develop, since its method is totally undialectical. The politics in the Communist Party Press can be made into a sinister-looking and derisory little mannequin because the politics of the Communist Parties by this time were not

intended to engage with and change reality through the activity of
the working class and its allies, but concerned to lie about reality, and,
above all, to preserve the Soviet leadership in power and preserve that
leadership's basis in 'socialism in one country'. It is difficult to precisely
identify the hat, but if it is intended to recall a Nazi officer's hat, then
possible readings of this might involve the comparison of the repressive
methods of Stalinism and fascism.

On the left leg is written 'Un pied à la campagne' (a foot in the
country), something with the date of 24 August, and 'dent' (tooth)
several times on the foot. The right arm has 'dent' at the top, the arm
has 'Fascisme hitlérien Espagne' (Nazi fascism Spain), the hand has
something about October, the right leg has 'Un pied à la ville' (a foot
in the town), 'demain' (tomorrow) and 'dent'.

This is certainly not a work of political propaganda, and is full of
ambiguities and contradictions, and could not be mass produced and
distributed as a mannequin, though in theory the photograph could
have been made into a poster. The photograph raises interesting
questions about the nature of political art and the ways in which
political criticisms can be made. Also we need to think of the work of
the spectator in engaging with the methods of art and their meanings
(construction, assemblage, juxtaposition, invention, montage, etc.) and
this effort by the viewer as a possible means of perceiving something
about politics (not simply ideology) that they did not previously know.

Les Paris Sont Ouverts

Cahun's Les Paris Sont Ouverts was published in 1934. The first section
was based on a report prepared by Cahun for the literature section of
the Association des Écrivains et des Artistes Révolutionnaires (AEAR)
founded in 1931 by the Communist Party. While this was virtually
identical to an organization being planned by the Surrealists, the latter
were not permitted to join it for about a year.[36] Relations between the
Communist Party and the Surrealists who had joined it were fraught.
Unfortunately at the time when some of the Surrealists were seeking
closer links with revolutionary politics, the Communist Party was
becoming increasingly bureaucratic, repressive and intolerant towards
avant-garde art. While it is not possible that Surrealism could ever have
been completely integrated with Bolshevism, this would not have
prevented genuine revolutionary militants who adhered to Surrealist
theory and practice from joining the Communist party during its
healthy period. However by the early thirties things were looking grim

for any Surrealist wanting to engage in revolutionary politics, given the political degeneracy and cultural philistinism of the majorities within Stalinist parties. As yet, there was little alternative for would-be revolutionaries who accepted October 1917 as a genuine workers' revolution apart from the tiny Trotskyist groups in France and in other countries, forcibly excluded from the Communist parties.

The second part of Cahun's booklet is a vitriolic attack on Aragon, well-deserved in my view, though not particularly clear and effective as a polemic. Aragon had been mockingly dismissive of Communist politics for much of the twenties, and had described the Russian Revolution as simply a ministerial crisis.[37] Aragon had also mocked attempts to write political poetry. However his later work is full of the sort of banalities he previously scorned. His conversion occurred when he was sent as a delegate from the Surrealists (along with the writer Sadoul) to a literary conference in the Soviet Union in 1930. They did not advance the positions they had been mandated to argue for, and instead publically recanted and apologized for various Surrealist 'errors'.

> We must make it clear that we do not support all of the individual works . . . published by members of the Surrealist group. However, insofar as these works bear the name "Surrealism" and "Surrealist" we are responsible, especially for the *Second Manifesto of Surrealism* by André Breton insofar as it contradicts dialectical materialism. We wish to make it clear that we believe strictly in dialectical materialism and repudiate all idealist ideologies, notably Freudianism. We also denounce Trotskyism as a social-democratic and counter-revolutionary ideology, and we are committed to combatting Trotskyism at every opportunity. Our only desire is to work in the most efficacious manner following the directives of the party to whose discipline and control we submit our literary activity.[38]

It was pretty clear from this that a huge gulf separated Aragon's views on culture and politics from those of his previous collaborators, although Aragon's break with them did not follow immediately. However the Surrealists were ousted from the AEAR in 1933, which probably explains why Cahun decided to publish her views on revolutionary literature and art. The first part of *Les Paris Sont Ouverts* has been reprinted, but the second part is still available only in the original, to my knowledge, so I will discuss Cahun's arguments in some detail.[39]

The title, which could be translated as *Place Your Bets*, refers to the two antagonistic conceptions of revolutionary poetry and other art forms, and the politics which subtend them, discussed by Cahun in

the essay. The result of the conflict between these two opposing political forces is uncertain. The opening dedication is to Trotsky, because, writes Cahun, even in the direst political crisis of Soviet and world revolution, he did not ignore the plight of a writer driven to suicide by the state of his personal and artistic life under Stalinism. This writer was Mayakovsky.[40] Cahun states that the creation of poetry is an inherent human need, doubtless linked to sexual desire. Some, however, argue that there is a kind of poetry which is counter-revolutionary and reactionary, and thus we can know what revolutionary poems are. Not so, says Cahun. There are no recipes for writing revolutionary poetry. Poetry cannot be deemed revolutionary (or not) except to the extent that poems secretly within themselves represent the poets who have made them. Sometimes the poet can therefore express something unintentionally and unconsciously. This instant of expression can be like an attack on the conscious person, occurring without any premeditation. Tristan Tzara's proposed distinction between the manifest and latent content of the poem is helpful here. The manifest content, says Cahun, can only be revolutionary in a fugitive way, since circumstances and social movements will change. Therefore the meaning of the politics of the poem will change. Thus Cahun feels satirists and journalists are the most suitable sort of political writers. However, ideological constrictions are not favourable to poetry, and manifest political content only encourages trickery and deceit. Beneath the manifest content of the poem can often be discovered the unconscious, reticent hidden content, unknown to the poet him/herself. Spiritual, rather than political, works, can also reveal meanings unknown to the author. For example, a man photographs the hair of the woman he loves full of pieces of straw as she sleeps in a field. The photograph reveals thousands of arms, fists, waving in the air, a riot. These are provisional observations, stresses Cahun.

She moves on to the question of evaluating the success of revolutionary art works. How would we measure their success on the readers and spectators? Only psychoanalysis might be in a position to do this, she states, if it were more widely practiced. The emotive and psychological effects of the poem cannot be measured, and these are its propaganda value. She moves on to distinguish three possible sorts of poetic action that a poem might attempt. Firstly, direct action, by affirmation and reiteration e.g. the invocation that 'Workers of all countries unite'. Secondly, direct action by opposition, by provocation. Even a counter-revolutionary piece of writing can inflame a desire to destroy the class society and culture that gave rise to it. Thirdly, indirect

action. Suggestions can be made, something can be started and left unsaid, a truth (suggested, not expressed) can be contradicted, provoking another effort by the reader to engage with the original truth by contradicting its denial. (A really dialectical poetry this, proposed by Cahun!) Cahun stresses in the conclusion to part one that the indirect suggestion of action is the best, both from the political point of view and from that of poetry.

The second part starts with a quotation from Marx's *Poverty of Philosophy* criticizing the philosophical ideas of Pierre Paul Proudhon. This quotation stresses the conflict between opposites which leads to the eventual negation of one of them and the emergence of a new situation. By merely suppressing the 'bad side' of the contradiction, there is no dialectical understanding and no true progress to overcoming this contradiction. Cahun thus situates her method of understanding different conceptions of revolutionary literature, and by implication criticizes the lack of this method in the supporters of 'proletarian literature', e.g. Aragon and the Communist Party. Cahun launches into an attack on Aragon, making mincemeat of his latest Stalinist verses, which give no expression to contradiction or the sources of contradiction. She concludes by pointing out that all culture relies on myth, as long as human beings are alienated from reality. When this alienation is overcome, poetry will cease to have a specific purpose and existence, because poetry will have become one with human beings. While science seeks direct knowledge of the material world, and philosophy indirect knowledge of it, poetry intervenes everywhere to short-circuit human knowledge and consciousness in the same sort of 'magic' short-cuts that sexual desire and extreme suffering can also bring. The purpose of poetry cannot be decided now by the Communist Party as if nothing was going to change any more. Nor is there any possibility of dictating or even advising poets to put class politics directly into their work. This is not very effective, and, in any case, the role played by the unconscious in the making and reading of art can give totally unexpected results, no matter what the conscious intentions of the producer and her/his political standpoint.

Although Cahun's approach in the second part of the article, in particular, does not result in a particularly clearly argued essay, it is quite evident that these views are similar to those of Trotsky as opposed to those of the Communist parties. Her close friend André Breton also argued along these lines in his manifesto for a free revolutionary art written with Trotsky a couple of years later in 1938. In this manifesto, signed by Rivera as well but actually a collaborative effort by Trotsky

and Breton, complete freedom is demanded for art, because only then can art fulfil its true revolutionary potential. The signatories hoped to organize an international organization for revolutionary artists. The revolutionary role of art was emphasized, perhaps overemphasized, but this is understandable in the terrible conditions of isolation and dread of oncoming war and mass killings in which the manifesto was composed. It was necessary to reassert the freedom of creative potential against the oppressive régimes of imperialism, Stalinism and fascism. In lyrical and optimistic tones the authors wrote:

> The communist revolution is not afraid of art. It realizes that the role of the artist in a decadent capitalist society is determined by the conflict between the individual and various social forms which are hostile to him. This fact alone, insofar as he is conscious of it, makes the artist the natural ally of revolution. The process of *sublimation*, which here comes into play and which psychoanalysis has analysed, tries to restore the broken equilibrium between the integral "ego" and the outside elements it rejects. This restoration works to the advantage of the "ideal of self", which marshals against the unbearable present reality all those powers of the interior world, of the "self", which are *common to all men* and which are constantly flowering and developing.[41]

Cahun signed up as a member of the Fédération Internationale des Artistes Révolutionnaires Indépendants (FIARI), and was also a signatory of the last bulletin issued by the organization before it folded and its members were dispersed by the war. This bulletin opposed the arrest and detention without charge by the French state of three French leftists.[42] These were not the first political declarations that Cahun had signed. In 1935 she and Malherbe (Moore) had joined Contre-Attaque, Union de Lutte des Intellectuels Révolutionnaires, along with other writers and artists such as Breton, Eluard, Dora Maar, Léo Malet and Yves Tanguy. Their founding resolution was certainly left-wing and anti-Stalinist, but rather directionless and ultra-left at the same time. The resolution claimed that traditional revolutionary methods had been fine when dealing with dictatorial autocratic régimes, but completely new tactics and strategy would have to be formulated when dealing with an advanced bourgeois democracy. They nonetheless called for the dictatorship of the armed proletariat, quite correctly, given the revolutionary situation in France at the time, but without a strategy of how to achieve this through the formation of workers' councils, tactics or a political leadership, such a call was simply abstract. In order to

take power what was needed was 'la création organique d'une vaste composition de forces', a far cry from any understanding of the nature and function of a democratic-centralist Bolshevik party rooted in workers' organizations which Trotsky was trying to rebuild. However they resolutely opposed the Popular Front government, and called for the socialization of heavy industry. They called for a new social structure and stated: 'Nous affirmons que l'étude des superstructures sociales doit devenir aujourd'hui la base de toute action révolutionnaire.'('We declare that the study of social superstructures should today become the basis of all political action.') They denied that the revolution would be able to succeed within the boundaries of one country. We can see here both the revolutionary will, but the political confusion of the resolution.[43] However a group of Surrealists including Cahun and Malherbe (Moore) soon left Contre-Attaque and condemned what they termed its fascist tendencies. It is not absolutely clear what they meant by this. However Contre-Attaque statements preferring the 'anti-diplomatic brutality' of Hitler to the pussy-footing police diplomacy of the democracies, were hardly capable of offering a clear understanding and strategy to French workers.[44]

Poupée 1, therefore, was conceived by Cahun as a political art work, I would argue, but an artwork functioning in the indirect sense she describes in *Place Your Bets*. The unconscious of the artist and the viewer engages with the work to read it in ways perhaps not really fully defined consciously by the producer herself. However I would also argue that the unconscious can only function within a particular historical situation when it helps to create these meanings, and therefore we also need to understand the political situation in France in the autumn of 1936 when the photograph of the mannequin was produced. It is clear from Cahun's essay and her own art practice, that the imagination and the unconscious must be encouraged to function in a creative search for awareness and conscious discovery, but also that this occurs in a historical, social, cultural and sensual process, where progressive meanings at one point in time will perhaps be transformed later into something very different. Thus living history must be related to the individual's unconscious, and that individual necessarily exists within a social formation. Cahun's *Poupée 1* is, I think, an example of her own definition of effective revolutionary art, and also of Trotsky's and Breton's – 'true art is unable *not* to be revolutionary, *not* to aspire to a complete and radical reconstruction of society' – even although Cahun was not a conscious Trotskyist in a political sense.[45]

The Popular Front

In order to understand fully the meanings of this photograph, it is necessary to take a long look at the situation in France in the mid-thirties. The relevance of this will become apparent later. The situation in which Cahun evolved towards sympathies with Trotskyist politics was that of the Popular Front in France. Some reformist politicians and historians look back on this period as one of progress and an example of the possibility of fruitful class-collaboration within the boundaries of the nation state. However the effects of the Popular Front can be more accurately characterized as a defeat for the many workers and small-bourgeois who participated in strike action and demonstrations during the period, and the French working class was, as Dave Stocking says, 'poisoned with chauvinism. The way was prepared for the "democratic imperialisms" to lead the masses into another barbarous world war'.[46]

In France in January 1934 a financial scandal broke involving a swindler named Alexander Stavisky. It was rumoured that certain ministers, Radical Party members, were involved. The Radical Party, the chief bourgeois party in France, represented the great majority of the peasants, the small business people and independent artisans, a numerically large section of the population. Within this party were two opposing groups, the 'left' being led by Daladier, who was premier during most of 1933 and was selected again at the beginning of 1934. The petty-bourgeois social base of the Radicals was hard hit by the developing economic crisis, and sections of this desperate layer looked beyond their parliamentary representatives for action – to the growing fascist and royalist organizations. When the Stavisky scandal broke, it gave rise to a massive wave of agitation and public disorder. France was still a predominantly agricultural country that was late in being drawn into the great depression that had been raging in Britain, the USA and Germany since 1929–30. In France the real effect of the depression came in 1932–33, and industrial production fell.

A ministerial bloc between the Radical party and the SFIO (the Section Française de l'Internationale Ouvrière) the reformist Socialist Party, embarked on a savage austerity programme. However in the autumn of 1933 a group of deputies in the SFIO rebelled and the party split. These parliamentary and economic crises took place as the German workers, the best organized in Europe, allowed Hitler to come to power just over the border with France. This fascist victory had been possible, according to the Trotskyists, due to the disastrous policy of the

Communist Party, which had argued for a 'class against class' policy, refusing any united front with other workers' organizations which were not already Communist. The French Communist Party's numbers had plummeted from 60,000 members in 1926 to 28,000 in 1934.[47] By late 1934, Stalin had decided to form a pact with French imperialism as his moves to appease Hitler had not been successful. However the fascist leagues were growing in France as well as in Germany. Demonstrations by the fascists had led to the collapse of the Daladier government and the right-wing parties of the National Union took over the government. French workers responded with a massive general strike of 12 February 1934 where 150,000 communist and socialist workers joined in a mass demonstration. Thus the workers themselves led their unwilling leaders into a united front against the fascists.

However the Communist Party turned this united front (by which Marxists mean engaging in joint action with non revolutionary workers on key issues, while arguing for revolutionary politics) into a Popular Front, where the interests of workers were to be subordinated to the interests of the other partners in the pact. Stalin ordered an abrupt *volte-face* and the French Communists turned from scornful criticism of reformist parties to unqualified subordination. Common cause was made with the middle-classes, the Radical Party, and patriotic French capitalists, and the party dropped its opposition to military service, civil defence, ceasing its denunciations of French Imperialism. The period from Spring 1934 to summer 1935 saw the transition from the 'Third Period' Stalinist policies to the 'Popular Front'.

The programme of the Popular Front which appeared in the newspapers in January 1936 was a woolly and vague attempt to woo the Radicals. The programme made no specific or unequivocal promise to nationalize anything other than the war industries. It offered no new rights for French workers, and instead of launching a campaign of workers' action against fascism it called for the dissolution of all armed organizations. This would obviously give the state the right to disband and suppress workers' defence squads. All these measures were intended to coax members of the Radical party towards the Communists, rather than start by recognizing the needs of workers in France and internationally.

The Communists made huge gains in the 1935 elections when they stood for 'a free and happy France'. Thorez, a leading figure in the CP, was being promoted as a French Stalin figure to 'personalize' the party. The complete lack of class politics and misleadership of workers into cross-class chauvinism is quite clear in one of his election broadcasts:

We stretch out our hand to you, Catholic worker, employee, artisan, peasant, we who have no religion, because you are our brother and because you have the same worries as us. We stretch out our hand to you national volunteer, ex-servicemen belonging to the Croix de Feu [the main semi-fascist organization led by Colonel de la Rocque], because you are a son of our people and suffer like us from disorder and corruption, because you, like us, wish to prevent the country from sliding into ruin and catastrophe.[48]

The election results, however, encouraged workers to press on in their struggle for reforms, and huge strikes took place in a number of towns and key industries. By 10 June over 2 million workers were on strike. The Communist Party wanted these strikes contained, so that the bourgeoisie and petty-bourgeoisie would not be alienated. National security was more important than the interests of the workers: 'We consider it impossible in the face of the Hitler menace, to put in jeopardy the security of France for which the Popular Front is responsible' wrote a leading CP journalist in *L'Humanité* on 29 May,1936.[49] Though the workers made major gains, they could have achieved far, far more, but the CP instructed militants to break off the strikes. *L'Humanité* on 14 June carried the amazing (but entirely true) slogan 'The Communist Party is order!'[50]

The small numbers of French Trotskyists, who had left the Communist Party in 1933 after events in Germany made it impossible for them to support the CP any longer even as loyal oppositionists, attempted with Trotsky's help, to argue against the politics of the Popular Front. It was obvious that the situation in France was a revolutionary one, being held back by the Communists in pursuit of an alliance with the French bourgeoisie in accordance with the interests of Stalin and the Soviet bureaucracy. Stalin had by this time concluded a mutual defence pact with the French state, encouraging rearmament and thereby supporting the war preparations of an imperialist state, on whose orders thousands of workers were likely to be killed. Trotsky had been allowed to stay in France briefly from 1933–35, but was expelled by the French state who were obviously worried about having a successful revolutionary in the country only a few miles from Paris in a period of increasingly serious class struggle. Breton and other Surrealists were among those who protested against Trotsky's deportation. Trotsky and his followers continued their propaganda and exemplary practice in arguing for a genuine workers united front against the fascists, for workers' defence squads to protect strikes and demonstrations,

and for a resolute class opposition to the politics of the Popular Front.

As Trotsky had predicted, the employers soon began to plan their revenge on the workers and reverse the concessions they had made at the height of the strike waves. Capital was shifted abroad as the government refused to decree exchange controls. The big banks restricted government borrowing, so Blum, the SFIO government leader, resorted to printing money thereby fuelling inflation. The wage rises gained by the workers were fast being eroded. In early 1937 Blum announced a 'pause' in reforms, but actually it was a reversal in favour of the big bourgeoisie. The fascists began marching again from September 1936. In a scenario familiar to anyone involved in anti-fascist activity, 8,000 workers mobilized to stop a fascist rally at Clichy, a suburb of Paris on 16 March 1937. The police were there to defend the fascists, opened fire on the demonstrators and six were killed, 500 wounded. Thorez turned up at the town hall in the evening and refused to speak to the crowd. 'As he left he faced a group of workers calling for workers' militias. "Filthy Trotskyists" he called out as he passed.'[51] The Popular Front government now had workers' blood on its hands and, as one writer has commented, 'the CP was only too glad to help them wash them'.[52]

The political and economic crisis in France continued, with the CP ever more eager to preserve 'unity' with the national bourgeoisie at the expense of the workers. The Spanish Civil War was raging by this time. Blum would not alienate the City of London (who supported Franco) for financial reasons, and therefore the French state did not use its international right to defend its borders by supplying arms to the Spanish Republicans in any meaningful quantity. French Stalinists were increasingly annoyed and embarrassed by this, but after all this was in line with the policy of Stalin himself. Stalin supplied arms on a limited scale to the Republicans, was loyal to a policy of non-intervention, and at the same time sent enough agents to Spain to keep the left under control, make sure the workers in Spain never managed to gain any real independent political power, and murdered many of the best anarchist, Trotskyist and POUM (Workers' Party of Marxist Unification) fighters, including Andrés Nin. The events in Spain are important for allusions in Cahun's *Poupée 1* and also for Modotti's political evolution, as we shall see.

In February 1938 Hitler invaded Austria. A new strike wave in France developed and again the CP did their best to demobilize the workers. This time thousands of trade unionists and party members tore up their cards in disgust. The party was losing all the gains made by its

manoeuvres, and was no better off than before, having in the process wrecked the hopes and aspirations of thousands of militants who turned away from political activity as a result, just on the eve of the world war. Daladier, now in charge of the government, pressed home the defeat of the workers by cutting protective legislation at work and breaching the forty hour week. A deal was done with Hitler at Munich, finishing off any illusions in the Franco-Soviet Pact and the Popular Front, as Czechoslovakia was dismembered, the Soviet Union sidelined, and the two leading fascist states signed a non-aggression pact with the two leading European 'democracies'. Further attacks on the working week finally prompted the CP to call for a one day general strike in protest in eighteen days time, giving the government ample time to prepare repression. When workers returned the next day, lists of sacked militants awaited them. Even more tore up their party and union cards in disgust. The results of the Popular Front politics of the CP were drastic. France was invaded by Hitler, so its attempts to secure 'peace' failed, Franco was victorious in 1939, the Soviet Union was not defended by the governmental pact and Hitler invaded the USSR in 1941 which resulted in the deaths of the huge number of twenty million Soviet citizens, as well as the German casualties. Even Stalin's cynical pact with Hitler was of no avail. From a revolutionary situation in the mid-thirties, France was now split in two, Communism was discredited, and the forces of opposition to the CP increasingly hounded by state and Stalinist persecution.

In the context of political events in France in the mid-thirties, Cahun's *Poupée 1* can be read as a highly critical work, embodying cultural and political opposition to the public politics put forward by the Communist Party press in *L'Humanité*, as well as being formally and materially the embodiment of an art practice totally opposed to the concept of 'proletarian art' so beloved by Stalinist cultural organizations. In 1936 Cahun was everything that would have seemed alien to official Stalinist ideology – a lesbian/bisexual(?), Jewish (by this time Trotsky and Zinoviev had been scurrilously attacked in the Soviet media for their Jewish origins), a Surrealist and someone with Trotskyist sympathies. It is hard to imagine an artist or an artwork more potentially alien to Stalinist ideology and politics.

Tina Modotti

If we look now at the photographic work of Tina Modotti, we can discern a very different configuration of aesthetic, political and personal

factors. In particular Modotti's political choices took her away from an interest in Trotsky at one point in her life, to activity as a committed Communist Party agent sent to Spain during the Civil War by the Soviet CP. In an otherwise useful catalogue, *Frida Kahlo and Tina Modotti*, devoted to the work of Modotti and Frida Kahlo, the chapter 'Women, Art and Politics' sees the women's politics as a vague notion of radical political activity informed primarily by feminism. No understanding is offered of the real nature of political struggles during this period, and the massive split between adherents of Trotskyist politics and those of the Stalinized Communist Parties.[53]

Modotti arrived in Mexico with Edward Weston, her professional and personal partner, in 1923. Together they ran a studio and Modotti, although heavily influenced by Weston's formalist practice, soon began to develop her own approach to the use of photography. However the equipment used by Weston and Modotti was cumbersome and old-fashioned, even for its time. At first Modotti used a large camera with a tripod. After 1926 she used a hand-held Graflex as well. However as Sarah Lowe points out, 'like Weston, Modotti subscribed to the all-importance of composing an image on ground glass and to rigorous formal construction, as is evident in much of her work.'[54] She and Weston also used the contact method to print directly from negatives, using the bright sunshine in Mexico. The importance of adequate natural light for her work caused her difficulties when she was deported from Mexico due to her membership of the Communist Party in 1929 and had to go to Europe. In Berlin and in the Soviet Union she experienced neither the physical environment nor, apparently, the political environment conducive to her sort of photography. A friend, Concha Michel,

> visited Modotti in Moscow that year (1931) and found her despondent about her photography because "they" didn't appreciate her work. Modotti's photography failed to fit in with Stalinist concepts of revolutionary art, and as a Soviet Communist Party member working with IRA (International Red Aid) – and along with Vidali (her partner at this time), one of its leading officials – Modotti could not have produced anything other than "revolutionary" art. She was too much of an artist to see her photography reduced to mere propaganda, and at the same time too devoted to the Party to risk disapproval or expulsion.[55]

Political considerations aside, Modotti was hampered by her artisan-craft approach to photography, which in some respects embraced the

Modernist vision of the self-interrogation of the medium itself, but in other respects rejected the mass-reproducible technological developments of industrializing photographic practice.[56] As we shall see, in the later twenties when she was interested in Trotskyist ideas on revolutionary art and technology, a rejection of modern technology was not her position in theory, but her practice had not yet developed appropriately, and indeed it never did.

While it is easy to see how Modotti's formalist practice would make it difficult for her to fit in with notions of official Soviet Socialist Realism, a growing political awareness and an attempt to investigate the relation of form and content is apparent in her photography throughout the later 1920s. However I would argue that the main stumbling block for Modotti's development as a photographer was not the technical restrictions of her old-fashioned equipment, the lack of light or even her difficult material conditions as a refugee in the 1930s, but her decision to commit herself to Stalinist politics. This was not done in ignorance of the alternatives, but as a conscious decision which she put into practice. She joined the Mexican Communist Party in 1927. By 1933 Modotti, as a member of the Red Aid executive committee, was being sent to Spain, Poland, France and Austria, and by November 1935 she was in Madrid with Vidali. They were almost certainly among the numerous agents sent all over the world by the Stalinist bureaucracy, chosen for their loyalty to the party line, their implacable opposition to any waverers, and hostility to Trotskyism.

Vidali is thought to have been among the most notorious of Stalin's agents in Spain, and was implicated in the murder of Andrés Nin, leader of the POUM, according to Hugh Thomas' book on the Spanish Civil War.[57] When Modotti and Vidali returned to Mexico after the final defeat of the Spanish Republicans in 1939, Vidali, according to available evidence, was involved in an assassination attempt on Trotsky.[58] It is highly unlikely that Modotti was unaware of the political activities of her partner or disapproved of them. She appears to have made her political choices in the very late 1920s and after that there was little chance she could ever progress towards her own conception of a fusion of revolutionary politics and photography. Confronted by political choices and, indeed life-threatening persecution, she chose Stalinism, and the implication of this choice for her photography was to give it up. Cahun's situation, and her rejection of Stalinism, were very different. In the end, however, there is nothing which absolutely determines an individual's choice about political activity. The economic conditions may be dire, capitalism may be in crisis, but of course this

does not mean all thinking people will become revolutionaries. They may reject politics altogether, they may take refuge in their personal lives, or they may choose between different political parties and programmes. Modotti chose Stalinism precisely at the time when the Communist International under Stalin's control was to embark on the most repressive and politically disastrous period of its history both in the Soviet Union and abroad.

While the show trials resulted in the public execution of oppositionists in the Soviet Union, thousands more were murdered far from the limelight of the media. Men, women and children were worked to death, shot, blown up and gassed in gas-chambers during the later thirties in the Soviet Union, many after prolonged periods on hunger-strike.[59] When the Spanish Civil War was in full swing and the Republicans were straining every nerve to defeat the fascists, *Pravda* threatened vengeance not on Franco and his supporters, but on the non-Stalinist left: 'As for Catalonia, the purging of the Trotskyists and the Anarcho-Syndicalists has begun; it will be conducted with the same energy as it was in the USSR.'[60] One of the biographies of Tina Modotti is subtitled *A Fragile Life*.[61] I think it is much more likely that Modotti was as tough as old boots.

Modotti and Political Photography

Modotti, who in her early career did not believe that a political photography was possible, changed her mind during her stay in Mexico. When Weston left to go back to the States her letters to him show that she was moving away from the emphasis on art, as opposed to life, as she put it.[62] She began to involve herself with Communist Party campaigns, and met Alexandra Kollontai in 1926 when she was briefly the Soviet ambassador to Mexico. However this meant she did little photography, and needed to earn some money so in April 1925 she decided to take a job in a bookshop which lasted only a few hours. By this stage in her life the conditions of work endured by many others were insupportable to her, in spite of her communist leanings: 'I may be ridiculous absurd – a coward anything you want but I just had to quit – I have no other reasons in my defence only that during the first morning of work I felt *a protest of my whole being*.'[63]

Writing to Weston in early 1926 Modotti described how she sifted through her possessions, moving through a process which took her from the concrete and the material, to the abstract and the spiritual:

I have been all morning looking over old things of mine here in trunks – Destroyed much – It is painful at times but: "Blessed be nothing." From now on all my possessions are to be just in relation to photography – the rest – even things I love, concrete things – I shall lead through a metamorphosis – from the concrete turn them into abstract things . . . and thus I can go on owning them in my heart forever.[64]

This complex process appears to have related to both Modotti's photographic practice and her own personal development in the later 1920s. Lowe interpreted this as a desire to 'transmute matter into ideology' but I do not feel this is particularly accurate.[65] On a personal level it may mean that Modotti is destroying material relics of her past, as she changes and goes on to new developments in her life with corresponding concepts to live by. Her notion of metamorphosis is parallel to, but unlike that found in Cahun's work, which has more in common with the uncanny, the unexpected, the Surrealist and notions of radical knowledge gained by a perception of unconscious trans- formation and critique of surface appearances. Also Modotti's work in the 1920s attempts more and more to suggest that material reality as it appears in photographs suggests abstract concepts and values beyond itself, while never actually taking the formally abstract into the realms of the non-objective. Thus Modotti was moving from the problematic in Weston's work, appreciation of the abstract formal values in compositions of real objects and bodies, to an engagement which was to be crucial for all creative artists working close to the Communist Party – how to engage with what they perceived as revolutionary politics while walking an increasingly dangerous tightrope between involve- ment with material reality and the embodiment in their work of concepts beyond that immediate physical reality, whether of aesthetic or political consciousness. Lowe's idea that Modotti's aim was to transmute matter into ideology is not quite correct, for Modotti is grappling with the problem of representing more in her photographs than what is depicted in them. In any case political photography is concerned, as far as the photographer sees it, with the representation of some conscious knowledge or truth (according to Cahun this can 'surface' from the unconscious of spectator and/or viewer), either in terms of the individual or the class, or both at the same time. No revolutionary photographer worthy of the name would set out to represent an ideology, in the Marxist sense, unless it was being set up for criticism and to be superceded by knowledge. Revolutionary photographers seek to change the perception of the spectator in the

direction of knowledge, not to offer her/him merely a different ideology. I think this is where some writers on Modotti's work have got into difficulties. Since they are not particularly interested in Marxism, and understand little of the Stalinist and Trotskyist movements in the period, terms like 'ideology' 'politics' and 'propaganda' are used without a great deal of awareness. For example Lowe quotes approvingly the comments of Fredric Jameson, arguing that any reluctance to make political art is a Eurocentric point of view: 'What politics – what *a* politics – might be in the first place . . . (is) a perplexity no doubt meaningless in the rest of the world . . ., (in Latin America) . . . the political is destiny, where human beings are from the outset condemned to politics, as a result of material want.'[66] Now it is not the case that economic deprivation automatically gives rise to political activity. It may give rise to protests, rioting, looting supermarkets, crime, suicide, adherence to fascism, and many other things. It will not give rise to conscious political activity in and of itself. Nor is it likely, in Europe and well as in imperialized countries, that the poor will become political in a sense that will enable the eradication of economic exploitation without the existence of a revolutionary programme and party. If Jameson's argument was true, Latin America (or more likely Africa) would have been the most politically advanced area of the world long ago. Nor is it true that Modotti was automatically more political because she lived in Mexico than elsewhere.

It is certainly possible to produce a political photograph that is not propaganda (see Cahun's arguments and work), and politics is not always the same as ideology, especially in the case of Marxist politics. The photograph is crucially important in this sense, since it indeed has a direct relation with material reality at the same time as trans-forming it by a process of physical and intellectual labour into something qualitatively different, which at the same time opens up further possibilities of transformed perception on the part of the viewer. Modotti's photographs are more purely photographic than Cahun's in this respect, for Cahun already transforms, disguises and manipulates the reality in front of the lens before it is photographed. Modotti is reluctant to do this, preserving the notion of a pre-existing reality which is then worked on by the photographer during the photographic process.

This can be seen in her photographs of puppets made in 1929, in particular *Yank and Police Marionette* (figure 5). The two puppets and the stage are seen at an angle to the camera lens, and sinister patterns are cast on the white partition behind them as they raise their burly

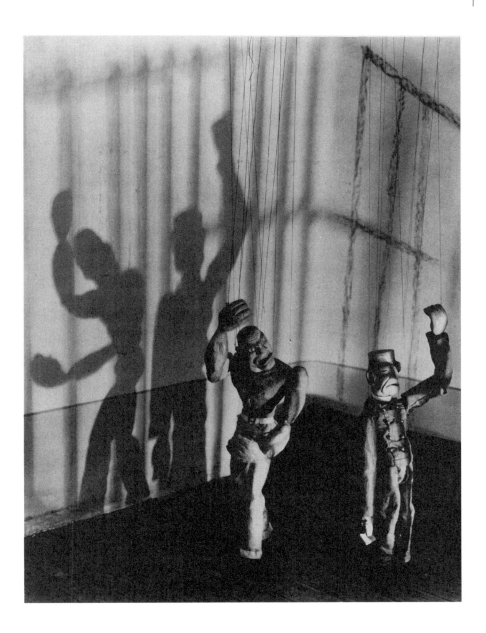

Figure 5 Modotti, *Yank and Police Marionette*, gelatin silver print photograph, 23.5 × 18.5 cms, 1929, Helen Kornblum collection.

arms. The shadows seem to enact a potentially different scene from the one in which the actual puppets are made to engage, and the vertical lines on the backdrop suggest the prison, within which a beating is taking place, different to what we see in front. The amount of space dedicated to the shadows is in fact the major part of the image, suggesting Modotti's ongoing interest in formal and decorative pattern-making as well as suggestive use of forms. However the puppets were not actually constructed by Modotti, but by Louis Bunin, a young artist from Chicago, for a performance of Eugene O'Neill's play of 1922, *The Hairy Ape*. Lowe comments: 'The marionette photographs underline the enduring attraction to Modotti of an art that makes its point by metaphor and association rather than with dry facts or blunt propagandizing. As an artist, she hoped to awaken in the viewer a sense of class consciousness rather than deliver a lecture on dialectical materialism.'[67] In my experience Stalinist lectures on dialectical materialism are simply formalistic exercises in political correctness which have little to do with either the historical reality existing at the time or with actual Stalinist political practice. In any case the photographic image is incapable of giving a lecture or even imparting a few sentences about dialectical materialism. My own view is that Modotti's photographs of the marionettes are still conceptions of a reality which has been constructed by someone else, and exists in its own right. She then comes to engage with that reality and to present it to us to alter our ideas about that reality, but she has not really succeeded in grasping the concept that reality itself is contradictory, is a process, or that potential for change exists within that material or social reality itself. With Modotti's photographs the subject and the object are still separate, not dialectically linked. In that limited sense maybe Lowe is unwittingly correct – Modotti is not delivering 'a lecture on dialectical materialism' to us because she has not grasped such a concept.

Modotti did, however, make serious attempts to become a revolutionary photographer (although in a manner very different to Cahun), but I would argue that the political milieu she existed in, did her no favours in this respect. In 1929 she wrote: 'I look upon people now not in terms of race (or) types but in terms of *classes*. I look upon social changes and phenomena not in terms of human nature or of spiritual factors but in terms of *economics*.'[68] Of course it is very difficult to translate your own perceptions as a photographer into an image that will convey these perceptions to someone else, and the sort of images Modotti generally produced with their concentration on still, undynamic formal clarity did not often convey a sense of change and

contradiction. When she arrived in Berlin some of these problems became clearer to her. She was neither a photomontagist, like Heartfield or Hannah Höch, nor a photojournalist, nor a worker-photographer. She was offered some newspaper work:

> but I feel not fitted for such work. I still think it is a man's work in spite (sic) that here many women do it; perhaps they can, and I am not aggressive enough.
>
> Even the type of propaganda pictures I began to do in Mexico is already being done here; there is an association of "worker-photographers" (here everybody uses a camera) and the workers themselves make those pictures and have indeed better opportunities than I could ever have, since it is their own life and problems they photograph. Of course their results are far from the standard I am struggling to keep up in photography, but their end is reached just the same.[69]

While Modotti made the transition from object of Weston's nude photographs of her to a conscious subject composing her own images, she clearly still had ideas of 'gendered' areas of photographic practice. Again Stalinist politics were hardly likely to help her oppose these internalized restrictions, as during the later twenties and thirties the trajectory of Stalinist policies on women's rights and roles in society was clearly reactionary. Abortion was banned in the Soviet Union in the mid-thirties and the family was clearly seen as a key location for women as well as the workplace.[70] When Modotti was sent to Spain her practical work was mainly in healthcare and 'social work'. When the Communist Party began its assault on the independent left in Spain, subordinating the militia to a regular Republican army under government control, women fighters were sent to the rear whether they liked it or not. The Communist Party made it clear that women had their 'separate spheres'. The Association of Anti-fascist Women led by the famous Stalinist La Passionaria, organized women under the slogan 'Men to battle, women to work'.[71] While this also involved factory work, women were primarily directed away from the front, away from carrying arms, and towards looking after the wounded, homeless and refugees.

La Técnica

The nearest Modotti came to solving the problem of the modernist political photograph came in a key work of 1928, *La Técnica* (figure 6).

Figure 6 Modotti, *La Técnica*, gelatin silver print photograph, 23.5 × 18.5 cms, 1928, Museum of Modern Art, New York.

The title means technique or technology. The image shows a typewriter seen from above and placed at an angle across the rectangular image. The focus is sharp and detailed. The text on the paper is incomplete, as if the writer had been interrupted. Had the angle been less difficult, we might be able to imagine ourselves sitting at the typewriter, but

this is not really a possibility due to the formal arrangement of the composition. I think it is possible here that Modotti has allowed the search for a pleasing formal composition to get in the way of possible interesting meanings of the material. However the formal properties of the composition recall some of Rodchenko's work from the later twenties in the Soviet Union, when more adventurous modernist work was subject to scorn, and he tried to combine 'moderate' modernism with documentary realist photography. Typical ploys to combine the two involved seeing workers from above or at an angle, but nothing too outrageous so as to avoid antagonizing the enemies of the leftist photographers.

Interestingly, Lowe interprets the fragments of text on the paper as a clever attempt by Modotti to use a kind of textual montage in her photograph, 'inspiration, artistic, in a synthesis, exists between the'. The same quote was used, printed in red ink along with the manifesto on photography which accompanied invitations to Modotti's one-person show in Mexico in autumn 1929.[72] By the time the Manifesto appeared in the magazine *Mexican Folkways* a few weeks later, the quote had been removed from the top of the first page. It is not clear if Modotti removed this herself or if someone else decided to remove it before publication. The quote is from a work by Trotsky, which I shall discuss shortly.

When Vittorio Vidali, Modotti's partner in the thirties, wrote about this work many years later, he renamed the work *Mella's typewriter*. Vidali claimed that the typewriter belonged to Modotti's then partner, the Cuban revolutionary Mella, who was engaged in writing an (unfinished) essay on Modotti's photography.[73] Thus Vidali, given his Stalinist politics, is concerned not only to erase Trotsky from the history and meaning of this image, but to personalize, not politicize, Modotti's best attempt at a political modernist photographic practice. Instead of an image concerned with art, technology, creativity, politics and socialism, we are instead invited to view the photograph as a fetishistic image of Modotti's absent lover. Modotti had in fact made the photo-graph before September 1928, long before Mella's murder, and Mella himself had admired the way it 'socialized' its subject-matter.

Mella was a Cuban revolutionary who had taken refuge in Mexico. However his relations with the Mexican CP were rather strained, mainly because he refused to follow their directives on his political activities and had met with Andrés Nin and some members of the Left Oppos-ition in Moscow in the summer of 1927. The Mexican Stalinists suspected him of supporting Trotsky and the latter's political opposition

to Stalin.[74] Mella was murdered, very probably by a Stalinist agent, early in 1929.

So what are the meanings of *La Técnica*? The text on the paper is taken from a section of Trotsky's book *Literature and Revolution*, published in 1924. It comes only a few pages from the end and reads: 'Technique will become a more powerful inspiration for artistic work, and later on the contradiction itself between technique and nature will be solved in a higher synthesis.'[75] Lowe actually mistranslates part of this as 'more profound inspiration than that of artistic production', giving the wrong impression that Trotsky was subordinating art to technology/technique, and that as socialized technology and innovation developed, art would have a lesser role to play. This is not what Trotsky wrote. His concept is entirely dialectical, and the intention is not to subordinate nature to technique/technology, but to point to the fruitful contradiction and interaction between the two, which will result in a progressive synthesis on a higher level, giving rise to new and different sets of contradictions. It is very interesting that Modotti chose this text (or parts of it needing to be reassembled) for inclusion in her photograph, because it relates very closely to the nature of photography in general, and the specific problems she was attempting to tackle in her own practice at this particular conjuncture. The immediately preceding sentences in Trotsky's writing emphasize the need to conquer hunger, poverty and want. Then he writes: 'The passive enjoyment of nature will disappear from art.' This 'passive enjoyment' is certainly something that Modotti no longer wanted her photography to offer to the viewer, and reading these words must have made it seem very appropriate to include parts of Trotsky's text in her photograph for her own reasons as well as perhaps because of her partner's sympathy for Trotsky's politics.

Trotsky's text comes from the final chapter of his book and is entitled 'Revolutionary and Socialist Art'. He points out that there is a difference between the two terms. Revolutionary art is not an easy concept to define, and works about Revolution are not the same as works of revolutionary art. There are, at present, hints of revolutionary art, but it does not yet exist. Neither does Socialist art, for there is as yet no basis for it. The powerful force of competition in bourgeois society will not disappear in a Socialist society but 'to use the language of psychoanalysis, will be sublimated, that is, will assume a higher and more fertile form'.[76] Liberated passions will be channelled into the production of art and culture. To the extent that the new art will be concerned with life, it will be realistic in this broad philosophical sense. He

mentions Tatlin's *Monument to the Third International*, and doubts whether this is really an example of revolutionary art, but he feels the Futurists are on the right lines: 'The wall between art and industry will come down. The great style of the future will be formative, not ornamental. Here the Futurists are right. But it would be wrong to look at this as a liquidating of art, as a voluntary giving way to technique.'[77] (Here we see the mistake made in Lowe's translation clearly set right.)

Trotsky illustrates his point by discussing the construction of a penknife. It can be decorated by embellishment, e.g. with a picture of the Eiffel tower, or it can be well-formed, to correspond to its purpose. This cannot be accomplished by technique alone, but by the interaction of knowledge of materials and their use, and by imagination and taste. This small example of the interaction and interdependence of art and industry will become increasingly important. Art and industry will no longer be separated, and neither will art and nature. The powerful inspiration for artistic work through technical development will accompany the development of human beings who will raise from the depths of their unconscious instinctual feelings, and from hidden recesses create self-knowledge, 'psycho-physical self-education' and 'all the arts . . . will lend this process beautiful form. More correctly, the shell in which the cultural construction and self-education of Communist man will be enclosed, will develop all the vital elements of contemporary art to the highest point.'[78]

In this optimistic mood, Trotsky concludes his discussion with a vision of future human beings able to experience their unconscious as a source of progress and creativity, which will make possible the highest forms of human development and cultural innovation. Alienation and repression, both psychic and socio-political, will be overcome.

Modotti's photograph *La Técnica*, is therefore an ambitious attempt to represent some of the abstract arguments in Trotsky's book. By showing us the typewriter and the paper, we can see how the modern writer and artist (using either print technology or camera plus imagination) can create a modern embodiment of an individual or class consciously seeking to know life and art in its revolutionary potential. The viewer is not invited to passively admire, but to engage with the work and the words on the typewriter, actively attempting to construct meanings which will supercede the various single elements of material reality presented in the image. This active reading must become even more political when Trotsky's words are taken from him, and must be reconstituted and recontextualized after their removal from Modotti's manifesto, and their misattribution to Mella by the Stalinist Vidali.

The whole image is an almost perfect example of the political modernism that Modotti sought, but obviously she could not go further along this road and remain in an increasingly oppressive, undemocratic, and even life-threatening political organization.

Siqueiros, who was later to be involved in an assassination attempt on Trotsky, delivered a lecture at Modotti's exhibition on the last day of the show. In the leaflet accompanying the show, Modotti reveals herself as struggling to integrate what she appears to view as two still separate aspects of photography – its formal and technical qualities, and its ability to directly represent contemporary reality. In a classically Modernist passage she states that good photographic practice 'accepts all the limitations inherent in the photographic technique and takes advantage of the possibilities and characteristics the medium offers'.[79]

Photography had to be utilized by practitioners who saw with modern eyes, not 'with eighteenth century eyes'. The last paragraph in her statement situates photography also in the realist tradition, representing concrete, material life. However Modotti stresses that the photographer needs a historically informed perspective of the importance of her/his chosen medium as well as a concept of the photograph as a part of social production in a democratic sense:

> Photography, precisely because it can only be produced in the present and because it is based on what exists objectively before the camera, takes its place as the most satisfactory medium for registering objective life in all its aspects, and from this comes its documental value. If to this is added sensibility and understanding and, above all, a clear orientation as to the place it should have in the field of historical development, I believe that the result is something worthy of a place in social production, to which we should all contribute.[80]

Modotti and Stalinism

So what happened between Modotti's interest in Trotsky's writings on art and her later Stalinist activities?[81] After 1929 the Communists in Mexico were increasingly persecuted, and in early 1930 Modotti was jailed, released, and given two days to pack up and leave the country. This was the beginning of her European activities, where photography took a poor second place to increasing political activity alongside Vidali. If Modotti had been a committed Trotskyist in the late twenties, which is doubtful, she would not have been entrusted with any political activity by the Stalinist bureaucracy thereafter if she had wavered in

the slightest from the party line of the day. She would probably have been sent to a labour camp instead, or simply 'disappeared'.

When Modotti was in Mexico the ruling class had been in the process of constructing a bourgeois state along nationalist lines. Attempting basically to play a bonapartist role balanced between the peasantry and workers on the one hand, and the imperialist powers, especially the USA on the other, the Mexican bourgeoisie struggled to preserve their position after the revolution. The Mexican economy became more and more dependent on the USA for imports, exports and government debts. Extraction of raw materials helped the Mexican economy, but when world prices for these dropped, the government was often obliged to suspend payments on its debts. The USA was never really without influence in the Mexican state apparatus. During the presidency of Calles, 1924–28, there were a number of big strikes, especially the rail-way workers' dispute, and a Catholic peasant revolt. Unofficial strikes, like that of the railworkers in 1926–27, were brutally suppressed. Government trade unions were the favoured means of bargaining with foreign bosses, and although they gave workers certain rights, it meant workers were tied to a state trade union bureaucracy.

During the thirties the Communist party of Mexico carried out the Popular Frontist politics that failed so miserably in Europe at the same time. As in Europe, the far right grew in strength. Foreign control of important sectors of the Mexican economy, debt and increasing dependence on the USA left Mexico weak and subordinate. However the Communists obeyed the Moscow line and never argued for a socialist revolution against the 'good' capitalists of Mexico. In 1938 Cárdenas expropriated the foreign oil companies, but with compens-ation, and after Pearl Harbour Mexico, completely tied to the US economy, entered the war on the side of the North Americans.[82]

Nonetheless Mexico was one of the few countries prepared to allow Trotsky asylum, and he and his wife Natalia arrived in Mexico on 9 January 1937, met by a welcoming party including Frida Kahlo, Diego Rivera, Max Schachtman and George Novack. The trials in the Soviet Union were still going on, and Trotsky knew there was little time left for him, even in the sanctuary of Frida Kahlo's house surrounded by armed guards. His family and co-thinkers had been subjected to persecution and even death by Stalin's agents. His daughter Zina had committed suicide in Berlin several years perviously, but her son had not been able to join his grandparents until he arrived in Mexico.[83] Kahlo and Rivera were close to Trotsky's politics for a while, and Kahlo and Trotsky even had a brief sexual relationship. However the influence

of the Communist Party eventually outweighed that of Trotskyist politics and both the painters eventually returned to CP membership. Rivera had been displeased at being criticized by the newly formed Trotskyist Fourth International for his indiscipline.[84]

When Modotti and Vidali arrived back in Mexico in 1939 after the defeat of the Republicans in Spain, Stalin had announced his pact with Hitler on 23 August that year. Hardened Stalinists accepted this, like almost everything else, but the Trotskyist movement was confused. Trotsky correctly defined the nature of the Soviet State by the property relations it rested upon, not by Stalin's policies, and argued for the defence of the Soviet Union as a workers' state in the event of a war. The Americans Burnham and Schachtman changed their minds about evaluating the Soviet Union as a workers' state, however degenerate, and split from the US Trotskyist movement. Trotsky's assassination was a terrible blow to the small number of genuine revolutionaries he had managed to guide through the thirties towards the foundation of a new, revolutionary International. By this time Modotti was so immersed in the Stalinist milieu there was really no possibility of her rekindling her early interest in Trotsky's ideas. In spite of some suggestions that her early death in 1942 was suspicious, and perhaps a political murder by fellow Stalinists, these are as yet unproven.

Frida Kahlo, too, often glorified in women's art history books as a strong, courageous woman who can practically do no wrong, appears in a bad light with regard to her later attitude to Trotsky.[85] Considering this woman was once his sexual partner, however briefly, and must have shared moments of trust and intimacy with him personally as well as politically, and also the fact that she had been extremely generous in her support of Trotsky and his wife when they were being hounded from pillar to post by both the Communist Party and bourgeois governments, her later attitude to him is quite despicable and unprincipled. Her later idolization of Stalin necessitated her destruction of anything positive about her association with Trotsky. In a vicious piece of character assassination (the real assassination had happened long ago) Kahlo said in an interview published in a leading Mexican paper:

> El viejo Trotsky and la vieja Trotsky arrived with four gringos, they put adobe bricks in all the doors and windows (of my house). He went out very little because he was a coward. He irritated me from the time that he arrived with his pretentiousness, his pedantry because he thought he was a big deal . . . When I was in Paris, the crazy Trotsky once wrote to

me (to influence Diego) . . . I told him: "I can't influence Diego at all. Because Diego is separate from me, he does whatever he wants and so do I, what's more, you robbed me, you broke my house and you stole from me fourteen beds, fourteen machine guns and fourteen of everything." He only left me his pen, he even stole the lamp, he stole everything.[86]

In 1938 Breton arrived in Mexico and in spite of alleged attempts by the Communist Party to discredit him, apparently had a very successful visit, met Trotsky and co-authored the *Manifesto: Towards a Free Revolutionary Art*.[87] The closing lines of the Manifesto emphasized the inextricable relationship of artistic and political freedom in the darkness of Stalinism, fascism and oncoming imperialist war – but this was a relationship which Modotti made a conscious choice not to develop in her own art and politics after a brief moment in 1928: 'The independence of art – for the revolution.
The revolution – for the complete liberation of art!'[88]

Zina Bronstein

I want now to look at Ken McMullen's film *Zina* (1985). In the words of one enthusiastic reviewer: '*Zina* may be the first masterpiece of a new genre which has attempted to psychoanalyse history and to "historicize" individual psychodrama.'[89] This is a fair assessment of this fine film with its ambitious scope and important themes of history, revolution, conscious and unconscious, Trotskyism and Stalinism, the rise of fascism, the Greek myth of Oedipus and Antigone, all presented in a densely interwoven fabric of image sound and silence, monochrome and colour. Much of the dialogue is taken from Trotsky's own writings and his daughter Zina's own letters. It is impossible here to give an accurate idea of this impressive film, and I can only urge readers to watch it for themselves. It does have certain weaknesses, which I will discuss later, but the importance and resonance of its thematic material are so powerfully handled as filmic text that its qualities far outweigh its failings.

In interviews, McMullen explained that he had been planning and thinking about the film for eight years or so before he was finally able to get finance, mainly from two public companies, Channel 4 (TV company) in Britain and ZDF in Germany.[90] Having raised about £400,000 McMullen made the film in the immediate context of the great miners' strike in Britain which lasted for more than a year.

Throughout the country much of the adult population (as well as some children) were in some way involved in support and solidarity with this massive industrial and community action. Alongside the miners, support committees were formed organizing people to collect and donate food, money and other forms of support. Demonstrations and pickets took place throughout the whole period of the strike and the roads of Britain were patrolled by more police cars than most of us had ever seen. A number of miners died, and many were imprisoned and victimized for their part in the strike. It was a highly politicized climate, though not sufficiently politicized for other unions to deliver the industrial action in support of the miners which would have enabled them to break out of their embattled isolation.

The film opens by situating Trotsky and the Russian Revolution in the world history of modern revolutions and the downfall of their leaders. Exiled on the island of Prinkipo in Turkey, near the island of Antigone, Trotsky is isolated and virtually imprisoned, dictating his books and articles while the outside world moves towards fascism, barbarism and war. He sees this through a process of scientific reasoning, while his daughter Zina sees the oncoming disasters for the working class in hallucinations, and mental instability and 'unreason'. The first images of the film show archive footage of Trotsky visiting the ruins of Pompeii, straight away establishing a parallel between classical civilization, myth and its destruction/partial survival, and the contemporary cultural and historical situation Trotsky and his daughter find themselves in. Trotsky speaks the words pivotal to the whole film, to which it returns in the final moments: 'Revolutions take place according to certain laws. This does not mean that the masses in action are aware of the laws of revolution. But it does mean that changes in mass consciousness are not accidental. It is this that makes prophecy possible.'

Trotsky's daughter Zina had spent nine months with him in exile on Prinkipo with her young son, Seva, who does not appear in the film. She had been forced to leave her other child, a daughter, as a 'hostage' in Leningrad as the Soviet government would not allow her a visa for her two children. Her husband was in a prison camp. Zina's anguish about her children and family is not dealt with in the film, which focuses mainly around the relationship of Zina and her father. It does seem true from what we know of her letters that she admired her father and felt herself deeply inadequate compared to him. Also she was still disturbed by the absence of her father from her early life, as he had escaped from exile in Siberia with his family when the two

daughters from his first marriage were infants. In a memory she recounts in the film to her analyst, she remembers going into his room to find a dummy in his bed, and putting her hand through it, finds it is dust, not her father.[91]

Although unwilling, Zina had left her son on Prinkipo with his grandparents in order to travel to Berlin for psychoanalysis. Trotsky had felt that this would help Zina, though she and her own mother felt that there were many things she wanted to repress which should remain buried. The film continues with a black and white sequence of Zina's analyst, Dr Kronfeld, listening to tapes of his assessment of Zina's condition. Then we see a sequence in colour of Zina and Trotsky on the island before her departure. She tells him that she will go to Berlin and 'be his eyes' there, be him, for he is impotent and a prisoner. McMullen explains the use of monochrome and colour in his film:

> When I began shooting, I thought I'd shoot everything that appeared like a document (such as her sessions with the psychoanalyst) in black and white, and everything marginally hallucinogenic in colour. Then, halfway through, I came to the conclusion that since her hallucinations turn out to be a prophecy of a reality to come, the merger between the two should take place in the form of the film. So suddenly, scenes start to come into colour. But I hope that even the black and white has the quality of colour because the detail is superb. I wanted the visual imagery to be really potent and seductive.[92]

Zina starts her analysis and we see she has no feelings of self-worth. She feels herself to be a liability to her father, whom she so much wants to help in his political work. She hates the past and feels she has no self-identity. Kornfeld tries to calm her and states: 'In this room you have no history.' At several points, through Kornfeld's words, we are presented with the relationship between history and the unconscious (which may have no history or time), the conscious and the rational, and the unconscious and the subjective. The whole film centers around the contradictions of these supposed opposites, but their opposition is a dialectical one. McMullen stated that he had found an extraordinary dramatic subject, 'a subject that deals with two cornerstones of intellectual thought – phsychoanalytic theory and Marxist ideology – and a contest between them'.[93]

Trotsky and Zina see what may happen – the rise of fascism symbolized by the emblem on a Mercedes car surrounded by fog – but by different routes. 'Prophecy' can be rationally predicted based on

knowledge or glimpsed in hallucinations and fantasy. At one point Zina recounts a dream (which she later states was a daytime fantasy) involving a sexual encounter with a blind and wounded man, who nonetheless is a figure of power. It is her father. She is Antigone and he Oedipus. In the plays by Sophocles, Antigone looks after her blinded father in exile. She insists on burying her brother against the orders of her uncle, and is condemned to death by being buried alive. She commits suicide. According to Radice, Oedipus in these plays becomes the symbol of man's ambition to be independent of the Gods and tradition but 'it is only when blinded that he sees that there may be riddles for which man is not the answer'.[94]

Zina's mind further disintegrates as she has more difficulty in distinguishing reality from fantasy. She becomes more troublesome to her half-brother Lyova, entrusted with important political work by Trotsky to the envy of Zina, and Lyova's partner Jeanne. She watches their political and sexual activity as an outsider.

In a very interesting scene in an art gallery exhibiting Soviet avant-garde Suprematist and Constructivist paintings, Zina tries to intervene in a conversation between Lyova and a Stalinist who is beginning to have doubts about the forced collectivisation programme and other repressive policies. Zina asserts that Trotsky is in Berlin, indeed that she is Trotsky. She is led off and as two Stalinist agents enter the frame we see the paintings have been replaced by examples of Soviet Socialist Realism glorifying Stalin. Trotsky's words of condemnation ring out in the quiet of the gallery. This type of art is contrasted with a scene shot from a camera moving up and down a metal girder construction (actually the Blackpool Tower) where Trotsky's voice speaks his views on art and technology (the passage with the words quoted by Modotti in her photograph with the typewriter).

Many of Trotsky's words refer to the unconscious. Artists do not just use their conscious minds he says, but build bridges into our unconscious wishes. He dictates a passage about the unconscious, the individual and the class, taken from *My Life*. In the whole passage, Trotsky speaks passionately of his experiences as a political leader addressing a mass audience. His writing is very moving.

> Above and around me was a press of elbows, chests, and heads. I spoke from out of a warm cavern of human bodies; whenever I stretched out my hands I would touch someone, and a grateful movement in response would give me to understand that I was not to worry about it, not to break off my speech, but to keep on. No speaker, no matter how

exhausted, could resist the electric tension of that impassioned human throng. They wanted to know, to understand, to find their way. At times it seemed as if I felt, with my lips, the stern inquisitiveness of this crowd that had become merged into a single whole. Then all the arguments and words thought out in advance would break and recede under the imperative pressure of sympathy, and other words, other arguments, utterly unexpected by the orator but needed by these people, would emerge in full array from my subconsciousness. On such occasions I felt as if I were listening to the speaker from the outside, trying to keep pace with his ideas, afraid that, like a somnambulist, he might fall off the edge of the roof at the sound of my conscious reasoning.

Such was the Modern Circus [the building where the meeting was taking place].It had its own contours, fiery, tender, and frenzied. The infants were peacefully sucking the breasts from which approving or threatening shouts were coming. The whole crowd was like that, like infants clinging with their dry lips to the nipples of the revolution . . . In a semi-consciousness of exhaustion I had to float on countless arms above the heads of the people to reach the exit. Sometimes I would recognize among them the faces of my two daughters, who lived nearby with their mother. The elder was sixteen, the younger fifteen. I would barely manage to beckon to them in answer to their excited glances, or to press their warm hands on the way out, before the crowd would separate us again.[95]

A few pages later Trotsky writes:

My daughters were being drawn more actively into political life. They attended the meetings in the Modern Circus and took part in demonstrations. During the July days they were both shaken up in a mob, one of them lost her glasses, both lost their hats, and both were afraid that they would lose the father who had just reappeared on their horizon.[96]

We can see that McMullen's film accurately evokes the interlinked themes in Trotsky's own relationship with politics and his family. He becomes like a father to the crowd, its leader and its sexual partner, almost. He feels them on his lips, women suckle their children as they respond to his words with passion. He becomes one with the masses of workers, allowing their unconscious to overcome repression using him as their mouthpiece. Yet at the same time the mass of people separate him from his own daughters, the ones he had had to leave behind in Siberia early in the century. Zina (for it must be she) loses

her glasses, and her lack of sight is linked to anxiety, powerlessness and fear of losing her father.

Trotsky sent Zina's letters to her analyst, intending to help in her treatment. However this must have seemed like a further betrayal to Zina, and in the film Kornfeld suggests that this might be an unconscious attempt on Trotsky's part to enter the analytical space. Zina's mental state becomes more and more precarious as reality and hallucination become more indistinguishable. Her hallucinations take place on the streets of Berlin as the fascists come nearer to total power. After the final session with Kornfeld, he dictates onto his recorder that Zina no longer appeared as the lost daughter of a famous father but as 'a poor little Jewish girl so courageous in her search for her own truth and so pitiable when seen beside the forces ranged against her'. In fact Zina committed suicide only a week after her son had been sent to join her in Berlin. She barricaded herself into her room and gassed herself leaving an anguished note about her son. She realized she was in no condition to look after him and he was distressed at her mental state.[97] On 5 January 1933 Lyova informed his parents of her death. On 30 January Hitler became chancellor. However in the film the scene of Zina's death is changed and she is shown lying outside on a flight of steps, as if she has thrown herself from a balcony. Her skirt reveals her naked legs and rain pours down on her dead body.

In the epilogue of the film Kornfeld is trapped in a hospital on the outskirts of Stalingrad which is being bombed by the Germans in 1942. He thinks of the uneven flows, developments and laws of revolutions that Trotsky analysed, like a psychoanalyst of history, rather than of the individual subject. He urgently presses the tapes of Zina's analysis on his assistant, telling her to preserve them for the future. She must memorize the following: 'Trotsky's prophecies have come about', 'We don't know what we take in on an unconscious level, what we internalize and how these things can re-emerge.' Kornfeld finds Trotsky's name carved on the wall, put there by a political prisoner. The building is bombed, and gas seeps in through an air vent towards the Jewish Kornfeld, as in a death camp, whether Nazi or Stalinist is ambiguous. Finally a text is shown taken from *Antigone*, where the Chorus informs us that the proud are felled by blows of fate, but yet we will be taught wisdom by their words.

This powerful visual and aural presentation of such world-historic themes has a sound base in historical fact. This is perhaps what gives it potency and the ability to engage the spectator in spite of the demanding structure of the filmic text. However there are some

problems in the treatment of the material which, without at all diminishing the artistic quality of the work, certainly need to be discussed. Zina is played in the film by an Italian actress, Domiziana Giordano, who had previously worked with the Soviet art cinema director Tarkovsky. Giordano has long blonde wavy hair, no glasses, and is reasonably tall and slim (figure 7). She looks glamorous, even in the depths of her anxiety and mental disintegration, as in this still which shows her on her analyst's couch with her legs drawn up between the spectator and Kornfeld.

In contrast the actual Zina Bronstein looked very much like Trotsky and shared many traits of his personality and appearance (figure 8). Zina was rather plump, wore glasses and had short dark hair. In photographs she appears rather ungainly and ill-at-ease in front of the camera and has none of the glamorous fashion-plate looks of the actress in the film.[98] This is a shame because it rather trivializes the historical meaning of Zina's life and experiences when they have to be presented in the guise of what is a distinctly ideological notion of female beauty. Similar comments could be made about the leading female characters in McMullen's later film *1871* about the Paris Commune. To be fair McMullen stressed that he selected Giordano because of her instinctive empathy with the part, but to me the gulf between the images of the fictional and the real Zinas is disturbing.

In addition, there is no mention of Zina's children, and especially of her son, in the film. This means that little attention is paid to Zina's anguish as a mother, and the effects on her and her family of Stalinist persecution. The main focus in on Trotsky and Zina in an examination of the Oedipus/Antigone parallel. Now the relationship of Zina and her father was certainly crucial to her, but the lack of any mention of her son, in particular, who was in Germany with her when she committed suicide, means that there is no suggestion of any alternative to the Oedipal reading of her situation. Of course her own relationship with her husband and children was ruined by Stalinist persecution, but nevertheless the perspective on Zina as a mother and a parent in her own right is not one that is considered by the film. However, her own mother felt that Zina was not 'family-minded', and her difficulties with this aspect of her life might also have resulted in mental distress.[99] But in the film the relationship between parent and child is always seen as father/daughter. Trotsky seems to have felt Zina's family responsibilities to be a reason for trying to distance her from political activity with him in exile, concerned that members of her family still in the Soviet Union would be made to pay for her opposition to Stalinism.

Figure 7 Still from *Zina*, director K. McMullen, 1985, British Film Institute Stills Library.

Figure 8 *Photograph of Zina Bronstein*, ca.1931, David King collection, London.

Yet this never troubled him to the same extent with respect to his son Lyova.

Trotsky and Psychoanalysis

The emphasis on psychoanalysis and its understanding of the individual psyche in the film, and the way this is related to wider class under-standings of history and its development, is certainly not merely fabricated by McMullen. There is evidence in Trotsky's writings, as we have seen, that he was interested in psychoanalysis, the study of the unconscious, and its relation to culture, politics and society. He was sympathetic to psychoanalysis and accepted the existence of the unconscious. It would be mistaken to think that Marxism, especially Trotskyism, simply rejects psychoanalysis as apolitical and ahistorical.

He wrote in his notebooks in May 1935, when he was reading Fritz Wittels' book on Freud, that psychoanalysis was completely compatible with dialectical materialism:

It is well known that there is an entire school of psychiatry ("psycho-analysis", Freud) which in practice completely removes itself from physiology, basing itself upon the inner determinism of psychic phen-omena, such as they are. Some critics therefore accuse the school of Freud of idealism. That psychoanalysts are frequently inclined toward dualism, idealism, and mystification . . . Insofar as I know, this is a fact. But by itself the method of psychoanalysis, taking as its point of departure "the autonomy" of psychological phenomena, in no way contradicts material-ism. Quite the contrary, it is precisely dialectical materialism that prompts us to the idea that the psyche could not even be formed unless it played an autonomous, that is, within certain limits, an independent role in the life of the individual and the species.

All the same, we approach here some sort of critical point, a break in the gradualness, a transition from quantity into quality: the psyche, arising from matter, is "freed" from the determinism of matter, so that it can independently – by its own laws – influence matter.

True, a dialectic of cause and effect, base and superstructure, is not news to us: politics grows out of economics in order for it in turn to influence the base by switches of a superstructural character. But here the interrelationships are real, for in both instances the actions of living people are involved; in one instance they are grouped together for production, in the other – under the pressure of the demands of the very same production – they are grouped politically and act with the switches of politics upon their own production grouping.

When we make the transition from the anatomy and physiology of the brain to intellectual activity, the interrelationship of "base" to "super-structure" is incomparably more puzzling.

The dualists divide the world into independent substances: matter and consciousness. If this is so, then what do we do with the unconscious?[100]

Thus Trotsky dismisses the dualist view of a total separation of matter and consciousness, in favour of a dialectical relationship between the two. After all, consciousness for a materialist can only exist as part of a brain, which is a high form of matter, but matter nonetheless, giving rise to thought. The unconscious must exist, since material conditions do not translate themselves directly into beliefs and actions based on direct conscious understanding, but only in a complex and highly mediated way. Many impulses remain in the unconscious and never progress to the pre-conscious or the conscious. Human beings, accord-ing to Marxism, carry out many actions whose real purposes and motives are unknown to them, though they may think otherwise.

When this occurs in accord with the prevailing social system and results in the acceptance and internalization of a repressive class society, then we are talking about ideology. This, however, is not the same as the unconscious, although ideology may play a role in the suppression of desires and urges which ensures that they never become consciously perceived and/or acted upon. It is clear that there is room for much fruitful collaboration between Marxism and pychoanalytic theory. Psychoanalyists such as Eric Fromm, Wilhelm Reich and Otto Fenichel attempted to investigate possibilities for developing a political psycho-analysis, with varying degrees of success.[101]

In the early twenties Trotsky wrote to Pavlov, whose theory of cond-itioned reflexes was not nearly as interesting to him as the work of Freud. However he tried to get Pavlov to keep an open mind concerning alternative approaches to the study of the psyche. A few years later in his essay 'Culture and Socialism' he again tried to defend Freud's work very clearly: 'The attempt to declare psychoanalysis "incompatible" with Marxism and simply turn one's back on Freudianism is too simple, or, more accurately, too simplistic.' Freudian ideas were working hypo-theses, he argued, which should be given time to develop evidence and conclusions.[102]

In an excellent commentary on Trotsky's writings on psychoanalysis Pomper looks at how Trotsky took a very positive attitude towards it. References to the unconscious appear frequently in his writings, and he obviously thought that the possibilities opened up by Freud for investigating the psyche were great advances for self-knowledge and the study of humankind. He thought Freud a genius. However Trotsky's revolutionary optimism led him to rather different conclusions from those of Freud. The unconscious for Trotsky contained the notion of a lower level of development, and one not easily accessible, dialectically embodying 'dark psychic forces' but amazing creativity and potential for knowledge and self-discovery as well. For Freud the unconscious is a source of neurotic symptoms and repression. This repression is seen as an inalienable characteristic of human psyche, where scarcity of resources leads to repression, renunciation and labour.[103] For Freud the human being was an object of history, not a subject, and essentially a particular individual. For Trotsky, at certain times the fusion of unconscious and conscious forces had revolutionary potential, as we shall see shortly. For Freud the Oedipal situation, repeated in all individual lives, was a model of renunciation and the sublimation of hatred into attachment to a role model. As Slater explains: '. . . what is most important of all (as in the resolution of the Oedipal situation)

the ego ideal, or super-ego, can be precisely that person, or group, who most deserves one's hatred and active hostility; thus, despite justified resentment, "the suppressed classes can be emotionally attached to their masters". This is Freud's central contribution to the theory of ideology.'[104]

In Trotsky's *My Life* where he describes speaking at the Modern Circus, Pomper points out, and we have already noted above, how Trotsky becomes one with the crowd, fusing together with them in the same psyche, as it were. This is a sensual experience. Pomper, who has studied the manuscript of the text, shows how Trotsky tried several times to express the way the drives of the crowd forced themselves to his lips. Firstly he wrote 'you physically felt in your entire body', replaced it with 'on your lips the physical pressure' and then used 'you felt with your lips the insistent searching'.[105]

Pomper argues that in another passage where Trotsky discusses the conscious and unconscious, he is careful to point out that he is using the terms in a 'historico-philosophical' sense rather than a psychological sense. Although it is useful to distinguish these two uses of the unconscious, I think in fact in this passage Trotsky tries to show how they interact and at times come together dialectically, rather than remain always distinct.

> Marxism considers itself to be the conscious expression of an unconscious historical process . . . a process that coincides with its conscious expression only at its very highest points, when the masses with elemental force smash down the doors of social routine and give victorious expression to the deepest needs of historical development. The highest theoretical consciousness of an epoch at such moments merges with the immediate action of the lowest oppressed masses who are the farthest away from theory. The creative union of consciousness with the unconscious is what we usually call inspiration. Revolution is the violent inspiration of history.
>
> Every real writer knows moments of creativity, when someone else, stronger than he, guides his hand. Every genuine orator knows minutes, when something stronger than he speaks through his lips. This is "inspiration". It issues from the greatest creative tension of all one's powers. The unconscious climbs up from its deep lair and subjects the conscious effort of thought to itself, merging with it in some kind of higher unity. The latent powers of the organism, its deepest instincts, its flair, inherited from animal ancestors, all of this rose up, smashed down the doors of psychic routine and – together with the highest historico-philosophical generalizations – stood in the service of the revolution.

Both of these processes, individual and mass, were based on the combination of consciousness and unconscious, of instinct, the mainspring of will, with the highest forms of generalizing thought.[106]

In fact Trotsky here is clear that revolutionary moments need the combination of the conscious and the unconscious of both the individual and the class. However the expression of unconscious historical forces will never result in a successful revolution automatically. Unconscious forces within a social formation in contradiction to the dominant order need to be raised to consciousness and articulated as political action. There is no automatic 'process'. Freud has no idea of revolutionary politics in his discussion of the psyche, but he does insist in a similar way to Trotsky on the process by which unconscious needs and desires can enter the preconscious where they are brought into connection with word-presentations. In order to progress to consciousness, the urges must be presented in language (or writing). Visual imagery, on the other hand, is for Freud closer to the unconscious than is thinking in words.[107]

Freud did make some comments on Marxism, but he seems to have had a conception of Marxism as economistic and at the same time misunderstands dialectical materialism. He believed Marxism saw historical development as identical to processes of natural history which would come to fruition without any conscious human agency:

There are assertions contained in Marx's theory which have struck me as strange; such as that the development of forms of society is a process of natural history, or that the changes in social stratification arise from one another in the manner of a dialectical process. I am far from sure that I understand these assertions aright; nor do they sound to me "materialistic" but, rather, like a precipitate of the obscure Hegelian philosophy in whose school Marx graduated.[108]

In another passage he criticizes Marxism for simply equating the super-ego with ideology which is ultimately based on economic relations:

It seems likely that what are known as materialistic views of history sin in underestimating this factor. They brush it aside with the remark that human "ideologies" are nothing other than the product and super-structure of their contemporary economic conditions. That is true, but very probably not the whole truth. Mankind never lives entirely in the present. The past, the tradition of the race and of the people, lives on in

the ideologies of the super-ego, and yields only slowly to the influences of the present and to new changes; and so long as it operates through the super-ego it plays a powerful part in human life, independently of economic conditions.[109]

In fact Marxism would not argue that ideologies were simply reflections of the economic, as we have seen. If this were the case, racism, sexism and homophobia would automatically disappear after the abolition of capitalism, for example, but in fact the erosion and disappearance of these backward views would take a very long time and could not in themselves be accomplished by economic measures which would only set up the necessary pre-conditions. The abolition of class society is only the indispensable starting point, and the more deeply embedded in the psyche these oppressive urges are, the longer it will take, especially if the fears and violent desires are merely repressed and not consciously dealt with. Also we have already seen that Trotsky believed in the autonomous existence of the psyche because not everything in the human mind is directly the result of an experience in the material world. Basically, as Pomper states, Trotsky 'had transformed the pessimistic Freudian vision of the role of the unconscious into an optimistic revolutionary one'.[110]

Notes

1. J. Rose, *Sexuality in the Field of Vision*, London and New York, 1986, p.7.
2. Ibid., p.23.
3. Ibid., p.15.
4. Ibid., p.96.
5. Ibid., pp.102–3.
6. For more on this see chapter 1 in my *Seeing and Consciousness*.
7. Ebert, '(Untimely) critiques for a *Red Feminism*', in M. Zavarzadeh, T. Ebert, D. Morton eds, *Post-Ality: Marxism and Postmodernism*, special issues of *Transformation. Marxist Boundary Work in Theory, Economics, Politics and Culture*, Washington D.C., Spring, 1995, pp.145–6.
8. L. Trotsky, *In Defence of Marxism*, New York, pp.50–1. Trotsky also used the photograph/film analogy to elucidate the dialectical relationship of the abstract to the concrete as we have noted in a previous chapter: 'In order to

obtain a concept "concrete" enough *for a given need* it is necessary to correlate several abstractions into one – just as in reproducing a segment of life upon the screen, which is a picture in movement, it is necessary to combine a number of still photographs'. Ibid., p.118.

9. P. Pomper ed., *Trotsky's Notebooks 1933–1935. Writings on Lenin, Dialectics and Evolutionism*, New York, 1986, pp.97–8. Trotsky notes that this process is explained in Hegel's *Wissenshaft des Logik*, 1, pp.26–7 (though not of course by using the analogy of photography and film).

10. *In Defence of Marxism*, p.84.

11. See for example the essays in M.A. Caws, R.E. Kuenzli and G. Raaberg eds, *Surrealism and Women*, Cambridge Mass., and London, 1991. For a slightly different view and a survey of some of the key texts on this question see R.A. Greely, 'Image, Text and the Female Body: René Magritte and the Surrealist Publications', *The Oxford Art Journal*, vol.15, no.2, 1992, pp.48–57.

12. See for example X. Gauthier, *Surréalisme et Sexualité*, Paris, 1971, p.38. Certain left centrist and reformist groups also held views similar to this until quite recently, for example the group formerly known as Militant (G.B.) on homosexuality.

13. J. Roberts, *Renegotiations: Class, Modernity and Photography*, exhibition catalogue, Norwich Gallery, Norfolk Institute of Art and Design, 1993, p.5. I am grateful to John Roberts for inviting me to participate in a panel discussion to accompany this exhibition, and subsequent discussion with him which made me think about the issues concerning politics and photography which are discussed here.

14. L. Trotsky, *Literature and Revolution*, Ann Arbor, 1975, pp.218,221.

15. See in particular the exhibition catalogues *Claude Cahun Photographe*, Musée d'Art Moderne de la Ville de Paris, 1995, and *Mise en Scène. Claude Cahun, Tacita Dean, Virginia Nimarkoh*, Institute of Contemporary Arts, London, 1994. To date, the main book on Cahun is by F. Leperlier, *Claude Cahun, l'écart et la métamorphose*, Paris, 1992, which is in process of being translated for publication by Verso.

16. R.R. Hubert, *Magnifying Mirrors: Women, Surrealism and Partnership*, Lincoln, Nebraska and London, 1994, pp.1–2.

17. W. Chadwick, *Women artists and the Surrealist movement*, London, 1985.

18. H. Lewis, *The Politics of Surrealism*, New York, 1988, p.134.

19. M.A. Caws et al. eds, *Surrealism and Women*, Cambridge Mass., and London, 1991.

20. S.R. Suleiman, *Subversive Intent: Gender, Politics and the Avant-Garde*, Cambridge Mass., and London, 1990.

21. These are discussed in Leperlier's book and in a useful article by H. Lasalle and A. Solomon-Godeau, 'Surrealist Confession: Claude Cahun's photo-

montages', *Afterimage*, March 1992, pp.10–13. See also J. Blessing, 'Resisting Determination: An Introduction to the Work of Claude Cahun, Surrealist Artist and Writer', *Found Object*, Fall 1992, vol.1, part 1, pp.68–78.

22. Her work participates in all the categories mentioned by Andy Grundberg in his article 'On the Dissecting Table: The Unnatural Coupling of Surrealism and Photography', in C. Squiers ed., *The Critical Image: Essays on Contemporary Photography*, London, 1990, pp.80–1.

23. This is quoted, with disapproval, by R. Kuenzli in his article 'Surrealism and Misogyny', in M.A. Caws et al. eds, *Surrealism and Women*, p.22.

24. Ibid., p.24.

25. Freud, *On Metapsychology: The Theory of Psychoanalysis*, Harmondsworth, 1991, p.55.

26. Ibid., p.81.

27. E. Grosz, 'Lesbian Fetishism?' in E. Apter and W. Pietz, *Fetishism as Cultural Discourse*, Ithaca and London, 1993, pp.101–15.

28. E. Grosz, *Jacques Lacan, a Feminist Introduction*, London, 1990, p.31.

29. J. Butler, *Bodies that Matter*, New York and London, 1993, chapter 8 'Critically Queer', p. 234, distinguishes her notion of performativity from performance. The latter is a bounded act, whereas performativity 'consists in a reiteration of norms which precede, constrain, and exceed the performer and in that sense cannot be taken as the fabrication of the performer's "will" or "choice"'. In an excellent article discussing recent feminist work inspired by Foucault which investigates notions of the gendered subject and reality, Teresa L. Ebert points out that Butler concludes that 'subjects/agents, are . . . effects of the agency of a reiterative power that she calls performativity', and also that Butler redefines matter so that 'Materiality is thus entirely confined to the level of the "superstructure", to discourse'. T.L. Ebert, '(Untimely) Critiques for a *Red Feminism*', in M. Zavarzadeh, T.L. Ebert, D. Morton eds, *Post-Ality: Marxism and Postmodernism*, pp.135 and 137–8.

30. For a recent discussion of lesbians looking see R. Lewis and K. Rolley, 'Ad(dressing) the Dyke: Lesbian Looks and Lesbians Looking', in P. Horne and R. Lewis, *Outlooks: Lesbian and Gay Sexualities and Visual Cultures*, New York and London, 1996, chapter 15.

31. The quotation is cited in Rose Jennings, 'Out of the Closet', *Independent Magazine*, 8.10.1994, p.31. Many thanks to Mary Weston, our art librarian, for giving me a copy of this article. See also Leperlier's book, *Claude Cahun*, p.235, where he quotes from the diary of the Nazi commandant, Baron Von Aufsess, who had the photographs seized. Among photographs apparently of an exhibitionist, sado-masochistic and lesbian character, were a series representing 'une femme, le crâne rasé, photographiée nue sous tous les angles'.

32. Illustrated on p.238 of Leperlier's book.

33. Ibid., p.245.

34. Leperlier in *Claude Cahun Photographe*, exhibition catalogue, p.19.

35. Workers Power and the Irish Workers Group, *The Degenerated Revolution*, p.35.

36. H.Lewis, *The Politics of Surrealism*, New York, 1988, pp.99–100.

37. Ibid., p.27.

38. Ibid., pp.105–6. For an account of Aragon's political *volte-face* in the context of debates within the politics of French psychoanalysis see chapter 11 'Marxisme, psychanalyse, psychologie', in E. Roudinesco, *La Bataille de Cent Ans: Histoire de la Psychanalyse en France*, vol.2, 1925–1985, Paris, 1986.

39. Part one is available in M. Nadeau, *Histoire du Surréalisme. Documents Surréalistes*, Paris, 1948, pp.260–70.

40. Trotsky's article 'The Suicide of Vladimir Mayakovsky' was first published in the *Bulletin of the Opposition*, no.11, May 1930. See Trotsky, *Leon Trotsky on Literature and Art*, ed. P. Siegel, New York, 1977, pp.174–8.

41. 'Manifesto: Towards a Free Revolutionary Art' in *Leon Trotsky on Literature and Art*, p.118.

42. Nadeau, pp.389–91.

43. Ibid., pp.316–21 for the resolution.

44. Ibid., p.335–6.

45. The quote is from 'Manifesto: Towards a Free Revolutionary Art', p.117.

46. D. Stocking, '*Not Everything is Possible*: French Stalinism and the Popular Front, 1936–38', *Permanent Revolution*, 5, Spring 1987, p.25. In addition to this article see T. Kemp, *Stalinism in France*, vol.1: *The First Twenty Years of the French Communist Party*, London, 1984; L. Trotsky, *Leon Trotsky on France*, New York, 1979; L. Trotsky, *The Crisis of the French Section 1935–36*, New York, 1977.

47. Stocking, p.14.

48. Kemp, p.128.

49. Stocking, p.19.

50. Ibid., p.20.

51. Kemp, p.152.

52. Stocking, p.22.

53. *Frida Kahlo and Tina Modotti*, exhibition catalogue, Whitechapel Art Gallery, London, 1982, with introductory essay by L. Mulvey and P. Wollen, chapter three, pp.9–10.

54. S.M. Lowe, *Tina Modotti: Photographs*, Philadelphia Museum of Art, 1995, p.21.

55. M. Hooks, 'Assignment, Mexico: The Mystery of the Missing Modottis', *Afterimage*, November 1991, p.11.

56. *Frida Kahlo and Tina Modotti*, p.24.

57. See L. Trotsky, *The Spanish Revolution (1931–39)*, New York, 1981, introduction by L. Evans, pp.29 and 47.

58. M. Hooks, *Tina Modotti: Photographer and Revolutionary*, London, 1993, p.242.

59. D. King, *Trotsky: A Photographic Biography*, London, 1986, pp.274–5.

60. R. Brenner, 'Land and Freedom', *Workers Power*, no.193, October 1995, p.8.

61. M. Constantine, *Tina Modotti: A Fragile Life*, London, 1993.

62. Lowe, p.29.

63. Ibid., p.30.

64. Ibid., p.30.

65. Ibid., p.30.

66. Quoted ibid., p.37.

67. Ibid., p.43. O'Neill's rather depressing expressionist play centers on Yank, a brutalized stoker, who cannot fit in with the world of humans, so tries to return to animality and is crushed by a gorilla after breaking into the Zoo. In the prison scene, scene VI, he learns of the existence of the IWW (Industrial Workers of the World – a militant syndicalist workers' organization), from other prisoners, one of whom reads a speech by a Senator condemning them from a newspaper. Yank rails against the rich, tries to destroy the bars of his cell and decides to blow up a steel factory owned by the father of an anaemic rich woman who humiliated him in his stoke-hole on a luxury liner. Guards come with a power hose and straight-jacket to contain Yank.

68. Ibid., p.36.

69. M. Hooks, *Tina Modotti*, p.210.

70. For a discussion of Bolshevik and Stalinist attitudes to women's oppression and their cultural implications see chapter 5 of my *Seeing and Consciousness*.

71. D.B. Genevois, 'The women of Spain from the Republic to Franco', in G. Duby and M. Perrot eds, *A History of Women: Toward a Cultural Identity in the Twentieth Century*, Cambridge Mass., 1994, p.189.

72. Hooks, *Tina Modotti*, p.191. Modotti's short Manifesto is reprinted in L. Heron and V. Williams eds, *Illuminations: Women Writing on Photography from the 1850s to the Present*, London and New York, 1996, pp.260–1.

73. Lowe, p.40.

74. Hooks, *Tina Modotti*, pp.162–3.

75. Trotsky, *Literature and Revolution*, p.253.

76. Ibid., p.230.

77. Ibid., p.249.

78. Ibid., p.256.

79. Lowe, p.44.

80. Hooks, *Tina Modotti*, p.193.

81. Herbert Molderings does not appear to have noticed Modotti's interest in Trotsky's writings on culture in the later twenties, and sees her as a Stalinist stalwart through and through, though there is much of interest in his article 'Tina Modotti: Fotographin und Agentin der GPU', *Kunstforum International*, November 1982, vol.9, pp.92–103.

82. For information on Mexico in the twenties and thirties see F. Tannenbaum, *Mexico: The Struggle for Peace and Bread*, New York, 1956, and L. Bethell ed., *Mexico since Independence*, Cambridge, 1991, especially chapters 4 and 5.

83. King, *Trotsky*, p.287.

84. Ibid., p.287.

85. Both Kahlo, and to a lesser extent Modotti, are almost cult figures in women's art history, and their importance as strong, creative women has tended to result in a lack of criticism of their politics, even among writers who bother to investigate what these politics were. The singer and actress Madonna is well known as a collector with a great interest in Kahlo's work and strong personality, and she partly financed the exhibition of Modotti's work at the Philadelphia Museum of Art which Lowe's book accompanies.

86. H. Herrera, *Frida: A Biography of Frida Kahlo*, London, 1989, p.396.

87. Lewis, p.144.

88. *Leon Trotsky on Literature and Art*, p.121.

89. *Sight and Sound*, May 1986, p.220.

90. *Stills*, November 1985, vol.22, p.13.

91. For useful information on Zina's life, based on archival material including her letters, see I. Deutscher, *The Prophet Outcast*, Oxford, 1963, pp.146–52, 176–81, 188–9, 195–8.

92. *City Limits*, 1.5.1986, no.239, p.25.

93. *Cinéaste*, vol.16, part 1/2, 1987/8, p.4.

94. B. Radice, *Who's Who in the Ancient World*, London, 1971. Entry on Oedipus.

95. L. Trotsky, *My Life: An Attempt at an Autobiography*, Harmondsworth, 1975, pp.307–8.

96. Ibid., p.330.

97. Deutscher, p.195.

98. For photographs of Zina see D. King, *Trotsky: A Photographic Biography*, Oxford and New York, 1986, pp.220, 221, 232, 233.

99. Deutscher, p.147.

100. Pomper, *Trotsky's Notebooks*, pp.106–7.

101. See I.H. Cohen, *Ideology and Unconsciousness: Reich,Freud and Marx*, New York and London, 1982; P. Slater, *Origin and Significance of the Frankfurt School: A Marxist Perspective*, chapter 4, 'Historical materialist psychology: the psychic

dimension of manipulation and revolt', London, 1977; and R. Jacoby, *The Repression of Psychoanalysis: Otto Fenichel and the Political Freudians*, New York, 1983. Jacoby points out that Fenichel's radical seminar group of forty-six analysts was almost half female, and that psychoanalysis in Europe attracted significant numbers of radical women (p.148). For a more recent attempt to theorize the relationship between Marxism and psychoanalysis, see E.V. Wolfenstein, *Psychoanalytic-Marxism: Groundwork*, New York and London, 1993. Wolfenstein's book, though interesting, is rather problematic. His project is one of trying to relate Marxist ideas and Freudian ideas to one another, that is to see Marxism as a body of ideas. Thus he has little understanding of how Marxist ideas can, and indeed must, be put into practice.

102. B. Knei-Paz, *The Social and Political Thought of Leon Trotsky*, Oxford, 1978, pp.482–5. Trotsky is much more sympathetic to Freud than the Soviet writer V.N. Vološinov, who argued in the late twenties that the unconscious did not exist. There were only official and unofficial sites of consciousness. See Vološinov, *Freudianism: A Marxist Critique*, New York, 1976.

103. Cohen, p.107.

104. Slater, p.103.

105. Pomper, p.70.

106. Ibid., pp.70–1, quoted from *My Life*, Penguin edition, Harmondsworth, 1991, pp.348–9.

107. S. Freud, 'The Ego and the Id', in *On Metapsychology: The Theory of Psychoanalysis*, Harmondsworth, 1991, p.358.

108. Pomper, p.65.

109. R. Osborne, *Freud for Beginners*, New York and London, 1993, p.116.

110. Pomper, p.72.

Concretizing the Abstract

In this chapter I want to look at some attempts by radical art historians, many of whom consider themselves Marxists of one sort or another, to discuss examples of abstract and non-figurative art. I do not intend to offer an exhaustive survey of this material, but to open up some areas for further investigation. Most radical art and cultural historians tend to work on paintings and other types of visual imagery which represent recognisable people and objects. They then seek to situate these subjects and their artistic treatment in a historical and critical context while discussing the ideological meanings of the chosen works. The reason for this is often cited as the result of Marx's and Engels's supposed preference for realist and naturalist art, and/or a conscious or unconscious adherence to the notion of some variant of (Soviet Socialist) Realism as the best way of communicating with a mass, rather than an élite, audience.

There has certainly been a tendency for leftist art historians to avoid non-figurative/non-objective art in favour of, for example, French nineteenth-century art, until fairly recently. Max Raphael was something of an exception in his analysis of Picasso's Cubism in *Proudhon, Marx, Picasso*, published in 1933. Hadjinicolaou refuses to discuss any 'so-called abstract painting' or even any twentieth-century painting, as debates on contemporary art are 'stifled with false problems'.[1] Janet Wolff, taking a sociological approach, states that 'many kinds of work do not seem amenable to sociological analysis (chamber music and abstract art, for instance), except in the sense of examining the social conditions of their appearance and success'.[2]

Many of the writers I will be referring to use abstract and non-figurative/non-objective as if they were interchangeable terms. However I think we need to distinguish between abstract art, much of which refines and simplifies forms (from the verb to abstract meaning 'to separate or withdraw something from something else') and may still

represent recognizable objects and situations, and non-objective or non-figurative art which is supposed to resemble nothing.[3] Another distinction found in the literature of art history is between abstracted (art manipulating and deriving from natural forms) and abstract (painting which is non-objective). Malevich gives a good description of his own brand of non-objective painting:

> By Suprematism I mean the supremacy of pure feeling or sensation in the pictorial arts . . . In the year 1913 in my desperate struggle to free art from the ballast of the objective world I fled to the form of the Square and exhibited a picture which was nothing more or less than a black square upon a white ground . . . It was no empty square which I had exhibited but rather the experience of objectlessness.[4]

Non-objective art has tended to be discussed by writers interested in the philosophy of art, rather than its history, and, as we shall see, much of this writing is heavily idealist. Although I do not have the space to discuss this is in any detail, there seems to be a tendency for art historians who elect to discuss non-objective art to do so in line with the particular sort of radical or left politics which interests them. This influences their choice of, for example, Russian and Soviet avant-garde art, or American Abstract Expressionism. Whereas T.J. Clark has never shown much interest in Soviet material in his published writings, he recently moved away from French nineteenth-century art towards a more philosophical tone in his discussion of Abstract Expressionism as the collapse of the Soviet Union became more and more apparent. On the other hand writers who are interested in the concept of a Bolshevik revolutionary party and the relationship of party politics to modernist works of the avant-garde tend to show an interest in discussing the Russian and Soviet material, for example Paul Wood and John Roberts.[5] It is at first sight surprising that few of the major figures in Marxist art history such as Schapiro, Raphael, Adorno, Clark and Jameson show any sustained interest in the Soviet material, but not so surprising when we consider that Bolshevism was largely anathema to them.

We should also notice the attempts of some left writers on Abstract Expressionism, for example Fred Orton, to over-radicalize Abstract Expressionism and major artistic and critical figures connected with this school, arguing, for instance, that the practice of Abstract Expressionism was political, and that Harold Rosenberg, one of its main defenders, was a Trotskyist. As I will point out later, this sort of argument

has more to do with the aspirations of the writers themselves than actual historical events.

Although much postmodern theory rejects Marxism as economistic, reductive, and interested mainly in forms of realism, in fact postmodern theory does not really offer a significant step forward in the study of non-objective culture. Modernism is linked to master-narratives of progress, now discredited, goes the argument. The abstract and non-figurative art of modernism has been superceded by visual culture which has returned to the representational, for example in computer and television imagery, the cinema, video, the visual arts. Postmodern theory, especially that of the Baudrillard variety, argues that the image is totally detached from the material world and is more real than the real. Now in order to argue this, postmodern theorists would still have to compare the image with reality which they claim has no independent existence (to know that the image is more real) and to work with representational signs and images (for how would this argument work with non-figurative visual images on television, for example). So in fact many strands of postmodern theory, including Jameson's writings, assume all visual culture to be figurative and thus these theories are possibly even less able to deal with non-figurative art than the allegedly economistic approach of Marxism.

I want to look fairly briefly at the comments of some writers who have discussed non-figurative art, before moving on to Althusser's essay on the painter Cremonini. I will then discuss the Hegelian legacy of approaches to non-figurative art before examining radical art historical writings on American Abstract Expressionism. Finally I will look at the work of Malevich as an example of a brief case study of a Marxist approach to this kind of art.

Lyotard, unlike many other postmodernists, discusses examples of abstract and non-figurative art in an early work, *Driftworks*, of 1984. Lyotard, using Paul Klee as an example, argues that art can deconstruct and demystify ideology by freeing art from the depicted object and reality, providing a glimpse into the elsewhere. Only formally innovative art can be deconstructive, and art which criticizes through representational means is still a prisoner of ideological discourse. Lyotard's interpretations of the Kantian sublime have resulted in art historical studies of such non-objective works as paintings by Malevich and the American Abstract Expressionists.[6] Like Adorno, whom Jameson reveres as a precursor of postmodern thought, Lyotard believes only formally avant-garde art can be truly radical. However Adorno directly links abstractness to monopoly capitalism. In his view this

painting embodies the essence of the eclipse of concreteness. It cuts through the illusion that material life still subsists by showing us a representation of the mystification of abstractness. There is a parallel here between Adorno's linking of what he calls 'abstract painting' and Jameson's coupling of postmodern art with late capitalism. The difference between him and Jameson is of course that Jameson links postmodernism to late capitalism, in a situation where he believes the image is increasingly more powerful than reality from which it is detached. Adorno sees high modernism as the cultural representation of high capitalism.

Adorno writes as follows:

> Just as in the period of monopoly capitalism what is being consumed is no longer the use-value of things but their exchange value, so in modern works of art the irritating abstractness, which always leaves in doubt what they are and what they are for, becomes a cipher of the essence of the works themselves. This abstractness has nothing in common with the formalism of aesthetic norms of old, for example those of Kant's philosophy. Rather, the abstractness of modernism is a provocative challenge to the illusory notion that life still subsists.[7]

A few pages later he states that modern art is as abstract as the real relations among men and that notions of realism and symbolism are now invalidated.

> What is vaguely called abstract painting preserves traces of the tradition that it destroys. We get a glimpse of this continuity by contemplating traditional paintings. To the extent to which we detect in them images rather than replicas of something, they are "abstract". Thus art consummates the eclipse of concreteness, whereas reality refuses to face up to this fact, even though it is in the real world first and foremost that the concrete is no more than a mask of the abstract, that the determinate particular is no more than a representative and mystifying example of the universal which is identical with the ubiquity of monopoly capital.[8]

Adorno's difficult language actually covers over quite a crude method which sees cultural abstraction as an expression and embodiment of the spirit of monopoly capitalism. There are many different kinds of non-objective painting, and it would be extremely crude and reductive to argue that even all American high modernist art at the time of the Cold War embodied the spiritual values of monopoly capitalism.

Max Raphael, for all his subtlety in other respects, draws similar sweeping parallels between the art of Picasso in his Cubist period and the development of imperialist capitalism and the spiritual and ideological impasse of the European bourgeoisie.[9] However Raphael has some suggestive comments to make on the Cubist collages of Picasso. He sees their extreme abstraction overlayed and juxtaposed with real collaged materials such as wallpaper and newsprint as examples of an undialectical dualism which Picasso, although a radical, was unable as a European bourgeois, to overcome.

> Here Picasso was confronted with the most crucial problems of all ideology: idealism and materialism. The paradox of taking idealism so abstractly, and materialism so literally, is not a solution, but rather confirms his inability to solve the problem. His exaggeration of the two poles of the opposition shows, first, Picasso's torn personality, devoid of any dialectical element, and second, the overall limitations of his idealism. These two facts are inseparable, and of great importance from the sociological point of view.[10]

Raphael's comments here are suggestive and are certainly worth further investigation, but are not really backed up by documentation or a close study of particular examples of art works situated in particular historical contexts. The contradictions between materialism and idealism are brought to the fore because they are important concepts in Raphael's theory rather than because they have been shown to emerge from the material under discussion.

There are some interesting articles arguing about the political and ideological significance of the Cubist collages by Braque and Picasso, and again some attempt to over-politicize the works, in my opinion. In some cases historians are tempted to elevate the artworks they find interesting into examples of cultural political practice, or even directly political practice.[11] Of course sometimes they are justified, but on other occasions not. However the over-politicization of art works is not confined to discussions of non-objective art.

There is not much evidence of dialectics in Schapiro's approach to abstract art, though he does a competent demolition job on Alfred H. Barr's formalist presentation of the historical development of modern art in his famous article 'The Nature of Abstract Art'. In this article Schapiro dismantles the notion that abstract art arose primarily as a reaction against figurative art and ends by dealing with three case studies of abstract art, Malevich, Kandinsky and the Italian Futurists.

Only in the case of Futurism though, does he attempt to situate the works in relation to their material economic and social context, and his discussion of Malevich's work is rather disappointing. Most of his discussion of Suprematism and Malevich's earlier works is concerned with formal questions, although he suggestively at one point relates the creation of non-objective works to the historical and social position of the artist: 'the formal character of the abstraction rests on the desire to isolate and externalize in a concrete fashion subjective, professional elements of the older practice of painting, a desire that issues in turn from the conflicts and insecurity of the artist and his conception of art as an absolutely private realm.'[12]

Althusser

One of the few Marxist cultural critics to discuss abstract painting has been Althusser in his essay of 1966 on Leonardo Cremonini. Althusser's concept of ideology, still very prevalent today among left cultural historians, is borrowed from bourgeois sociology and holds that all societies, have been and will be, bound together by lived experiences of ideology as a material factor which interpellates (or calls to) subjects to place them in their ideological positions. Althusser argued that there was a break between the humanistic early Marx and the later scientific Marx, largely as a result of his opposition to the drift into bourgeois reformism of the French Communist Party which used the early Marx to justify its rightward-moving political trajectory. As Althusser put it, ideology in general *'has no history'* and is *'eternal*, exactly like the unconscious'.[13] Art can render ideology visible and can suggest a new ideology. Sprinker argues that Althusser is impressed by Cremonini's painting because it has achieved the epistemological break for painting that Marx achieved for the materialist conception of history. A pretty amazing claim![14] Starting with paintings of rocks, animals, tools and finally 'men', Cremonini finally succeeded in painting the relations between men or as he puts it:

> Cremonini "paints" the *relations* which bind the objects, places and times. Cremonini is a *painter of abstraction*. Not an abstract painter, "painting" an absent, pure possibility in a new form and matter, but a painter of the real *abstract*, "painting" in a sense we have to define, real relations (as relations they are necessarily *abstract*) between "men" and their "things", or rather, to give the term its stronger sense, between "things" and *their* "men".[15]

So Cremonini is hailed as a painter who visualizes social relations of commodification. The structure of ideology can never be depicted by its presence, argues Althusser, but only by its traces and absences. Thus Cremonini also must be absent from his own paintings if he is to make ideology visible, his paintings cannot be expressive of his own subjectivity. The great work of art makes ideology visible, and thus exercises a directly ideological effect, according to Althusser's argument. Thus the great work of art has a privileged relationship to ideology, '. . . a great artist cannot fail to take into account in his work itself, in its disposition and internal economy, the ideological *effects* necessarily produced by its existence.'[16] Now Althusser's philosophical approach to Cremonini's work is obviously part and parcel of his own particular views on ideology and his rather undialectical method. For Althusser, spheres of the ideological, cultural and political are 'structured' by the economic base but not rooted in it. These different spheres 'collide' (by chance?) and change occurs. There is no real Marxist notion of internal contradiction and negation within societies, classes or ideologies. Further more, Althusser's reading of Cremonini's works is totally subjective and not a single piece of evidence is produced to justify his philosophical points about the nature of relations, things and abstraction. This is made especially difficult by his argument that the real meanings of the works reside in what is not there. Looking at one of Cremonini's works, it is hard to see what makes him very different from many other post-war abstract artists, although Althusser himself makes no attempt to relate his work to any other contemporary painters, or contemporary history (figure 9).

Clark and Hegel

The temptation to ally abstract philosophizing thought to abstract and non-objective art is a strong one. Clark, having previously called for the reformulation of the Hegelian legacy in his article of 1974, in 1990 published an essay on Jackson Pollock which bases its method on Hegelian idealism. 'The whole section on the Unhappy Consciousness, from Paragraph 206 onwards, [in Hegel's *Phenomenology of Spirit*] remains for me the essential framework for an understanding of modernism and its permanently unresolved dialectic, and time and again the terms of Hegel's discussion seem to apply to Pollock's practice almost too directly.'[17] Taking as his starting point some Cecil Beaton photographs published in *Vogue* in March 1951 (figure 10), Clark considers such issues as recuperation, audience, and, ultimately, art

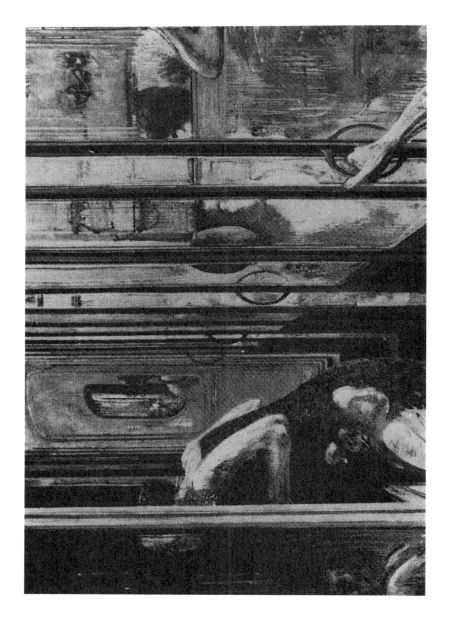

Figure 9 Cremonini, *The Compartments*, oil on canvas, 97 × 146 cms, Bologna, Raccolte Comunali, photo Witt Library.

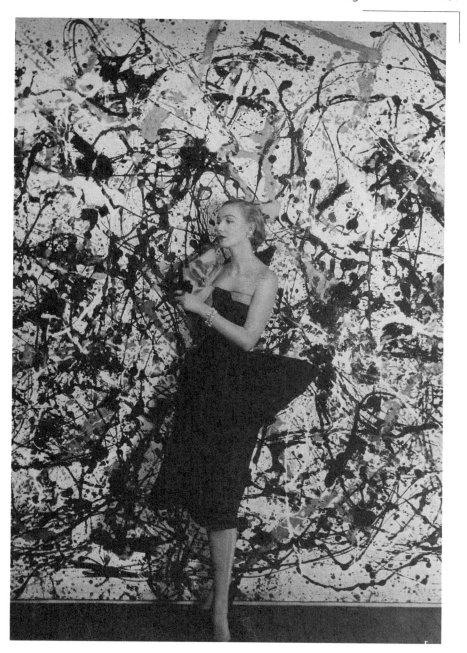

Figure 10 C. Beaton, photo of Model in front of Pollock Painting from *Vogue*, 3.1.1951, 24 × 18.5 cms. Courtesy Vogue. Copyright 1951 The Condé Nast Publications Inc.

and kitsch. However the essay meanders off into philosophical terrain to engage with the notion of the Unhappy Consciousness. This Hegelian notion was not preserved in Marxist thought but rather developed into notions of alienation and true, unalienated consciousness. For Hegel, the Unhappy Consciousness is 'the consciousness of self as a dual-natured, merely contradictory being'.[18] This consciousness is both free and unfree at the same time. It can never achieve unity with 'its unchangeable essence'. For Hegel this takes on a religious significance. As Wolfenstein explains, the Unhappy Consciousness

> 'assigns free and universal selfhood (the content of stoicism) to an Unchangeable Being. It then aims at establishing its unity with this most objective of objects. This can only be accomplished by self-abnegation. The selfhood it so fervently sought and so proudly asserted now stands between it and the ultimate truth. It self-consciously turns its power of negation back upon itself.'[19]

However Wolfenstein points out that the salvation of the Unhappy Consciousness is at the same time domination and bondage. The lord forces the serf to submit, but the Unhappy Consciousness does so willingly. He concludes that 'The Unhappy Consciousness is false consciousness and the experience of the Unhappy Consciousness is 'best seen as a dialectic of domination'.[20] Of course as Marx points out in his critique of Hegel's philosophy, because Hegel equates man with self-consciousness, the estranged essential reality of man is also posited as nothing but consciousness, and so the abstract alienation is overcome by an equally abstract and hollow abstraction, the negation of the negation. These concepts are simply abstract, empty forms of real living acts.[21] For Hegel, says Marx, 'The various forms of estrangement which occur are therefore merely different forms of consciousness and self-consciousness.'[22] For Hegel they cannot be changed by action on and in the actual material world.

For Hegel, art can show us a 'higher reality' than life and 'history has not even immediate existence, but only the intellectual presentation of it'.[23] He believed that painting of his day was in decline, and in future the highest form of culture would be philosophy (not surprisingly!). However Hegel has some interesting things to say about painting and we can see how these writings might be attractive to later scholars interested in an idealist philosophical approach to non-objective art, although of course there was not such art in Hegel's time and all his comments are about figurative painting. He writes:

'Painting . . . opens the way for the first time to the principle of finite and inherently infinite subjectivity, the principle of our own life and existence, and in paintings we see what is effective and active in ourselves', and 'Painting as representation and as painting is pure appearance of the inner spirit contemplating itself.' 'The chief determinant of the subject-matter of painting is, as we saw, subjectivity aware of itself.' Painting, he says, must press on to achieve 'the extreme of pure appearance, i.e. to the point where the content does not matter and where the chief interest is the artistic creation of that appearance'.[24] In his desire to subordinate the material to the spiritual, Hegel divorces the essence of painting from what the artist seeks to represent. However there are problems attempting to relate Hegel's ideas of the Unhappy Consciousness to non-figurative art. For Hegel, the consciousness needs to become aware by reflecting itself off its object. In non-objective art, of course, there are no objects, and so in Malevich's art, for example, the feelings and subjectivity are supposedly present and self-expressed without any need for objects. The idealist argument here would see the being of feeling and subjectivity as a result of the negation of the object and its supersession.

Donald Kuspit, in a recent Adorno-esque article entitled 'The Will to Unintelligibility in Modern Art. Abstraction Reconsidered', also turns to Hegel's notion of the Unhappy Consciousness, which he sees as an early attempt to grasp the concepts formulated by modern psychoanalysis. In a completely ahistorical and idealist manner, Kuspit describes modern abstract art as motivated by a will to create enigma in reaction to the reason and clarity of Enlightenment values. This is in line with postmodern theory. However he then argues that the unintelligibility of abstract art is psychologically intelligible. Using theories of D.W. Winnicott and Melanie Klein, he reads abstract art as a manic and masochistic attempt to counteract the 'falsification of ourselves by modern reason'. 'Artistic withdrawal to unintelligibility is one "mystical" way of doing so' (i.e. reverting to pre-conscious and unconscious authenticity).[25] He cites, but does not analyse, works from Monet and Van Gogh to Newman and Pollock as examples of this abstract will to unintelligibility.

This article implies that there are two apparently distinct approaches to art. One is idealist, philosophical, Kantian or Hegelian, and goes on to use a variety of later sources such as Adorno to discuss abstract and non-figurative art. The other is historical, materialist, apparently rather crude and based on Reason and scientific method, and talks about figurative art, preferably realism and/or naturalism. Now it is certainly

not the case that Marxism is incapable of discussing non-objective art, although we have seen that it has rarely done so. In fact in avoiding discussions of the history of non-objective art, Marxism has left the field open to philosophizing and ahistorical approaches.

Abstract Expressionism

I want now to look briefly at some writings on American Abstract Expressionism where we can see attempts to situate this work artistically and historically. I will consider the methods and conclusions put forward in these writings, together with an assessment of the political and ideological positions of their authors. There is a vast amount of literature on Abstract Expressionism, much of it reading like a 'Who's Who' of 'the social history of art'. From the early seventies when articles by John Tagg and others began to appear linking Abstract Expressionism to the ideology of the Cold War period in the USA to the recent article of T.J. Clark 'In Defence of Abstract Expressionism', this high point of modernist art has been a site of debate for radical art historians. The earlier articles tended to be slightly crude and probably overemphasized the determination of ideological uses and meanings of the art works.[26] However this was an understandable, (if over)reaction to the Greenbergian divorce of modernism from its social situation.[27] Tagg, Serge Guilbaut, David Craven, Andrew Hemingway, Fred Orton and Griselda Pollock, Roger Cranshaw and Clark have all written on the social and political significance of Abstract Expressionism, and their works are referred to in the course of this chapter. Why so much attention by practitioners of 'the new art history' and/or 'the social history of art'? Of course the art of Post-War America is obviously of international significance in art history since, as many of these writings show, the US after the war emerged as the most dominant economic and political force in the world. It is arguable that it was probably the most powerful cultural force also. Furthermore when most of these writers were in higher education, the prestige of modern American art was immense. It has been this period of non-figurative art, rather than the Russian and Soviet avant-garde, which has been in turn damned, saved and perhaps both, by radical art historians over the years.[28] At times there seems to be a project to rescue the paintings of Pollock and the others for radicalism and for politics, sometimes by drastically overstating the case. Like Harold Rosenberg, some of these art historians want to turn Abstract Expressionist painting, and the critical appraisal of it, into a political act. Thus the art historian as intellectual validates his/her

projects by implying they have some kind of political effect or revolutionary significance. In my opinion, art history simply cannot be said to have such political importance.

As many articles carefully point out, the independent left in late thirties America, including Harold Rosenberg and Clement Greenberg, may have been anti-Stalinist but that certainly did not mean they were Trotskyist, or any other kind of revolutionaries, as some writers have claimed, including Callinicos and Orton.[29] Just because members of the US intelligentsia in the late forties were not Stalinists and agreed with the idea of freedom for art does not at all mean they were Trotskyists. Cranshaw and others have shown how Rosenberg in particular was adapting, consciously or unconsciously, to prevailing liberal ideas of the time, especially in his notion of the 'American' (a free theoretical being who could act without reference to the past and from whom the proletariat should learn), and 'possessive individualism'.[30] As Greenberg himself said in a famous statement: 'Some day it will have to be told how anti-Stalinism which started out *more or less as Trotskyism* turned into art for art's sake . . .'(my emphasis).[31] Jachec and others point out that Rosenberg quickly divorced art from politics, publishing in 1947–48 a statement with Robert Motherwell: 'Political commitment in our times means logically – no art, no literature.'[32] It is impossible to occupy oneself with culture and politics at the same time. Hardly very dialectical it must be said. Andrew Hemingway, in a perceptive review, has pointed out that even 'the Marxism which remains in the social history of art has become largely detached from any notion of class conflict, or any concern with the history of labour. I say this not out of some ouverierist romanticism, but because Marxist history is by nature dialectical'. He adds shortly after:

> What I am suggesting is that if we are to understand the middle-class cultures within which it [Abstract Expressionism] was to resonate, either positively or negatively, then the labour struggles and realignments in political culture of the 1940s will need to be in the picture. One of the problems with the current theoretical overload within art history is that it has given license to airy abstractions which stand in for the analysis of real historical forces and real historical actors.[33]

One could also mention that many of the articles written by social historians of art on Abstract Expressionism neither illustrate nor analyse a single painting. The debate about politics, creation and a specific historical conjuncture takes place away from the art works, away from

any economic or class struggles, and away from any dialectics too. This can certainly not be said about Clark's work on Abstract Expressionism, whatever its other failings. Clark always looks closely at the works, one of his advantages over some of his 'followers', and although there are increasingly fewer economic or class contradictions to be seen in his field of vision, there is certainly the struggle of dialectical thought, as we shall see shortly. One definitely gets the impression from Orton's and some other more recent authors' essays that the desire to politicize intellectual practice on the part of the art historian has taken over the historical material. Orton writes: 'For Rosenberg, that was what the work of American action painters was. If action painting had any meaning, it was about revolutionary political agency arising from the contradictions of capitalism, the reality of which could not be totally excluded if the prospect of radical change was to be kept open . . . sometime . . . somewhere . . .'[34] So is Orton right to see Trotskyism in Rosenberg?

In a word, no. Rosenberg's writings from 1940 onwards are basically defending the rights of the individual radical against political oppression. 'The Heroes of Marxist Science' berates the Bolsheviks and Lenin, whose maneuverings and political deviousness got him his own way against Rosa Luxemburg and others. Rosenberg sees the roots of Stalinism already apparent in Bolshevism and tries to divorce Trotsky from Bolshevism (an impossible task, for everything Trotsky did and wrote after 1917 would prove he never wavered from Bolshevism after joining the party). Rosenberg writes: 'The love of the Bolshevik is the love of the shepherd for his flock; and its tolerant facial expression, made up of a mixture of smugness, boredom, and absent-mindedness, is duplicated on Sunday mornings in homes and chapels throughout the world.'[35] The volume of essays from which this is taken is replete with cynical jibes written by a self-centered intellectual trying to justify his rejection of organized politics. He hates the 'smugness' of Bolsheviks (and their flocks?) who think workers might know more than intellectuals, and identifies the main victim of Stalinist persecution as 'the independent radical'.[36] This simply is not true. Many intellectuals were persecuted by Stalinists but their numbers are far less that the ordinary workers murdered either directly by Stalinists, or indirectly as a result of disastrous political leadership by the Stalinized Communist parties. If Rosenberg really had been a Trotskyist, he would not have been so concerned with his own plight as an intellectual, in the face of much more serious persecution of many other people. There is not any evidence to claim that Rosenberg was a Trotskyist, given his opinions

about Bolshevism, and his perspective on political persecution.

What of Clark's writings on Abstract Expressionism? In his essay which begins by considering Cecil Beaton's 1951 *Vogue* photographs of models in front of Pollock paintings, Clark seeks to investigate the public life of Pollock's paintings as 'the bad dream of modernism' – the photograph shows the recuperation in glossy, upper-class consumerist imagery of this bad dream of the primitive, the chaotic and the '*informe*' (figure 10). One of his conclusions is that 'The photographs are nightmarish. They speak to the *hold* of capitalist culture, the way it outflanks any work against the figurative and makes it an aspect of its own figuration – a sign of that figuration's richness, the room it has made for more of the edges and underneath of everyday life.'[37] Capitalist culture recuperates its *informe* and we end up with 'the same aesthetic mix'. Clark compares Pollock's creative process and the whole framework for an understanding of modernism with the struggles of Hegel's Unhappy Consciousness – 'the positive moment of practicing what it does not understand'. In the massive footnote 44, Clark states that these passages by Hegel on the Unhappy Consciousness are 'the essential framework for an understanding of modernism and its permanently unresolved dialectic'. Now whereas early Clark certainly advocated a return to Hegel, this did not result in the relegation of material history to a subordinate space in his overall method. I think, however, the opposite is the case in his later writings on Abstract Expressionism. He moves his stance significantly onto the terrain of critical theory, philosophy and even pure speculation, e.g. he imagines, and goes on to state, what Michel Foucault *might* have thought about the Beaton photographs. He points out mistakes made by Rosalind Krauss in her interpretation of Hegel's philosophy (such mistakes are very easy to make when deciphering Hegel's writings, and I have probably made quite a number myself!). Clark writes:

> I understand Rosalind Krauss to be stating the following about abstract art: that in it, or some of it, experience(s) is (are) "despecified" but nonetheless represented. Sure. But this is where the interesting questions start. What experience(s)? Difficult or easy ones, concentrated or vestigial; represented with what degree of salience or vividness; interpreted by viewers how (with what kinds of criteria for correct or incorrect reading); contributing how, if at all, to some shared or shareable remapping of consciousness and its modes (everybody wants that: Hegel, Fichte, Mondrian, Malevich, Pollock, you name 'em)?[38]

Leaving aside the statement that abstract art is about the representation of experiences, which perhaps deserves some interrogation, Clark's citation of idealist philosophers along with non-figurative artists indicates the drift of his method. Marx is nowhere to be seen. The dialectic is Hegelian and so is modernism. Answers come not from the study of history, economics, politics and society in relation to culture, but increasingly from philosophers (Hegel, Foucault, Adorno, etc.) and the centrality of the struggles of an abstractly conceived, not materially rooted, consciousness – the Unhappy Consciousness.[39]

In a more recent article, Clark links the beginnings of modernism to Hegel's notion put forward in the 1820s that art was basically finished, and could not be the prime cultural embodiment of the modern Spirit. 'Modernism, as I conceive it, is the art of the situation Hegel pointed to, but its job turns out to be to make the endlessness of the ending bearable, by time and again imagining that it has taken place.'[40] Clark wants to defend Abstract Expressionism as something which is not in the past and which has not 'finished'. The end of (art) history has not happened. Our inability to simply have done with it means that 'for us art is no longer a thing of the past'. He categorizes Abstract Expressionist paintings as vulgar – abject and absurd both in terms of the materiality of the paintings themselves and their social existence. (He seems to be using abject here in the sense of Julia Kristeva's term where the abject is defined as part of the subject which tries unsuccessfully to expel and eliminate it e.g. tears, saliva, vomit, bodily waste. These must be expelled to achieve a clean and socially proper body.) Basically his argument is that Abstract Expressionism, at a particular time, represented a form of petty-bourgeois culture which became the form of bourgeois class power. He refers to previous writings on Abstract Expressionism which attempted to investigate the ideological and political positionings of the works, and distinguishes between talking of 'the painting's place in a determinate class formation' which is different from speaking of the work(s) in a State apparatus or a patronage system.

> Not that the latter are irrelevant. But they cannot be what we mean, fundamentally, when we talk about a certain representational practice inhering in the culture of a class. We mean that the practice somehow participates in that class's whole construction of a "world". We are talking of overlap and mutual feeding *at the level of representational practice, at the level of symbolic production (ideology).*[my emphasis] When we say that the novel is bourgeois, the key facts in the case are not eighteenth-century subscription lists or even the uses early readers made of *Young Werther*.[41]

Clark's emphasis on symbolic (ideological) representational practice does not explain how we would identify these ideologies as class ideologies and to which class (or class fraction) they belong. Of course I agree that a sociological description of producers and/or consumers of culture is not enough, and in any case this leaves out the question of the consciousness of the individuals and social groups, which may not be the same as their sociological origin. However there must be historical and dialectical materialist study to enable us to relate the representational level to the social and economic if we want to identify a certain cultural form with the petty-bourgeoisie or the bourgeoisie, as Clark does here. He is not clear on this at all and refers to 'culture' as including 'a set of political and economic compromise formations', which in Abstract Expressionism become the form of bourgeois class power. He again tries to explain that he does not mean to speak of actual social classes but of 'fictions' or 'constructions':

> Abstract Expressionism is the form of the petty bourgeoisie's aspiration to aristocracy . . . when the petty bourgeoisie has to *stand in* for a hidden – nay, vanished – bourgeois elite. (Of course we are dealing here with two class *formations*, two fictions or constructions, not two brute sociological entities.) We are dealing with forms of representation – which is not to say that the kind of representational doubling described here does not have specific, sometimes brutal, sociological effects.[42]

I may be reading this wrongly, but it appears here as if Clark is trying to equate the historical and material with the sociological, and somehow dismissing it as inferior in the process. So classes become fictions and constructions, and methods of representation cause McCarthyite witch-hunts. This whole argument seems somewhat confused to me, as if Clark wants to ascribe a class-specific ideological character to Abstract Expressionism in a reductive (pseudo-Marxist) way at the same time as shifting the whole issue away from any material roots of class and class ideology onto the terrain of the discourse and the cultural representation which manages to become historically more causal than the material (now dismissed as the 'sociological').

In a sense Clark seems to have come full circle from his investigation of the early Modernist works of Manet and the Impressionists in the mid-nineteenth century, in which he describes the petty-bourgeoisie's emergence as the creators and subjects of modernity, and the same class fraction's cultural role in the mid-twentieth century in the fabrication of high modernist culture. It may be, certainly, that the

bourgeoisie as a class (rather than as individuals) cannot create its own modernist culture, since the mass cultural forms and media developed by capitalism and imperialism promote different meanings and purposes from modernist painting. However Clark does not really give any examples of the kind of historical material presented in his earlier writings on French art to enable us to judge if what he says about the historically classed representations embodied in Abstract Expressionist works is true.

Malevich's *Black Suprematist Square*

But do we really have to move into the realms of philosophy and retreat from Marxism to Hegelianism in order to understand non-objective and/or abstract art? I do not believe so. Malevich's *Black Suprematist Square* (figure 11) 1913–15, mentioned in passing a couple of times by Clark, can serve as a small case study. Malevich was interested in philosophy. There is no question about that. Recent articles on his work

Figure 11 Malevich, *Black Suprematist Square*, oil on canvas, 79.5 × 79.5 cms, 1913–15, Tretyakov Gallery, Moscow.

have used this to analyse his work in terms of the Kantian Sublime and the ideas of Ouspensky and Schopenhauer.[43] What we need to do is to examine philosophical texts and art works by Malevich using a historical, not a philosophical method. It is also the case, however, that embodied in Malevich's artworks is a physically represented conflict between the abstract and the concrete, the material and the conceptual. The actual working of the paint was important to him, and he wrote in 1930 'Two principles always begin to clash. Both claim supremacy – the principle of knowledge, the centre of consciousness, and, on the other hand, the centre of subconsciousness, or sensation.' For Malevich these tensions were expressed through the dialectical relationship of colour and form in painterly work.[44]

Malevich's own (confusing and contradictory) statements on Suprematism were often unintelligible to his artistic contemporaries, so it is difficult to say with certainty what the meanings of the *Black Square* were. He called Suprematist painting the representation of 'pure feeling', the active perception of non-objectivity, and wrote of this particular painting: 'The square framed with white was the first form of non-objective sensation, the white field is not a field framing the black square, but only the sensation of the desert, of non-existence, in which the square form appears as the first non-objective element of sensation.'[45] However this should not be interpreted as complete idealism. Malevich wrote in 1915 that nature needed to be seen not as objects and forms, but as pure material, as masses from which to make non-objective forms by intuitive feeling. Suprematism was the new painterly realism: 'The square is not a subconscious form. It is the creation of intuitive reason.'[46] The artist wrote in December 1920 concerning his small book of thirty-four drawings that the conception of the Suprematist canvas was 'as a window through which we discover life' as 'a state of dynamism' – not consciousness, feeling or spirituality, but life.[47]

However just as we need to avoid over-philosophizing Malevich, a Marxist approach does not mean the search for political meanings in works where they obviously are not there. Alexei Gan stated quite correctly in 1927 that it was wrong to look for crude ideological and political meanings in Suprematist paintings:

The novelty, purity and originality of abstract Suprematist compositions undoubtedly fosters a new psychology of perception of volumetric and spatial masses. This is where the great contribution of Malevich will lie . . . Nobody is writing about Malevich here in the Soviet Union. Probably this is because our brooding art-historians cannot decide what his black

square on a white ground represents: the decay of the bourgeoisie or, conversely, the ascent of the young class of the proletariat? That, comrades, is not the right way to go. New forms of artistic labour require a quite other approach to criticism that is related to conditions of production.[48]

Malevich made several versions of his *Black Suprematist Square*, but the first was exhibited in 1915 at the Last Futurist Exhibition at Nadezhda Dobychina's Art Bureau on the Field of Mars, Petrograd. Dobychina was an important figure in avant-garde art circles who encouraged modernist artists to show their work. The painting was given pride of place in Malevich's section of the exhibition, and hung high in a corner at right angles to both walls. It has been suggested that this was intentionally supposed to recall the way icons were hung in Russian homes. Other versions of black square paintings were also exhibited. His work drew outraged responses, notably from Alexander Benois, a prominent critic and a founder of the Symbolist World of Art movement. Benois condemned the *Black Square* as an affirmation of the 'principle of vile desolation. Through its aloofness, arrogance and desecration of all that is beloved and cherished, it flaunts its desire to lead everything to *destruction*.'[49] Benois obviously felt the work to be akin to the glorification of destruction in anarchist politics.

Malevich in fact wrote articles in early 1918 for an anarchist journal, and his views expressed there were typically blustering and ultra-left individualist anarchism:

All the foundations of the old (should) be destroyed, lest things and states may rise from the ashes. Social revolutions will be fine when all the fragments of the old set-up are removed from the organism of social structures. The ensign of anarchy is the ensign of our "ego", and our spirit like a free wind, will make our creative work flutter in the broad spaces of the soul.[50]

In another article written in 1918, he stated: 'The avant-garde of revolutionary destruction is marching over the whole world, life is being cleaned of its old mould, and on the square of the fields of revolution there should be created corresponding buildings.'[51] However it is not clear from these articles whether Malevich was a political anarchist or merely a cultural sympathiser of anarchism.

Malevich certainly saw the square and its intensified form, the cube, as powerful representations of unity, consciousness, space and a

perfection superceding the material world to which humankind could aspire. In a text written in January 1924 only a few days after Lenin's death, he links the cube with Leninism, human aspirations, and utopian harmony. He writes that the cube is the result of all human strivings, culture and development. 'Therefore the burial vault (for Lenin) is a cube, like the symbol of eternity, because "He" too is in it as eternity ... a geometrical paradise... Every Leninist workman must have a cube in his house.'[52] An art critic writing in 1924 described Malevitch's design for Lenin's tomb (rejected) as a plinth incorporating agricultural and machine tools surmounted by a cube symbolizing Lenin.[53]

What did it mean for Malevich to associate himself with anarchism around the time of his development of Suprematism, the First World War and the two revolutions of 1917 in Russia? He had produced posters supporting the war effort in 1914, either for financial reasons or for patriotic reasons. However the majority of Bolsheviks and anarchists were in favour of the destruction of the capitalist state in Russia so did not support the war effort. Much joint work between the two political groupings was carried out in the period before the October Revolution. However problems arose soon after. Many anarchists did not accept a state of any kind, and wanted the immediate destruction of the existing workers' state based on soviets of workers, soldiers and peasants deputies. Some anarchists thought that for the moment, however, they should side with the Bolsheviks against the counter-revolution and fight determinedly alongside their political opponents.

Anarchists in Russia held a variety of political views. Avrich describes three main groupings: anarchist-communists, who believed in a federation of free communities; anarcho-syndicalists who wanted a decentralized society based on labour organizations; and individualist anarchists, unorganized individuals taking their cue from Nietzsche and Max Stirner, who believed only unorganized individuals could remain true to anarchist ideals.[54] It is likely that Malevich was closest to this last group. His articles published in the anarchist magazine were primarily about artistic questions, and he criticized the soviet state for its conservative notions of art and culture. However, as we have seen, he revered Lenin as a guide to a utopian future even in the period after the Bolsheviks had closed down the anarchist centres in Moscow in April 1918.

The anarchists had been against making peace with Germany, a measure seen by the Bolsheviks as a dire necessity for the war-ravaged population of the new Soviet Union. Local anarchist clubs formed Black Guards, named after the anarchist Black flag. Fearful of internal

Materializing Art History

opposition and uprisings, the Bolsheviks surrounded the anarchist centres and called on them to surrender their weapons. Six hundred people were arrested, one quarter of whom were released at once. Certain anarchist groups (and left Social Revolutionaries) carried out assassination attempts on Bolsheviks and other political figures, including the German ambassador. Anarchists bombed the headquarters of the Communist Party Committee, killing twelve people and wounding fifty-five.[55] However even after this anarchist journals still appeared.

It seems at first sight somewhat strange that Malevich could have been able to move towards an art of detachment from material objectivity and towards a purity of feeling and consciousness in a period of intense violence and social crisis. Russia at the outbreak of World War One was a subordinate imperialist power, in whose economy stronger imperialisms such as France were investing heavily, and making large profits. Its economy exhibited at the same time huge backwardness in the countryside, combined with the most modern, concentrated and intense forms of industrialized production in certain cities. Similarly in the cultural sphere it combined ignorance and poverty in vast areas of the country with the most sophisticated modernist culture where Malevich was soon to supercede even the most advanced forms of French Cubism and Italian Futurism.

In the period 1912–14 political strikes increased, and in 1915 striking textile workers were fired on by soldiers and a number of them were killed. This sparked off protest strikes in response. Malevich was called to report for military service in 1916, but this does not appear to have affected his work very much. By the end of 1916 huge price rises affected the poorest sections of the war-weary population and land-hungry peasants increasingly turned against the war. Malevich's identification with peasant subjects and the countryside is an enduring feature of his art. It is tempting to see him as basically a peasant painter, and it would be interesting to investigate his return to peasant subjects in the later twenties in relation to the situation in the Soviet countryside under Stalin's rule. In an autobiographical text written near the end of his life Malevich explained how he wanted to liberate painting from the object, and how the icon had influenced him in this. He viewed icon painting as a high-cultural form of peasant art, yet as a youth he understood nothing of religion and therefore viewed the icons as representing nothing recognisable in the world. He therefore took the path of peasant, icon art, combining spirituality and the materiality of paint.[56]

Malevich resolutely argued for the autonomy of art. He wrote in 1928

that 'The influence of economic, political, religious and utilitarian phenomena on art is the disease of art. At some stage the evaluation of art from the viewpoint of economic conditions will cease, and then the whole of life will be seen from the viewpoint of art, constant and invariable'. He added that 'Not one engineer, military leader, economist or politician has ever managed to achieve in his own field a *constant, beautiful forming element such as that achieved by the artist*'.[57] As can be imagined, such views did not endear him to the art bureaucracy of the time. He was arrested in 1930, imprisoned for three months, and perhaps tortured. He publically exhibited works in 1932 though the authorities entitled the show *Art in the Age of Imperialism*.

The issue of gender also needs some consideration in relation to Malevich's non-objective work. Did the non-objective nature of the work mean women firstly, were not objectified in it (Malevich scorned paintings of the female nude which represented 'female hams') and secondly, had a more equal chance of producing it? In his 1915 essay Malevich mentions two women Suprematists among the six creators of this new movement, Boguslavskaya and Rozanova.[58] A feminist 're-creation' of the *Black Square from 1990* entitled *M.K.K.M.* (Maria Konstantinova/Kasimir Malevich) has been hailed as exposing 'some of the gender assumptions of high art by turning painting into women's work – making a large pillow of Malevich's Suprematist *Black Square*', and exhibiting it in a glass case as a fine art, rather than applied art object. One of the aims of this work is to criticize the masculine bias of modernist fine art, by exhibiting so-called women's work in textiles in its stead.[59] I do not consider this a particularly apposite example of high art to criticize from a feminist perspective, though there remains much work to be done on issues of non-objective art and gender.[60] Maria Konstantinova may not have realized that even in 1917 there were textile reproductions and imitations of Suprematist works which appear to have been quite popular, though of course they were not produced as feminist critiques of Suprematism. An anonymous author wrote in 1917 that 'It is curious that the public indignant at their [the Suprematists] paintings willingly buys the pillows, books and other objects which in most cases appear to be almost exact copies of Suprematist paintings!'[61]

Of course Malevich's work needs to be situated in the context of events before and after the October Revolution in Russia, but, as Gan points out, this need not, and should not, mean that we should assign it a class ideology or a political meaning. Nor should we be tempted to see it as a visual representation of the defining characteristics of

imperialism, in the manner in which Jameson sees postmodern culture as the embodiment of late capitalism. Also, in spite of the rather idealist philosophical writings of Malevich himself and of later cultural historians, we have to remember that the painting itself is the result of a transformation of materials by labour, resulting in an art work that is at the same time a material object *and* an embodiment of non-objectivity. This apparent contradiction at the heart of Malevich's project is fortunately never really resolved, and the ongoing tension it generates is built into his work. In some senses this contradiction is the real meaning of his work, which represents a purified and abstracted perception of material life from a position which posits itself as outside it. This in an impossibility, since consciousness is located in the brain and not a disembodied spirit. Although embodied in a material artefact, this perception is as abstracted and non-objective as possible, while ironically affording the artist and the viewer sensual pleasure through colour, form and the manipulation of the paint as substance. There is obviously far more to be asked about Malevich's *Black Square* and our understanding of it in a dialectical materialist way. My main point, though, is that there is no reason why such questions cannot be asked about non-objective art from a Marxist standpoint and reasonably well-answered according to the state of our present knowledge. A Marxist art history should not be confined to representations of social issues in a naturalist style. Nor should it seek to read political and class meanings into paintings when this is totally inappropriate. It is perhaps also relevant to ask why so much attention is paid to Abstract Expressionism when arguably Malevich's *Black Square* and the works of the other Suprematist painters are far more art historically significant and far more suitable as candidates for the designation of 'the painting to end art' than either the art of Hegel's day or post-war American painting. But this is definitely an ideological question and would require another chapter to answer!

Notes

1. Hadjinicolaou, *Art History and Class Struggle*, London, 1978 (first published 1973), pp.105–6.
2. Wolff, *Aesthetics and the Sociology of Art*, 2nd ed., Basingstoke, 1993, p.23.

3. I am taking this use of the terms from S. Selwood in her introduction to the Open University course unit A315, *Abstraction and Kandinsky*, Milton Keynes, 1983, p.6.

4. Quoted in Schapiro, 'The Nature of Abstract Art', in Schapiro, *Modern Art: 19th and 20th centuries. Selected Papers*, London, 1978, p.202. The painting was actually exhibited in 1915 though it is thought that Malevich was working on it in 1913.

5. See Wood's 'Art and Politics in a workers' state' in *Art History*, vol.8, no.1, March 1985, pp.105–24, and his essay on 'The Politics of the Avant-Garde' in the exhibition catalogue *The Great Utopia. The Russian and Soviet Avant-Garde 1915–1932*, 1992, exhibition catalogue, Guggenheim Museum, 1992, pp.1–24. John Roberts' catalogue essay in *Renegotiations. Class, Modernity and Photography*, Norwich Gallery, 1993, discusses avant-garde Soviet photography rather than non-objective painting.

6. See the discussion of Lyotard by Chaplin, *Sociology and Visual Representation*, pp.123–6. See for example R. van de Vall, 'Silent Visions. Lyotard on the Sublime', *Art and Design*, vol.10, January–February 1995, pp.68–75, on the sublime and Abstract Expressionism.

7. Adorno, *Aesthetic Theory*, p.33.

8. Ibid., pp.45–6.

9. Raphael, *Proudhon, Marx, Picasso*, p.142. This is similar to the position of John Berger in his discussion of Cubism in *The Success and Failure of Picasso*, Harmondsworth, 1965, pp.60–4.

10. Raphael, pp.133, 142.

11. For articles on the politics of Cubist practice see R. Cranshaw and A. Lewis, 'The Practice of Cubism', *Art Monthly*, April 1989; R. Cranshaw, 'Cubism 1910–12: The Limits of Discourse', *Art History*, December 1985, pp.467–83; R. Cranshaw, 'Notes on Cubism, War and Labour', *Art Monthly*, April 1985; D. Cottington 'What the Papers say: Politics and Ideology in Picasso's collages of 1912', *Art Journal*, Winter 1988; P. Leighten, 'Picasso's Collages and the Threat of War 1912–13', *Art Bulletin*, December 1985, pp.653–72.

12. Schapiro, 'The Nature of Abstract Art', in *Modern Art: 19th and 20th centuries*, p.202. There is an article devoted to the discussion of 'Meyer Schapiro, Marxist Aesthetics, and Abstract Art' in *The Oxford Art Journal*, vol.17, no.1, 1994, pp.76–80 by G. Mosquera, but I did not find this particularly useful. Donald Kuspit concludes that it is Schapiro's view of abstract art as a rebellion against the de-individualizing and demoralizing qualities of capitalist society that makes him a Marxist. See D.B. Kuspit, 'Meyer Schapiro's Marxism', *Arts Magazine*, vol.53, no.3, November 1978, pp.142–4.

13. Quoted on p.271 of the useful chapter on Althusser by M. Sprinker, *Imaginary Relations. Aesthetics and Ideology in the Theory of Historical Materialism*,

London, 1987. Much less useful on Althusser on art is R. Eldridge, 'Althusser and Ideological Criticism of the Arts', in S. Kemal and I. Gaskell, *Explanation and Value in the Arts*, Cambridge, 1993, chapter 10.

14. Sprinker, p.286.

15. L. Althusser, 'Cremonini, Painter of the Abstract', in *Lenin and Philosophy and Other Essays*, New York and London, 1971, p.230.

16. Ibid., p.242.

17. T.J. Clark, 'Jackson Pollock's Abstraction', in S. Guilbaut ed., *Reconstructing Modernism. Art in New York, Paris and Montreal 1945–64*, Cambridge Mass. and London, 1990, p.234. This was originally given as a paper in 1986.

18. G.W.F. Hegel, *Phenomenology of Spirit*, Oxford, 1977, p.126. The title of this is sometimes translated as *The Phenomenology of Mind*.

19. E.V. Wolfenstein, *Psychoanalytic Marxism. Groundwork*, New York and London, p.204.

20. Ibid., p.206.

21. Marx, 'Economic and Philosophical Manuscripts', in L. Colletti ed., *Early Writings*, Harmondsworth, 1975, p.396. See the whole section entitled 'Critique of Hegel's Dialectic and General Philosophy', pp.379–400.

22. Ibid., p.385.

23. Hegel, *Introductory Lectures on Aesthetics*, Harmondsworth, 1993, p.11.

24. Quoted from Hegel, *Aesthetics. Lectures on Fine Art*, translated T.M. Knox, 2 vols, Oxford 1975, vol.2, pp.797, 801, 802, 812.

25. D. Kuspit in *Signs of Psyche in Modern and Postmodern Art*, Cambridge, 1993, p.120.

26. For example the articles by Eva Cockcroft, Max Kozloff and David and Cecile Schapiro republished in F. Frascina ed., *Pollock and After: The Critical Debate*, London, 1985; and J. Tagg, 'American Power and American Painting. The Development of Vanguard Painting in the U.S. since 1945', *Praxis*, 1, no.2, Winter, 1976, pp.59–71. For a good discussion of these revisionist histories of Abstract Expressionism, see R. Burstow, 'The Limits of Modernist Art as a "Weapon of the Cold War": Reassessing the Unknown Patron of the Monument to the Unknown Political Prisoner', *The Oxford Art Journal*, 20:1, 1997, pp.68–80. For Clark's 'In Defence of Abstract Expressionism' see *October*, 69, Summer, 1994, pp.23–48.

27. For a summary of some literature on Abstract Expressionism see the useful article by Nancy Jachec, '"The Space Between Art and Political Action": Abstract Expressionism and Ethical Choice in Postwar America 1945–1950', in *The Oxford Art Journal*, vol.14, no.2, 1991, pp.18–29.

28. In a very useful article on the Russian/Soviet avant-garde Paul Wood remarks that 'as the historical account has developed both extensively and intensively, the question of the politics of the avant-garde has been left

relatively underresearched'. I think this is very different from the approach taken to Abstract Expressionism. See Wood, 'The Politics of the Avant-Garde' in *The Great Utopia*, 1992, pp.1–24, quote from p.2.

29. Callinicos, *Against Postmodernism*, p.150. F. Orton, 'Action, Revolution and Painting', *The Oxford Art Journal*, vol.14, no.2, 1991, p.6, where Orton claims Rosenberg's article of 1940 on the fall of Paris was 'thoroughly Trotskyist in its art and politics', and refers to his 'espousal of international Trotskyism'. Orton repeats this argument in another version of this paper in D. Thistlewood ed., *American Abstract Expressionism*, Liverpool, 1993, pp.147, 178. (Griselda) Pollock and Orton were more accurate in their article '*Avant-Gardes* and Partisans Reviewed', where they point out that Greenberg was not a Trotskyist, although he disagreed with Stalin. See the version of this article in F. Frascina ed., *Pollock and After*, p.175. (The article was originally published in 1981.)

30. See R. Cranshaw, 'The Possessed. Harold Rosenberg and the American Artist', in *Block*, no.8, pp.3–10, and James D. Herbert, 'The Political Origins of Abstract-Expressionist Art Criticism', *Telos*, vol.62, 1984–5, pp.178–87.

31. Quoted in S. Guilbaut, *How New York Stole the Idea of Modern Art*, Chicago and London, 1983, p.17.

32. Jachec, p.20.

33. Hemingway, 'The Two Paths', *The Oxford Art Journal*, vol.19, no.1, 1996, pp.115, 116.

34. Orton, 'Action, Revolution, Painting', in *American Abstract Expressionism*, Liverpool, 1993, p.167.

35. Rosenberg, *The Tradition of the New*, London, 1970, p.162.

36. Ibid., p.208, in 'Couch Liberalism and the Guilty Past', originally published in 1955.

37. Clark, 'Jackson Pollock's Abstraction', p.222. *Vogue* editors in Britain obviously did not think British women ready for an exposure to the *informe* alongside their high fashion. The photographs were not published in the British edition. Instead there was a bizarre feature in the March 1951 issue about a painter Marcel Vertès whose recent show in New York featured his 'impressionist'-style representations of how famous people might have looked as children. These included Eleanor Roosevelt aged six, Winston Churchill aged one, captioned 'The crux of the portrait, the defiant stance and poise of the head that foretold the courage and the brilliance of a lifetime of attack', and Pablo Picasso aged eight, with 'extraordinary bull-like eyes'.

38. Clark, 'Jackson Pollock's Abstraction', p.235.

39. J. Bernstein contests Clark's reading of Hegel, and explains that for Hegel art in modern times becomes a thing of the past since the Spirit becomes represented in Man, not in art. Meaning could only be representational and pictorial in art when its meaning was supposed to reside in the Spirit (God).

'Meaning could be indefatigably representational – picture thinking – only when the ground of existence was assumed to be outside the subject, in God, or, what is the same, His history: in a remote (past) origin or a remote (future) telos. Once there are only historical communities without determinate origins or ends, then metaphysical meaning can no longer be represented in pictorial form. Hence, the primacy of philosophy and the prose character of the modern world for Hegel.' 'The Death of Sensous Particulars. Adorno and Abstract Expressionism', *Radical Philosophy*, no.76, March/April, 1996, p.8. Obviously Hegel did not foresee the concept and development of non-objective art, and the attempts of some non-objective artists to represent the metaphysical in their images.

40. Clark, 'In Defence of Abstract Expressionism', *October*, no.69, Summer 1994, p.25.

41. Ibid., pp.34–5.

42. Clark, p.36.

43. M. Oblak, 'Kant and Malevich. The Possibility of the Sublime', in *Malevich. Art and Design Profiles*, London and New York, 1989. Paul Crowther, 'Philosophy and Non-objectivity' in the same publication states 'it is almost certain that Malevich had a working knowledge of the text of *Tertium Organum* itself, or at least a *very* well-developed second-hand knowledge of some of the ideas expressed in it' (p.51). It should be pointed out that many of the philosophical influences on Malevich's writings are not securely proven. For example Husserl has been suggested as an influence on Malevich's development of Suprematism as going beyond the object to pure feeling and consciousness. Husserl wrote in 1913 that 'even an inanimate and non-personal consciousness is conceivable'. R. Crone and D. Moos, *Kasimir Malevich. The Climax of Disclosure*, London, 1991, pp.193–6. However a reading of Malevich's own texts clearly shows his interest in philosophy.

44. Crone and Roos, p.124.

45. Oblak, p.40.

46. K. Malevich, 'From Cubism and Futurism to Spurematism: The New Painterly Realism', 1915, in J. Bowlt ed., *Russian Art of the Avant-garde. Theory and Criticism*, London, 1988, p.133.

47. Malevich, *Art and Design Profiles*, London and New York, 1989, p.17.

48. A. Gan, 'Notes on Kasimir Malevich', *Malevich. Art and Design Profiles*, London and New York, 1989, p.36.

49. Quoted in *Kasimir Malevich 1878–1935*. Russian Museum Leningrad, Tretiakov Gallery, Moscow and Stedlijk Museum, Amsterdam, 1989, p.158.

50. From K.S. Malevich, *The World as Non-Objectivity. Unpublished Writings, 1922–25*, vol.111, ed. T. Andersen, Copenhagen, 1976, pp.53, 55.

51. From 'Architecture as a Slap in the Face to Ferro-concrete', originally published in *Anarkhiya*, no.37, April 6, 1918, and reprinted in December in *Iskusstvo Kommuny*. Quoted from Andersen ed., p.63.

52. From D. Karshan, 'Behind the Square: Malevich and the Cube', *Kasimir Malewitsch zum 100 Geburtstag*, Exhibition catalogue Galerie Gmurzynska, Cologne, June–July 1978, p.256.

53. Ibid., p.257.

54. P. Avrich ed., *The Anarchists in the Russian Revolution*, London, 1973, pp.10–14.

55. Details in Avrich, ed., pp.21–2, and E.H. Carr, *The Bolshevik Revolution 1917–1923*, vol.1, Harmondsworth, 1975, pp.170–8.

56. See *Kasimir Malevich 1878–1935*, pp.109–11.

57. Ibid., pp.130–1.

58. Bowlt, ed., p.135.

59. J.A. Isaak, *Feminism and Contemporary Art. The Revolutionary Power of Women's Laughter*, London and New York, 1996, p.119. I was not able to get permission to reproduce this work, but Isaak illustrates it as Figure 3.26 in her book.

60. For more on Russian and Soviet women artists and non-objective art see my *Seeing and Consciousness*, p.117, and for a discussion of non-objective art and gender in the recent past see Rosie Betterton, *An Intimate Distance. Women, Artists and the Body*, London and New York, 1996, chapter four.

61. Quoted by C. Douglas, 'Non-objectivity and Decoration', *Vosprosy Iskusstvoznania*, Moscow, nos.2–3, 1993, p.105. Many thanks to Tania Chinova for this reference.

Marxism, the Postmodern and the Postcolonial

The collapse of Stalinism in Eastern Europe since 1989 has been seen as proof that Marxism is now irrelevant to contemporary society and politics. This has been welcomed in some quarters, while certain erstwhile Marxists have gone back to the drawing board (or more accurately the study and the library) to see whether anything can be salvaged from the theory and method of revolutionary politics based on dialectical materialism. The collapse of the so-called grand narrative of Marxism, initiated by two white, bearded men, has also been welcomed by many who would consider themselves as radicals. The vacuum left by the demise of Marxism (more accurately Stalinism), is often seen as a welcome space in which to develop the analysis of black, lesbian and gay, and feminist cultural politics. Micro-politics of localized and autonomous communities are seen as more valid and progressive than discredited totalizing theories of political (and cultural) change. The small, the fragmented and the decentered networks are hailed as alternatives to the monolithic, authoritarian dinosaurs of the left organizations and the trade union movement.

However the real situation is rather more complex. The supposed demise of the single (and collective) conscious subject of history has not been seen by all left cultural theorists as an unequivocally progressive development. Nor have the events in Eastern Europe necessarily disproved the validity of Marxism as a means of understanding the social and political world. It is significant that Trotsky's critical analysis of the Soviet Union and its bureaucratic Stalinist ruling caste are rarely, if ever, mentioned in connection with the disintegration of state power in most of the Stalinist states.

As writings proliferate on the postmodern, the postcolonial and the postfeminist, we need to situate these recent theoretical developments

in their material context, evaluate their validity, and investigate whether Marxism is still able to explain and offer a critique of their existence and their growing influence. After a brief discussion of postfeminism, I want here to concentrate more on the postmodern and the post-colonial, since I have discussed the relationship between gender and the postmodern elsewhere.[1]

Postfeminism

Briefly, postfeminism takes the view that the main obstacles to women's oppression have been addressed, and political and legal frameworks are now in place to enable women to enjoy equal opportunities, equal pay and the chance to rise to the top in many professions previously thought unsuitable for them. Thus, it is argued, the time has come for a less militant and aggressive form of feminism – one which reflects on its gains and decides how to put them to best use, whether in academic life, in industry, commerce, finance or in state organizations. In the academic sphere, this postfeminism has expressed itself in a move from studies of women's oppression in (and omission from) history and culture to a concentration on the ways in which language and other forms of culture construct 'women' and their subjectivities as categories of discourse. This kind of approach, heavily influenced by the work of Foucault and Lacan, is seen as a way in which to unravel and deconstruct the more subtle forms of gender oppression, while empowering women in their possession of the 'in-between' spaces and 'third spaces', or 'nomadic subjectivities' which are constituted beyond binary oppositions. This hybrid moment of deconstructive analysis as carried out by the postmodern and postfeminist academic is seen as the sphere of political empowerment and change. As Bhabha puts it, referring exceptionally to an actual historical struggle: 'Here the trans-formational value of change lies in the rearticulation, or translation, of elements that are *neither the One* (unitary working class) *nor the Other* (the politics of gender) *but something else besides*, which contests the terms and territories of both.'[2] He is referring here to the British miners' strike of 1984–85 and the participation of the miners' wives, mothers, girlfriends and daughters, along with other women supporters of the strike, in running kitchens, picketing, organizing demonstrations and speaking tours.

Bhabha's argument is that these events were new and not explicable in terms of the old notions of 'women' on the one hand, and 'working class' on the other. These two discourses came together and clashed in

creating an 'in-between' space which enabled the old binary oppos-
itional categories to be contested. This is one way of looking at the
situation in the miners' strike, of course, but it was not exactly a new
situation for women to be involved in a strike or in militant support
of a strike, e.g. the Teamsters' strikes in the US in the 1930s. It certainly
was the case that the women's involvement was hugely positive and
changed both male and female perceptions of gender roles quite
dramatically. However it is not the case that postmodern theory was
the only body of thought capable of understanding such developments.
Marxists, as dialectical materialists, do not have a concept of a 'unitary
working class' or some monolithic notion of 'politics of gender', but
attempt to see the contradictions within and between such notions.
Women are also, after all, members of the working class. The point is
to locate the contradictions and their significance within particular
historical and economic conditions which give rise to oppression by
class, gender, sexuality, 'race' and so on. However for such scholars as
Bhabha these contradictions are primarily located in language and
discourse, and for some theorists twentieth-century Marxism is seen
as having 'used the generalizing categories of production and class to
delegitimise the demands of women, black people, gays, lesbians, and
others whose oppression cannot be reduced to economics'.[3]

Some women have hailed the postmodern as opening up a space
for 'others' to emerge and articulate their own discourses: women,
homosexuals, ethnic groups, and the disabled.[4] However, others are
more wary and question the usefulness of theories which deny the
possibility of an overall understanding of, say, women's oppression in
history. Janet Wolff, for example, states quite bluntly: 'the radical
relativism and scepticism of much postmodern thought is misplaced,
unjustified, and incompatible with feminist (and indeed any radical)
politics.'[5] It is for this reason that postfeminism and postmodernism
have become closely linked. Some writers, such as Wolff and Griselda
Pollock, want to utilize certain aspects of postmodern thought while
remaining committed to feminism as a project of social change, and
therefore tend to see postmodernism as a development of modernism.
In this way they attempt to preserve the relationship of modernism/
feminism in opposition to postmodernism/postfeminism.

I want to look now in more detail at postmodernism and postcolon-
ialism, by firstly outlining the main theories of these two approaches,
and secondly raising some criticisms of them from the point of view
of Marxism. I then want to examine the economic, historical and
political conditions in which these two approaches have developed.

Following on from this, I will discuss the book *Postmodernism or the Cultural Logic of Late Capitalism* (1991) by Fredric Jameson as an example of a 'neo-Marxist' analysis of postmodern culture. I will then look at specific works by the Afro-American artists Renée Green and Lyle Ashton Harris in order to discuss the contributions which can be made by a Marxist analysis of postcolonial culture.

Postmodernism

The literature on postmodernism is vast, and I intend merely to give a summary of the main strands of thought within this body of ideas. Developing out of poststructuralism, postmodernism is seen as a consequence of the political disillusionment of left intellectuals after the failure of the struggles of May 1968 in France, and the ability of capitalism to regenerate itself and, supposedly, avoid major crises. These factors are seen as proof that Marxism has failed.[6]

On the other hand, the continuing wars, famines and genocide taking place throughout the world are seen as evidence that the ideology of liberal free-market capitalism tending always to progress and enlightenment (the heritage of the eighteenth century bourgeois Enlightenment) is also bankrupt. Thus, goes the argument, grand narratives of history and progress are discredited and impossible. It is not possible to know reality, in history or in the present. In addition, there is no individual or collective subject of history present in this late capitalism, where all subjectivity is constructed by language and discourse. Knowledge and power are not controlled by the state, it is argued, but by 'régimes of power' which constitute us as subjects fragmented and in flux. Foucault in particular has rejected Freudian notions of the individual subject in whose psyche conscious and unconscious forces of the sexual and the social come into conflict. Foucault, following Nietzsche, set out to write what he termed the genealogy of the modern subject, in order to show there is nothing unconstituted by power and language. The state and the dominant ideology do not repress, but control and create even sexuality through discourse. There is no escape from this situation, only tactics of survival on an individual level, for example, in 'care of the self'.[7] Any attempt to overthrow the existing order and construct a new society will inevitably construct its own régime of power within which we will be imprisoned. Power is a multiplicity of relations in every society, and consequently no causal priority can be assigned to the economic, as Marxists argue.[8]

For Lacan, as against Freud, the unconscious (imaginary) is also the

product of our conceptualizations: 'Thus one can make no sense of any notion of reality, whether material or immaterial, conscious or unconscious, that is not mediated by the symbolic order, by our system of concepts.'[9] So there is no possibility of unmediated knowledge and consciousness, and even the Freudian unconscious is not a source of oppositional energy and desire. For Lyotard also language constitutes subjectivity and power: 'knowledge is the principal force of production.'[10] These positions have greatly influenced cultural historians. For example Jeffrey Weeks, author of a number of books on sexuality and gay and lesbian oppression, writes that 'Society does not influence the autonomous individual, on the contrary the individual is constituted in the world of language and symbols which come to dwell in, and constitute, the individual'.[11] Similarly Kobena Mercer, author of a number of works on 'black culture', writes: 'the subject is constituted in language.'[12] Lyotard and Derrida respond to this situation by advocating 'deconstruction', which can lead to demystification. Deconstruction can empower us, believes Bhabha, glorifying the 'contingent, indeterminate articulation of social "experience"', and he concludes that 'it is the realm of representation and the process of signification that constitutes the space of the political'.[13] Lyotard argues that 'demystification is the permanent revolution'.[14] This rather feeble echo of Trotsky's theory of permanent revolution, with which it has nothing at all in common, exposes the idealist and politically moribund nature of most postmodern attempts to theorize forms of resistance.

In postmodern theory, the individual cannot be alienated in capitalism, because there is no true self either now or in the future, to be alienated from. Also we would never be able to work in a social system of any kind free from the alienating nature of work for the majority of people under capitalism. All social systems would lack a coherent and conscious individual (and collective) subject. Whatever fragmentation and disjunction we experience is an effect of our constitution by discourse, not the impingement of something oppressive and alien onto a coherent pre-existing person. Thus, as Harvey points out, postmodernists reject Marxist theories of alienation as an explanation for the ways we live through the experiences of imperialism in imperialist or imperialized countries in the late twentieth century.[15]

A major figure among postmodern theorists of culture is Jean Baudrillard. Baudrillard rejects a Marxist analysis of history based on economics and different forms of production, preferring to focus on consumption. This he does by arguing that historical change can be perceived by changes in the function of signs. In the postmodern

period, the sign has become totally unhinged from any material reality, and itself constitutes that reality.[16] He writes: 'Disneyland is presented as imaginary in order to make us believe that the rest is real, whereas in fact all of Los Angeles and the America surrounding it are no longer real, but of the order of the hyperreal and of simulation.'[17] Baudrillard's political conclusions are dire. He advocates withdrawal and refusal of political action, as the practice of the latter will only in its turn institute repressive social forms: 'withdrawing into the private could well be *a direct defiance of the political*, a form of actively resisting political manipulation.'[18] Behind most of this political abstentionism is a belief that the Russian revolution inevitably degenerated into repression and totalitarianism, and that Marxism, Bolshevism and Stalinism are indistinguishable.

I will briefly make criticisms of the above positions here. Obviously the rejection of reality and the possibility of knowledge of reality which is not already a language of power (in 'old-fashioned' language, ideology) would be criticized by Marxists, and has been by Callinicos in particular. However one would not have to be a Marxist in order to put forward serious criticisms of postmodern theories.[19] As I have mentioned in previous chapters, the equation of Marxism and Stalinism is incorrect, and the political conclusions drawn from this are mistaken. The concept that a totalizing theory (or master narrative) inevitably results in totalitarian repression and lack of democracy is not true. The fact that a bureaucratic caste arose in the USSR in particular historical conditions does not in itself mean the inevitability of repression everywhere and at all times wherever Marxist ideas root themselves in the working class and the oppressed. This does not mean, therefore, that micro-politics, or networks of power-relations subsisting at every point in a society, will prevent certain individuals from leading these micro-groupings, or that such a network can destroy powerful bourgeois state apparatuses backed by weapons, the police, the armed forces and the judiciary on a world scale.

Harvey welcomes aspects of postmodernism which show that 'all groups have a right to speak for themselves, in their own voice, and have that voice accepted as authentic and legitimate'.[20] The implication is that modernist theories, including Marxism, gave these groups no such rights. Now while it is true that there are many instances when modernist culture ignored gay and lesbian sexuality, for example, and Marxism did not pay enough attention to racial oppression, these were not inevitable outcomes, nor were they universally true. Marxism does not argue that the oppressed should be silenced and that their voices

should not be heeded. What Marxist politics does argue is that a centralized and democratic political organization, in the form of a party with its programme, must draw all the oppressed into its ranks, articulating their needs and integrating their struggles into a struggle for socialism so that all forms of social oppression will eventually be eradicated. This does not mean ignoring the oppressed or preventing them from forming special organizations. What Marxists believe is that if you have a separate black or gay or women's revolutionary party you will not be able to destroy capitalism, because proletarians must take the lead in this. They may be lesbian, black or Jewish proletarians, but proletarians they must be. Both democracy and centralism are crucial in this project. Therefore it is certainly true that different oppressed groups within a Marxist party should meet together, discuss their particular needs and criticisms of the party, and put resolutions to party committees and conferences to make sure these issues are taken up by *all* party members as a matter of policy.

What Marxists would not accept however, is the idea that specifically oppressed groups would have special rights and privileges within the party, and that only their views on a particular subject would be the 'authentic' voice, and could veto suggestions made by other 'non-oppressed' groups. For example, in this situation only Irish people would be the 'authentic' voice of Irish oppression, only women would be able to make policies on women's oppression, etc. Since we would all be constituted by discourse and language, it is not clear how the oppressed groups' voices would be any more 'authentic' than any others. Also this view totally ignores the fact that within oppressed groups and communities, there is no 'authentic' voice which is innocent of class position, although of course sociological position does not inevitably determine one's ideas. Surely the idea of postmodernism opening up opportunities for intervention to oppressed groups of women, blacks, gays and lesbians tends to fall into the sort of essentialism that postmodernists accuse Marxists of, viz. that women, lesbians, etc. are a coherent and unified group with 'their' view of the world, which can now be articulated in the interstices of disintegrating masternarratives and ever-self-constituting discourses. It is also of course highly debatable that within the postmodern condition the voices of child labourers in India, for instance, are deemed as influential and 'authentic' as such postcolonial academic voices, for instance that of Homi K. Bhabha.

What kind of idealism is present in postmodern theories? How does it differ from earlier forms of idealism argued against by Marxists? In

Engels's polemics against idealism he identified certain characteristics of idealist philosophy. One such feature is the construction of interconnections fabricated in the mind of the philosopher rather than the demonstration of real interconnections in history and the material world. Another such characteristic is the notion of an ideal goal towards which the interconnections of events and history are impelled to move in a process of realization.[21] Lenin, in 1908, characterized idealism as giving primacy to the subject over the object i.e. the object cannot exist unless there is a human subject, idea or thought there to realize it.[22] However postmodernism offers a different kind of idealism, because the thinking individual subject is no longer the subject which thinks reality into existence. In postmodernism, discourse and language become the agents which construct human individuals – the subjects have become objects. Lenin described the idealism he was attacking as subjective idealism: 'The absurdity of this philosophy lies in the fact that it leads to solipsism [i.e. the notion that the self is the only knowable thing], to the recognition of the existence of the phil-osophizing individual only.'[23] At first sight this would seem different from postmodernism, which claims that the individual subject does not exist as such. However if we consider this further, Lenin's statement is true of postmodern thinkers like Lyotard, Baudrillard, etc. For although they claim that the individual subject is constituted by discourses of power, signs and the like, they themselves are the individual subjects who invent their theories, write their books and influence large numbers of students and academics. Their own theories cannot explain how it is that they come to know the position from which they write, or offer a theoretical overview of the state of modern society and culture. In a very general sense, postmodernism shares the concerns of other earlier idealisms in that it seeks to discredit and destroy materialism and any practical application of materialism. As for dialectics, certain postmodernists, Jameson for example, are attracted to a Hegelian, or more properly an Adornian form of negative dialectics, but as I shall show later, this dialectical thought is seen as paralyzing and immobilizing for the thinker, rather than as something emerging from material and social reality which is perceived by the conscious subject seeking for a way to understand and intervene. However the main differences between postmodernism and earlier forms of idealism are necessarily to be found in the specific configurations of economics, politics, culture and society in late twentieth century imperialism. I will briefly consider these factors later in my discussion of Jameson's *Postmodernism*.

Postcolonialism

Within the same configuration, and greatly influenced by post-modernist theories, critical notions of the postcolonial have developed, and it is to the postcolonial that I now want to turn. There has been a great deal written in the last few years about the postcolonial, and I am not attempting here to give a comprehensive summary of all this material. What I want to do is briefly explain the term, relating it to postmodernism, and to draw out some problems in its use. It is also the case that many cultural critics who utilize the term postcolonial, do so from a perspective of opposition to what they term 'classical' Marxism, if not outright hostility to any sort of Marxism, and I also want to discuss reasons for this.

The term postcolonial has been used to refer to a configuration of (mainly) cultural processes seen as opposed to, and resulting from, colonial modernism and its demise. Like postmodernism, it rejects notions of grand totalizing narratives and political strategies, focusing instead on the study of discourse and language in the construction of the postcolonial subject. The publication of Said's influential book *Orientalism*, was a crucial step in the development of postcolonial studies. Said, like Homi K. Bhabha, wrote from the position of the exiled postcolonial intellectual, who was seen as the key figure in the construction of postcolonial oppositional discourse, and the most fragmented, hybrid and contingent subjectivity. Bhabha in particular sees the intellectual as the key to constructing a postcolonial perspective which moves away from class and 'holistic forms of social explan-ation'.[24] It is significant that Bhabha and Said are keen to jettison notions of class since the postcolonial intellectual, exiled in the imperialist academies, is likely to be from the bourgeoisie or petty-bourgeoisie of so-called 'Third World' countries, and though unable to escape racial oppression, is obviously in a far more privileged position than the impoverished masses of Africa, Asia and Latin America, who are less likely to engage in the textual deconstructive politics of postcolonial criticism.[25]

Base and superstructure are not differentiated with any theoretical clarity in their writings, and thus culture, politics and economics are given equal weight. As Jan Nederveen Pieterse and Bhikhu Parekh have pointed out 'discourse is viewed as both a mode of expression and a set of practices and institutions – as in orientalism'.[26] Thus it is implied that a radical political strategy is instigated by criticizing the discourse of colonialism, for example. As William Roseberry points out: 'The

words "colonialism", "postcolonialism", "power", and "the state" are among the most popular and frequently occurring in recent titles. One is often struck, however, by how little the authors actually have to *say* about colonialism or the state . . . There is no attempt to conceive of capitalism (or colonialism) in active and particular terms . . .'[27] In fact the state is given no special emphasis as a key site of oppression, power and military repression. It is merely one element among others in discourses of power and knowledge. However behind notions of the postcolonial in some critics' work there is certainly a hierarchical framework of more or less important discourses of oppression. Class is usually never the most important, but for Said, race certainly is. He declared that 'in the relationship between the ruler and the ruled in the imperial or colonial or racial sense, race takes precedence over both class and gender . . . I have always felt that the problem of emphasis and relative importance took precedence over the need to establish one's feminist credentials'.[28]

For me the issue is not about 'establishing credentials', as a feminist, anti-racist, gay activist or whatever, but rather about developing a theoretical framework to understand contemporary culture which roots itself in a materialist method and is therefore able to articulate the relative positions of class, gender, sexual and racial oppression. With a dialectical grasp of contradiction and complexity which at the same time believes that arguments and statements can be tested using evidence and facts, it is possible to produce writings which theoretically and practically relate to the actual social and cultural processes being studied, rather than construct an autonomous system which usually has little connection with the real motor forces of cultural and social change. For instance Said has bravely criticized the recent Middle East peace deal which has attempted to stifle the Palestinian resistance and enable the PLO to police and torture its opponents.[29] Yet it is diffic'lt to see how his concept of the primacy of race within 'Orientalism' explains this suppression of the Palestinian struggle by other Palestinians with different political ideas, without looking at the material bases for the petty-bourgeois nationalism and its accommodation with imperialism which motivate the PLO leadership.

I would argue that the continued use of the term semi-colonial is more useful that the new term postcolonial. Semi-colonial means that although formaly politically independent, semi-colonial countries are still dominated by imperialist powers in various ways. The world banking and finance organizations can force their governments to implement policies detrimental to the masses of the population, and

multi-national corporations can exploit their workforces by direct (paying low wages to workers in unsafe conditions) or indirect means (investing capital in local companies who do the same thing). Agriculture in semi-colonial countries is geared to the needs of the world market rather than the requirements of the indigenous population, and can result in single-crop, unbalanced management of the land and its resources. The political legacy of semi-colonialism often means repressive regimes of a military nature cynically manipulated by imperialist states (and destabilized when it suits France, the USA or Britain) or by large imperialist companies. Ethnic oppression and rivalry bequeathed by 'divide and rule' colonial domination is also common.

The use of the term postcolonial obscures, rather than clarifies, this colonial legacy. The world is sometimes referred to as postcolonial, totally obliterating the differences between the imperialist and the imperialized world. For example in an article on black women and film, Pajaczkowska and Young refer to Britain as a 'post-colonial' society.[30] This is rather unclear, to say the least, as Britain has a colony in the North of Ireland, and not too long ago carried out an imperialist war of aggression against the semi-colonial Argentina to maintain control of the Malvinas (Falkland Islands). Postcolonial also seems to be used almost exclusively to refer to issues of 'race'. As in the case of Ireland and Argentina, not all colonization and imperialist aggression against semi-colonies is primarily concerned with 'race', although of course racial stereotypes and insults may be mobilized and constructed in imperialist propaganda against its victims, whether they are 'Paddies' or 'Argies'.

The key issue is the way in which many postcolonial and postmodern critics conceptualize imperialism. I will discuss this at greater length shortly. However, for the moment I want to look briefly at some remarks by Jameson and Said published in 1990. Jameson, for example, states that Marxist theories of imperialism see it as positive for the imperialized countries, and largely ignore the devastation and oppression that imperialism inflects on colonized countries.[31] This simply ignores the dialectical view of imperialism that Marx, Engels, Lenin and Trotsky brought to the historical and political analysis of economic development in the later nineteenth and earlier twentieth century. It also recalls Said's attack on Marx's view of India in *Orientalism*, where he categorizes Marx as an Occidental who cares little for the human suffering of mere Orientals.[32] Marxists see it as a matter of principle to side with the oppressed against imperialism. Of course this does not mean that the various strands of contemporary 'Marxism' always agree that a country

is imperialized or not. The confusion of much of the British left over the nature of Argentina during the Malvinas war is proof of this. Jameson also argues that there is no longer inter-imperialist rivalry, but that all imperialist aggression is directed at the Third World (another term which would be better replaced by semi-colonial countries).[33]

Said, writing in the same collection of papers as Jameson, states his belief that imperialism as a specific economic development of capitalism did not date from the 1870s, and does not differentiate the possession of colonies from the development of imperialism in the later nineteenth century as described by Lenin i.e. the export of capital, creation of monopoly trusts and the fusion of banking and finance capital. Thus Said can posit Orientalism as a relatively timeless and unchanging mode of discourse dating from early modern times till the present. Said locates the experience of imperialism for the colonized as follows: 'their land was and had been dominated by an alien power for whom distant hegemony over nonwhite peoples seemed inscribed by right in the very fabric of European and Western Christian society, whether that society was liberal, monarchical, or revolutionary.'[34] This boils down to an opposition between the Occident and the Orient, without really explaining why the Occident was ever in a position to impose its will on the Orient – to do so would entail an examination of economic factors as a primary, but not sole, cause.

In a useful article about the difficulties involved in using the term postcolonial, Anne McClintock points to the problems in using such a term to refer to the situation of countries as disparate as Argentina, Ireland and Hong Kong. She correctly points to the continuing military and economic domination of much of the world in this supposedly postcolonial age. However inspite of many excellent points, McClintock's theoretical framework is one I would quibble with. She describes the former Soviet Union as bent on arriving at a Hegelian-Marxist utopia, an imperialist power on a par with the USA, for example, and conceives of male elites and masculine militarism in imperialized and imperialist countries as a prime factor in the continuing impoverishment of millions of people. She concludes that 'Asking what *single* term might adequately replace "post-colonialism", for example, begs the question of rethinking the global situation as a *multiplicity* of powers and histories, which cannot be marshalled obediently under the flag of a single theoretical term, be that feminism, marxism or post-colonialism.'[35] In McClintock's recent book she reiterates this position: 'I wish to avoid privileging one category over the others as an organizing trope', seeking to maintain a commitment to equality

among oppressions of class, race and gender throughout her investig-ation.[36] She believes Marxism is economistic, and therefore cannot adequately conceive of the complex interactions of class, race and gender. 'A proliferation of historically nuanced theories and strategies is called for, which may enable us to engage more effectively in the politics of affiliation, and the currently calamitous dispensations of power.'[37]

McClintock believes that race, class and gender (and the theories that accompany their conceptualisation) must be borne in mind at all times, and at specific historical conjunctures and instances of cultural production, one of these categories will be more significant than the others. She believes that Marxism as a meta-theory cannot do this, but as I have argued above, this depends on a view of Marxism as concerned only with the economic in a reductive, not a dialectical way. McClintock does not want to concentrate only on race (she does not use the form 'race' in her writings), for example, but on all major categories of social oppression. Whatever category is seen to be most influential at any one time is apparently left up to the sensitive perception and knowledge of the particular critic, not embodied in the theoretical method with which s/he is working, nor emergent from the material being worked on. Now I would not disagree with the argument that certain images, books and other cultural products are more about gender, 'race' or sexuality than they are about other issues. They may of course be about none of these things. However where I would disagree with McClintock, in spite of her many interesting remarks about postcolonial criticism, is that the economic and material basis of a social structure such as imperialism is no more important than notions of gender and race in understanding historical and cultural developments. On the contrary, I would argue that we cannot fully understand particular representations of such notions as gender, 'race' and class if we do not ultimately attempt to locate them in specific economic conjunctures, and in the social relations which flow from these.

McClintock is willing to take on aspects of Marxist thought, purged of course of its supposed economism, and she allows class to operate as one category among others in her understanding and explanation of culture. However over the last few years many postmodern and postcolonial critics have scornfully rejected Marxism and the left in any shape or form, with varying degrees of antagonism. Cornel West, for instance, designates himself a Nietzschean genealogical materialist, stating that Marxism is Eurocentric, cannot account for racism, and does not concern itself with culture. For West the privileged material

mode of production is not located in the economic sphere, and at any given moment can manifest itself in the cultural, the political or the psychic.[38] Another writer on black culture, Paul Gilroy, states that 'Obviously people still belong to classes, but belief in the decisive universal agency of the dwindling proletariat is something which must be dismissed as an idealist fantasy. Class is an indispensable instrument in analysing capitalism, but it contains no ready-made plan for its overcoming'.[39] I think this last point is rather obvious, but it is certainly not something that has been argued by Marxists. If it were that simple, we would all now be living in postcapitalist societies. Stuart Hall, hugely influential on many younger black cultural critics, has moved further and further away from Marxism and now refers to its 'orthodoxy, doctrinal character, its determinism, its reductionism, its immutable law of history, its status as a metanarrative . . . a certain reductionism and economism, which I think is not extrinsic but intrinsic to Marxism . . . the profound Eurocentrism of Marxist theory'.[40] Similarly Kobena Mercer denigrates the 'puritanical conception of agency found in Marxist economism and class essentialism' and 'the political culture of sectarianism on the British Left – dominated by macho dogmatism and the authoritative stance of Leninist vanguard leadership . . .'.[41] This litany of scornful rejection continues when Bhabha, discussing the works of Franz Fanon, states that the memorable titles of his works

> reverberate in the self-righteous rhetoric of "resistance" whenever the English left gathers, in its narrow church or its Trotskyist camps, to deplore the immiseration of the colonized world . . . they sound the troubled conscience of a socialist vision that extends, in the main, from an ethnocentric little Englandism to a large trade union internationalism . . . Whenever questions of race and sexuality make their own organizational and theoretical demands on the primacy of "class", "state" and "party" the language of traditional socialism is quick to describe those urgent, "other" questions as symptoms of petty-bourgeois deviation, signs of the bad faith of socialist intellectuals.[42]

It is clear that there exists a strong dislike of, and antipathy to, Marxism and left politics among the 'radical' intelligentsia, especially among many black critics who see themselves as postcolonial and/or postmodern. This is understandable in some ways given the reluctance of many in the trade union movement to support anti-racist struggles, and the failure of some sections of the left to see racial oppression as a specific form of oppression which cannot be reduced to class, and which

will not automatically be overcome when capitalism is destroyed. However not all Marxists would argue this position. Even after the destruction of capitalism, much work would have to be carried out to educate and legislate people out of deeply ingrained ideological notions of 'race', gender or homophobic prejudice. Ideological notions will not disappear automatically 'after the revolution'.

However white writers on cultural studies have also been keen to distance themselves from Marxism, stating that we are now in the 'Post-Marxist' period. Angela McRobbie writes:

> Marxism, a major point of reference for the whole cultural studies project in the UK, has been undermined not just from the viewpoint of the postmodern critics who attack its teleological propositions, its meta-narrative status, its essentialism, economism, Eurocentrism, and its place within the whole Enlightenment project, but also, of course, as a result of the events in Eastern Europe, with the discrediting of much of the socialist project and with the bewildering changes in the Soviet Union which leave the Western critic at a loss as to what is now meant by right- or left-wing politics.

She concludes that a return to a 'pre-modern Marxism' as marked out by Jameson and Harvey is 'untenable because the terms of that return are predicated on prioritizing economic relations and economic determinations over cultural and political relations by positing these latter in a mechanical and reflectionist role'.[43] It should be clear to anyone who has followed my arguments in the earlier part of this book that a genuine Marxist analysis of politics and culture would never seek to explain them in a mechanistic and reflectionist way, and the crimes of degenerate Marxism cannot fairly be imputed to the method of Marxism itself. However all is not gloom and doom, and materialist arguments written from a left political perspective against postmodern and postcolonial approaches, particularly in relation to 'race', have appeared in, for example, the journal *Race and Class*.[44]

Late Capitalism

What is it about the present economic and political climate that has resulted in such a widespread rejection of, and sometimes revulsion from Marxism, not just from the right, but from the radical left in the field of art history and cultural studies? In order to examine this, I want to look at what Harvey and Jameson categorize as late capitalism

in the latter part of the twentieth century. I will then study in more detail Jameson's notion of postmodern culture and the political conclusions he draws from this. In doing so I will discuss whether it is accurate to characterize Jameson as a Marxist or Neo-Marxist (as he is commonly designated), and if so, what kind of Marxism he is practising.

Harvey basically sees postmodern culture and theory as progressive and radical, though he has some criticisms to make. He also attempts to relate postmodernism to its economic roots in late capitalism, and in this he is similar to Jameson. However Harvey is unsure as to whether capitalism has entered a distinct new phase or whether we simply perceive (or misperceive) the workings of late capitalism in new ways. Harvey seems to imply that capitalism can avoid crises and regenerate and stabilize itself, which Marxists would agree could happen on a short or medium-term basis, but not indefinitely. For Marxists, capitalism is riven with deep contradictions which cannot be overcome by peaceful, self-regulatory means. Both nationally and internationally, capitalism will compete for profits, and certainly will attempt to find new ways of doing this, but wars, famine and destruction of human beings and their environment are the increasingly common results of late capitalism in its old age. Harvey discusses capitalism after the Second World War, and describes the period 1945–73 as a Fordist-Keynesian one, where a boom based on mass-production of standardized products directed at mass markets allowed capitalism to stabilize itself. This was accompanied by state intervention and protected national markets. Fordism did not really spread to Europe till the 1950s, says Harvey, though it had been developed in wartime. The idea that capitalism can be stabilized by paying workers more for mass producing goods which they can then afford to buy is basically an under-consumptionist theory of capitalist crisis – give consumers more money and they will consume, and so there will be no crisis. However this assumes no competition for profits, and no tendency of the rate of profit to fall, which results from the fact that capitalists have to invest more and more of their profits into ever more expensive new technology, buildings, etc. Also Harvey pays no attention to the semi-colonial world where millions cannot afford the bare necessities of life, let alone cars, televisions, videos and fridge-freezers. He does not mention that a large part of the world in the post-war period was not capitalist, but postcapitalist, where the law of value was not the main factor in dictating production and distribution in the USSR, China, Poland, etc. The contradiction on a world scale between these two opposing economic systems for much of the post-war period was a major source

of conflict and instability and obviously had a huge influence on capitalist economics and the political strategies of imperialist governments.

Harvey describes the transition from Fordism to late capitalism as a move to what he terms 'flexible accumulation', thus solving the overaccumulation problems of capitalist crises.[45] He sees accumulation as the aim of capitalism (though he never really discusses the difference between imperialism and capitalism), but this is debatable in any case. The goal of capitalism is to realize profits – any society would seek to accumulate a surplus for emergencies, or even to barter, this would not make the accumulated goods commodities or the society capitalist. Some of this argument is similar to that of Callinicos, who, as a member of the British Socialist Workers Party, saw the former Soviet block as state capitalist, and capitalism defined by a drive to accumulation. Callinicos, though, certainly does not think that capitalism can avoid crises. He locates the difference between post-war Fordism and the postmodern period as a move from production-led to consumption-led capitalism. Specialized markets, designer values become more important than use values, 'just-in-time' stock-keeping, the use of a smaller multi-skilled workforce, and the development of a core/ periphery proletariat where smaller numbers of skilled workers are full-time while others are part-time and casualized.[46] Harvey argues that capitalism now seeks to recuperate itself in space and time, minimizing the time lapse between production, consumption and realisation of profit. He writes: 'Since crises of overaccumulation typically spark the search for spatial and temporal resolutions, which in turn create an overwhelming sense of time-space compression, we can also expect crises of overaccumulation to be followed by strong aesthetic movements.'[47] This is rather vague. Since capitalism is the dominant economic force in the world, it is clear that all aspects of human life, including perceptions and utilizations of time and space will be influenced by it, and they have been for a long time. Harvey ends up by hedging his bets about whether we are in a qualitatively new stage of capitalism – imperialism is scarcely mentioned by him as a useful category of economic periodization. He also has some odd ideas about Marxism for someone who has been termed a neo-Marxist, and describes the now defunct local London administration, the Greater London Council, as having been controlled by a Marxist left in the early 1980s when it is clear that their policies, though progressive, were left reformist and not designed to threaten capitalism or drastically reorganize local government through empowering self-elected organiz-

ations of local workplace and community groups. Also the concentration on consumption, advertizing and the instant gratification of media and commodity desire, which we will also find in Jameson's *Postmodernism*, may be true of certain classes in imperialist countries, and a much smaller number of people in the imperialized world, but it certainly overlooks the fact that instant consumption is not really an option for the vast majority of people in the world today.

Jameson's *Postmodernism*

Jameson also finds postmodern culture and thought exciting and stimulating. He is explicit in attempting to argue that postmodernism is explicable in terms of later twentieth-century economics, which he terms 'late capitalism', and, like Harvey, he prefers this term to imperialism. It is clear that this attempt to argue for the influence of economics on culture is what leads many to see Jameson as a leading Marxist critic. On the cover of *Postmodernism* is an extract from a review of the book by Terry Eagleton, a leading left literary critic in Britain: 'Fredric Jameson is America's leading Marxist critic ... *Postmodernism* is an intellectual blockbuster ... a timely riposte to fashionable leftist pessimism as much as it is an intellectual feast.' In fact Jameson is only somewhat less pessimistic than some other cultural critics, as we shall see later.

Jameson stresses that postmodernism is not primarily a stylistic definition but is the 'cultural dominant of the logic of late capitalism'.[48] He locates the beginnings of late capitalism in the post-war period, although postmodern culture is seen as emerging later. He believes that in late capitalism culture has no autonomy from the economic, therefore the whole issue of postmodernism is a political one. However he rather contradicts himself by later arguing that the sign is relatively free and autonomous from its object/referent and referent and reality are completely split, writing 'we are left with that pure and random play of signifiers that we call post-modern'.[49] Jameson uses Mandel's book *Late Capitalism* to periodize capitalist developments in three phases – market capitalism; monopoly capitalism or imperialism; and multinational capitalism – with three corresponding cultural movements of realism; modernism; and postmodernism.[50] Jameson states that Lenin's theory of imperialism was one describing 'little more than a rivalry between the various colonial powers', and has been developed into something much more useful for the understanding of contemporary capitalism by Mandel. This is debatable, for Lenin had already

noted the internationalization of capital and the growth of massive trusts and monopolies in the early twentieth century. For Jameson, the qualitative differences between the old imperialism and the new late capitalism are transnational businesses, international division of labour, international banking and stock exchanges, new forms of media interrelationship and transport systems, computers and automation and the movement of production to advanced 'Third World' areas.[51] I think it is debatable as to whether these developments constitute a modification and development of imperialism or whether they constitute a qualitative change based on the demise of imperialism as an economic system and the emergence of a distinctive new form of capitalism.

Jameson believes there is no individual or collective subject of history at present. He make no distinction between socialism and Stalinism, and states that the Soviet bureaucracy could have reformed themselves into genuine Marxists in the Khrushchev era.[52] He really does not understand Stalinism and has a soft spot for Castro whom he refers to by his first name, Fidel.[53] He does not seem to understand the inevitability of violence even in a healthy worker's revolution to overthrow the state: 'indeed the most effective form of counterrevolution lies precisely in this transmission of violence to the revolutionary process itself.'[54] He writes that we are in a trough where politics must concern itself with debate about concepts such as planning and socialism. There is no international proletariat at present, but one may emerge in the future. 'What is wanted is a great collective project in which an active majority of the population participates, as something belonging to it and constructed by its own energies.'[55]

Jameson's political pessimism results from a lack of understanding of the rise and nature of Stalinism and events after the Second World War. He even goes so far as to offer an apology for Heidegger's Nazi sympathies, stating that an engagement with fascist politics is at least better than being apolitical![56] For a critic hailed by so many as a Marxist, Jameson has a strange grasp of dialectics, and experiences it as paralyzing rather than empowering, rather like a rabbit caught in the two headlights of a car.[57]

Considering his interest in Hegel, it is surprising he does not investigate the contradictions and tensions within late capitalism and postmodernism. In fact his interest in dialectics is not really a Marxist one. For Jameson, Marxism is not a body of ideas that can be taken into struggle in the labour movement and among the oppressed where it can be a material factor. For Jameson Marxism remains at the level

of being a body of ideas. This political pessimism which links him to Adorno's negative dialectics and the Frankfurt school is rooted culturally in Jameson's admiration for Adorno whom he sees as a pioneer in the cultural analysis of the postmodern.[58] At times Jameson's distortion (or misreading) of Marxism is quite surprising for such a major scholar. For example he writes that politics is now concerned with economics in the postmodern age. Marxist political thought, however, has always been 'exclusively to do with the economic organization of society and how people cooperate to organize production'. Thus socialism is not a political idea, says Jameson, nor, presumably are various tactics and campaigns to tackle social oppression of various forms, abolish the age of consent, socialize childcare and housework, etc., etc.![59] It is not my intention here to deny the interesting and thought-provoking nature of Jameson's work. What I am concerned to question is the view that Jameson is a Marxist who offers a model of Marxist understanding of economics and society, and the political conclusions we can draw from this. As we have seen, politics is not really Jameson's strong point, and he states that Marxist politics are limited to the economic sphere. This really is not an adequate characterisation of Marxism.[60]

Paul Crowther writes that the neo-Marxism of Jameson fails to deal with postmodern society and suggest a response, concluding that 'This reflects fundamental problems which have always bedevilled Marxism; namely its continuing failure to articulate theoretically a positive theory of the relationship between the individual agent and broader socio-historical forces; and to clarify the relation between the cultural superstructure and socio-economic infrastructure of society'.[61] This statement is wrong on a number of counts. Specifically in relation to Jameson it is wrong because as we have seen it is not possible to take Jameson's views as articulating a Marxist view of the relationship of economics, culture, the individual and collective subject, and political action. It is certainly true, however, that changes have occurred in modern imperialism, and Lenin's work dating from the early twentieth century needs to be updated. Lenin located the export of capital mainly from the imperialist countries to the colonies, whereas in the post-Second World War period capital export is mostly between imperialist nations. He did acknowledge the fact of inter-imperialist investment but underestimated its potential growth.[62] During the 1980s, semi-colonial countries paid more to imperialist countries than they received in new loans and investment and through foreign trade, due to huge debt repayments.[63] The continuing financial interdependence of the major imperialist powers is in contradiction to their increasing rivalry,

and attempts to create new multinational trade blocks such as the European Union. The USA is at the same time still the most powerful nation in the world, and the world's biggest debtor. Nearly forty per cent of capital invested in the USA comes from Japan, one of its biggest economic rivals.[64] The imperialist powers do not have the capital to exploit the disintegrating Soviet block after winning the Cold War, as the remains of the bureaucratically planned economies are dismantled. It has been argued, convincingly in my view, that:

> The years 1969–73 were a major watershed in the world capitalist economy. The years before and after can be designated distinct periods in the imperialist epoch. These five years encompass the first significant US recession, a major acceleration in inflation, the end of fixed exchange rates, the declaration of economic unilateralism by the USA and the first generalized world economic recession of the post-war era.
>
> Before these years US imperialism was absolutely dominant; after them it was only relatively so, the first among equals.
>
> Before this transition period the USA could sustain world growth unilaterally; after this period it could do so only with the co-operation of first Europe, and later of Japan.[65]

Before this period, growth in the OECD countries was sustained, but after 1973 growth was lower and accompanied by inflation. Profitability declined in the 1970s with the exception of Japan. The ending of fixed exchange rates together with a massive influx of funds from oil-producing countries into the world money markets 'gave rise to a qualitative leap in the internationalization of finance, banking and equities which was outside of the control of national governments and central banks. This added to instability and increased the problems of policy co-ordination'.[66]

It has also been argued that service industries and consumerism have replaced an emphasis on production in heavy industry, so that late twentieth century capitalism is one of consumption, not production. There is certainly a destruction of heavy industry in mining and steel making, but it is somewhat undialectical to conceive of consumption without production. Commodities can be goods, but labour power is also a commodity, and the workers in service industries sell their labour power on the market. It is generalized commodity production which defines capitalism as an economic system, so the development of services and consumerism does not necessarily indicate some qualitative change in capitalism, as critics such as Baudrillard argue, though it can be termed a quantitative shift.

The problem for Marxists was to account for the revitalisation of capitalism after 1945. Trotsky had argued that Stalinism and imperialism would not survive the war, and optimistically predicted revolutionary upsurges. In the latter case he was correct, but these revolutionary movements were defeated by the Stalinists in a pact with the imperialists struck at the end of the war. Various theories were put forward to account for the survival and expansion of capitalism. One, the theory of the permanent arms economy, argued that military spending by the two 'imperialist blocks' offset the tendency for the rate of profit to fall, thus ensuring the medium-term survival of imperialist capital.[67] Another was Mandel's attempt to tackle the problem. Mandel, a leader of the United Secretariat of the Fourth International, one of the major splits from the Trotskyist Fourth International after the war, elaborated a theory of 'neo-capitalism' in the early 1960s. He argued that this was a new stage of capitalism qualitatively different from imperialism as defined by Lenin. Thus this new stage of capitalism would require a modified revolutionary programme based on 'structural reforms'. In a complete turn-around Mandel ditched his theory of 'neo-capitalism' in the early 1970s and published his theory of 'late capitalism' in 1972, stating that this theory developed the insights of Lenin and that 'late capitalism' is 'merely a further development of the imperialist, monopoly-capitalist epoch'.[68] Jameson, on the other hand, is concerned to distance 'late capitalism' from a Leninist notion of imperialism, stating that the new type of capitalism entails 'above all, the vision of a world capitalist system fundamentally distinct from the older imperialism'.[69]

Now this is not simply a scholastic or theological argument, as Jameson claims, before briskly moving on. As we see with Mandel, any Marxist who studies economics cannot ultimately separate economics from politics (though as we have seen, this is what Jameson does). Mandel's economic and political views interacted and influenced one another. Putting it crudely, if you argue that capitalism has transformed itself into something new, then the revolutionary methods valid for an earlier, different period are now outmoded and invalidated and need to be changed. And this is so for Jameson. The political conclusions drawn from his study of 'late capitalism' and its culture are rather dismal. It is true also that Mandel did attempt on occasion to separate economics and politics, and any reader who manages to reach the end of *Late Capitalism* will be left wondering what a Marxist response to this economic survey actually is.

In this situation much of the left struggled to come to terms with

the post-war world, and after 1968 many left intellectuals became disillusioned even with the student movements and guerillaism. Increasingly divorced from the labour movement and struggles of the oppressed, Foucault, Baudrillard and others gave up any commitment to Marxism, even as a theory, and their pessimistic trajectories are only different in degree from the likes of Jameson. Situating himself in the tradition of the Frankfurt school and post-structuralism, Jameson basically utilizes Hegelian Marxism as an interesting academic and theoretical method of cultural criticism. To be fair, he does not claim to be writing a book criticizing contemporary society and its culture. His application of dialectics seems to me to be rather wooden and convoluted at the same time, and he does not focus on contradictions within postmodern culture itself, merely seeing postmodernism as a strand in contemporary culture in conflict with others. There is a lack of theorization as to whether producers of postmodern culture consciously or unconsciously express the values of late capitalism. This is due to Jameson's avoidance of the whole issue of whether ideology is something different from reality. Similarly he takes over some of the postmodern notions of the death of the subject, but does not explain how this relates to the production of art works by known individuals in either a conscious or unconscious manner. There is a tendency in Jameson (and in Harvey) to try too hard to find forced analogies between economic aspects of contemporary capitalism e.g. consumerism, computer technology marketing as related to surface appearance and lack of depth in artworks. This is rather ironic since both are obviously claiming to distance themselves from what they designate 'economistic' Marxism. Jameson tries to get round this problem by claiming that contemporary culture is no longer the relatively free and autonomous modernism that it was under imperialist monopoly capitalism. So actually, for all the sophistication and density of Jameson's prose, in the end he is being identified as a Marxist because he tries to show that economics is *reflected* in culture, which is not what Marx and Engels said at all. He has not changed people's perception of Marxist analyses of culture, merely reinforced mistaken views and has taken a different route to do it – not via Marx, Engels, Trotsky, etc. but via Hegel, Lukács, Adorno and post-structuralism.

Stepping into Jameson's Shoes

Let us look at what this means for his discussion of the difference between modernism (Van Gogh) and postmodernism (Warhol). In a

well-known section of his book, Jameson compares and contrasts a painting of a pair of old shoes by Van Gogh (cf. figure 12) and a work by Andy Warhol, *Diamond Dust Shoes* (figure 13). Jameson is most vague about the actual works he is referring to, giving neither date, medium, location, nor mentioning any aspects of the historical context that art historians would want to consider in analysing the meanings of these works. He also does not mention that these works are part of groups, or series, of similar images. In fact the Van Gogh painting illustrated in Jameson's book is the 'wrong' painting. It shows a pair of old boots with the laces undone, and the tongue of one hanging out. One boot is turned upside-down and we can see the nails or studs facing upwards. The boots are resting on a dullish blue surface and the painting is signed in orange/red in the same colour as the boot-leather, 'Vincent 87'. However this first colour plate in Jameson's book is not the painting previously discussed by Heidegger, which he intended to analyse. This has been pointed out by several writers, notably by Meyer Schapiro, who illustrates the correct picture discussed by Heidegger in an article examining the painting (figure 12).[70] Warhol's black and white image of *Diamond Dust Shoes* is one of a number of images he produced of this subject in 1980 (figure 13). Jameson's lack of concern for the historical specificity of these works is symptomatic of his lack of interest in history in favour of rather general discussions in the sphere of philosophy of culture. One suspects he has chosen the Van Gogh because of the people who have written on it – which include Heidegger, Schapiro and Derrida – rather than because of the painting itself.[71]

The peasant shoes, says Jameson (following Heidegger) embody the truth of toil, misery and the soil, whereas Van Gogh's glorious coloured images of blossoming fruit trees represent the division of the senses replicating the specializations and divisions of capitalist life. This is a similar argument to that of Meyer Schapiro in his article from the late nineteen thirties, 'The Nature of Abstract Art', where he offers a view of impressionism as creating a field of specialized visual enjoyment for the enlightened bourgeois spectator.

In contrast, says Jameson, Warhol's *Diamond Dust Shoes* signify nothing and are merely a glossy surface appearance – a fetish in both Freudian and Marxian senses. The gender of the shoes, seen by Heidegger as belonging to a peasant woman, becomes important, as we shall see. While Jameson obviously enjoys postmodern culture, and does not condemn its lack of engagement with politics, he does ask the question of Warhol's work – why is it so apolitical when it is clearly about commodification? This is a significant difference from Van Gogh's

Figure 12 Van Gogh, *A Pair of Old Shoes*, oil on canvas, 37.5 × 45.5 cms, 1886, Stedelijk Museum Vincent Van Gogh, Amsterdam.

Figure 13 Warhol, *Diamond Dust Shoes*, synthetic polymer paint, diamond dust and silkscreen ink on canvas, 229 × 178 cms, 1980, The Andy Warhol Foundation. Photo copyright the Andy Warhol Foundation, Inc./Art Resource, N.Y., and permission from Design and Artist Copyright Society, London.

painting. Although commodities now, Van Gogh's pictures generally failed to enter the market when he was alive. He sold only a tiny number of works, and it is likely that even the shoes in the painting were not commodities in a pure sense since it is probable that Van Gogh bought them at a flea-market in Paris to wear himself.[72] Jameson muses on Warhol's shoes, which remind him of discarded shoes after a fire in a dance hall or mass murders at Auschwitz. The image 'which explicitly foreground(s) the commodity fetishism of a transition to late capital' puzzles Jameson with its emptiness, and lack of depth and emotion. Since the commodity is the defining feature of capitalist production, it is difficult to see how it relates so specifically to the transition to late capitalism rather than any other capitalism, and Jameson does not attempt to situate the image historically and economically to explain this. Instead he concentrates on the mutations in 'the disposition of the subject' and object world, which has now become a set of texts of simulacra (images of which there has never been an original in reality).

Whereas Van Gogh expressed anguish and alienation, Warhol's subject-ivity merely represents fragmentation. There is no dominant class ideology any more which we can conceptualize or represent, says Jameson.

Later in his book he explains that this is because 'no *functional* conception of a ruling group, let alone class, can be conceived. There are no levers for them to control and not much in the way of production for them to manage. Only the media and the market are visible as autonomous entities'.[73] Jameson remarks:

> If there is any realism left here (in postmodern culture) it is a "realism" that is meant to derive from the shock of grasping that confinement and of slowly becoming aware of a new and original historical situation in which we are condemned to seek History by way of our own pop images and simulacra of that history, which itself remains forever out of reach.[74]

Actually Jameson never really attempts to seek the history behind either the Warhol or the Van Gogh images. His remarks on the Warhol appear to owe a lot to Baudrillard's discussion of Warhol and the simulacrum.

For Baudrillard, the emergence of the simulacrum in contemporary culture is 'a question of substituting signs of the real for the real itself'.[75] Successive phases of the image have meant its disassociation from reality in phases linked to three historical periods: Renaissance to industrial revolution (reflection of reality); industrial era (it masks the absence of a basic reality); current phase (the image bears no relation to any reality whatsoever). We are no longer in the Situationist 'society of the spectacle', says Baudrillard, because the spectacle and the real have become the same. War is a simulacrum – the bombing of Hanoi in the Vietnam War is a simulacrum. (I hope I need not comment on the idealist nonsense of this sort of statement.) The global process of capital is founded in the sphere of the simulacrum, and Marx 'negligently' got it all wrong. Production of commodities, the sale of labour power, and the operation of the law of value in determining production are not what capitalism is really about:

> We know now that it is on the level of reproduction (fashion, media, publicity, information and communication networks), on the level of what Marx negligently called the nonessential sectors of capital (we can merely take stock of the irony of history), that is to say in the sphere of simulacra and of the code, that the global process of capital is founded.[76]

Now of course if Marx has got it all wrong, we have to discard Marxism as a method for understanding and attempting to change society and the economic system on which society rests. Jameson basically goes along with much of Baudrillard's remarks on the sign, but finds himself uneasy with the work of Warhol when it does not 'say' anything political. For Baudrillard, of course, this is not a problem. Baudrillard's idealist system-building does not illuminate particular art works much either. He states that Warhol's works show the duplications of the sign destroying its meaning. Multiple replicas 'of Marilyn's face are there to show at the same time the death of the original and the end of representation'.[77] In fact there are very few exact replicas in Warhol's work, and there are subtle differences in the repeated images of Monroe, Elvis, Jackie Kennedy and others whose images he used. Warhol's 'production line' was not in fact completely mechanical, but interestingly incorporated art, craft, and commercial production techniques in a more complex way than suggested by both Jameson and Baudrillard.

Jameson's admiration for Heidegger is a factor in his analysis of Van Gogh, as noted above. It is interesting that he makes a reference, almost in passing, to Auschwitz, as Jameson is keen in various parts of his book to stress the validity and interest of Heidegger's work in spite of his Nazi sympathies. These were clear enough. Heidegger welcomed the withdrawal of Germany from the League of Nations as a step towards its renewal so that the German people might 'grow in its unity as a work people, finding again its simple worth and genuine power, and procuring its duration and greatness as a work state. To the man of this unheard of will, our Fuhrer Adolf Hitler, a three-fold Sieg-Heil!'[78]

Strangely enough, when Meyer Schapiro discussed Heidegger's views on Van Gogh's old shoes, he does not mention anything about the political nature of Heidegger's beliefs and the context in which he wrote about the Van Gogh painting. However he quite rightly criticises Heidegger's writings on the picture as philosophy rather than art history. Heidegger's tedious style basically takes us through a Hegelian argument that the painting enables us to grasp the 'equipmental being of equipment' i.e. the truth of the shoeness of the shoes: 'This equipment belongs to the *earth* and it is protected in the *world* of the peasant woman. From out of this protected belonging the equipment itself rises to its resting-in-itself.'[79] Schapiro argues that the shoes probably belong to Van Gogh, and Heidegger has 'imagined' what he wanted to see in the painting influenced by his 'social outlook'. Also, although Heidegger states that he wants to conceptualize the materiality of the painting,

Schapiro correctly points out that everything Heidegger writes could have been written about an actual pair of shoes, and not a representation of one. However as an alternative to this Schapiro biographizes the shoes and sees them as a part of the 'self' of Van Gogh.

Heidegger's writings on the Van Gogh, first given as a lecture in 1935, are indeed full of subjective and tortuous 'readings-in' of the painting. In Van Gogh's painting, he writes, *'Art then is the becoming and the happening of truth'*. When art happens, there is a beginning and a thrust in history, a 'transporting of a people into its appointed task as entrance into that people's endowment'.[80] Not surprisingly, Heidegger defines Hegel's writings on art as 'the most comprehensive reflection on the nature of art that the West possesses'.[81] Heidegger completely detaches the work from its social and material context while claiming to emphasize its 'truth' and 'materiality'. However for Heidegger these concepts are idealist essences which manifest themselves and come into being through art. It is significant that there is not a discussion of the spectator in any of these articles. Although the painting is of course a material object and exists whether or not a spectator is there to view it, meaning is constructed by the spectator in various ways, according to her/his knowledge, education, social background, gender and so on. Even Jameson does not pay enough attention to the spectator's construction of meanings. This is not surprising, since he is very close to the postmodern positions which argue that the spectator cannot construct meanings, for it is s/he who is being constructed by the texts and images of postmodern culture.

In an excellent article which is a useful corrective to the weaknesses of the texts discussed above, John A. Walker correctly identifies the Van Gogh painting, situates it historically and artistically, and also situates the various critics and writers who have discussed it. The result is a stimulating and intelligent article, unfortunately overlooked by Jameson, which demonstrates how Heidegger's misreading of a city-dwelling man's shoes as a toiling peasant-woman's shoes was related to his Nazi sympathies and the ideology of 'blood and soil'. Walker concludes:

> What this study has highlighted, then, is the basic difference between philosophy and art history, namely, the fact that philosophy is not a *historical* discipline; neither Heidegger nor Derrida attempt to explain Vincent's painting by recourse to history. For the art historian, questions of truth and interpretation can be settled with a reasonable degree of certainty by situating the production and consumption of artistic signs

socially and historically. It is this ground which saves the art historian from the philosopher's fantasy world of metaphysical speculation.[82]

Although Walker's article was written before Jameson's book, these remarks could also apply to a philosophizing tendency in Jameson, which leads him away from actual historical specificities and towards a one-sided Hegelian tendency to seek for rather abstract embodiments of the 'spirit' of late capitalism in examples of postmodern culture. This is what he does with Warhol's *Diamond Dust Shoes* (figure 13).

Jameson sees Warhol's shoes as turning centrally around commodification, displayed as depthlessness accentuated by the 'deathly quality' of the X-ray elegance of the photographed image transferred onto silkscreen and/or canvas. The shoes used by Warhol had been bought by his assistant from a shop liquidating its old stock of shoes dating from the nineteen forties and fifties.[83] Warhol had started his commercial career in art as a designer of window displays and publicity and one of his first big clients was the shoe store I. Miller Shoes. The works therefore link the late to the early Warhol, inviting a 'biographisation' of the subject but also underlining the notion of a Warhol *oeuvre*, spanning several decades, in contrast to the non-subject Warhol of the postmodernists, or the positing of three Warhols by Tom Crow. For Crow, Warhol's work from the early nineteen sixties is qualitatively superior to anything he did later, and involved a humanistic critique of commodity capitalism arising from memory-traces of the working class youth of the artist. Crow's principal thesis 'is that Warhol, though he grounded his art in the ubiquity of the packaged commodity, produced his most powerful work by dramatizing the breakdown of commodity exchange'.[84] Crow argues that this breakdown is due to the death and suffering of the subjects of Warhol's work at this period, Monroe, Jackie Kennedy, Liz Taylor, etc. On the contrary, I think the production of images of these women (and others) as saleable commodities hardly epitomizes the 'breakdown of commodity exchange', as he puts it. Crow is concerned to rescue a part or a self of Warhol that can explain why such an apparently shallow media personality can make interesting images. In some ways this is similar to Jameson's unease with his admiration for the *Diamond Dust Shoes*. How can someone represent commodification and its fetishisation so perfectly yet seem to have no critique to make of it, either formally or in terms of use of subject matter? There still seems to be a desire to find a conscious subject Warhol whose intentions can be understood even in the midst of postmodern culture where the subject is fragmented and unknowable.

In a recent essay Terry Atkinson has taken issue with Crow's reading of Warhol as offering a critique of aspects of late capitalism, and he also rejects the notion of several Warhols. Atkinson sees Warhol as the perfect late-capitalist artist, 'the complete counter-revolutionary artist'. If there were several Warhols, argues Atkinson, they were personae cynically developed by the artist to better market his work.[85] Atkinson describes Warhol's use of diamond dust on his portrait of Joseph Beuys as 'a cardinal gesture of anointing Beuys's image on behalf of late capital . . . As I have suggested earlier, I think diamond dust is used as a proxy, a kind of understudy, for the promise of that fabulous wealth which acts as a main, yet indefinitely postponable, promissory note at the heart of late capital'.[86] This is obviously a subjective reading of the meaning of the image, and it is arguable that a more accurate embodiment of 'late capitalism' would be something to do with dealing in futures on a computer screen rather than anything as material as gold or diamonds. However the main point at issue here is an argument over the political and social critiques embodied, or not, in Warhol's works from different stages of his career. For Atkinson there is no historical distinction made – Warhol was always a reactionary artist. For Jameson too, historical periodization of his *oeuvre* is not an issue – Warhol is and was interesting, but he is disappointingly apolitical. Attempts are made to identify Warhol's conscious attitudes to politics and society to decide the meanings of his works, which indicates to me that even if Warhol's works are postmodern *par excellence*, they are certainly not being evaluated using postmodern theories, except in the pseudo-philosphizing references of Baudrillard.[87]

Warhol certainly stated that his works, even in the early sixties, were about the power of the commodity in social life: 'I adore America and these (works) are some comments on it. My image is a statement of the symbols of the harsh, impersonal products and brash materialistic objects on which America is built today. It is a projection of everything that can be bought and sold, the practical but impermanent symbols that sustain us.'[88] The fetish of the commodity, which objectifies and takes the place of the (suppressed) existence of social relations of production and consumption is certainly what is being discussed by Warhol here. However he implies that these symbols are not lasting, though it is not clear if he means that nothing is therefore permanent, or whether there is something more important and lasting that the commodity. Warhol's work, for me, embodies all the contradictions of American imperialism itself, the ability to develop genuinely interesting and pleasurable global media culture combined with and equally

unpleasurable global exploitation and disregard of basic human concerns, and I think it is rather mistaken to try to argue that Warhol was *either* progressive *or* reactionary. Many of his works represent in visual form both the attractive and pleasurable experience of consumer gratification, *and* the empty symbols of fetishism which displace real human relationships and history.

Warhol also managed to combine the creation of a star authorial persona with a relative creative distancing from many of his works, carried out in his so-called Factory by his assistants. In October 1980 Warhol recounts in his diary the production, indeed creation, of the diamond dust shoes prints:

> Rupert brought the proofs for the prints by that he's taken it upon himself to finish completely without ever showing them to me. He tried to be artistic and he sure was, he sure was. This is the Shoes with the diamond dust. He had them completely finished, with the diamond dust on and everything. I don't know why he did that. I'm doing shoes because I'm going back to my roots. In fact, I think maybe I should do nothing but (laughs) shoes from now on.[89]

Shortly after this entry Warhol mentions canvases developed from the prints: 'I decided to stay at the office and get some work done with Rupert on the diamond dust. If it were real, it would cost 5 dollars a carat and that would be 30,000 dollars or 40,000 dollars for each painting for the diamond dust alone.' He then goes out to the theatre and writes down details of the theatre tickets (32 dollars) and cab fare (6 dollars).[90] Combined with Warhol's use of the diamond dust and its cost, we find, throughout the diaries in fact, a meticulous and probably obsessive detailing of relatively small amounts spent on items like pizzas and cab fares. Yet from the seventies, Warhol's business was financially successful, and individuals were charged 25,000 dollars for a photoshoot and the production of a four foot square canvas portrait.[91]

John A. Walker points out that Warhol's production methods are at the same time challenges to, and affirmations of, the notion of creative art. Silkscreen printing involving photographic and printing processes implies repetition, partial mechanization and the use of other workers in the production process. Yet it is not fully mechanized and is artisan/ skilled labour. At the same time Warhol's factory products were definitely consumed as art works authorized by Warhol, not mass produced anonymous images. Attempting to assess Warhol's significance, Walker offers a coherent and astute summary of the contradictions in repres-

entations of American capitalist society in Warhol's work. He concludes: 'his work is about the politics of pictorial representation as opposed to the political issues directly depicted by such representations.'[92] Warhol's stated admiration for consumerism, the fact that the president, Liz Taylor, and a down-and-out tramp can all drink a Coke and consume exactly the same product, does make a valid point about mass production and consumption, says Walker. However Warhol's oft-quoted statements about the similarity of capitalism and communism as social systems which result in levelling, uniformity and gradual eradication of human individualism, are obviously rather crude. As Walker puts it:

> He does not pause to consider whether or not a drink such as Coke is socially beneficial or necessary, whether or not it meets any real needs of the human species. Nor does he consider the reasons for its worldwide manufacture: it is not produced as a social service but in the interests of private profit. Choice in terms of consumption does not mean choice in terms of production (that is, control by the people over what is made, how much, and for whose benefit). The poor and the rich can consume the same soft drinks but the rich can consume them in much larger qualities. Also, it is obvious that this 'equality' of choice does not apply to more expensive items such as housing, welfare, health and education.[93]

Walker sees the contradictions in Warhol's work and locates them within American imperialism, its economy and culture. He also makes aesthetic and historical judgements about the contribution of Warhol to the development of visual culture without opting for the either/or, progressive/reactionary choices which are fundamentally undialectical. Walker terms Warhol a 'capitalist realist', 'one of the few contemporary artists willing to be honest about the capitalist nature of art under capitalism'.[94] Jameson, however, although he clearly admires Warhol's work, remarks later in *Postmodernism* that he is not in the business of approving or disapproving of various forms of culture: 'The point . . . is to search out radical historical difference and not to take sides or hand out historical certificates of value.'[95] It is certainly true that we should not be seeking to elaborate a cultural history or criticism which takes sides according to crude political allegiances, but the idea that one cannot and should not make value judgements based on historical evaluation seems to me to be a rather dubious abstentionism on Jameson's part, and related to his attitude to Heidegger and De Man, whose Nazi sympathies Jameson divorces from their philosophical writings.[96] Since Marxism seeks to understand history with a view to

situating ourselves consciously in the present and elaborating a politics for changing the future, the notion that we cannot make any value judgments about culture seems rather un-Marxist. Culture is not the same as economics or society but as part of the material world it demands understanding and assessment, otherwise we would all simply be in the position of passive consumers who accepted everything that was offered to us by individual artists, media companies or arts organizations funded by local and national state bodies.

The Art of the Postcolonial

While some postmodernists still retain an interest in the statements of artists themselves and their intentions, most sympathize with theories which undermine the ability of producers and spectators consciously to interact with cultural productions, since the visual culture is primarily seen as a text which constructs the viewing subject. This is a contradiction which is also present in much postcolonial criticism, as, for example, when the views of black artists are incorporated into discussions of how cultural discourses construct us as gendered and racialized decentered subjectivities. I want now to examine this further by discussing work by Renée Green and Lyle Ashton Harris.

The main problems I have with the application of postcolonial criticism to culture are firstly, serious disagreements with the project of postcolonial criticism itself, and secondly the inadequate nature of postcolonial theory and method in analysing actual works of visual culture. As for the first point, I can add little to the excellent critiques of postcoloniality put forward by Aijaz Ahmad, both in his book *In Theory* and in his 1995 article on literary postcoloniality.[97] Ahmad explains how the term postcolonial was developed in the 1970s as part of a political debate on the changed nature of imperialist exploitation of semi-colonial countries. This political and economic dimension has now been completely lost, particularly in the work of Bhabha. The specificity of the term used politically has now been dissolved into a vague glorification of political and, especially cultural, hybridity, in-betweenness, marginalization and contingency. Hybridity is now seen as universal in postmodernity and postcoloniality, gutted of any links with the exploitative relationship of imperialism to semi-colonial countries. As Ahmad states:

> By the time we get to Bhabha, the celebration of cultural hybridity, as it is available to the migrant intellectual in the metropolis, is accented even

further: America leads to Africa; the nations of Europe and Asia meet in Australia; the margins of the nation displace the centre . . . The great Whitmanesque sensorium of America is exchanged for a Warhol blowup, a (Barbara) Kruger installation, or Mapplethorpe's naked bodies.

Ahmad points out correctly that 'Among the migrants themselves, only the privileged can live a life of constant mobility and surplus pleasure, between Whitman and Warhol as it were'. Most migrants are poor, perhaps seeking political asylum, locked up in detention centres, or illegal immigrants liable to persecution by the state and the police. The abstract glorification of hybridity by writers such as Bhabha, and to a lesser extent Stuart Hall and Kobena Mercer, simply ignores the questions concerning whose culture one is to be hybridized into, and on whose terms. (Think of being 'hybridized' into the recent culture of the Bosnian Serbs.) Ahmad rightly points out that 'Postcoloniality is also, like most things, a matter of class'.[98]

Mercer, Hall and Bhabha were all recently involved in a series of cultural events in Britain organized around a celebration of the work of the political psychiatrist and writer Franz Fanon. Born in Martinique, Fanon later worked in Algeria, supporting the anti-imperialist struggles of the Algerian nationalists before his early death in 1961. An exhibition of visual arts, *Mirage. Enigmas of Race, Difference and Desire*, Institute of Contemporary Arts, London, 1995, was organized to explore issues raised in Fanon's famous book *Black Skin, White Masks*, 1952. Mercer contributed a major essay to this publication, arguing for the key positions of postmodernity and postcoloniality in an age where Freud and Marx are (ethnographic?) museum pieces. Mercer asks why the new directions developed by the postcolonial critics including hybridity have not been acknowledged:

> While the insights of postcolonial theory arose from what could be called an anaclitic [attachment to another] relationship to the 1970s feminist turn to psychoanalysis, for the purposes of thinking why it is that social relations are so resistant to progressive political change, there seems to be a paucity of acknowledgement of the genuine process of hybridisation whereby diaspora practitioners have re-accentuated the dialogue which previous generations sought in the hyphenation of Freudo-Marxism (a word which today reeks of the funky, musty, smell of hippy kinship arrangements).[99]

Linked to the exhibition, a symposium was organized at the Institute of Contemporary Arts, London, bringing together participants who

included some key postcolonial critics and artists exhibiting in *Mirage*. A book of the contributions has been published.[100] In this, Hall and Bhabha not surprisingly use Fanon and his work to explore their own interests in hybridity and postcoloniality. Fanon is presented, especially by Bhabha, as a precursor of the postmodern and postcolonial critic, in whose footsteps they follow – a migrant, diasporic intellectual, dismissive of traditional psychoanalysis and Marxism. This usage of Fanon is suspect, in my view, but it is quite clear that it fits into the general political and cultural trajectories of Hall, Mercer and Bhabha, who in varying degrees now reject Marxism. In his foreword to Fanon's *Black Skin, White Masks*, Bhabha writes, as we noted above, that the titles of Fanon's books 'reverberate in the self-righteous rhetoric of "resistance" whenever the English left gathers, in its narrow church or its Trotskyist camps, to deplore the immiseration of the colonized world.'[101]

The exhibition and the symposium attempted then to construct a postcolonial analysis of visual culture – most of the previous work of postcolonial criticism focuses on literature. In both the catalogue and the published symposium discussions, quotations from the artists are used, quite rightly of course, and artists participated in the discussions. However Renée Green interestingly queried the notion of the 'artists' panel' on which she had been invited to sit, as if the real theoretical debates were the province of the 'critics' while the art was in danger of merely becoming a decorative backdrop.[102] Now of course it is crucial to involve artists in the discussion of the meanings of their own works, and to break down barriers between artistic theory and practice. However I would argue that this causes a problem for postcolonial criticism. Since it views the subject as decentered, constantly in flux and reinvention, constituted by discourses, why should we pay any particular attention to what artists say about their intentions in creating works? After all it cannot be 'true', the artist is not a coherent subject, intentionality and agency are fictions, so why are the statements of artists given any more weight than the words of any other person speaking about the works? The answer is of course, that Bhabha and other postcolonial critics give privileged position to the artist's discourse' when it happens to agree with their own views, as we shall see. What I will consider in more detail now, is whether the theories of post-coloniality and the analyses of the artworks actually provide a more accurate assessment of the meanings of 'postcolonial' art than can be achieved by refocusing the theories of the old moth-eaten Freud and Marx. Are notions of hybridity, in-betweenness (Bhabha's favourite),

marginalization, nomadic subjectivities, contingency and displacement really the main issues in the work of Green and Harris in the *Mirage* exhibition? I cannot discuss all of the works exhibited so have chosen to concentrate on *Revue* (1990) by Green (figures 14 and 15), and *Toussaint l'Ouverture* (figure 16) and *Venus Hottentot 2000* (1994) by Harris (figure 17).

Revue is a mixed media installation. The title appears to refer to the revue as in *Revue Nègre*, the show in which Josephine Baker made her first major appearance in Paris in 1925, and revue as in re-seen or seen again, referring to images and texts we are already familiar with, but need to look at again. Horizontally are placed eight variations of a photograph of Josephine Baker in an 'artistic' but revealing pose; a box on the wall with plastic models of children's toy wild animals (probably made in China in a special economic zone factory if they are the same as the ones on sale in Britain) including a giraffe, a gorilla, and lions; underneath on the floor inside what looks like a pianola roll is a white box on which is placed a leopard. This revolves slowly and light shining through the holes in the pianola roll makes spots which move over the leopard and the box. Vertically, framed pieces of paper are mounted on the wall. Printed in an old-fashioned typeface and made to look 'archival' these texts range from remarks of theatre and dance critics about Baker's performances, an extract from the contemporary cultural historian Sander Gilman's famous essay on representations of the sexuality of the black woman and the prostitute, and a reply from Josephine Baker herself: 'The rear end exists. I see no reason to be ashamed of it. It's true there are rear ends so stupid, so pretentious, so insignificant that they're only good for sitting on.' Some texts make the link between the way Baker was seen and the display of the so-called 'Hottentot Venus' as the supposed essential African woman in the early nineteenth century.[103] Another text raises questions of the stereotyping of racial identity and difference: 'I got so into the dance that for a moment there I really thought I was black myself.' Perhaps the most telling is one written by André Levinson in 1925:

> Certain of Miss Baker's poses, back arched, haunches protruding, arms entwined and uplifted in a phallic symbol, had the compelling potency of the finest examples of Negro sculpture. The plastic sense of a race of sculptors came to life and the frenzy of African Eros swept over the audience. It was no longer a grotesque dancing girl that stood before them, but the black Venus that haunted Baudelaire.[104]

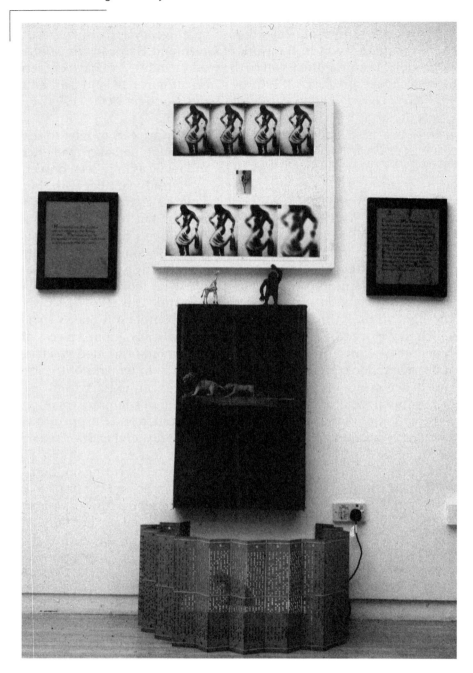

Figure 14 Renée Green, *Revue,* Mixed media installation, 241 × 638 × 36 cms, 1990, Courtesy Pat Hearn Gallery New York.

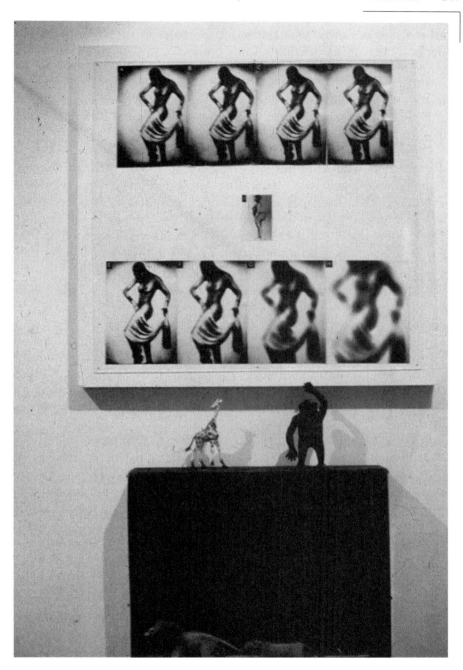

Figure 15 Renée Green, *Revue*, Mixed media installation, 241 × 638 × 36 cms (detail), 1990, Courtesy Pat Hearn Gallery New York.

Thus Baker is viewed as a classic fetish object in the Freudian sense, her body becoming the phallus in a process of (mis)recognition which reassures the pleasured male viewer that the woman and specifically the black woman, is no threat to his masculinity or his Frenchness. Indeed the real Baker ('a grotesque dancing girl') is in essence an abstract and unattainable concept of a 'haunting' Black Venus – a myth responsible for gems of European modernist culture.

Green has constructed a powerful installation which at the same time deconstructs what it represents – the essence of the African woman. This essence never was, in reality, but was constructed by white explorers, 'race' scientists, cultural critics and modernist poets. Baker was from an urban environment in the USA, yet her initial fame in Europe depended on her being presented as the quintessential African female. As a professional performer, Baker certainly had to negotiate her own relationship to cultural images of the beautiful black female body in somewhat contradictory ways. Alongside mass produced models, made by highly exploited workers, of exotic animals and 'endangered species' displayed in boxes and a small 'peep-show', the photograph of Baker begins as a focused image of an individual but gradually distorts to a vague iconic type. Green has explicitly stated that: 'I wanted to make shapes or set up situations that are kind of open . . . My work has a lot to do with a kind of fluidity, a movement back and forth, not making a claim to any specific or essential way of being.'[105]

Bhabha emphasizes these views by Green as examples of postcolonial hybridity and empowerment, contingency and contradictoriness. However, leaving aside the argument that much good art will be open, fluid and suggestive, rather than attempting to articulate one meaning or way of being, is Green really representing what Bhabha defines as the postcolonial in method and meaning? It is clear that Green wants viewers to reject the essentialist notion of the 'African woman', but this rejection does not necessarily entail an acceptance of contingency and hybridity. In order to understand why and how black people, and black women in particular, were commodified and sexualized, we need to think beyond the contingent. Otherwise how do we conceptualize the historical and cultural meanings of Saartje Baartmann, (the 'Hottentot Venus') and Josephine Baker? Discussing the anti-essentialism of poststructuralists and postcolonialists, Kenan Malik argues that their anti-essentialism has thrown the baby out with the bathwater: 'For poststructuralists . . . it is an outlook that renders all determinate relations contingent, bereft of any inner necessity.' Defending the need

for totalizing theory, Malik writes that a racist and non-racist inter-
pretation of history are not equally valid, just as are views which see
the French Revolution as a bourgeois revolution and those which argue
the opposite. Ironically, writes Malik:

> The paradox of poststructuralist anti-essentialism, then, is this: it is an
> outlook that arises from a desire to oppose naturalistic explanations and
> to put social facts in a social context. But in rejecting all essentialist
> explanations, in celebrating indeterminacy and in opposing the idea of
> totality it has undermined its own ability to explain social facts histor-
> ically. Facts, wrenched from their living context, are apprehended only
> in their isolation. The irony is that this methodology resembles nothing
> so much as the empiricism of the positivists, the very outlook anti-
> essentialism sought to overturn.[106]

Green's work obviously encourages a questioning of essentialism, but
also an awareness of history and of social oppression – a social oppress-
ion based on gender and 'race' which concerns the women referred to
in *Revue* but also the artist herself. However once these questions are
embodied visually in the form of suggestive art, the viewer may, or
may not, interrogate her/his own position in relation to this historical
and cultural 'revue' of the oppression of black women. In a contribution
to the panel discussion at the ICA Green stated that she was trying to
develop ideas round spectatorship and pleasure raised by Laura Mulvey
and other film theorists in the 1980s:

> without relinquishing pleasure or history. I used a clinical engraved image
> of the Hottentot Venus, a combination of texts by critics of Josephine
> Baker and a nineteenth century traveller's text, an iconic and progressively
> altered photographic image of Baker herself, a quote from Baker and a
> simulated toy circus with a revolving toy leopard. These elements in
> combination were intended to stimulate viewers into imagining in-
> between spaces: in-between what is said and what is not said and ways
> of being that didn't quite fit into what seemed to be the designated
> categories . . . For myself I try to think of how I also occupy various kinds
> of positions; as a visual producer, as a theorist, as a critic, as a viewer and
> as a reader.[107]

This refusal of essentialism and stereotypes is obviously important
for black artists, who generally do not want to be seen as 'a black artist'
even if their work explores areas of 'race' and identity. However I do

feel that the kind of 'in-betweenness' and fluidity suggested so power-
fully by Green in *Revue* and other works, along with her interrogations
of her positions and identities, are not the same as what is being argued
by Bhabha in his theories of postcoloniality even though many black
artists acknowledge the impact of Bhaba's writings on them. Green is
obviously a contemporary artist, female and black, and therefore in
some ways a discursively constituted subject, as we all are, yet primarily
Green is a real-life woman in a particular economic, historical and
cultural conjuncture both within the contemporary USA and within
the world position of the USA. Clearly Green as a black woman is aware
of the history of black oppression and exploitation of black women.
However for Bhabha this would merely be a minor consideration in
his emphasis on the superior and exciting positionalities open to the
postcolonial intelligentsia. I must confess I found Green's work much
more engaging and thought-provoking that the comments of Hall,
Mercer and especially Bhabha. In fact the above critics rarely mentioned
actual works in any detail, leaving the reader to attempt to relate the
poststructural and postcolonial theories to actual artworks. When this
is done, 'in-betweenness' does not seem the major explanatory concept
in political or cultural history, though it is probably relevant to any
decent art work ever made. Bhabha argues that 'it is the realm of
representation and the process of signification that constitutes the space
of the political'.[108] This is why it is important to challenge his cultural
theories, since for him they are political theories. In postcoloniality,
the cultural becomes the social foundation and the ideological becomes
the real. However Green's work is not offering a theory of postcolonial
culture and although informed by theory, does its work by visual
suggestion and juxtaposition. Although the spectator who views the
work will clearly be in some senses 'constructed' by the work for
however brief a time, the spectator is an actual person who pre-exists
the work and will presumably go on with her/his life after encountering
the work. Also we should remind ourselves of all the now unfashionable
discussions from the 1970s about accessibility, public and community
art, etc. which tried to address the question of access to art, class and
audience and other related issues. Although I personally found Green's
work powerful, effective and accessible, I was already aware of the
archival and visual references she drew on. I am not arguing here for
all art to be in the street or 'popular' and so on, merely that we should
not forget in the airy discussions of academic postcoloniality that there
is another world 'out there' that is increasingly ignored by critics such
as Bhabha.[109]

Lyle Ashton Harris' contribution to the *Mirage* show was entitled *The Good Life* (1994). It consists of a series of large full-colour photographic prints by Harris and smaller photographic images taken from a large archive created by Harris' grandfather, an economist at the Port Authority in New York City, dating from the 1940s. The smaller photographs from the past are grouped together and pinned onto the walls, whereas the large saturated colour prints are more like public art objects framed for display in galleries. The private and public aspects of black history and the black 'family' are constructed by Harris and further developed: 'In exploring his archive I became very interested in the different ways he and I portrayed the family.I see my project as an expansion of his documentation.' For Harris, history, accompanied by a questioning of the self in history, is crucial to his project. As a gay man, he asks questions about sexuality and identity often absent from 'black culture'. Significantly he also desires to participate as an equal in what he calls 'international humanism', a notion rejected by Bhabha in favour of the contingent and the marginalized. 'To what extent has the notion of black masculinity betrayed femininity or has betrayed us? Do we have access to international humanism? I'm interested in that but not as a second class citizen. I am interested in the extent to which my history and I have charted the ground.'[110]

In Harris' own large-format polaroid portraits the sitters are posed against the luscious colours of the red, green and black UNIA (Universal Negro Improvement Association) flag. Harris, in various guises, and other models are posed as Michael Stewart (a young black man beaten to death by police), the Venus Hottentot, and Toussaint l'Ouverture, among others. *Toussaint l'Ouverture* (figure 16) is Harris himself in a masquerade self-portrait, at once an image of revolutionary and heroic black masculinity (l'Ouverture was leader of a successful slave revolt in San Domingo against the French), and a beautiful desirable body in drag, complete with false eyelashes and make-up.[111] He is sitting on a gilded chair. The photograph is framed in an ornate gold frame. This is a stunning, luscious but amusing image, aptly described in the handout provided by the ICA as interweaving 'black pride, pleasure, desire and black history'.

In *Venus Hottentot 2000* (figure 17) a collaboration between Harris and Renée Valerie Cox, the millennium black Venus appears not as a specimen of natural history scrutinized by scientists, but directly engaging the spectator's look. Tied on to the body are false breasts and buttocks, mockingly disguising the lack of such essential 'black' characteristics for the racist definitions of the black woman, and/or

Figure 16 Lyle Ashton Harris, *Toussaint l'Ouverture*, Duraflex colour print 40.5 × 50 cms, 1994, photo courtesy of Jack Tilton Gallery, New York.

Figure 17 Lyle Ashton Harris, *Hottentot Venus 2000*, Duraflex colour print 40.5 × 50 cms, 1994, photo courtesy of Jack Tilton Gallery, New York.

making it impossible for us to know whether a particular modern black woman has these characteristics or not. Functioning as racial and sexual fetishes simultaneously, they reassure and yet always embody the unease and instability of the viewer, caught in pleasure which can never reveal enough to satisfy.[112] Harris intended this collaborative work to reclaim the image of the Hottentot Venus, whose large buttocks were exhibited to viewers in the early nineteenth century and after her death as proof of the primitive sexuality of the African woman. Harris describes his relationship with the work as

> a way of exploring my psychic identification with the image at the level of spectacle. I am playing with what it means to be an African diasporic artist producing and selling work in a culture that is by and large narcissistically mired in the debasement and objectification of blackness. And yet, I see my work less as a didactic critique and more of an interrogation of the ambivalence around the body. Engaging the image of the Hottentot Venus has deepened my understanding of the body as a sight of trauma and excess.[113]

Harris situates the body and desire within his own family and extended family but also within a black historical family, drawn from male and female heroic figures and martyrs. Importantly, these images are not representing victims, although the actual deaths of the original 'Hottentot Venus' and Michael Stewart were obviously tragic. The playfulness and element of performance in Harris' images accompanies an attempt to engage the spectator on a number of levels including serious awareness of black history. Harris makes his own history and constructs his own historical family at the same time as we realize that it is not constructed as contingent and 'in-between' but as part of an over-reaching totality mapped out by the colours of Marcus Garvey's UNIA flag which were also painted on the gallery walls as well as being used as a ground for the portraits. Yet Harris' exhibit obviously transcends Garveyism in its examination of issues concerning sexuality and gender. While questioning identity, sexuality and social and historical location, Harris' work in this exhibition, for me, went beyond the limitations of postcolonial theory, not only in its content but in its form. The desire to situate oneself in history, while at the same time questioning that self and that history, does not need to culminate in a poststructuralist disintegration of the self into the fragmentary and the contingent. Also the convoluted nature, and somewhat

pessimistic implications of many postcolonial critics seem drab along-side the striking images produced by artists who live through and with contradictions, and yet manage to embody these in images full of sensuality and visual pleasure.

Notes

1. Doy, *Seeing and Consciousness*, chapter 7.
2. H.K. Bhabha, *The Location of Culture*, London and New York, 1994, p.28.
3. E. Chaplin, *Sociology and Visual Representation*, London and New York, 1994, p.145.
4. Ibid., p.144, quoting L. McDowell.
5. Wolff in R. Boyne and A. Rattansi, *Postmodernism and Society*, Basingstoke, 1990, p.205.
6. For a sound political analysis of these issues see C. Lloyd, 'Marxism Versus Postmodernism', *Trotskyist International*, 21, January–June 1997, pp.38–48.
7. On Foucault see J. Teichman and G. White eds, *An Introduction to Modern European Philosophy*, Basingstoke, 1995, chapter 13, by S. Christmas.
8. A. Callinicos, *Against Postmodernism*, p.82.
9. Teichman and White, p.187.
10. D. Harvey, *The Condition of Postmodernity*, Oxford and Cambridge Mass., 1990, p.46.
11. Quoted by K. Malik, 'Universalism and Difference: Race and the Post-modernists', *Race and Class*, vol. 37, part 3, 1996, p.8.
12. Ibid., p.8.
13. Bhabha, *The Location of Culture*, pp.179, 190.
14. Chaplin, p.124.
15. Harvey, p.53.
16. For a summary of Baudrillard's theories, see Chaplin, pp.126–32.
17. Boyne and Rattansi, p.130.
18. Callinicos, p.145.
19. See for example J. Wolff, mentioned above, and the various books on postmodernism by Christopher Norris, e.g. *The Truth about Postmodernism*, Oxford and Cambridge Mass., 1993.
20. Harvey, p.48.
21. Engels, *Ludwig Feuerbach and the End of Classical German Philosophy*, Moscow, 1978, pp.47–8.

22. Lenin, *Materialism and Empirio-criticism*, p.77.

23. Ibid., p.90.

24. Bhabha, *The Location of Culture*, p.173. Rosi Braidotti's approach parallel's Bhabha's within feminist postmodernist theory, though with more emphasis on corporeality as a site of shifting subjectivities. See R. Braidotti, *Nomadic Subjects: Embodiment and Sexual Difference in Contemporary Feminist Theory*, New York, 1994.

25. A. Ahmad, *In Theory. Classes, Nations, Literatures*, London and New York, 1992, p.196 writes: 'Books that connected oppression with class were not very useful, because *they* (the postcolonial intellectuals) neither came from the working class nor were intending to join that class in their new country. Those who said that the majority of the populations in Africa and Asia certainly suffered from colonialism, but that there were those who benefitted from it, were useless, because many of the new professionals who were part of this immigration themselves came from those other families, those other classes, which had been the beneficiaries.'

26. J. Nederveen Pieterse and B. Parekh eds, *The Decolonisation of Imagination. Culture, Knowledge and Power*, London and New Jersey, 1995, p.14.

27. Ibid., quoted on p.13.

28. Quoted by Ahmad, p.197. Ahmad's book has some very perceptive comments on the postcolonial critic, Orientalism, and notions of Third World literature which are very useful in formulating critiques of the approaches of Said and Bhabha.

29. See for example Said's article 'He won't gag me' in *The Guardian*, August 23, 1996, p.13.

30. C. Pajaczkowska and L. Young, 'Racism, Representation, Psychoanalysis', in J. Donald and A. Rattansi eds, *"Race", Culture and Difference*, London, 1992, p.198.

31. T. Eagleton, F. Jameson, E.W. Said, *Nationalism, Colonialism and Literature*, intro. S. Deane, Minneapolis, 1990, p.47.

32. See my *Seeing and Consciousness*, pp.186–9; Ahmad, 'Marx on India: A Clarification', in *In Theory*, chapter 6; B. Chandra, 'Karl Marx, his theories of Asian societies and colonial rule', chapter 14 in *Sociological Theories: Race and Colonialism*, Unesco, Paris, 1980.

33. For critiques of Jameson's position as 'too utopian' and his continued construction of 'otherness' in the Third World, see respectively C. West, 'Fredric Jameson's American Marxism', chapter 11 in *Keeping Faith: Philosophy and Race in America*, New York and London, 1993, and Ahmad, 'Jameson's Rhetoric of Otherness and the "National Allegory"', chapter 3 in *In Theory*.

34. Said, 'Yeats and Decolonisation' in *Nationalism, Colonialism and Literature*, p.71.

35. A. McClintock, 'The Angel of Progress: Pitfalls of the Term "Post-colonialism"', in P. Williams and L. Chrisman eds, *Colonial Discourse and Post-Colonial Theory. A Reader*, Hemel Hempstead, 1994, pp.302–3.

36. A. McClintock, *Imperial Leather. Race, Gender and Sexuality in the Colonial Contest*, London and New York, 1995, p.8.

37. Ibid., p.396.

38. West, *Keeping Faith*, p.266.

39. Gilroy in Donald and Rattansi eds, *"Race", Culture and Difference*, p.58.

40. L. Grossberg, C. Nelson, P. Treichler eds, *Cultural Studies*, London and New York, 1992, p.279.

41. K. Mercer, *Welcome to the Jungle. New Positions in Black Cultural Studies*, London and New York, 1994, pp.279, 281.

42. Bhabha, 'Remembering Fanon: Self, Psyche and the Colonial Condition', in Williams and Chrisman, *Colonial Discourse*, p.112.

43. McRobbie, 'Post-Marxism and Cultural Studies: A Post-script', in Grossberg, Nelson, Treichler, *Cultural Studies*, p.719.

44. See for example, S. Vieux, 'In the Shadow of Neo-liberal Racism', *Race and Class*, vol.36, no.1, 1994, pp.23–32, and K. Malik, 'Universalism and Difference: Race and the Postmodernists', *Race and Class*, vol.37, no.3, 1996, pp.1–17. Malik's recently published book *The Meaning of Race. Race, History and Culture in Western Society*, Basingstoke, 1996 is also very useful. Thanks to Val Hill and Abish Eftekhari for references from *Race and Class* and other journals. The first three issues of the journal *Transformation. Marxist Boundary Work in Theory, Economics, Politics and Culture* include materialist theoretical discussions of imperialism and the postcolonial, lesbian and gay issues, and postmodernism. Also interesting is the collection edited by Donald Morton, *The Material Queer. A LesBiGay Cultural Studies Reader*, Boulder, Colorado and Oxford, 1996.

45. Harvey, *The Condition of Postmodernity*, pp.174–5.

46. Callinicos, *Against Postmodernism*, pp.134–6.

47. Harvey, p.327.

48. Jameson, *Postmodernism*, p.46.

49. Ibid., p.96.

50. Ibid., pp.35–6.

51. Ibid., p.xix.

52. Ibid., p.274.

53. Ibid., p.354.

54. Ibid., p.402.

55. Ibid., p.278.

56. Ibid., p.257.

57. Ibid., p.47.

58. See Jameson, *Late Marxism. Adorno, or, the Persistence of the Dialectic*, London and New York, 1990. See also the review of this book by J. Murphy '"The Wrong State of Things". Adorno's Marxism for the '90s', in *Afterimage*, May 1991, pp.12–13.

59. Jameson, p.265.

60. For other critiques of Jameson from somewhat different perspectives, see A. Callinicos, 'Drawing the Line', *International Socialism*, no.53, Winter, 1991, pp.93–102; S. Giles, 'Against interpretation? Recent Trends in Marxist Criticism', *British Journal of Aesthetics*, vol.28, no.1, Winter 1988, pp.68–77; D. Latimer, 'Jameson and Post-modernism', *New Left Review*, November/ December 1984, pp.116–28. A recent book by C. Burnham, *The Jamesonian Unconscious. The Aesthetics of Marxist Theory*, Durham and London, 1995, shares many of Jameson's views, for example, on 'state communism' in Eastern Europe, the Stalinist bureaucracy, the designation of any nationalist liberation movements as Marxist e.g. the ANC and the FMLN. He quotes interesting comments from Jameson interviewed in 1982 where Jameson stated that the first step to real social change is the creation of a 'social democratic movement' and for that you need 'a Marxist intelligentsia and a Marxist culture' (p.40).

61. Crowther, *Critical Aesthetics*, p.ix.

62. K. Hassell, 'Revolutionary Theory and Imperialism. From Hilferding to Trotsky', *Permanent Revolution*, no.8, Spring 1989, p.53.

63. A. Callinicos, 'Marxism and Imperialism Today', in *Marxism and the New Imperialism*, London, Chicago and Melbourne, 1994, p.36. See also 'Capitalism and Nationalism in the "Third World"', in *Trotskyist International*, no.15, October/December 1994, pp.22–6.

64. 'Chaos in the New World Order', *Trotskyist International*, no.15, October/ December 1994, p.9.

65. 'From Cold War to New Imperialist Order. World Politics and Economics from the 1960s to the 1990s', *Trotskyist International*, no.5, Autumn 1990, pp.4– 41. Quote from p.6. This excellent article gives an overview and analysis of the whole period of 'late capitalism' (as Mandel terms it) during which post-modernism developed.

66. Ibid., p.7.

67. This theory is still advocated by the Socialist Workers Party (Britain) and its international sister organizations. For a summary see J. Rees, 'The New Imperialism', in *The New Imperialism*, pp.94–101. For critiques of this theory see 'The "Permanent Arms Economy"', in *Trotskyist International*, no. 17, May– August 1995, pp.30–1; Mandel, *Late Capitalism*, chapter 9; and P. Mattick, *Economic Crisis and Crisis Theory*, New York, n.d. 1981?, pp.213–16. For a summary of debates within Marxism about the nature and survival of capitalism

in the imperialist epoch see chapter 4 of J. Townshend, *The Politics of Marxism. The Critical Debates*, London and New York, 1996.

68. E. Mandel, *Late Capitalism*, London, 1978 edition, p.9. For an assessment of this work see M. Roux, 'From Trotskyism to centrism. Ernest Mandel (1923–1995)', *Trotskyist International*, no.18, October/December 1995, pp.22–6; P. Mattick, *Economic Crisis*, chapter 5, pp.165–226; B. Rowthorn, 'Late Capitalism', *New Left Review*, no.98, July–August, 1976, pp.59–83.

69. Jameson, *Postmodernism*, p.xix.

70. M. Schapiro. 'The Still Life as a Personal Object – a Note on Heidegger and Van Gogh', in M. Simmel ed., *The Reach of Mind*, New York, 1968, pp. 203–9.

71. For a summary of Derrida's deconstructive approach to the Van Gogh painting see chapter 8 'Semiotics 11: Deconstruction', in L. Schneider Adams, *The Methodologies of Art. An introduction*, Icon Editions, New York, 1996, pp.162–78.

72. See J.A. Walker, 'Art History Versus Philosophy. The Enigma of the "Old Shoes"', in Walker, *Van Gogh Studies*, London, 1981, p.65. I am greatly indebted to this useful and clearly written article for teasing out some of the issues raised by various writers on Van Gogh's shoe paintings.

73. Jameson, *Postmodernism*, p.349.

74. Ibid., p.25.

75. J. Baudrillard, *Simulations*, New York, 1983, p.4.

76. Ibid., p.99. Baudrillard suggests that Warhol (and Baudelaire) conceive of the work of art as absolute commodity, defying both the domain of use value and that of exchange value. It now enters the domain of pure sign exchange value. How this prevents it having a use value and an exchange value is not clear to me, although the use value of an art representation of a tin of soup is obviously different from the use value of a tin of soup, for instance. Benjamin Buchloh agrees with Baudrillard's argument stating: 'The conditions of semantic atrophy acquired by the absolute commodity under late capitalism function now merely as an affirmation of a universally governing principle of sign exchange value as it rules everyday perception.' Buchloh in G. Garrels ed., *The Work of Andy Warhol*, Seattle, 1989, p.65. As a commodity, absolute or not, the commodified sign still functions as a commodity embodying and obscuring, at the same time, social relations, specifically relations of production and consumption.

77. Baudrillard, p.136.

78. Quoted in Harvey, *The Postmodern Condition*, p.208.

79. Quoted by Schapiro, 'The Still Life as a Personal Object', p.204.

80. M. Heidegger, *Poetry, Language, Thought*, New York, 1975, pp.71, 77.

81. Ibid., p.79.

82. Walker, *Van Gogh Studies*, p.70.

83. R. Castleman, *The Prints of Andy Warhol*, New York, 1990, p.26.

84. T. Crow, 'Saturday Disasters: Trace and Reference in Early Warhol', in Guilbaut, *Reconstructing Modernism*, p.313.

85. T. Atkinson, 'Warhol's Voice, Beuys' Face, Crow's Writing', in Roberts, *Art Has no History!*, p.161.

86. Ibid., p.163.

87. R. Castleman refers to Warhol's donations to charities and other good causes, and support for the political campaigns of McGovern, Carter and Edward Kennedy, as well as his donations of prints to fund a chair in art history in honour of Meyer Schapiro at Columbia University! See *The Prints of Andy Warhol*, p.31.

88. Ibid., p.36, quote from Warhol in 1962.

89. P. Hakett ed., *The Andy Warhol Diaries*, New York, 1989, p.306.

90. Ibid., p.330.

91. Castleman, p.32.

92. J.A. Walker, *Art in the Age of Mass Media*, London, 1983, p.42.

93. Ibid., p.36.

94. Ibid., p.41.

95. Jameson, *Postmodernism*, p.175.

96. Other criticisms have been made of Jameson which I do not want to examine here in any great detail. However I recently read an essay on Jameson and Warhol which accuses Jameson of being 'aggressive' to the artist due to Jameson's attempt to defend himself against 'homosexual contamination'. The author writes: 'Jameson's recoil from Warhol, his envious delight of the subject dissolving in sensation, and his anxieties about the loss of agency in the public sphere pertain to a general class of straight-identified, male left intellectuals, in particular, vanguard marxists.' I think this statement is based on a misreading of Jameson on Warhol, and although it is true that Jameson does not mention homosexuality at all in his discussion of Warhol, Dellamora's arguments misunderstand Jameson's position. Certain statements in the article are simply wrong, for example: 'Taking Warhol as the representative figure of this epoch, Jameson poses against him the loss of the pursuit of collective good that Marx and Engels worked to gain for both the proletarian subject and the vanguard intellectual.' R. Dellamora, 'Absent Bodies/Absent Subjects. The political unconscious of postmodernism', in P. Horne and R. Lewis eds, *Outlooks. Lesbian and Gay Sexualities and Visual Cultures*, London and New York, 1996, p.29.

97. Ahmad, 'The Politics of Literary Postcoloniality', *Race and Class*, vol.36, no.3, 1995, pp.1–20.

98. Ibid., pp.13, 16, 17.

99. K. Mercer, 'Busy in the Ruins of Wretched Phantasia', in *Mirage. Enigmas of Race, Difference and Desire*, ICA London, 1995, p.50. The other essays are by David A. Bailey.

100. A. Read ed., *The Fact of Blackness. Franz Fanon and Visual Representation*, London and Seattle, 1996. The most useful essay in this book is by Françoise Vergès, 'Chains of Madness, Chains of Colonialism: Fanon and Freedom'.

101. Fanon, *Black Skin, White Masks*, translated C.L. Markmann, London, 1986, p.vii, introduction by Bhabha.

102. *The Fact of Blackness*, p.146.

103. For more information and analysis see S. Gilman, 'Black Bodies, White Bodies: Toward an Iconography of Female Sexuality in Late Nineteenth-century Art, Medicine and Literature', in H.L. Gates Jr ed., *"Race", Writing and Difference*, Chicago and London, 1986, pp.223–61.

104. The text is also quoted in P. Rose, *Jazz Cleopatra. Josephine Baker in her Time*, London, 1990, p.31. Also useful on Baker, 'Africanicity' and French modernity are the articles by B. Gendron, 'Fetishes and Motorcars: Negrophilia in French Modernism', *Cultural Studies*, vol.4, no.2, May 1990, pp.141–55; and J. Kear, 'Vénus Noire: Josephine Baker and the Parisian music-hall', in M. Sherringham ed., *Parisian Fields*, London, 1966, pp.46–70.

105. Quoted in Bhabha, *The Location of Culture*, pp.2–3.

106. K. Malik, *The Meaning of Race*, pp.257–8.

107. *The Fact of Blackness*, p.146.

108. *The Location of Culture*, p.190. Bhabha develops this argument from Arendt's *The Human Condition*. Malik shrewdly discusses Arendt's influence on poststructuralism and postcolonialism. As a student of Heidegger, 'her theory of totalitarianism [she argued there was no difference between fascism and communism-GD] carries over the main themes of Heidegger's thought in its anti-mass character, its incipient anti-rationalism and in particular its hostility to the Enlightenment as the embodiment of both'. Malik, *The Meaning of Race*, p.244.

109. These issues are briefly touched upon in the interesting piece by J. Decter, 'Renée Green. Re-mapping Narratives of History and Identity', *Forum International*, vol.iv, no.16, January/February 1993, pp.48–53. Very many thanks to the Pat Hearn Gallery for sending me this article, along with other useful material on Renée Green.

110. *The Fact of Blackness*, p.151.

111. On Toussaint l'Ouverture see C.L.R. James, *The Black Jacobins. Toussaint l'Ouverture and the San Domingo Revolution*, London, 1991, first published 1938. For more on masculinity and masquerade see the book accompanying the exhibition *The Masculine Masquerade. Masculinity and Representation*, Cambridge, Mass. and London, 1995.

112. For useful essays on fetishism in culture and the visual arts see E. Apter and W. Pietz eds, *Fetishism as Cultural Discourse*, Ithaca and London, 1993, and A. Shelton ed., *Fetishism. Visualising Power and Desire*, exhibition catalogue, South Bank Centre, London, 1995.

113. *The Fact of Blackness*, p.150.

Conclusion

This book has attempted to lay some groundwork for attempts to reconstruct and reformulate a Marxist method of art and cultural history for the new millennium, as well as tracing some of the genealogies of social/ist histories of art. It has been my concern to differentiate Marxist theories of culture from more general social history approaches to the understanding of visual culture. However Marxism is not some fossilized or fetishized body of thought, and while we need to be familiar with, and utilize, the method of Marxism as developed throughout the nineteenth and twentieth centuries, this method must itself be developed in history to be refocused on the present. I disagree strongly with the recently published views of Carrier, who writes that 'My sense is that, as cultural historians look back, Marx's work will come to seem to belong to a period style, to nineteenth-century ways of thinking that tell us nothing about how to proceed in the present.'[1]

However as a basic starting point, we need to understand what Marxism and dialectical materialism actually are, and not simply accept what they have been described as at second-hand. The first sections of this book were devoted to making this clear. We also need to be aware of the reasons why, and the manner in which, Marxism has been interpreted in various ways, in different economic and political situations. The material reasons for different interpretations, distortions and reformulations of Marxism are important in understanding the state of Marxist art and cultural history today.

I have written this book from a Trotskyist position, as is probably apparent by now. No doubt many would claim to be Marxists and reject Trotskyism, and many do. However in my view Trotskyism represents the best available development of theory and practice available to us in the last years of the twentieth century, and that is why it is the theoretical basis of my investigation of history, both cultural and political.

We cannot escape our material situation in moribund capitalism and imperialism by individual reconstructions of ourselves or elaborate theorizing. We can, however, if we choose to, consciously struggle against it. We are not prisoners of economic determinism, and neither is art. Am I offering some model of Marxist art and cultural history, then, simply as a more sophisticated method than other theories of culture? I hope not. I have no wish to repeat the arguments of the likes of Arnold Hauser and others who saw 'good' and 'bad' sides to Marxism – an interesting dialectical appreciation of culture on the one hand, and a misguided utopian desire to smash up the capitalist state on the other. You can pick and choose, of course, but then what remains will not be Marxism.

So can we really have a Marxist art history and Marxist art historians? Should all Marxist cultural theorists engage in politics? I cannot answer that in this book. That is for individuals to answer for themselves. In any case, if people are Marxists it would show a lack of understanding of dialectical materialism for them to separate off different spheres of their lives into discrete categories such as being a Marxist cultural historian, yet a non-Marxist parent, for example. All this is not easy, of course, and involves a conscious struggle in all aspects of life. Given the weight of internally and externally lived ideology, new ways of thinking and acting have to be consciously worked for.

In discussing the work of particular scholars and its usefulness for a Marxist enquiry in our academic field, we need to look both at questions of method and questions of documentation and findings, for there is much of significance in many works written by non-Marxists of course. However the question of method is the kernel of my enquiry in this book, and I have taken this to be more significant than actual discoveries and conclusions by various scholars. This is also why I have spent some time refuting what I consider to be the prevailing idealism of much recent writing in art history and cultural studies. We should never lose sight of the fact that all these writings are produced by actual people in particular material situations, and ultimately these material conditions will play the most significant role in enabling us to understand the reasons for the development of discourse, text and theory in contemporary cultural writings. As the early Marx wrote 'The question whether objective truth can be attributed to human thinking is not a question of theory but is a *practical* question. In practice man must prove the truth, that is, the reality and power, the this-sidedness of his thinking. The dispute over the reality or non-reality of thinking which is isolated from practice is a purely *scholastic* question.'[2]

Notes

1. D. Carrier, 'Art Criticism and the Death of Marxism', *Leonardo*, vol.30, no.3, 1997, pp.241–5, quote from p.244.
2. Marx, 'Theses on Feuerbach', thesis 2, in Marx and Engels, *Selected Works in One Volume*, London, 1968, p.28.

Select Bibliography

Adorno, T.W. (1984), *Aesthetic Theory*, London.

Ahmad, A. (1992), *In Theory. Classes, Nations, Literatures*, London and New York.

Althusser, L. (1971), *Lenin and Philosophy and Other Essays*, New York and London.

Baudrillard, J. (1983), *Simulations*, New York.

Bernstein, J. (1996), 'The Death of Sensuous Particulars: Adorno and Abstract Expressionism', *Radical Philosophy*, no.76, March–April, pp.7–18.

Bhabha, H.K. (1994), *The Location of Culture*, London and New York.

Blessing, J. (1992), 'Resisting Determination. An Introduction to the Work of Claude Cahun, Surrealist Artist and Writer', *Found Object*, vol.1, no.1, Fall, pp.68–78.

Brown, B. (1989), 'The Look We Look At. T.J. Clark's Walk Back to the Situationist International', *Arts Magazine*, January, pp.61–4.

Burnham, C. (1995), *The Jamesonian Unconscious. The Aesthetics of Marxist Theory*, Durham and London.

Butler, J. (1993), *Bodies that Matter. On the Discursive Limits of 'Sex'*, New York and London.

Cahun, C. (1934), *Les Paris sont Ouverts*, Paris.

Callinicos, A. (1983), *Marxism and Philosophy*, Oxford.

—— (1989), *Against Postmodernism. A Marxist Critique*, Cambridge.

——, Rees, J., Harman, C., Haynes, M. (1994), *Marxism and the New Imperialism*, London.

Caronia, M. and Vidali, V. (1981), *Tina Modotti. Photographe et Révolutionnaire*, Paris.

Chaplin, E. (1994), *Sociology and Visual Representation*, London and New York.

Clark, T.J. (1974), 'The Conditions of Artistic Creation', *Times Literary Supplement*, May, pp.561–2.

—— (1990), 'Jackson Pollock's Abstraction', in S. Guilbaut ed., *Reconstructing Modernism. Art in New York, Paris and Montreal, 1945–1964*, Cambridge Mass. and London, pp.172–243.

—— (1994), 'In Defense of Abstract Expressionism', *October*, no.69, Summer, pp.23–48.

Claude Cahun. Photographe. (1995), Musée d'Art Moderne de la Ville de Paris, Paris.

Clayson, H. (1995), 'Materialist Art History and its Points of Difficulty', *Art Bulletin*, vol.LXXVII, no.3, pp.367–71.

Constantine, M. (1993), *Tina Modotti: A Fragile Life*, 2nd ed., London.

Cornforth, M. (1974), *Dialectical Materialism. An Introduction*, 3 vols, London.

Cranshaw, R. (1983), 'The Possessed. Harold Rosenberg and the American Artist', *Block*, 8, pp.3–10.

Crary, J. (1989), 'Spectacle, Attention, Counter-memory', *October*, part 50, Fall, pp.97–107.

Crowther, P. (1993), *Critical Aesthetics and Postmodernism*, Oxford.

Deutscher, I. (1963), *The Prophet Outcast*, Oxford.

Doy, G. (1995), *Seeing and Consciousness. Women, Class and Representation*, Oxford and Washington D.C.

Ebert, T.L. (1995), '(Untimely) Critiques for a *Red Feminism*', in M. Zavarzadeh, T.L. Ebert, D. Morton eds, *Post-Ality: Marxism and Postmodernism*. Special issue of *Transformation. Marxist Boundary Work in Theory, Economics, Politics and Culture*, Spring, pp.113–49.

Eldridge, R. (1993), 'Althusser and Ideological Criticism of the Arts', in S. Kemal and I. Gaskell eds, *Explanation and Value in the Arts*, Cambridge, pp.190–214.

Engels, F. (1978), *Anti-Dühring. Herr Eugen Dühring's Revolution in Science*, Moscow.

Freud, S. (1991), 'The Psychogenesis of a Case of Homosexuality in a Woman', in *Penguin Freud Library*, vol.9, pp.369–400.

—— (1991), *On Metapsychology. Penguin Freud Library*, vol.11, Harmondsworth.

Frida Kahlo and Tina Modotti (1982), exhibition catalogue, Whitechapel Art Gallery, London.

Gilbert, J.B. (1968), *Writers and Partisans: A History of Literary Radicalism in America*, New York.

Gombin, R. (1975), *The Origins of Modern Leftism*, Harmondsworth.

—— (1978), *The Radical Tradition. A Study in Modern Revolutionary Thought*, London.

Guilbaut, S. ed. (1990), *Reconstructing Modernism. Art in New York, Paris*

and Montreal, 1945–1964, London and Cambridge, Mass.

Hadjinicolaou, N. (1978), *Art History and Class Struggle*, London.

Harvey, D. (1990), *The Condition of Postmodernity*, Oxford.

Hauser, A. (1959), *The Philosophy of Art History*, London.

—— (1962), *The Social History of Art*, 4 vols, London.

Hegel, G.W.F. (1927), *Phenomenology of Spirit*, translated A.V. Miller, Oxford.

—— (1975), *Aesthetics. Lectures on Fine Art*, translated T.M. Knox, 2 vols, Oxford.

—— (1993), *Introductory Lectures on Aesthetics*, Harmondsworth.

Heidegger, M. (1975), *Poetry, Language, Thought*, New York.

Herbert, J.D. (1984–5), 'The Political Origins of Abstract-Expressionist Art Criticism', *TELOS*, vol.62, pp.178–87.

Hooks, M. (1993), *Tina Modotti: Photographer and Revolutionary*, London.

Jacoby, R. (1983), *The Repression of Psychoanalysis. Otto Fenichel and the Political Freudians*, New York.

Jameson, F. (1991), *Postmodernism or the Cultural Logic of Late Capitalism*, London.

Kaminsky, J. (1962), *Hegel on Art. An Interpretation of Hegel's Aesthetics*, New York.

Kellner, D. ed. (1977), *Karl Korsch: Revolutionary Theory*, Austin and London.

Kemp, T. (1984), *Stalinism in France. vol.1 The First Twenty Years of the French Communist Party*, London.

King, D. (1986), *Trotsky. A Photographic Biography*, Oxford.

Leahy, J. (1986), 'Zina', *Monthly Film Bulletin*, vol.53, part 628, May, pp.136–7.

—— (1986), 'Taking Objective Shape on the Streets', interview with Ken McMullen, *Monthly Film Bulletin*, vol. 53, part 628, May, pp.138–40.

Lenin, V.I. (1947), *Materialism and Empirio-Criticism. Critical Comments on a Reactionary Philosophy*, Moscow.

Leperlier, F. (1992), *Claude Cahun. L'Ecart et la Métamorphose*, Paris.

Lewis, H. (1988), *The Politics of Surrealism*, New York.

Lowe, S.M. (1995), *Tina Modotti. Photographs*, New York.

Lloyd, C. (1997), 'Marxism versus Postmodernism', *Trotskyist International*, 21, January–June, pp.38–48.

Malevich (1989), *Art and Design Profiles*, London and New York.

Malik, K. (1996), *The Meaning of Race. Race, History and Culture in Western Society*, Basingstoke.

Mandel, E. (1978), *Late Capitalism*, London.

Marx, K. (1975), 'Economic and Philosophical Manuscripts (1844)', in *Marx. Early Writings*, ed. L. Colletti, Harmondsworth, pp.279–400.

—— (1976), *Capital*, vol.1, introduction by E. Mandel, Harmondsworth.

—— and Engels, F. (1973), *Selected Works in One Volume*, London.

Mattick, P. (1981?), 'Ernest Mandel's Late Capitalism', in *Economic Crisis and Crisis Theory*, New York, pp.165–226.

McClintock, A. (1995), *Imperial Leather. Race, Gender and Sexuality in the Colonial Contest*, London and New York.

Mirage: Enigmas of Race, Difference and Desire (1995), exhibition publication, INIVA and ICA, London.

Mise en Scène. Claude Cahun, Tacita Dean, Virginia Nimarkoh (1994), catalogue of exhibition, ICA, London.

Molderings, H. (1982), 'Tina Modotti. Fotographin und Agentin des GPU', *Kunstforum International*, vol.9, November, pp.92–103.

Novack, G. (1978), *Polemics in Marxist Philosophy*, New York.

Orton, F. and Pollock, G. (1996), *Avant-gardes and Partisans Reviewed*, Manchester.

Orwicz, M.R. (1985), 'Critical Discourse in the Formation of a Social History of Art: Anglo–American response to Arnold Hauser', *The Oxford Art Journal*, vol.8, no.2, pp.52–62.

Podro, M. (1982), *The Critical Historians of Art*, New Haven and London.

Pomper, P. ed. (1986), *Trotsky's Notebooks 1933–1935. Writings on Lenin, Dialectics and Evolutionism*, New York.

Raphael, M. (1968), *The Demands of Art*, London and New York.

—— (1981), *Proudhon, Marx, Picasso. Three essays in Marxist Aesthetics*, London.

Read, A. (1996), *The Fact of Blackness. Frantz Fanon and Visual Representation*, London and Seattle.

Rees, A.L. and Borzello, F. eds (1986), *The New Art History*, London.

Roberts, J. ed. (1994), *Art has no History! The Making and Unmaking of Modern Art*, London.

Rose, J. (1986), *Sexuality in the Field of Vision*, London.

Rosenberg, H. (1970), *The Tradition of the New*, London.

Rowthorn, B. (1976), 'Late Capitalism', *New Left Review*, no.98, July–August, pp.59–83.

Rutherford, J. ed. (1990), *Identity, Community, Culture, Difference*, London.

Schapiro, M. (1968), 'The Still Life as Personal Object – a Note on Heidegger and Van Gogh', in M.L. Simmel ed., *The Reach of Mind: Essays in memory of Kurt Goldstein*, New York, pp.203–9.

Schlossman, M. and di Giovanni, J. (1987–8), 'Trotsky's Troubled Daughter. Ken McMullen discusses *Zina*', *Cinéaste*, vol.16, part 1/2, pp.44–5.

Shohat, E. and Stam, R. (1995), 'The Politics of Multiculturalism in the Postmodern Age', *Art and Design*, vol.10, no.7/8, July–August, pp.10–16.

Slaughter, C. (1975), *Marxism and the Class Struggle*, London.

—— (1980), *Marxism, Ideology and Literature*, Basingstoke.

—— (1987), *Marx and Marxism. An Introduction*, London and New York.

Solomon, M. ed. (1979), *Marxism and Art, Essays Classic and Contemporary*, Brighton.

Sprinker, M. (1987), *Imaginary Relations. Aesthetics and Ideology in the Theory of Historical Materialism*, London.

Stocking, D. (1987), '*Not Everything is Possible*: French Stalinism and the Popular Front, 1936–38', *Permanent Revolution*, 5, Spring, pp.14–25.

Teichman, J. and White, G. (1995), *An Introduction to Modern European Philosophy*, Basingstoke.

Thistlewood, D. ed. (1993), *American Abstract Expressionism*, Liverpool.

Trotsky, L. (1973), *In Defence of Marxism*, New York.

—— (1975), *My Life*, Harmondsworth.

—— (1977), *The Crisis of the French Section (1935–36)*, New York.

—— (1977), *Leon Trotsky on Literature and Art*, ed. P.N. Siegel, New York.

—— (1979), *Leon Trotsky on France*, New York.

Walker, J.A. (1981), 'Art History versus Philosophy: The Enigma of the "Old Shoes"', *Van Gogh Studies. Five Critical Essays*, London.

Werckmeister, O.K. (1991), 'A Working Perspective for Marxist Art History Today', *The Oxford Art Journal*, vol.14, no.2, pp.83–7.

—— (1995), 'From a better history to a better politics', *Art Bulletin*, vol.LXXVII, no.3, September, pp.387–91.

Witkin, R.W. (1995), *Art and Social Structure*, Cambridge.

Wolff, J. (1981), *The Social Production of Art*, Basingstoke.

—— (1993), *Aesthetics and the Sociology of Art*, 2nd. ed., Basingstoke.

Wollen, P. (1989), 'The Situationist International', *New Left Review*, no.174, pp.67–96.

Wood, P. (1992), 'The Politics of the Avant-Garde', *The Great Utopia. The Russian and Soviet Avant-Garde 1915–1932*, Exhibition Catalogue, Guggenheim Museum, Tretiakov State Russian Museum, Schirn Kunsthalle, Frankfurt, pp.1–24.

Index